The Gender of the Gift

STUDIES IN MELANESIAN ANTHROPOLOGY

General Editors

Gilbert H. Herdt
Fitz John Porter Poole
Donald F. Tuzin

The Gender
of the Gift

Problems with Women and
Problems with Society in Melanesia

Marilyn Strathern

UNIVERSITY OF CALIFORNIA PRESS
Berkeley · Los Angeles · London

University of California Press
Berkeley and Los Angeles, California

University of California Press, Ltd.
London, England

Copyright © 1988 by
The Regents of the University of California

Library of Congress Cataloging in Publication Data

Strathern, Marilyn.
 The gender of the gift / Marilyn Strathern.
 p. cm.—(Studies in Melanesian anthropology)
 Bibliography: p.
 Includes index.
 ISBN 0–520–06423–2 (alk. paper)
 1. Melanesians—Social life and customs. 2. Women—Melanesia—
Social conditions. 3. Feminism. I. Title. II. Series.
DU490.S79 1988 305.4′0993 88–14267

Printed in the United States of America

1 2 3 4 5 6 7 8 9

For B. H. M., H. T. and A. L.

Woman is a social being, created within and by a specific society. As societies differ, so too do women. It is easy to forget this and to see 'woman' as a timeless, changeless category. Woman in ancient Greece is seen to be the same as woman today; only their circumstances differ. From this view emerges an ahistorical sense of the meaning of being a woman, and of the simple continuity of our oppression. An anti-woman quotation from Xenophon sits comfortably beside one from St. Augustine, and both chime in with those of Rousseau, Hegel and Norman Mailer. Woman, man and misogyny become constants, despite the world around them turning upside down.

I would argue instead that women and men and the nature of misogyny and oppression are all qualitatively different in different times and places. The sense of similarity, of easily drawn parallels, is illusory. Women themselves change. It is precisely the differences in circumstances that is crucial to the meaning and sense of becoming a woman. We must therefore understand the particularity of our own circumstances in order to understand ourselves.

Jill Julius Matthews
Good and Mad Women
1984

The unit of investigation is the social life of some particular region of the earth during a certain period of time.

A. R. Radcliffe-Brown
Structure and Function in Primitive Society
1952

The future of Western society lies in its ability to create social forms that will make explicit distinctions between classes and segments of society, so that these distinctions do not come of themselves as implicit racism, discrimination, corruption, crises, riots, necessary 'cheating' and 'finangling' and so on. The future of anthropology lies in its ability to exorcise 'difference' and make it conscious and explicit.

Roy Wagner
The Invention of Culture
1975

Contents

Preface

It was an early hope that feminist-inspired scholarship within anthropology would change not just ways of writing about women or about women and men but would change ways of writing about culture and society. That hope has been realized to some extent through experimentation with narrative modes. The present exercise is an experiment that exploits orthodox anthropological analysis as itself a literary form of sorts. Its style is argumentative.

Although part of the impetus for this exercise comes from outside anthropology, there is also an internal necessity to it: I am concerned with an area of the world, the islands of Melanesia, where gender* symbolism plays a major part in people's conceptualizations of social life. Few ethnographers can avoid the issues of gender relations. Few to date have thought it necessary to develop anything one might call a theory of gender. By 'gender' I mean those categorizations of persons, artifacts, events, sequences, and so on which draw upon sexual imagery—upon the ways in which the distinctiveness of male and female characteristics make concrete people's ideas about the nature of social relationships. Taken simply to be 'about' men and women, such categorizations have

*In this work, 'gender' as an unqualified noun refers to a type of category differentiation. I do not mean gender identity unless I say so. Whether or not the sexing of a person's body or psyche is regarded as innate, the apprehension of difference between 'the sexes' invariably takes a categorical form, and it is this to which gender refers. The forms 'male' and 'female' indicate gender constructs in this account.

often appeared tautologous. Indeed, their inventive possibilities cannot be appreciated until attention is paid to the way in which relationships are construed through them. Understanding how Melanesians present gender relations to themselves is not to be separated from understanding how they so present sociality. To take gender as a theoretically distinct subject, then, will require one to address the principles upon which such categorizations are based and to ask about their generality across the societies of this region.

No such attempt could ignore the origin of this interest in issues raised by Western feminist scholarship. Part 1 of this book tacks back and forth between certain anthropological and certain feminist-derived questions pertinent to the writing of Melanesian ethnographies over the last two decades. My initial intention was to document the influence that feminist theory might have had on the anthropology of the region: whether there were new facts and themes originating from the new feminism that emerged in Western Europe and North America over the later 1960s and early 1970s, also a period of expanding anthropological fieldwork in Melanesia.

In the end, I did not accomplish that historical accounting. It seems that it is easier to take on board new ideas as a matter for discussion and debate than to adopt them as precepts for ethnographic practice. Early exceptions include the work of Annette Weiner and Daryl Feil. On the whole, however, the flood of general discussion on the 'anthropology of women' or on 'gender relations' has not been matched by feminist-informed descriptions of entire societies. Even where there have been apparent shifts, the connections may be left to inference. Few Melanesian ethnographers refer directly to their work as feminist; some admit it as a context for their anthropology, while others on whom I draw would eschew the label.

It may well be that my intention was premature, for in the mid-1980s we are in the midst of a burgeoning 'second wave' of Melanesian studies, including recently published monographs by Brenda Clay, Deborah Gewertz, Lisette Josephides, Miriam Kahn, Rena Lederman, Nancy Munn, and Lorraine Sexton, to mention only women anthropologists and only some of them. However, even the limited range of earlier material that I did scrutinize raised queries as equally against feminist as against anthropological assumptions. Yet these were not to be conflated. The one mode was not simply to be subsumed under the other, hence the alternations.

Part 2 is a synthesis of sorts. It describes certain techniques or

strategies in the conceptualization of social relations that appear common to a range of Melanesian cultures, both those of a 'patrilineal' and of a 'matrilineal' cast. The synthesis is necessarily a product of the alternations traversed in Part 1. And these techniques necessarily embody and are thus our evidence for the principles to which I referred. Yet, really, one should dismantle this conflation in turn and grasp the cultures at stake by a further alternation: between elucidating the manner in which these techniques seem to work for the actors involved and the only way in which the anthropologist can make them work for him or her—by laying them out *as though* they embodied principles of organization. These are in fact quite different kinds of productions. Anthropological analysis achieves its proximity to and replication of its subjects' comprehensions through a form of comprehension, of knowledge, that belongs distinctively to itself.

The opening two chapters, which introduce issues in the relationship between anthropological and feminist approaches, can also be read as an ethnography of Western knowledge practices. If the body of the book is an exposition of what I think of instead as Melanesian knowledge practices, the conclusions reconsider strictly feminist (male domination) and anthropological (cross-cultural comparison) questions in its light.

The concept of 'the gift' has long been one of anthropology's entry points into the study of Melanesian societies and cultures. Indeed, it provides a springboard for general theorizing: the reciprocities and debts created by the exchange of gifts are seen to comprise a form of sociality and a mode of societal integration. In Melanesia, gift exchanges regularly accompany the celebration of life-cycle events and are, most notably, instruments of political competition. Often gifts subsume persons themselves, especially under patrilineal regimes where women move in marriage from one set of men to another, although this is not the only context in which objects, as they pass from donor to recipient, appear to be categorized as male or female. However, one cannot read such gender ascriptions off in advance, not even when women appear to be the very items which are gifted. It does not follow that 'women' only carry with them a 'female' identity. The basis for classification does not inhere in the objects themselves but in how they are transacted and to what ends. The action is the gendered activity.

This is no quibble. In the conventional anthropological view, gift exchange is taken as a self-evident act, a transaction that happens to deploy items of various kinds, including male or female ones, as assets or

resources at the transactor's disposal. The behavior is assumed to be categorically neutral with power residing in the control of the event and of the assets, as in the manner in which 'men' control 'women'. But in Melanesian culture, such behavior is not construed as gender neutral: it itself is gendered, and men's and women's ability to transact with this or that item stems from the power this gendering gives some persons at the expense of others, as does the necessity and burden of carrying through transactions. To ask about the gender of the gift, then, is to ask about the situation of gift exchange in relation to the form that domination takes in these societies. It is also to ask about the 'gender' of analytical concepts, the worlds that particular assumptions sustain.

Exploring the manner in which gender imagery structures concepts and relations is among feminism's projects; however, my assessment of explicit feminist writing remains focused on one or two of the debates that have defined the self-described 'feminist anthropology' of the last decade. Many of the concepts and assumptions that inform these debates prompt self-inquiry. Yet the feminist movement has roots so clearly in Western society that it is also imperative to contextualize its own presuppositions. The motive is a proper one, since feminist thought itself seeks to dislodge assumptions and prejudgments. I take this endeavor seriously, through questioning the premises of its assault on anthropological ones. At the same time, I have wanted to document ways in which anthropology might respond to feminist debate, in anthropology's context. This requires reference back to the social and cultural data (viz. ethnography) through which anthropology creates itself. Only thus can one take anthropology as seriously as feminism and not simply pick at what tidbits take one's polemical or theoretical fancy.

It is also important that there remain more data than my particular interests address, in order to preserve a sense of a partial job. Ethnographies are the analytical constructions of scholars; the peoples they study are not. It is part of the anthropological exercise to acknowledge how much larger is their creativity than any particular analysis can encompass. By the same token, although it is necessary to present arguments through an historically and geographically specific range of material, and the cultures and societies of Melanesia provide this range, this book is not only about Melanesia. It is also about the kinds of claims to comprehension that anthropology can and cannot make.

Acknowledgments

The cause and origin of this book have separate sources. Its cause was an invitation from the Department of Anthropology in the University of California at Berkeley to give a series of general lectures in 1984. Its origin belongs to The Australian National University in Canberra, where I spent 1983–1984 as a member of a Research Group in the Department of Anthropology. The Group addressed itself to "Gender Relations in the Southwestern Pacific: Ideology, Politics, and Production," and I borrowed this title for my lectures.

I owe special thanks to the then chair of the Department at Berkeley, Nelson Graburn, and to Elizabeth Colson, whose last teaching year it was, for making me so welcome. I also owe much to the interest of a class of students who made sure I did not get away with too many liberties—Jeanne Bergman, Nicole Constable, Roger Lancaster, Nancy Lutz, Kamala Visweswaran. Gayle Rubin and Marilyn Gelber both made substantial comments. Gail Kligman, Amal Rassam, and Kirim Narayan will know why I might wish to remember them here, as will Paul Rabinow.

The Californian stimulus has since been sustained through the extensive and critical appraisal that this work received from the editors of the Melanesian Studies series. I have been fortunate in continuing to be provoked by student interest, including those students of the Department of Social Anthropology in Manchester on whom I hazarded my ideas in 1986–1987. Colleagues in the Department have all, intellectu-

ally and otherwise, assisted in this enterprise, and I do thank them.
However, it was during the intervening year at Trinity College in Cam-
bridge that the first draft was written, and the interlude was invaluable.

The A.N.U. Research Group was convened by Roger Keesing, Marie
Reay, and Michael Young. Elsewhere I have joined with members of
the group in publication: here I acknowledge my debt to their support.
I am grateful to James Weiner for his apt criticism of an earlier draft,
to David Schneider and Lisette Josephides for their comments, and to
Margaret Jolly for furnishing me with both material and ideas. Christina
Toren will recognize, I hope, the effect of her advice. With unstinting
generosity the Head and staff of the Department of Anthropology at
A.N.U. assisted with the preparation of this manuscript some time after
I had left their company: my thanks here are a very inadequate return,
as they are to the skill and help of Jean Ashton in Manchester.

The Berkeley lectures were an occasion for bringing together topics
treated in other contexts. They postdate but also draw upon several
years of cooperation with Andrew Strathern. I am, in addition, grateful
to the editors and publishers of the following articles for allowing me
to make use of them here:

"Subject or object? Women and the circulation of valuables in High-
 lands New Guinea." In R. Hirschon, ed. *Women and Property,
 Women as Property*. London: Croom Helm 1984.

"Domesticity and the denigration of women." In D. O'Brien and S. Tif-
 fany, eds. *Rethinking Women's Roles: Perspectives from the Pacific*.
 Berkeley, Los Angeles, London: University of California Press 1984.

"Knowing power and being equivocal." In R. Fardon, ed. *Power and
 Knowledge: Anthropological and Sociological Approaches*. Edin-
 burgh: Scottish Academic Press 1985.

A special obligation must be acknowledged to Gilbert Herdt. The
book could not have been written without the sharpness with which he
brings into focus certain analytical approaches to the study of ritual.
Although it takes the form of complementary rather than symmetrical
schismogenesis, my response is to be read as positive rather than nega-
tive. There is a different kind of debt to those whose work has been
absorbed to become part of one's own. In my mind, they stand as figures
other than myself, but it would be false to thank them separately from
the use I make of their ideas here—and as ridiculous as expressing

gratitude for being born. I must own to having cheated in one respect, however. My account represents the bibliographical limits on this exercise as it was in 1985, though I have, of course, been influenced by work which has appeared since. Without doubt, Roy Wagner's most recent writings have been by far the most significant.

I have not thanked at all my other sources, which are the accounts of themselves that so many hospitable Melanesians have given to intruding anthropologists of one persuasion or another and, for myself, people from Hagen and Pangia. It is not they who need this book or who would need to write one like it. But if any should care to read it, I hope the present tense and the use of 'we' to mean 'we Westerners' will not prove too much of an irritant. The problem with tense is that neither past nor present will really do—the latter suggesting timeless issues, frozen in the ethnographic record, the former that they belong to a vanished and no longer relevant era. Neither, of course, conveys the truth since ideas are not so mobile nor so immobile as any such attempt to locate them suggests. It is a pity that one is tied to the grammatical choice. And it is a pity that English does not have a dual, for then one could also use 'we' in the sense of 'we two', an inclusion that would not obliterate separateness. Indeed, the work can be read both as an apology and an apologia for a language and a culture that does not make that particular possibility of central concern to the way it imagines itself.

Trinity College, Cambridge, 1985 Marilyn Strathern
University of Manchester, 1987

Introduction

Introduction

1
Anthropological Strategies

It might sound absurd for a social anthropologist to suggest he or she could imagine people having no society. Yet the argument of this book is that however useful the concept of society may be to analysis, we are not going to justify its use by appealing to indigenous counterparts. Indeed, anthropologists should be the last to contemplate such a justification. Scholars trained in the Western tradition cannot really expect to find others solving the metaphysical problems of Western thought. Equally absurd, if one thinks about it, to imagine that those not of this tradition will somehow focus their philosophical energies onto issues such as 'the relationship' between it and the individual.

This has, nonetheless, been among the assumptions to have dogged anthropological approaches to the peoples and cultures of Melanesia. One may think of the kind of attention that has been paid to their rich ceremonial and ritual life, and in some areas as rich a political life. Observers have taken initiation rites, for example, as essentially a 'socialization' process that transforms the products of nature into culturally molded creations. And this process is understood from the actor's point of view: in the case of male initiation, it has been argued that men complete culturally (the growth of boys and their acquisition of adult roles) what women begin, and may even accomplish for themselves, naturally. Equally, it has been argued that political activity is prompted by a need for cohesion, resulting in social structures of areal integration that overcome the refractory centrifugal inclinations of indi-

viduals. Thus social control, the integration of groups, and the promotion of sociability itself have all been read into people's engagement in ceremonial exchange. Far from throwing out such frameworks for understanding, however, I argue instead that we should acknowledge the interests from which they come. They endorse a view of society that is bound up with the very impetus of anthropological study. But the impetus itself derives from Western ways of creating the world. We cannot expect to find justification for *that* in the worlds that everyone creates.

For many purposes of study, this reflection may not be significant. But it must be highly significant for the way we approach people's creations. One of the ethnographic interests of this book will be ritual of a kind often regarded as quintessentially constituted through 'symbolic' behavior. In the process, I propose that political activity be apprehended in similar terms. It becomes important that we approach all such action through an appreciation of the culture of Western social science and its endorsement of certain interests in the description of social life. That affords a vantage from which it will be possible to imagine the kinds of interests that may be at stake as far as Melanesians are concerned. There is, moreover, a particular significance in keeping these interests separate. For much symbolic activity in this region deploys gender imagery. Since the same is true of Western metaphysics, there is a double danger of making cultural blunders in the interpretation of male-female relations.

The danger stems not just from the particular values that Western gender imagery puts upon this or that activity but from underlying assumptions about the nature of society, and how that nature is made an object of knowledge. Only by upturning those assumptions, through deliberate choice, can 'we' glimpse what 'other' assumptions might look like. The consequent we/they axis along which this book is written is a deliberate attempt to achieve such a glimpse through an internal dialogue within the confines of its own language. There is nothing condescending in my intentions.

THE COMPARATIVE METHOD

No doubt it is an exaggeration to say that the comparative method has failed in Melanesia, though there is a special poignancy about the suggestion, for the region as a whole, and especially the Highlands of Papua New Guinea, has long been regarded as an experimental par-

adise. The close juxtaposition of numerous diverse societies, it was thought, could register the changing effect of variables as a gradation of adaptations. Yet few writers have individually attempted systematic comparison beyond the scope of a handful of cases.

Notable exceptions include Brown (1978), who addresses the interconnections between social, cultural, and ecological systems in the Highlands, and Rubel and Rosman's study (1978) of structural models of exchange relations as systemic transformations of one another. Gregory (1982) subsumes the comparison of economic and kinship systems under a general specification of a political economy type: each variant established as a member of a general class or type also validates the utility of the classification. All three works deal with Papua New Guinea. The only general attempt to cover Melanesia remains Chowning's (1977) ethnographic overview. Island Melanesia, beyond Papua New Guinea, has been treated comparatively by Allen (1981; 1984) through a focus on political associations and leadership. His procedure overlaps with the more usual strategy of taking up individual themes for investigation, such as kinship terminologies, male initiation, ritualized homosexuality, trade and exchange, and the institution of *kula* exchange.[1] Collected essays have appeared on all these topics (Cook and O'Brien, eds. 1980; Herdt, ed. 1982c; 1984a; Specht and White, eds. 1978; Leach and Leach, eds. 1983).[2] Here, stretches of ethnography are laid side by side, analytical categories being in part derived from and modified by the examination of each case. This now frequent practice invites contributions from separate authors: the collected-essay format allows each unique case to be presented through the vision of a unique ethnographer.

If there is a failure in all this, it lies in the holism of the original ethnographies. These comparative exercises necessarily draw upon particular ethnographic monographs, and one reason, I think, for their paucity is faintheartedness at both the richness and the totality of these primary sources.

Melanesia is blessed with much good work, not a lack of it. The situation is almost like the one that faced Lessing's perpetrators of *The Sirian Experiments*: the ends of inquiry are already known and what must be found are the reasons for pursuing it.[3] We have considerable information about the distinctiveness of these particular cultures and societies but much less idea why we acquired it. For the holism of the monograph rests on its internal coherence, which creates a sense of autonomous knowledge and of its own justification. Consequently, the

terms within which individual monographs are written will not neces-
sarily provide the terms for a comparative exercise. It is of interest, in
fact, that Melanesianists are currently turning to the possibilities of
historical accounts, for history connects events and social forms while
simultaneously preserving their individuality. Perhaps historical under-
standing will yield a plot to fix the relations between phenomena.

This last phrase comes from Beer's (1983) dual investigation of, on
the one hand, Darwin's narration of the connections he perceived
among life forms and, on the other, the contrivance of nineteenth-
century novelists to make fiction, as deliberately conceived narrative, a
commentary on life and growth. She writes of Darwin's desire to specify
complexity without attempting to simplify it. He conserved, in the
profusion and multivocality of his language, the diversity and multiple
character of phenomena. For, as she puts it, his theory "deconstructs
any formulation which interprets the natural world as commensurate
with man's understanding of it" (1983:107).

> The complexity of interrelation is another reason why he [Darwin] needs
> the metaphoric and needs also at times to emphasise its transposed, meta-
> phorical status—its imprecise innumerate relation and application to the
> phenomenological order it represents. The representation is deliberately lim-
> ited to that of 'convenience' and does not attempt to present itself as a just,
> or full, equivalent. (1983:101)

It is not to history that I myself look, then, but to the way that one
might hold analysis as a kind of convenient or controlled fiction.

However provisional and tentative anthropologists are about their
findings, the systematic form that analysis otherwise takes is its own
enemy:

> We apply the conventional orders and regularities of our science to the
> phenomenal world ('nature') in order to rationalize and understand it, and
> in the process our science becomes more specialized and irrational. Simplify-
> ing nature, *we* take on its complexity, and this complexity, appears as an
> *internal* resistance to our intention. (Wagner 1975:54, original emphasis)

This is especially true when the phenomena are human subjects. Analyt-
ical language appears to create *itself* as increasingly more complex and
increasingly removed from the 'realities' of the worlds it attempts to
delineate, and not least from the languages in which people themselves
describe them. Making out how diverse and complex those worlds are
then seems to be an invention of the analysis, the creation of more data
to give it more work. There is thus an inbuilt sense of artificiality to

the whole anthropological exercise—which prompts the apparent solution that what one should be doing is aiming to simplify, to restore the clarity of direct comprehension. But this returns us to the very issue that in his narration of the development of life forms Beer suggests Darwin was trying to avoid.

The organicist fiction in its nineteenth-century mode was strong because it operated as "both a holistic and an analytical metaphor. It permitted exploration of totalities, and of their elements, without denying either, or giving primacy to either" (Beer 1983:108). There are other metaphors today on which the anthropologist draws: communicational field, ecosystem, social formation, even structure, all of which construct global contexts for the interconnection of events and relations. Their danger lies in making the system appear to be the subject under scrutiny rather than the method of scrutiny. The phenomena come to appear contained or encompassed by the systemics, and thus themselves systemic. So we get entangled in world systems and deep structures and worry about the 'level' at which they exist in the phenomena themselves.

Here I resort to another mode by which to reveal the complexities of social life. One could show how they provoke or elicit an analytical form that would not pretend to be commensurate to them but that would, nonetheless, indicate an analogous degree of complexity. It is to this fictional end that I contrive to give the language of analysis an internal dialogue.

This is attempted in two ways. First, I sustain a running argument with what I identify as the premises on which much writing on Melanesia (though not of course restricted to it) has been based. These premises belong to a particular cultural mode of knowledge and explanation. Second, I do not imagine, however, I can extract myself from this mode: I can only make its workings visible. To this end, I exploit its own reflexive potential. Thus my narrative works through various relations or oppositions; to the we/they axis I add gift/commodity and anthropological/feminist viewpoints. Let me spell this out. The difference between Western and Melanesian (we/they) sociality means that one cannot simply extend Western feminist insights to the Melanesian case; the difference between anthropological/feminist viewpoints means that the knowledge anthropologists construct of Melanesia is not to be taken for granted; the difference between gift/commodity is expanded as a metaphorical base on which difference itself may be apprehended and put to use for both anthropological and feminist purposes, yet remains rooted in Western metaphysics. While all three are fictions, that

is, the oppositions work strictly within the confines of the plot, the cul-
tural reasons for choosing them lie beyond the exercise, since the exer-
cise itself is no more context-free than its subject matter.

Comparative procedure, investigating variables across societies, nor-
mally de-contextualizes local constructs in order to work with context-
bound analytic ones. The study of symbolic systems presents a different
problematic. If theoretical interest becomes directed to the manner in
which ideas, images, and values are locally contextualized, de-contex-
tualization will not work. Analytic generalities must be acquired by
other means. The task is not to imagine one can replace exogenous
concepts by indigenous counterparts; rather the task is to convey the
complexity of the indigenous concepts in reference to the particular
context in which they are produced. Hence, I choose to show the con-
textualized nature of indigenous constructs by exposing the contex-
tualized nature of analytical ones. This requires that the analytical
constructs themselves be located in the society that produced them. For
members of that society, of course, such a laying bare of assumptions
will entail a laying bare of purpose or interest.

To take the third of the fictions: one possibility of acquiring distance
on anthropological constructs lies in critiques of the kind afforded by
feminist scholarship. Such critiques incorporate clearly defined social
interests, and thereby provide an indirect commentary on the contexts
of anthropologists' ideas and on their interests. These comprise both
the accepted premises of social science inquiry and the peculiar con-
straints of scholarly practice itself, including its literary form. It is as a
constant reminder of such Western academic interests that I juxtapose
anthropological concepts with ideas and constructs drawn from a do-
main of a scholarly discourse with which it both overlaps and is at
odds. The difference between them is sustained as a fiction if only
because I separate and objectify distinctively 'feminist' and distinctively
'anthropological' voices. A rather limited range of material is presented
on both sides. But that limitation is partly determined by the attempt
to provide some kind of history of the way anthropological and feminist
ideas are intertwined, although there is nothing linear here. In the
crossings-over and blockages between ideas, we shall encounter repeti-
tions and contradictions of all sorts that emulate not only social life
but also our haphazard methods for describing it. In addition, their
proximity is also sustained as a fiction within the narrative form ('anal-
ysis') of this account. A strong feminist tradition, especially on the

Continent (e.g., Marks and de Courtrivon 1985), would see this as subverting feminist writing's distinctive aims (see also Elshtain 1982). Indeed, although many axioms of feminist scholarship appear to have continuities with anthropological ones, its different aims indicate the different purposes that motivate inquiry in the first place. Its debates are not grounded in anthropological terms—making them at once awkward and interesting. Thus the significance of feminism is the relative autonomy of its premises as far as anthropology is concerned: each provides a critical distance on the other. Ideally, one would exploit the extent to which each talks past the other.

Ideally one would do the same for the cross-cultural exercise, for it cannot be assumed that 'their' contexts and 'ours' will be recognizably equivalent. What has to be analyzed are precisely 'their' contexts for social action. This is the subject matter of those holistic monographs which present such self-contained, self-referential worlds. To go beyond them is to proceed in the only way possible, to open up 'our' own self-referencing strategies.

For much anthropology, including that of a Radcliffe-Brownian kind, symbolic systems are intelligible within contexts apprehended as a social order or society. Radcliffe-Brown himself separated '(social) structure'—the roles and positions that make up a society—from 'culture', the tokens and signals by which its members know about themselves. Gellner suggests that Radcliffe-Brown's particular formulation allows one "to ask what kind of structure it is which does, and does not, lead to a self-conscious worship of culture" (1982:187). One may ask the same question of 'society' as a conceptualized whole. In what kinds of cultural contexts do people's self-descriptions include a representation of themselves as a society? Yet the question is absurd if one assumes that the object of study is "all that is inscribed in the relationship of familiarity with the familiar environment, the unquestioning apprehension of the social world which, by definition, does not reflect on itself" (Bourdieu 1977:3, emphasis removed). It would be like requiring characters linked by an author's plot to entertain the idea of that plot. What becomes remarkable, then, is its taken-for-granted status in much anthropological inquiry into symbolic forms, the ease with which it is argued that people represent 'society' to themselves. This assumption on behalf of others is, of course, an assumption on behalf of the observers who 'know' they belong to a society.

Runciman underlines the paradox. After all, it is the characteristic

of sociological explanation (he argues) that "it requires the invocation of theoretical terms unavailable to those to whose behaviour they are to be applied" (1983:53). For instance,

> [t]o understand in the tertiary sense the social theory of the writers of ancient Rome, it is necessary to be aware that they themselves were *not* aware of the need to describe the society in which they lived from any other than what we would now regard as a limited and unrepresentative point of view. (1983:53, original emphasis)

Runciman inverts the accepted priorities by which social scientists often imply that the end of their endeavors is explanation. After reportage and explanation comes description. This is what he means by understanding in the tertiary sense: conveying as much as can be conveyed about an event to give a sense of what it was like for those involved in it. Indeed, in his view, the distinctive problems of social science are precisely those of description, not explanation. Good descriptions in turn have to be grounded in theory, "that is, some underlying body of ideas which furnishes a reason for both readers of them and rival observers of what they describe to accept them" (1983:228). This is the reason why "the concepts in which descriptions are grounded are unlikely to be those used by the agents whose behaviour is being described" (1983:228). Yet that knowledge of unlikeliness has itself to be contrived in order to be conveyed. Tertiary understanding includes its own sense of difference from its objects. If my aims are the synthetic aims of an adequate description, my analysis must deploy deliberate fictions to that end.

I am concerned, then, not to elucidate specific local contexts for events and behavior, but to elucidate a general context for those contexts themselves: the distinctive nature of Melanesian sociality. Taken for granted by Melanesians, this general context can only be of interest to 'ourselves'. Evidence must rest with the specificities, but the use of them is synthetic. This being the case, the comparative procedure of laying out the relations between different social systems cannot be an end in itself. At the same time, it would be obviously self-defeating to turn aside from greater systematisation into greater ethnographic detail. Rather, I hope that the exogenous intervention of feminist-inspired scholarship will contribute towards an understanding of general Melanesian ideas about interaction and relationships which will be evidently not reducible to those of Western social science. These contexts are to be contrasted, not conflated. At the least, confronting the premises of

feminist scholarship should prevent us from apprehending those in any axiomatic way.

All that can be offered initially is a prescription: one cure to the present impasse in the comparative anthropology of Melanesia might be to indulge less in our own representational strategies—to stop ourselves thinking about the world in certain ways. Which ways will prove profitable will depend on our purpose. Simply because it itself, as a metaphor for organization, organizes so much of the way anthropologists think, the idea of 'society' seems a good starting point.

NEGATIVITIES: REDESCRIBING MELANESIAN SOCIETY

This is no new strategy. In recent years, I have made an easy living through setting up negativities, showing that this or that set of concepts does not apply to the ethnographic material I know best, from Hagen in the Western Highlands Province of Papua New Guinea.

One set centers on the unusual status Hagen enjoys vis-à-vis other Highlands societies. It is among the few that do not define the sexes through general initiation into cults or through puberty rituals.[4] In reflecting on this absence, I was led into other absences: for instance, that Hageners do not imagine anything comparable to what we would call the relation between nature and culture. This is a negativity of a different order. The former case draws on a comparison with other Melanesian societies where initiation ritual exists; the latter on a comparison with constructs of Western society,[5] for the circumstances where the categories seem applicable have to be defined by exogenous criteria. Now when Leach (1957:134) remarked of Malinowski that he would "need to maintain that, for the Trobrianders themselves, 'Trobriand culture as a whole' does not exist. It is not something that can be reported on by Trobrianders, it is something that has to be discovered and constructed by the ethnographer," his sarcasm was directed at the extent to which Malinowski underplayed the ideological significance of what the Trobrianders did say and report upon. "He appears to have regarded the ideal construct of the native informant as simply an amusing fiction, which could at best serve to provide a few clues about the significance of observed behaviour" (1957:135). But my intentions were the opposite—not to fill in the terms that indigenous conceptualizations lacked but to create spaces that the exogenous analysis lacked. It is not that Melanesians have no images of unities or whole entities but that

we obscure them in our analyses. The hope here, then, is for something more comprehensive than simply demonstrating the inapplicability of this or that particular Western concept.[6] It is important to show that inapplicability is not just a result of poor translation. Our own metaphors reflect a deeply rooted metaphysics with manifestations that surface in all kinds of analyses. The question is how to displace them most effectively.

I approach the artifacts and images—the cultures—of Melanesian societies through a particular displacement. We must stop thinking that at the heart of these cultures is an antinomy between 'society' and 'the individual'.

There is nothing new about this admonition. The history of anthropology is littered with cautions to the effect that we should not reify the concept of society, that the individual is a cultural construct and an embodiment of social relations, and so on. They derive, by and large, from reflexive scrutiny of Western categories of knowledge and from radical positions on their ideological character. Indeed, one of my intentions in introducing feminist debate is to point to a contemporary critique autochthonous to Western culture. However, of all the various cultural propositions that one could upturn, I choose this displacement for three reasons. First is the tenacity of its persistent appearance as a set of assumptions underlying a whole range of approaches in anthropological thinking about Melanesia. Second is its usefulness as a focus for organizing how one might think about Melanesian ideas of sociality. I wish to draw out a certain set of ideas about the nature of social life in Melanesia by pitting them against ideas presented as Western orthodoxy. My account does not require that the latter are orthodox among all Western thinkers; the place they hold is as a strategic position internal to the structure of the present account. Finally, it is germane that the proposition is framed as a relationship between terms.

Society and individual are an intriguing pair of terms because they invite us to imagine that sociality is a question of collectivity, that it is generalizing because collective life is intrinsically plural in character. 'Society' is seen to be what connects individuals to one another, the relationships between them. We thus conceive of society as an ordering and classifying, and in this sense a unifying force that gathers persons who present themselves as otherwise irreducibly unique. Persons receive the imprint of society or, in turn, may be regarded as changing and altering the character of those connections and relations. But as indi-

viduals, they are imagined as conceptually distinct from the relations that bring them together.

While it will be useful to retain the concept of sociality to refer to the creating and maintaining of relationships, for contextualizing Melanesians' views we shall require a vocabulary that will allow us to talk about sociality in the singular as well as the plural. Far from being regarded as unique entities, Melanesian persons are as dividually[7] as they are individually conceived. They contain a generalized sociality within. Indeed, persons are frequently constructed as the plural and composite site of the relationships that produced them. The singular person can be imagined as a social microcosm. This premise is particularly significant for the attention given to images of relations contained within the maternal body. By contrast, the kinds of collective action that might be identified by an outside observer in a male cult performance or group organization, involving numbers of persons, often presents an image of unity. This image is created out of internal homogeneity, a process of de-pluralization, manifested less as the realization of generalized and integrative principles of organization itself and more as the realization of particular identities called into play through unique events and individual accomplishments.

It is not enough, however, to substitute one antinomy for another, to conclude that Melanesians symbolize collective life as a unity, while singular persons are composite. Such a distinction implies that the relation between them might remain comparable to that between society and individual. And the problem with *that* as a relationship is the Western corollary: despite the difference between society and individual, indeed because of it, the one is regarded as modifying or somehow controlling the other. At the heart of the antinomy is a supposed relation of domination (as in our contrasting ideas about society working upon individuals and individuals shaping society). Whatever they are concerned with, key transformations of Melanesian cultures are not concerned with this relation. While collective events do, indeed, bring together disparate persons, it is not to 'make' them into social beings. On the contrary, it may even be argued that such de-pluralized, collective events have as much an amoral, antisocial character to them as do autonomous persons who go their own way.[8] The relations at issue involve homologies and analogies rather than hierarchy.

In one sense, the plural and the singular are 'the same'. They are homologues of one another. That is, the bringing together of many

persons is just like the bringing together of one. The unity of a number
of persons conceptualized as a group or set is achieved through eliminat-
ing what differentiates them, and this is exactly what happens when a
person is also individualized. The causes of internal differentiation are
suppressed or discarded. Indeed, the one holistic condition may elicit
the other. Thus a group of men or a group of women will conceive of
their individual members as replicating in singular form ('one man',
'one woman') what they have created in collective form ('one men's
house', 'one matrilineage'). In other words, a plurality of individuals as
individuals ('many') is equal to their unity ('one').[9]

The suppression of internal differentiation occurs, however, in a
pluralized context of sorts. This is the plurality that takes the specific
form of a differentiated pair or duo. 'Many' and 'one' may be homolo-
gous, but neither is to be equated with a pair. When either a singular
person or a collective group comes into relation with another, that re-
lation is sustained to the extent that each party is irreducibly differen-
tiated from the other. Each is a unity with respect to or by analogy
with the other. The tie or alliance between them cannot be subsumed
under a further collectivity, for the dyad is a unity only by virtue of its
internal division. Consequently, paired entities cannot be brought to-
gether, as we might be tempted to suggest, under the integrating rubric
of 'a wider society'.

Single, composite persons do not reproduce. Although it is only in
a unitary state that one can, in fact, join with another to form a pair,
it is dyadically conceived relationships that are the source and outcome
of action. The products of relations—including the persons they cre-
ate—inevitably have dual origins and are thus internally differentiated.
This internal, dualistic differentiation must in turn be eliminated to
produce the unitary individual.

Social life consists in a constant movement from one state to another,
from one type of sociality to another, from a unity (manifested collec-
tively or singly) to that unity split or paired with respect to another.
This alternation is replicated throughout numerous cultural forms, from
the manner in which crops are regarded as growing in the soil to a
dichotomy between political and domestic domains. Gender is a princi-
pal form through which the alternation is conceptualized. Being 'male'
or being 'female' emerges as a holistic unitary state under particular
circumstances. In the one-is-many mode, each male or female form may
be regarded as containing within it a suppressed composite identity; it
is activated as androgyny transformed. In the dual mode, a male or

female can only encounter its opposite if it has already discarded the reasons for its own internal differentiation: thus a dividual androgyne is rendered an individual in relation to a counterpart individual. An internal duality is externalized or elicited in the presence of a partner: what was 'half' a person becomes 'one' of a pair.

As there are two forms of plurality (the composite and the dual), so there are two forms of the androgyne or, we might say, two forms of the singular. To say that the singular person is imagined as a microcosm is not simply to draw attention, as observers repeatedly do, to the extensive physical imagery in Melanesian thought that gives so much significance to the body. It is to perceive that the body is a social microcosm *to the extent* that it takes a singular form. This form presents an image of an entity both as a whole and as holistic, for it contains within it diverse and plural relations. The holistic body is composed in reference to these relationships, which are in turn dependent for their visibility on it. The two modes to which I have referred may thus also be described as stages in body process. To be individuated, plural relations are first reconceptualized as dual and then the dually conceived entity, able to detach a part of itself, is divided. The eliciting cause is the presence of a different other.

The singular person, then, regarded as a derivative of multiple identities, may be transformed into the dividual composed of distinct male and female elements. But there is a difference between the two constructions or modes. In the first, plurality can be eliminated through difference being encompassed or eclipsed, while in the second case, elimination is achieved through detachment. These operations are basic to the way in which relationships and the productivity of social life are visualized. Because gender provides a form through which these visions are realized, it is also formed by them. If we must stop thinking that at the heart of Melanesian culture is a hierarchical relation between society and the individual, we must also stop thinking that an opposition between male and female must be about the control of men and women over each other. Realising this ought to create fresh grounds for analyzing the nature of that opposition and of intersexual domination in these societies.

BEYOND NEGATION

We do not, of course, have to imagine that these ideas exist as a set of ground rules or a kind of template for everything that Melanesians

do or say. Rather, as in the manner in which Westerners may think about the relationship between individual and society, they occur at moments when Melanesians dwell on the reason or causes for actions. They are the (cultural) form that their thoughts take—tantamount to a theory of social action. As an implemented or acted upon theory, we might equally well call it a practice of social action. Indeed, these constructs become visible on occasions when people do not simply wish to reflect on the causes of action but to create the conditions for fresh actions. Actions are known by their effects and outcomes. These constructs are thus also a theory and practice of production.

I return to the point that one kind of productive activity (the Western anthropological analysis found in this book) is being used to evoke another kind of productive activity (how the people I call Melanesians conceptualize the causes and outcomes of action). Even if commensurability were desirable, however close the attempt to represent the one in terms of the other, the aims of the two activities are quite disparate. It is obviously shortsighted merely to be disparaging, to say that 'our' ideas are 'ethnocentric' and that we should look at 'their' ideas. Instead, as I have argued, we need to be conscious of the form that our own thoughts take, for we need to be conscious of our own interests in the matter (in this case, the interests of Western anthropologists in the analysis of other societies).

An appreciation of the interested nature of all productive activity, academic or otherwise, is one thing. The fact that our thoughts come already formed, that we think through images, presents an interesting problem for literary production itself. Their ideas must be made to appear through the shapes we give to our ideas. Exploiting the semantics of negation (the X or Y have 'no society') is to pursue the mirror-image possibility of suggesting that one type of social life is the inverse of another. This is the fiction of the us/them divide. The intention is not an ontological statement to the effect that there exists a type of social life based on premises in an inverse relation to our own. Rather, it is to utilize the language that belongs to our own in order to create a contrast internal to it. Consequently, the strategy of an us/them divide is not meant to suggest that Melanesian societies can be presented in a timeless, monolithic way, nor to assume some fixity in their state-of-being which renders them objects of knowledge. And there is more to it than their entry into anthropological accounts as figments of the Western imagination. The intention is to make explicit the practice of anthropological description itself, which creates its own context in

which ideas drawn from different social origins are kept distinct by reference to those origins. Creating a kind of mirror-imagery gives a form to our thoughts about the differences.

The strategy of negation can contribute to a larger strategy. To say the X do not have this or that is a statement highly dependent on the character of what this or that is for those who do have it. It can thus be seen simultaneously as a displacement of meaning *and* as an extension of it. I displace what 'we' think society is by a set of different constructs, promoted in opposition to order to suggest an analogy with 'their' view. At the same time, that very analogy grasped as a comparison, treating both sets of ideas as formulae for social action,[10] then extends for us the original meaning of the concept.

The idea of 'analysis' is integral to the argument. Much of the material of this book rests on symbolic exegesis, that is, on the elucidation of what an earlier anthropology would call people's representations of themselves, in their values and expectations and in the significances they give to artifacts and events. The analytical procedure thus appears to be that of a decoding type. But it is important to be clear what the object of the exercise is. One is not following through a decoding procedure that Melanesians would also follow through if they wished to bring to the surface a total map of their construction of meanings. As we know, indigenous exegetical activity consists in the creation of further symbols and images, for which further decoding on the observer's part then becomes necessary. Sperber puts it: "exegesis is not an interpretation but rather an extension of the symbol and must itself be interpreted" (1975:34). Indigenous decoding, so to speak, takes the form of transformation or symbolic innovation.

> The necessity to innovate is . . . characteristic of all cultural activity. It amounts to the cultural necessity to attribute meaning to every successive act, event, and element, and to formulate that meaning in terms of already known referents or contexts. The metaphor may be one that has been repeated millions of times before, or it may be a completely original creation, but in either case it achieves its expressive force through the contrast that it presents and the analogy that this contrast elicits. (Wagner 1972:8)

This can be no less true of exogenous decoding procedures, of the relations that anthropologists lay out and the imitations or analogies they strive to create.

Anthropological exegesis must be taken for what it is: an effort to create a world parallel to the perceived world in an expressive medium (writing) that sets down its own conditions of intelligibility. The creativ-

ity of the written language is thus both resource and limitation. By language, I include here the arts of narration, the structuring of texts and plots, and the manner in which what is thus expressed always arrives in a finished or completed (holistic) state, already formed, already a composition of sorts. Decomposing these forms can only be done through deploying different forms, other compositions.

As a style of narration, analysis itself is a mode somewhat underrated in the current debates on ethnographic writing. Yet one might see analysis as a trope for the representation of knowledge, "a way of speaking relative to the purposes of a discourse" (Tyler 1984:328). Fascinating literary issues lie in the manner in which we do indeed decompose events, acts, significations in order to interpret 'meanings' or theorize about the relationship between variables. I thus find interest in the categories of analysis that have been applied to the elucidation of social systems in Melanesia, most prominently perhaps that of 'the gift'. They are all heuristics. And it is in this sense that I take gift exchange as a heuristic.

As with the other two fictions, the power of gift exchange as an idea lies in the contrivance of an internal dialogue of sorts. Here, the dialogue belongs strictly to discourse within anthropology. The contrast sustained in this book between commodity systems and gift systems of exchange is taken directly from Gregory's (1982) work. Gregory himself insists that the two types of exchange are found together. Certainly this is true for contemporary Melanesian societies for as long as they have been studied by Westerners, and his own account is embedded in a study of change and the coexistence of both forms in colonial and postcolonial Melanesia. Nevertheless, insofar as he grounds the predominance of gift exchange in a 'clan-based' as opposed to a 'class-based' society, he does suggest that the character of the predominant form of exchange has distinctive social correlates. It is important to the way I proceed that the forms so contrasted are different in social origin, even though the manner in which they are expressed must belong commensurately within a single (Western) discourse. Thus a culture dominated by ideas about property ownership can only imagine the absence of such ideas in specific ways. In addition, it sets up its own internal contrasts. This is especially true for the contrast between commodities and gifts: the terms form a single cultural pair within Western political-economy discourse, though they can be used to typify differences between economies that are not party to the discourse, for example non-Western economies that may behave according to a particular

political-economy theory without themselves having a political-economy theory.

The metaphor of the 'gift', then, holds a particular place within Western formulations, and that placement is one I exploit in delineating its relation to its implied counterpart 'commodity'. Imagining that one might characterize a whole economy in terms of the prevalence of gift exchange as opposed to one dominated by commodity exchange opens up conceptual possibilities for the language that conceives of a contrast between them. Thus one can manipulate received usages of terms such as 'persons' and 'things' or 'subjects' and 'objects'. And thus one can contrive an analysis which, to follow Tyler's musings about discourse as trope, in being "[n]either fully coherent within itself nor given specious consistency through referential correspondence with a world external to itself, . . . announces brief coherences and enacts momentary 'as if' correspondences relative to our purposes, interests, and interpretive abilities" (1984:329). The internal dialogue is formed from the multiple ways in which we might organize our knowledge of Melanesian societies through a single language of analysis. That analysis, one might add, is of course at its own historical point in time. When Mauss (1954:chap. 4) was defending his use of the term 'gift' to refer to economies based on gift exchange, he then had in mind a contrast with the principles of the 'so called natural economy' or 'utilitarianism'. The idea of 'commodities' allows us to organize a different range of data. For the moment, I merely assert the advantage of the contrast. To talk about the gift constantly evokes the possibility that the description would look very different if one were talking instead about commodities.

Finally, then, if our cultural productions depend on innovation, it is no surprise that much anthropological writing is polemical. The arrangements of analytical categories are overthrown. But displacement can only come from a previous position. It thus extends that previous position rather than refutes it.

This activity is the hallmark of social science. Too often we disparage the movement from one position to another as relativity. The disparagement hides the cumulative achievement of social science, which is constantly to build up the conditions from which the world can be apprehended anew.[11] That regenerative capacity constitutes the ability to extend meanings, to occupy different viewpoints. More than mimesis—social science imitating its subject matter—it makes a distinctive contribution to a world that in so many other contexts draws on tech-

nology for its models for innovation. The metaphoric expansions of technology are persuasively self-referential and self-validating. There appears to be a natural transformation of ideas into engines that work and thus evince the ideas at work. The process images a special kind of cumulative knowledge: it celebrates the possibility of making the entire universe 'work', that is, of proving that our ideas about the universe work. Technological knowledge builds up to this end, but not so the knowledge accumulated through social science. At stake here are ways to create the conditions for new thoughts.

Meyer Fortes was fond of pointing out that the force of food taboos lay in the knowledge that a person can eat only for him or herself; it is not an activity someone can do for another. The same is true of thinking. Thoughts exist only as 'newly thought', by this or that person. As Wagner observes:

> Human actions are additive, serial, and cumulative; each individual act stands in a particular relationship to the life of the individual or the group, and it also 'adds' something, in a literal or figurative sense, to these continuities and to the situation itself. Thus every act, however habitual or repetitious, *extends* the culture of the actor in a certain sense. (1972:8, original emphasis)

If this is true of human action in general, we succumb it to an interesting division of labor. Western technology assumes the constant production of new and different things, an individuating obsession Sahlins (1976) attributed to the culture of bourgeois society. But in the bourgeois view, social life consists in the constant rearrangement of the same things (persons). It follows from this view that social arrangements can never work out in any finished sense, if only because our apprehension of them not only shifts but must be made to shift. Yet what is freshly grasped each time is the possibility of a holistic description. Creating the grounds for new thoughts emerges as a kind of deliberate counterproduction.

The necessity to conceive each new understanding as at once totalizing and incomplete is intrinsic to Western culture, as it would have to be with that culture's ever incomplete project. Social science seeks to make that project an object of knowledge. Its preoccupation is the totalizing 'relationship' between the individual and society, between culture and nature. The terms are apprehended as irreducible; the transformation of one into the other as partial. I am aware as I write that dichotomy belongs to a (modernist) phase already culturally superseded. Nevertheless, it still has power as a collectivizing obsession—

defining a culture that defines itself as less than the universe. By definition, it can never work completely. The Western view of Western culture, then, like its view of social science, is that it is perpetually unfinished. The autonomy of the individual and the recalcitrance of nature seem to prove the point. The extent to which we also perceive the scope of humankind's domination over the world merely provides alternative proof, for we regard that relationship as both open to constant modification and based on an ultimate difference, as indeed we do that between men and women.

2

A Place in the
Feminist Debate

Feminist debate lies beyond the social sciences in another sense. Its premises are not those of an incomplete project, an openness to the diversity of social experience that presents itself for description. Its openness is of a different kind, its community of scholars differently constituted. After all, the idea of an incomplete project suggests that completion might be possible; feminist debate is a radical one to the extent that it must share with other radicalisms the premise that completion is undesirable. The aim is not an adequate description but the exposing of interests that inform the activity of description as such.

I exaggerate the contrast. Feminist scholarship and social science share a similar structure in that their overt premises are not the axiomatic apprehensions of the world that inform paradigms in a natural science mode. They are competitively based. It is as common to find viewpoints being held openly in relation to one another as to find one superseding another. To a much lesser extent, however, has feminist inquiry an interest in the relativity of viewpoints. For it does not, I think, seek for constantly fresh conceptualizations of social life: it seeks for only one. It seeks for all the ways in which it would make a difference to the worlds we know to acknowledge women's as well as men's perspectives. Knowledge is thus dually conceived and to that extent mirrors perpetual conflict.

It is a distinctive characteristic of social science that it can accommodate such a view among its many positions. Yet at the same time, a

conflict view of knowledge must displace *all* other positions. One cannot be a half-hearted radical. The consequences are interesting.

The changing perspectives of social science, its promotion of multiple viewpoints, each contributing its part to the whole, yield a sense of perspective itself, at least in its modernist phase. Descriptions are framed by different perspectives on a subject matter. One moves from one to another. Indeed, the subject matter, so to speak, may also have its own 'perspective'. Creating a distance between scholar and object of knowledge thereby establishes exactly that kind of tertiary understanding that empathizes with its subjects in a distinctive form not available to the subjects themselves.

Feminist scholarship also appears full of perspectives. The multiple base to its debates is created through its deliberate interdisciplinary openness and the competitiveness between its own internal approaches. Indeed, the self-conscious labelling of its positions are illuminating here. Liberal, Radical, Marxist, Socialist feminists talk in relation to one another. One position evokes others. Yet the manner in which these multiple positions are constantly recalled has a further effect. They do not come together as parts of a whole but are held as coeval presences within discussion. Each bears its own proximity to experience. The optical illusion of holding among ourselves many perspectives all at once simultaneously achieves a sense of no perspective. And thus the constitution of our discourse, the internal pluralism, in fact endorses feminism's chief aim. At stake for feminist as opposed to other scholars is the promotion of women's interests, that is, the promotion of a single perspective. In the end, the 'interests' are not so much those internal to the construction of knowledge—the canons of an adequate description—as ones external to it. They come from the social world of which we are also part. Precisely because women's perspective is conceived in resistance to or in conflict with men's, feminists occupy only one of these two positions. The creation of the other happens outside us. From the internal standpoint of our own position, then, to have 'one' perspective means to have no 'perspective'. One inhabits the world as one finds it. Having no perspective is diacritic of the postmodern epoch.

The way in which feminist scholarship organizes knowledge challenges the manner in which much social science, including anthropology, also organizes knowledge. Inevitably, among other things, it takes apart the concept of 'society'—there is no such transcendental entity in the feminist view that is not the ideological artifact of a category of persons who are rather less than the society upon whose behalf they claim to speak.

ORGANIZING KNOWLEDGE

'Feminism' cannot be spoken of as a unitary phenomenon. But rather than here replicate the complexity and range of writing that goes under its name, I offer a brief comment on that complexity itself. There is an emphatic stylization to our self-described differences. While many feminists assume that women everywhere occupy positions comparable to one another (in one way or another oppressed), in terms of their own scholarly practice they sustain a differentiation of positions. If at base these are equivalent (one can comprehend women's oppression through a Radical position on women's separateness, or through a Socialist position that gives equal weight to sexism and capitalism in accounting for sexual inequality, and so on), then only through theoretical work are the views kept differentiated. The possibility of feminists differing "as to whether there are any real theoretical differences between them at all" (Sayers 1982:171) thus lies in the conventional or artificial character of the differentiation. The positions are created as dependent upon one another.

Theoretical differences contribute, then, to a debate constituted and sustained by cross-reference. In our self-representations, feminists are in constant dialogue, an interlocution that maintains internal connections. It looks as though there is an impossible array of positions, but the positions are openly held in relation to one another. They comprise "a self-referential body of thought" (Eisenstein 1984:xix). Much feminist writing is consequently concerned with making explicit one viewpoint with respect to others (e.g., Barrett 1980; Elshtain 1981; Sayers 1982). In the English-speaking world, for instance, to which my remarks largely refer, Marxist/Socialist feminism places itself in relation to both Radical and Liberal feminism. The strategy of separatism or the arguments of biological essentialism have to be countered. But these other viewpoints are never dispatched. No viewpoint alone is self-reproductive: all the positions in the debate comprise the theoretical base of any one. In other words, the vast number of internal debates (criticism; counter-criticism and commentary; writers talking about one another; a fragmentation at the level of the individual arguments) together create a field of sorts, a discourse. Feminism lies in the debate itself.

If, in the tradition of radical criticism, feminist inquiry exposes assumptions about the inevitability of prevailing conditions, it does so through a counterpart vision of society that takes a plural rather than a holistic form. Thus feminist organizations, sensitive to the particular

interests of women, are also sensitive to the interests of ethnic minorities and to the ethnicization of attributes such as sexuality. A definitive attribute comes to denote a political position, or a theoretical one in critiques of society.[1] For the potential for all positions to be 'ethnically' conceived is the political/theoretical face of the aesthetics of plural style. The "modernist aesthetic" that provided a perspective on the world was "linked to the conception of a unique self and private identity" (Jameson 1985:114). If nobody now has a unique, private world to express, then it remains only for styles—attributes—to speak to one another.

This throws light on a notable debate between Marxist/Socialist and Radical feminism: whether primacy should be accorded to class or to gender divisions. It comes, I think, from our pluralist, ethnicist vision that is intrinsically at odds with the systemic, structured modelling of society upon which class analysis must rest.[2] Barrett states that the "ideas of [R]adical feminism are for the most part incompatible with, when not explicitly hostile to, those of Marxism and indeed one of its political projects has been to show how women have been betrayed by socialists and socialism" (1980:4). She endorses Kuhn and Wolpe's observation, "that much marxist analysis, in subsuming women to the general categories of that problematic—class relations, labour process, the state, and so on, fails to confront the specificity of women's oppression" (1978:8). Young et al. (1981) deal with the same issue in the context of feminist theories of development (see also Caplan and Bujra 1978). And MacKinnon writes, "Marxists have criticized feminism as bourgeois . . . [for] to analyze society in terms of sex ignores class divisions among women. . . . Feminists charge that marxism is male defined . . . that analyzing society exclusively in class terms ignores the distinctive social experiences of the sexes" (1982:3–4).

Distinctively, then, 'feminism', that is, the feminist component of this or that theoretical approach, takes system or structure for granted. It does not pretend to an independent (holistic) theory of society as such.[3] Its ends are not those of representation, and system, being taken for granted, is not replicated as the *aim* of its scholarly practice. To appreciate the diversity of conditions to be found in different societies is not to reflect on different modes of systematization but to lay out the variety of circumstances that practical action must take into account.[4]

Consequently, feminism's theoretical concerns are critical and interpretative. They focus upon the manner in which certain structures are perpetuated to the advantage of men, upon the extent to which "women

suffer from systemic social injustice because of their sex" (Richards 1982:11–12). Where it addresses formulations of 'society', feminist scholarship draws on specific theorizing from other intellectual domains such as psychoanalysis or Marxism itself (McDonough and Harrison 1978:15). Yet class analysis would require a holistic model of society. Specific interests would be located in relation to one another, the subordination or exploitation of particular categories of persons seen as a systemic consequence of relations of production. From this point of view, ideas such as property or person belong to the common ideology which these relations promote and of which they are part. The particular forms that internal conflict and contradiction take are determined by productive processes, and it is the interconnections between processes and relations that analysis lays open. Feminist analysis, on the other hand, by and large prompts a more autonomous view of power relations. Men and women, as gendered beings, are always differently situated. The interrelationship between 'female' and 'male' interests may be understood with respect to each other, but the motivation behind those interests is generally held to inhere in the separate existence of the social categories themselves. For the pluralist vision implies that ideologies have their origins in the promotion of identifiable, mutually externalized interests, rather than in the internally interconnected workings of a system. An immediate remedy appears to lie in autonomy. Since domination is regarded as constituted by the very relations that exist between men and women, it makes sense for women to demonstrate that the relations themselves can be dispensed with. Thus Matthews (1984:19): "The feminist historian looks first at women, not in relation to men, but as autonomous shapers and creators of meaning." 'The system' that puts women in a dependent position is regarded as an artifact of male interests. Despite disclaimers to the contrary, such as Richards' assertion that feminism is not concerned with a group of people but with a type of injustice (1982:326), the comprehension of counterpart female interests is crucial.

This debate reveals the doubly problematic standing of the concept of 'society' in feminist discourse. It either has a taken-for-granted status, as a system beyond the interests of feminist inquiry, and/or is assaulted as the locus of a male ideology that fails to recognize the plural character of the real world. But this world is more than plural; it is also one of conflict.

The politicized labels by which different feminist positions advertise themselves indicate that the field of debate is seen as deriving from

lived experience. Its grounding lies in questions to do with reform and change. This placement of reflective debate and practical premise/application is part of the tension between a theoretical position—feminist thought as an intellectual activity—and a concretized aim—exorcizing the problem of women. Feminist academics apply their scholarship to concepts and ideas whose origins lie in a world of conflict, where categories such as 'women' and 'male-female relations' cause people to act. Thus "any analysis of ideology is an analysis of *social relations* [original emphasis] themselves, not a reflection of social relations in the world of ideas" (McDonough and Harrison 1978:17). An experiential dimension invests conceptual categories with ontological status: to that extent they do not need thinking about; they are acted upon. Feminist awareness of other women takes the category 'women' for granted (Bujra 1978). Hence, the foreword to *Feminist Theory* collapses theory into experience: "feminist theory is fundamentally experiential" (Keohane and Gelpi 1982:vii).

Yet general Western knowledge practices also suggest one can turn to academics for illumination of such states of affairs. If experience presents categories such as 'oppressed women' and 'sexual inequality', then systematizing disciplines should be able to explain, order, arrange such experiences. Anthropologists are repeatedly asked questions about the universal validity of biological determinism in questions of sexual inequality (Rosaldo 1980:392). Conversely, academic activity may take apart the slogans of feminist politics. Barrett (1980:96) properly argues that such criticism often fails to "appreciate the grounding of such slogans in particular historical struggles"; one cannot reword political struggle as a conversation. So two radicalisms emerge: (1) a radical politics: concerned to change our own condition, we see it in the condition of others too, and seek for change wherever we encounter persons like ourselves; and (2) a radical scholarship, which questions the grounds upon which identity is constructed or conditions shared. Changing the way one thinks may or may not be regarded as practical action, but academic radicalism often appears to result in otherwise conservative action or nonaction. Radical politics, in turn, has to be conceptually conservative. That is, its job is to operationalize already understood concepts or categories, such as 'equality' or 'men'. It is in the radical nature of much feminist scholarship that potential lies for anthropological scholarship, but the field of or context for feminist debate itself (women's oppression) entails the activation of conceptually conservative constructs with which anthropologists may too easily lose patience.[5]

Insofar as the feminist debate is necessarily a politicized one, our common ground or field is thus conceived as the practical contribution that feminist scholarship makes to the solution or dissolution of the problem of women. Because of the nature and constitution of the debate, any piece of scholarship must occupy a position on this issue: there is none that is not a viewpoint, that does not either contribute internally to the debate or externally oppose its premises. Thus ethnographic accounts of other societies cannot be seen as simply a more or less unbiased elucidation of the subordination or freedom of women. They sort into the camps of those who take inequality to be universal in relations between the sexes and those who see it as a product of particular social forms. To present an ethnographic account as authentic ("these are the conditions in this society") cannot avoid being judged for the position it occupies in this particular debate. By failing to take up an explicit feminist position, I have, on occasion, been regarded as not a feminist.

Here one can sympathize with the impatience sometimes shown towards general anthropology. Within feminist scholarship, it is the relations between the various viewpoints which are of absorbing interest. They reflect the multiple experiences of the female condition. However divisive, these also establish something of a unity of purpose. They necessarily displace the absorbing interests of anthropology, which would set out relations between women's condition in this or that society via the relationship between actors' and observers' perspectives. In the same way as mainstream anthropology tends to reduce feminist theory to one among many theories, encompassing it as part of its theoretical diversity (eclecticism), feminist activists might well reduce anthropological knowledge of other societies to little other than more or less informed documentation of the diversity of conditions under which women live.

Quoting Rosaldo's statement that gender is not a unitary fact determined everywhere by the same sorts of concerns, Eisenstein describes one direction for feminist theory:

> to incorporate the insights of a woman-centered analysis without jettisoning the basic understanding of the social construction of gender, into a renewed commitment to the struggle for fundamental social change . . . First among [its necessary constituent elements] would be a retreat from a false universalism, and a sensitivity to the diversity of women's experiences and needs. (1984:141)

But she assimilates this diversity to dialogue. Belief in the automatic commonalities of all women is to be superseded "by the sounds of a

dialogue among many voices, black, white, and brown" (1984:142). It may be the case, as she goes on to adduce, that women speak to one another even as they also speak from their own histories and cultures. But unlike the discourse created by different theoretical positions, taken up competitively in explicit relation between themselves, different histories and cultures are not necessarily formed with other histories and cultures in mind. 'Dialogue' is as much a contrivance as is the anthropologist's 'translation of cultures'. And a dialogue of cultures is a fancy. It certainly cannot be taken for granted that, simply because they are collected together, the voices will address in their different versions the same problem.

THE PROBLEM OF WOMEN

The structure of feminist debate has interesting consequences. Its pluralist vision endorses a view of society at large as a composite of multiple, irreconcilable interests; there is no single rubric under which one could describe them all and thus no 'society' in a collective sense. At the same time, from the viewpoint of any one of these interests, such as the women's movement itself considered in relation to other enclaves 'within' society, society is taken as external to it. The result is a dualistic vision.

> In its account of itself, women's point of view contains a duality analogous to that of the marxist proletariat. . . . Feminism does not see its view as subjective, partial, or underdetermined but as a critique of the purported generality, disinterestedness, and universality of prior accounts. (MacKinnon 1982:22–23)

That single critical perspective is created in the external challenge of another ('patriarchy') whose perspective it would be nonsense also to adopt. One further result is that this external constraint can be seen, from the point of the single perspective that constitutes it, to be ever present. Thus it makes sense to ask feminist questions anywhere.

Inequalities between the sexes have been interpreted as a universal phenomenon. In fact, within feminist anthropology, there is a lively debate about the status of this assumption. Feminists who are also anthropologists are engaged in the double negotiation of both anthropological and feminist premises. Yet one might remark upon the convergence of certain premises that appear to belong to both. These stem from the location of both feminist scholarship and anthropology within Western culture and its metaphysical obsessions with the relationship between the individual and society. While the hegemony of these ideas

is open to radical critique, much of the critique is, in fact, fuelled by them, seduced by their hierarchical form: the conditions of existence are held to lie beyond the fact of form itself. Forms—as in the form of social arrangements—appear approachable as autonomous objects of knowledge.

The classic premise of the comparative method in anthropology, for instance, that social institutions, roles, and so forth can indeed be compared, runs close to the assumption within feminist inquiry that it can be asked of women everywhere whether they are dominated by 'men', or by 'society' for that matter. In both accounts, different societies appear as analogues of one another. Although they obviously do things 'differently', they all solve or confront the same original problems of human existence. Men and women provide prime exemplars of the issues in question. The biology that makes them irreducibly different is regarded as at once determining and being overcome by the infinite varieties of cultural experience that adapt, elaborate on, and modify the givens of nature. What is seen as most open to elaboration is, of course, culture or society itself—that is, not so much the bodies of men and women but the conventional arrangement of the relationship between them.[6] Depending on how culture and society is regarded, the relationship may then be perceived as the vehicle through which to overcome difference, or else it is set aside and the incontrovertibility of bodily difference is used to defy what is then held up as a rationalist world view (Elshtain 1984). But that ultimate difference is seen as universally presenting a problem for relationships as such.

In a conclusion to a work that appeared at the beginning of the recent upsurge of interest in gender relations, Hutt (1972:133) discusses the implications of difference between the sexes. That sex differences exist, she argues, is an incontrovertible biological fact, but whether such differences should result in differential treatment of men and women is a social decision. In practice, of course, the question of equality is often grounded in the attempt to show that there is 'no difference', a confusion that lies at the heart of the manner in which Westerners think about symbolic activity. We like to think that conventional and customary as our social arrangements are, they come to terms with (adapt to, modify) realities that exist independently of convention. Justification can even be sought for the conventions themselves in the extent to which they successfully deal with what is known about environment, biology, or the intransigence of human nature. For difference lies, it seems, in the nature of things. Things are to be compared in terms

of their intrinsic qualities; and if this is a precept of a Baconian science, it continues to inform models of social life. Every class of things, including persons defined by their gender, poses to society a simple choice: to adapt convention to reflect their intrinsic attributes or by convention strive to overcome them. Hutt's fiat is a clear statement of one of these possibilities against the background of the other. Either possibility employs the same idea: the conventions of society have to come to terms with irreducible facts of nature. All human societies may be seen as grappling with this problem and thus be comprehended as conventions built on or in the face of common givens of human existence.[7]

It is a working tenet of the comparative method in anthropology that societies everywhere do similar jobs in terms of exploiting the environment, providing nurture, reproducing their internal organization. This tenet yields the rubrics of cross-cultural comparison: to consider the ways in which societies are similarly organized and to comprehend the variety of organization as evidence of the complex systems people devise for themselves. A presumption of natural similarity comes to justify the ethical stance that all societies are equivalent, at least all equally worthy of investigation and understanding. The feminist analogue lies in the assumption of equivalence among the members of one sex wherever they live, an assumption that derives symbolic weight from ostensible bodily similarity. Extended to universal features of human nature, to qualities such as aggressiveness or verbal skills, the degree to which these are regarded as intrinsic or not supposedly reflects the degree to which they may be seen as determining social relations. A presumption of natural similarity between all the members of one sex comes to justify the ethical stance that the same questions must be asked of their conditions everywhere: to do less would be to treat some as less.

In universalizing questions about women's subordination, then, feminist scholarship shares with classical anthropology the idea that the myriad forms of social organization to be found across the world are comparable to one another. Their comparability is an explicit Western device for the organization of experience and knowledge. It holds not only for judging the way societies adapt to this or that environment (are similar in their problem solving) but for considering the differences between those adaptations. These ideas contain the further intriguing supposition that there is a sense in which persons are homologues of societies.

Societies are conceived as entities with their own special sets of

features (cultures), each internally organized and thus also constituted by attributes intrinsic to themselves. Insofar as any set of concepts or acts gives a distinctiveness to members of a particular society/culture, that distinctiveness acquires the status of a given. It becomes an axiomatic context for their actions. I suspect a persuasive Western model of ethnic identity.[8] Differences between persons are comprehended as (intrinsic) attributes of the 'groups' from which they come; societies evince not only a natural similarity among themselves (solving the same problems) but also a series of differences that are internally 'natural' to them when taken as the further contexts for individual behavior. Individual behavior, this model suggests, would be similar if it were not for these differences, and individual persons have to solve the problems these differences present for them. Society thus presents itself to the person much as the nature of the world (natural environment, other societies) presents itself to society.

In the Western postulate that knowledge is organization, comparison consequently lays out the relationships between these factors. Understanding inheres in the perceived relations themselves, as though in a set of diagrams or tables,[9] between all the features characteristic of this situation as opposed to that. The very act of comparison instantiates the premise that there is some natural parallel (of either similarity or difference) between the entities being brought into relation to one another. For anthropology, the concepts of culture or society are consequent artifacts of such comparison.[10] But here feminism diverges.

Feminist scholarship challenges the cross-cultural enterprise for the tautology of proposing that relations between the sexes are to be so explained by other relations, by a view of the constitution of society which makes society simply a context for them. In truth, the advice comes most strongly from within anthropology itself, from feminist anthropologists. According to this cadre there is nothing in social life that is not to be understood *through* gender constructs and sexual relations. Society is not constructed independently of gender and cannot in this sense be an explanatory context for it. Gender relations are neither more nor less autonomous than all social relations.

A second critique is found in Hutt's (1972) advice about the treatment of gender differences and in the Radical premise about the incontrovertible bodily difference between men and women. It ought to be possible to accept that societies are also incontrovertibly different but still to include them within our intellectual universe. In stressing the differences rather than the similarities in people's arrangements, one

would challenge that monstrous ethnocentrism that extends under-standing only so far as the observer is prepared to recognize in the devices of others similarities and parallels to devices of his or her own. Wagner (1975) observed that Westerners are ready enough to allow other cultures creativity and invention in the way they elaborate social life but assume they do so in reference to the same facts of nature as inform Western inventions. Alas, anthropologists often go further than this, and in their interpretations of other people's symbolic systems as-sume a reference to the same *ideational* constructs as inform their own inventions. Yet on this double advice, it seems that the pursuit of the exotic is to be embraced for the same reasons for which it is commonly despised. It leaves the grounding on which the notion of 'society' rests, namely that social conventions should be understood in the first place as ways of solving universal problems of human existence.

In truth societies are not simply problem-solving mechanisms: they are also problem-creating mechanisms. This is the other side of that model which regards individual persons as having to solve the problems presented by their embeddedness in a particular context. In the terms of that model, society may overcome natural differences between indi-viduals, but in so doing presents individuals with problems peculiar to their context and with which they have to grapple as so many obvious differences within the human condition. In this sense, societies present problems equally for men and for women. At the least, then, we should abandon the technological metaphor that imagines society is like an engine that 'makes' things out of natural resources in order to extend human potential, and lay open the issue of whether all human problems are the same ones. 'Women' are a case in point.

The problem of women was never just about women. Over the last twenty years, the woman question, as it was once called, has become explicitly a gender one, in anthropology and beyond. Many of the issues raised by feminist writers touch on the kinds of relations and interrela-tions that preoccupy anthropologists, and a significant contribution of social anthropology has been its insistence on the conventional nature of gender constructs, on the way differences between male and female are conceptualized. However other cultures root these constructs in what they perceive to be immutable sexual characteristics, the con-structs themselves are analyzed as mutable. It might follow that if everything is constructed, then nothing is inevitable, since the relation-ship between social convention and the intrinsic nature of things is exposed as arbitrary. But anthropology has more to say than this.

It is also concerned, as we have seen, with the 'naturalness' of structures—that is, with the manner in which sets of actions or concepts constrain behavior, and consequently with relationships that are not arbitrary, and with outcomes that may well be inevitable. Thus, to argue that what happens to women qua women is a function of what happens to men qua men is not to postulate that women's concerns are relative to or subsumed by those of men but that neither can be understood without comprehending the relationship between them.

Present from the start of the new wave of feminist scholarship has been the implication that in tackling this relationship one is in a sense tackling all relationships. It is not just the general point that one relationship cannot be considered independently of others. Feminist work is specifically devoted to elucidating the reach of ideas about gender and the gendering of ideas throughout Western culture. Considering women's place in society leads to questioning the foundation of society itself, and the highly charged concept of patriarchy signals this inquiry. Social conventions are seen as so imbued with the values appropriate to and created by one sex rather than the other that a double arbitrariness is revealed: society is convention, and it is convention that men are prominent in it. Anthropology is looked to for cross-cultural evidence on both scores. Whether women are the same 'problem' in all societies is to be answered both in terms of what the societies are like and what relations between the sexes are like. There is disagreement among feminist anthropologists about whether or not men are universally prominent (see e.g., the discussions in Schlegel 1977; Rosaldo 1980; Atkinson 1982; Bell 1983); but there is agreement that anthropology's task is to uncover the presence or absence of male prominence, and by the same token uncover the foundations of gender relations, in concrete social instances. To specify the context in each particular case reduces the arbitrariness for that case. Indeed, men's prominence has been documented again and again, with a kind of fascinating inevitability to it, even though each concrete, sociohistorical instance seems to offer its own reasons.

For the part of the world with which I am concerned, the Melanesian islands of the Pacific, and especially the Highlands of the largest of them, Papua New Guinea, men's general prominence in public affairs seems undisputed. My interest is, furthermore, in cases where whole phases of religious engagement are defined as exclusively male affairs, where the descent groups that form the principal political blocs are formed patrilineally, and where prominence in public affairs accompa-

nies overt expressions of dominance over women. However one might modify the picture by analyzing women's roles, considering informal domains of action or estimating women's input into politics, the delineation of the chief institutions by which we recognize 'society' take their cue from the organizational skills of men rather than women. Indeed, visible collective life appears a male rather than a female artifact.

In considering these cases, I propose to utilize the two critiques. The first challenges the view that societies differ among themselves but all have to cope with the same problems of human existence, including relations between the sexes as naturally given entities, so that what are to be explained are the independently conceived societies. I build on the feminist insight that in dealing with relations between the sexes, one is dealing with social relations at large. The one does not explain the other. The second critique concerns the incontrovertibility of difference. Ideas of natural difference support the significance given to relations *between* things in the exercise of systematization. In order not to assume that relations are everywhere apprehended as taking place against the same natural background, between the same 'things', or (as argued in the last chapter) in the same 'contexts', I shall deliberately eschew an implicit comparison between Highlands collective life and the Western idea of society. In doing so I shall also make it apparent that the assumptions of natural difference that Westerners locate in the bodily constitution of men and women are no more useful a guide to understanding the Melanesian imagination than is the Western privileging of relations between individuals as the locus of society. Western questions about male dominance 'in society' subsume the problem of women as a universal one for the organization of relations. Without that problem, the character of men's prominence becomes interesting in its own right.

FEMINIST ANTHROPOLOGY

Various of the questions raised here apply to both mainstream comparative anthropology and to what might also be called mainstream feminist scholarship; they exist as recognizable positions that each has on the other. But one might like to think that they were prompted also by interests that belonged completely to neither—that one could identify a 'feminist anthropology' facing both ways. Such a practice would occupy the special position of contextualizing both anthropological and feminist premises. But it would be wrong to give the impression that

feminist anthropology can out-contextualize them, that it operates as a kind of super-context or super-system or indeed that it is some embracing body of knowledge that encompasses both. It is neither system nor body. If the beast exists at all, it is a hybrid, a cyborg (Haraway 1985).

Feminists and anthropologists comprise different communities of scholars; Haraway's image of half-animal, half-machine captures their incompatibility. It is not that they cannot come together or that they fail to communicate. The point is that their combination produces the holism of neither organism nor engine. Together they do not form a whole. Feminist and anthropological scholarship endorse different approaches to the nature of the world open to investigation. These cannot be blended or matched. Their assumptions do not coexist in a part-whole relationship so that one could be absorbed by the other, nor do they have common objectives for mutual exchange between them: the one is no substitute for the other.

Something of this dissonance shows in the reception of feminist scholarship within mainstream anthropology. On the one hand, it has provided a significant impetus to the investigation of power relations and the exploration of indigenous models. On the other hand, feminist anthropology as such has remained tentatively defined, encountering resistance both from those anthropologists who are also feminists and from the profession at large. Possibly one intellectual reason is feminism's own particular potential for dissolving the notion of society. In asking pluralistic questions about the constitution of and authorship of rules, values, and models, feminist presumptions simultaneously tackle the self-description of anthropology as to do with the holistic analysis of society. Perhaps it is no surprise that feminist anthropologists who see themselves as taking on the whole of the subject are met with a tendency to hive off women's studies from the rest of the discipline.

Gender is easily relegated to male-female interaction, male-female interaction to the concerns of women, women to domesticity—always something relative to, contained by 'society' and 'culture'. The concerns of women are regarded as less than the concerns of society. From this process, something of a myth has arisen among anthropologists in recent years, that an interest in women or in male-female relations necessarily involves feminism as a theoretical stance, and that feminism invented the study of them. It is a myth of containment. It reduces a theoretical position to a singular and concrete subject matter, and it relegates interest in gender and the concerns of women to a particular theoretical position.

Augé discusses the recent ethnologizing of history, which he suggests increasingly "latches on to objects that are traditionally thought of as anthropological (like myth, women, childhood, death, etc.)" (1982: 112). The aside is illuminating. 'Women' are assimilated to 'objects' of study, on a par with what they also create or experience (myth, childhood, death); and they are regarded as specially the objects of anthropological concern. This gives them a mundane exoticism: mundane as part of the everyday life that history now discovers and exotic as the province of the discipline professionally concerned with other cultures. Yet there is a kernel of truth in Augé's remark. Anthropology long dealt with women and with gender as subjects of inquiry: 'the position of women', as it used to be called, was a regular item on the ethnographic agenda. But it is equally mythological to pretend that the new wave of feminist-inspired interest in women continues a traditional one to which anthropology can lay prior claim, so taking the study of gender in its stride. Two myths must be disposed of: that feminism invented anthropological interest in women and gender as subjects of study; and, its opposite, that current feminist interest in these matters simply sustains an old anthropological tradition. Both rest on an equation between feminism as a theory and women as its subject matter.

It remains true that anthropological accounts can no longer get by without examination. If formulations about the nature of society, its dominant institutions, power relations, or assumptions about human nature promote specific interests, then the account must specify whose 'view' is being described. Of course, identifying different views may lead to the post hoc identifying of social positions; differences and contradictions between views are externalized as the differences that lie between persons and that bring them into opposition. The feminist assumption is that men and women will be divided by social interest, and unless ideology is examined in relation to those interests, the analysis remains naive. Indicating the extent to which anthropological accounts incorporate male bias thus questions the specific origin of the ideas which inform the analysis itself. Yet this is all good anthropological advice, very much on anthropology's home ground (Atkinson 1982). It is not in itself an adequate explanation of the dissonance.

Much of the awkwardness in the relationship between feminism and anthropology lies rather in the structure of their epistemological styles. It renders their relationship a hybrid. One is contemplating a hybrid of epochs. Academic feminist scholarship—the way in which its many voices are positioned as speaking to one another, its "simultaneous

activity on multiple fronts" (Owens 1985:63)—has a postmodern structure. The perspectival, us/them dichotomies of much contemporary anthropology belong to a modernist epoch. This appreciation of its modernism might only have been made possible by current experiments in postmodern writing among anthropologists themselves, but the multidisciplinary, multivocal field of feminist conversations long anticipated such experimentation.

My account exploits perspectival devices, including the us/them dichotomy, as essential fictions to its argument. I even include 'the feminist voice' as one perspective. But I hope I have not thereby homogenized it. For Owens (1985:62) notes that the "feminist voice is usually regarded as one among many, its insistence on difference as testimony to the pluralism of the times," thereby making it victim to assimilation as an undifferentiated category in itself. Its internal differences are suppressed in the adoption of 'the feminist view'. This is certainly what seems to have happened within anthropology at large.

Here, a current pluralism of sorts encourages eclecticism and tolerance for a range of growths and directions. The feminist anthropology that emerged in the mid-1970s is seen to be part of the discipline's labile responsiveness to changing external conditions. It is tolerated as another approach, another way into the data to be put alongside multiple other ways. Facilitated by the apparent concreteness of feminist aims, such tolerance in the end has had the constraining effect to which I made reference. The pluralism of feminist debate is, by contrast, not so much the eclecticism of multiple potential viewpoints, to be occupied in turn, as the construal of a discourse. The several vantage points are not to be exchanged for one another but sustain their differences as so many distinct voices. Common ground lies in experience, consciousness, the motivation to change the present order.[11]

Examining 'feminism' in relation to other academic fields invites potential solipsism. Feminist theory will have drawn on the same common broad sources of thought shared by academic practice in general. Precisely because of such common sources, almost any single anthropological position on gender could be matched with some piece of writing in the feminist literature. But the status of the differences between internal positions will vary. The pluralism of anthropology allows a diversity of entries into the representation of human societies, thereby to some extent externalized from the observer. Feminism is admitted as one such entry. Internal debate concerns the quality of the representation and the status of the facts so worked upon. The pluralism of

feminist scholarship, however, is constructed as a matter of life-based decisions about where one stands in relation to other feminists. Anthropological studies, like historical, literary, or other studies, may be drawn upon for the evidence they give of circumstances elsewhere in the world, but the subject matter is a pluralist conception of one's own society, and debate itself is construed through a plurality of internal positions. The modelling of internal and external relations remains incompatible between the two styles of scholarship.

Feminist scholarship, polyphonic out of political necessity, accommodates anthropology as 'another voice'. Within this epistemology, anthropological analysis of male-female relations in non-Western societies in the end cannot explain Western experience, which is also personal experience, although it may contribute to the further experiences about which feminists must think. At the same time, different viewpoints are sustained in coeval parallel; indeed, the multiplicity of experience is retained as a sign of authenticity. Each is a feminist voice, but the voices create no single viewpoint, no single perspective, and no part-whole relation between themselves. The only perspective lies in the common challenge of patriarchy. The contrast with modernist anthropology is obvious. That endeavor does not find itself in a dichotomous position with the world. Rather, anthropology seeks to pluralize its relationships with many cultures, many cosmologies. It creates its dichotomies within, as in its modelling of an us/them knowledge of its own conceptual constructs. In turn, modernist anthropology accommodates feminism as it does its grasp of the intellectual systems of other peoples. Feminist scholarship is to be captured for its value as a specifically conceived 'other', a contributing part with its own aims and intentions that could not possibly be coeval with those of the discipline as a whole.

If there is anything distinctive about feminist anthropology, it lies in the attempt to retain the specificities of particular social/historical circumstances under the generalizing rubric of inquiry into "the sex/gender system" (Rubin 1975:167) or "the social relations of gender" and "what a theory of gender in society would have to include" (Young et al. 1981:ix). Yet anthropologists who are also feminist scholars continue to find themselves awkwardly placed. Like their nearest colleagues, Marxist-Socialist feminists, they may embrace both a holistic and a pluralistic understanding of social and cultural forms. The hybrid feminist-anthropology exists as the fruitful product of this graft. But when it comes to acknowledging the way in which they contribute to

one another, feminism and anthropology have quite disparate chromo-
some counts. The relationship works precisely because the graft has
been done between full grown parts with different origins.[12] It is a
provisional or interim misfortune that as a consequence one or other
position often seems to take a subordinate place in academic produc-
tions. One appears to be the context for thinking about the difference
the other would make. Meanwhile, cyborgs, muses Haraway (1985:99),
"might consider . . . the partial, fluid, sometimes aspect of sex and sex-
ual embodiment. Gender," she adds, "might not be global identity after
all." By gender she means sexual identity, that is, a dichotomous natu-
ral difference biologically conceived. We need the discipline to hold the
thought.

Part One

Part One

3
Groups: Sexual Antagonism in the New Guinea Highlands

The Papua New Guinea Highlands were opened up to investigation at a particular moment in the expansion of post-war anthropology. None of the ethnographic reportage from that era is untouched by the concerns of the day, and the residue of those concerns is deeply sedimented in the way in which the ethnographic materials themselves were shaped. Although my remarks are not confined to the region, I use it as the site for a minihistory of the changing formulations of what first the study of male-female relations and then the study of gender relations has come to mean.

It is easy to overlook how recently coined 'gender' is in its contemporary sense: until two decades ago, the term was rarely used except as a matter of grammatical classification—a purist position to which some occasionally demand return. It did not make a substantial appearance until the early 1970s.[1] Yet Melanesian anthropology had sustained a long and distinguished contribution to the study of what were once called 'male-female relations'.

The manner in which these issues were treated before the 1970s created the ethnographic materials with which subsequent conceptualizations of gender relations have had to deal, and it is important to have some sense of that conceptual history. This is particularly so for a region that displays in compressed form a general comparative problem concerning inter-sexual activities: how to specify the widely varying relationships that exist between public cult activity, ceremonial exchange,

and (formerly) warfare on the one hand and the organization of horticultural production and domestic kinship on the other. Put like this, the problem seems another rendition of the familiar dichotomy between political and domestic domains or of the articulation of exchange and production. Its symbolic expression, through a gender difference that makes the political arena largely a male concern which excludes females, also makes use of a familiar opposition. The character of these processes of exclusion and opposition have been a preoccupation of anthropological descriptions since the Highlands first became an ethnographic area.

The region offers no internal comparison between systems based on patrilineal and on matrilineal kin reckoning. I shall, nonetheless, extend conclusions based largely on my understanding of Highlands societies to what are, on the surface, the very different matrilineal regimes of seaboard Papua New Guinea and make claims indeed for their applicability to Melanesia in general. Many seaboard Melanesians appear to conduct their affairs with emphases that would challenge the generality of the comparative problem just outlined. Societies in the Massim and New Britain provide examples of public ceremonial life based on values associated with food production and of women prominent in ceremonial exchange. It would thus be possible to show the contrived nature of the problem through negative ethnographic instance. Indeed, it has been argued even for the Highlands that such oppositions are analytically contrived, and instances are adduced of the political nature of domestic decisions or the contribution of women to men's affairs.

Despite this, I take as my starting point instances where the oppositions work most strongly. Hagen society affords such an instance. Here, the collective life of men revolves round the mobilization of political groups (such as clans) in pursuit of both individual and collective prestige through exchanges with other groups, warfare, and cult celebration. In the context of extolling the maleness of these activities, men denigrate the sphere of domestic production in which women are prominent. By and large, women do not seek participation in men's collective life and, in certain situations, are specifically barred by virtue of their sex. They may support the underlying public values of prestige, but any denigration of men's efforts carries a private rather than a public value, which is also true for men's praise of women's productivity and hard work. Langness's (1977:6) characterization of Bena Bena, also in the central Highlands, is apt: "men are everywhere and always entirely in charge of public affairs," and if by politics is meant the manage-

ment of public affairs, "then men are in absolute control of politics." Women, he adds, may have influence but lack political power. But Langness cautions, as we shall see, against any easy equation between 'politics' and 'society' at large.

The comparative problem ascribed to Melanesia as a whole is more than my problem with the intransigent Hagen material writ large, although it is also that: the Hagen situation gives its form to the way I perceive the problem. What is pointed up in the extreme case in these central Highlands systems is not only a particular set of ethnographic issues but an anthropological approach that has shaped the way in which those issues are framed (as in earlier writings of my own). In turn, that approach has generated the form in which powerful criticisms have been couched. They include the suggestion that analysis emphasizing opposition and exclusion turns a cultural bias into a theoretical one. In one set of criticisms, such analysis has been held to neglect spheres in which women do have power; in another, to neglect the extent to which men's collective life is based on access to and exploitation of women's labor.[2] And that approach also gives us the contrary cases—by imagining that the division between male and female domains concerns men's and women's participation in social life, we lay weight on counterinstances where women do seem to so participate.

In approaching matters rather differently, I hope to contextualize both the criticisms and the search for counterinstances as themselves belonging to a particular phase of anthropological history. This chapter begins by considering the way in which issues concerning sexual identity in the Highlands were encapsulated within anthropological preoccupations with group structure in the 1950s and 1960s. Chapter 4 turns to a feminist-derived critique embedded in its own history of the emergence of gender relations as an autonomous topic for inquiry in the 1970s.

PARTIAL CONNECTIONS

My account makes explicit one common implicit practice: extending out from some core study certain problems that become—*in the form* derived from that core study—a general axis of comparative classification. The observer then investigates whether a relationship pertinent to one place holds elsewhere. For example, Meggitt's influential article (1964) explores the relationship between pollution beliefs and military alignments in one Highland society, and then applies the relationship across societies. In asking how well the one model holds up elsewhere,

this procedure also verifies the original connection; the relationship so utilized then may or may not become a 'principle' of organization or a 'structure'. Meggitt himself refers modestly to 'patterns' of relationships. What becomes objectionable in much comparative analysis is the decentering of the initial correlation, as though it somehow belonged between or across several societies and was not in the first place generated by one of them. In being frank about the center of my own interest, I made no apology that the present exercise contains an attempt to understand the particular cultural forms of Hagen society and thought, and that my interest takes its cue from just these. This strategy has two entailments.

First, a description that holds for Hagen ought also to hold to a degree for their neighbors across Melanesia. This would be, in part, an artifact of the process by which the analysis itself proceeds, in so far as it draws on material from those neighbors. A presumption of continuity is thus written into the enterprise. But it is a presumption based on the historical and spatial contiguity of the societies and cultures of this region, not on supra-societal correlations. The description does not have to be completely replicable in order to be valid; but it does have to be partially applicable. Second, and at the same time, very real differences must be countenanced. I thus sustain throughout a 'difference' between the societies of 'Eastern' and of the 'Western' Highlands (referring here to geopolitical areas and not to the provinces by these names). It is an artificial one in so far as that contrast must stand for all the possible contrasts that one might wish to bring in view between the several social and cultural systems of the Highlands. These we must apprehend as connected to one another but only partially so. Further 'differences' between the Highlands and societies of the island Massim and of Vanuatu underline the point.

The contrast itself dates back to the early days of anthropological investigation in the Highlands and to initial administrative boundaries. If instead of deploying a contrast, one were to overview the whole area, one might wish to pinpoint certain sociocultural gradients, by way of analogy with biotype gradients (e.g., Hyndman 1982). One would then become aware of a diverse number of centers from which to extend rather different problematics.

Despite all the continuities that exist, for example, between the societies of Papua New Guinea at large and Irian Jaya, it is clear that the differences between the Highlands of the former and the Lowlands of the latter are also quite radical. For much gender symbolism, the par-

ticipation of men and women in fertility rituals, and the organization of performances, one might seek for parallels in Aboriginal Australia rather than the eastern part of the same island. If that is so, then the driving fiction of this present account—the emphasis I give to gift exchange—will cease to so drive (see M. Strathern 1985a). Similar breaks could be constructed between Papua New Guinea systems that incorporate a hunting and gathering regime by contrast with exclusively horticultural economies, as Collier and Rosaldo (1981) hint in their comparison of brideservice- and bridewealth-based marriage arrangements; or between those with intensive and those with extensive horticulture (e.g., Rubel and Rosman 1978:341–345; Modjeska 1982). As is true of the distribution of flutes across the Highlands, what seems of fundamental importance in one area disconcertingly appears elsewhere in a trivial or nonessential context. That does not render them trivial in the original context of inquiry. But it forces on us an understanding of that context that goes beyond the presence or absence of particular traits, and thus beyond the capabilities of a variate analysis. Only experimental extension out from the original inquiry will yield the limits of the analytical power that particular conceptual devices hold.

I take, then, a Highlands-centric problematic in concentrating on the manner in which public, collective life is constituted as the affair of men. There is a concomitant to this.

Melanesian societies vary in the extent to which collective action is oriented towards kinship-based transactions and those where it is divorced from them and creates values only contingently involved with kinship (Rubel and Rosman 1978; Godelier 1982; Allen 1984). Thus, for some peoples, it is the central stages of life-crises and the documentation of kin relations which are the principal focus for ceremonial. The productivity of kin-based relations may be celebrated in exchanges accompanying reproduction and the production of food, or sister-exchange and the creation of moieties may make political formation indistinguishable from kinship relations. Instances are found in the Eastern Highlands. Yet, there may be parallel activities in these same societies whose ends are not simply justified by reference to some body of kin relationships but which autonomously refer to the desirability of collective action itself. Ceremonial exchange also appears to be for its own sake. Where, in other societies, this assumes a significant organizational role, group formation increases in scale. Peoples in the Western Highlands and their immediate Southern Highlands neighbors come to mind. The extent to which 'politics' can thus be separated out as a dis-

tinct domain of social life (with its own values) involves differences in the nature of group boundaries as well as in styles of leadership (whether there are big men or not), in the way in which 'wealth' exists as an independent category, and in the perceived autonomy of persons.

Major life crises are everywhere ceremonialized, and there is a greater or lesser degree of political interest attached to the organization of kinship. On the one hand, then, collective life may appear to create more kinship—to sustain and elaborate relations based on the cooperative activities of reproduction and horticulture. On the other hand, it may create values that have little to do with or are deliberately opposed to those of kinship. Prestige, for instance, can become conceptually detached as a goal in itself, evinced in the possibility of men comparing themselves in its terms alone. The degree of detachment of 'politics' as an autonomous sphere of action has consequences for the kinds of values structured through gender formulations.

Nevertheless, there is more to the comparison of these systems than acknowledgment of the inflated political activity of some. One cannot explain the presence of such 'politics' by itself. Rather, politics must be located within the same sets of conditions that give rise to differences between kinship structures. Specific structurings in interpersonal relations yield varying possibilities for the way in which persons relate to, are detached from, and transact with one another. Indeed, I shall argue that forms of collective life are intimately bound up with the constructs of domestic kinship. But this is quite different from suggesting that public life ('society') is domestic life ('kinship') writ large. An assumption which has dogged analyses of Highlands societies is that clan relations are a variety of kin relations, that somehow they are the public face of kinship. This has led to difficulties in the analytical conceptualization of clanship, captured in disputations over the nature of descent groups (de Lepervanche 1967–1968:138–139; Feil 1984a:52). It has also led to a misrecognition of their collective nature.

By collective, I mean forms of activity in which persons come together on the basis of shared characteristics. What they hold in common is regarded as the rationale of their concerted action. This is usually group affiliation or gender. Shared characteristics may lead to sharing actions, or they may promote competition and rivalry over what is not shared. Thus, I define as collective action not simply the mobilized internal solidarity of clan groups but relations between clans where they are divided by something to which they can all lay claim—such as their names or reputations and individual histories. As is well recorded in Melane-

sian ethnography, the creation of inequalities between men and clan groups is based on a premise of equality, and in so far as they are rivals and enemies, men are held to share common if competitive interests. Such relationships are, however, separate from those asymmetrically construed, where interaction proceeds on the basis of and in reference to the particularity of an inherent difference between the parties. Interaction here reproduces the dependency that such differentiated persons have upon one another; what is shared cannot be concretized as what they have in common, bar the relationship between them. The sexual division of labor is a case in point. Where production is seen to derive from the activities of two socially distinct persons, it is literally construed as the product of the relationship between them. It does not itself directly augment the one at the expense of the other, there being no common measure between them.[3]

Melanesian public and political activity has a collective character, whereas horticultural production and domestic kinship sustain particular relations. Collective and particular relations are combined and separated in differing ways. Indeed, on occasion, each may provide the rhetoric through which the other is perceived. From the early ethnographic writing on the Highlands, however, one would imagine that Highlanders conceived the contrast as between 'society' and 'individual' or, worse, between 'culture' and 'nature'.

ANTHROPOLOGY IN THE HIGHLANDS: GROUPS

The Highlands were first explored in the 1930s, and brought under administrative control after the Second World War: anthropologists embarked on studies in the 1950s. The prospecting party which first flew into the Wahgi valley saw wealth—creeks which might carry gold or potential cattle country; they also saw fertile soil and "a teeming population."[4] The social scale impressed the anthropologists. Highlands populations were numerically large for Papua New Guinea. More than that, they seemed highly organized and cohesive; warfare was conducted on a major scale, and men mobilized themselves in units and alliances for that purpose. In fact, the larger central Highlands societies—Mendi, Hagen, Enga, Chimbu, and those in the Goroka area—dominated the ethnographic map for twenty years. Nowadays, they appear rather atypical.

History goes that anthropologists discovered descent groups. Coming

from a traditional jural-political Africanist background, the early
ethnographers found tribes, lineages, clans. The impressive political or-
ganization of the Highlanders inspired works such as Meggitt's *The
Lineage System of the Mae-Enga* (1965), and a comparative interest in
lineality and agnation (e.g., Salisbury 1956; Brown 1962). African mod-
els were thus found in the New Guinea Highlands, while their con-
sequent demolition over time has since challenged descent theory itself.
This history does not tell its own story. Remarkably, at the same time
as descent groups were being described, so were the exceptions (see
A. Strathern 1982:35). Where patriliny and agnatic kinship were discov-
ered, so was the troublesome fact of 'nonagnates'. In addition, these
societies presented problems for the analytical conceptualization of co-
hesion and of organization itself. One early account was called *Excess
and Restraint* (Berndt 1962), another subtitled *Freedom and Confor-
mity* (Reay 1959); there was discussion about 'looseness' and 'flexibil-
ity'. What remained at the heart of the subsequent debates, however,
was a conflation between social structure and, whether they were to be
thought of as descent groups or local groups, the activities of political
units.[5]

Indeed, the very debates, including the question of alliance rather
than descent models,[6] served to demarcate the significant topic of study
as the organization of groups. The manner in which groups conferred
membership status might be ambiguous, but their coming together in
the defense of interests and self-promotion was not. Focus upon their
lineal or nonlineal character took for granted that these groups pre-
sented themselves to observers as organized political entities. The point
was grasped through an attempt to oppose locality as a principle of or-
ganization over and against descent (compare Langness 1964; de Leper-
vanche 1967–1968), arguments that in turn served to perpetuate the
notion that the impetus for collective behavior lay in the attributes that
these groups of men claimed to have in common. An ideology of shared
characteristics ('one father', 'one men's house') was regarded as the
cause of social identity and as the reason for protecting it. We might
put it that a universal relation between society and individual was taken
to assume a local form in the relationship between groups and their in-
dividual members.

From one viewpoint, the controversy over nonagnates remained a
formal matter, a question of the propriety of the concept of unilineal
descent. That claims to group membership could be made on the basis
of ties traced through mothers, as well as fathers, affected analytical

decisions about the nature of group constitution more than it did the perception of Highlands group solidarity. After all, one of the contentious points was that such solidarity was promoted regardless of lineality. That relations through women were involved was, in this view, simply a matter of how groups conceived of differences and similarities between themselves. From a second point of view, however, substantive significance was made of the troubling fact of women's presence. The necessary interdependence of clans through marriage was one thing; this did not preclude relations of hostility with affines. Incorporating sisters' sons was another. The female tie was a logical intrusion. Perhaps the controversy over nonagnates held center stage for so long in response to a contingent and adjacent area of ethnographic encounter, namely Highlands men's apparent preoccupation with their exclusiveness as a sex.

That 'patrilineal' groups were open to members recruited on nonmale ties appeared to compromise the efficacy of their claims to solidarity. Because of the tenor of male-female relations, as they were being described in contemporary anthropological accounts, the compromise made little psychological sense, and much analytical work was devoted to showing the manner in which the intractable givens of nonlineal status were subject to conversion, so that over time nonagnates became agnates, or residence came to determine kinship (e.g., Ryan 1959; A. Strathern 1972). Preoccupation with the descent issue must be understood, then, in relation to the analyses of male-female relations being made at the same time. Male dogmas of solidarity were being interpreted not only in terms of inter-group competition between men, but also as a matter of men's relations with women. Women, whose kinship position on formal grounds might merely signify the manner in which men classified their relations to one another, were simultaneously being credited with posing real life threats to male cohesion.

When Langness and Weschler offered their readings on Melanesia, they noted that the most sustained research effort to focus on a single topic was in the "study of social structure" (1971:95). Under this head they gathered five papers dealing with disputes over the nature of segmentary lineage systems. The book was also organized according to the categories ecology and economics, social process, and social change. Excluded from structure, but included in process, in their terms a matter of 'life' as opposed to 'structural principles', is ceremonial exchange, conception theory, mortuary and fertility ritual, and, passim, male-female relations. That particular notion of structure belonged to a theoretical

tradition also concerned to specify the conditions of social integration.[7] In the absence of indigenous preoccupations with legal rights and statuses, the study of groups in the Papua New Guinea Highlands became very much a study of group solidarity. And it was precisely those areas of activity demarcated as 'process'—ritual and male-female relations—that offset the whole issue of solidarity. As Wagner (1974) observed, anthropologists consequently set about making Highlanders' problems their own. Patrilineal descent became a problem of male identity and thus a problem that their analytical models shared with men's apparent folk models: how to preserve the idea of the (descent) group as a male body of agnates in spite of the possibility of claiming ties through women. Given the emotional requirements of solidarity and cohesion, Highlands men had to preserve their maleness from the threats, intrusions, and allurements of women. Positive ties with women (see Langness 1967; although compare 1964:180) were as challenging to their collective maleness as negative ones.

This was the state of the art on the eve of the new feminism. Gender entered almost every account of Highlands societies through the supposition that social structure was concerned with (male) groups; that groups faced problems of cohesion; that cohesion was bound up with group definition and group definition with solidary feelings among its members; that things to do with women threatened male solidarity; and that this was a problem men faced. Keesing (1982:23) sums up the argument: "In a social order where male loyalty to fellow males is the foundation for warfare and the solidarity of the local group . . . it is ties with women that pose the greatest threat, from both within and without." So it was not that women were ignored by either the men in their societies, or by their observers: it was, as E. Ardener (1972) remarked in quite another context, that women were the whole problem.

The issue of solidarity was always presented through a strong experiential dimension. For instance, Meggitt's 1964 paper on male-female relations addressed the "antagonism pervading inter-sexual encounters," a characterization established by one of the first anthropological fieldworkers in the Highlands, Read (1954). Variations in inter-sex hostility between societies, Meggitt argued, could be correlated with the presence or absence of purificatory cults to rid men of female pollution, differences in women's social status, and the degree of hostility between affinally-related groups. Meggitt turned the argument in two ways: first, in terms of cultural categories that associated men with one constellation of cultural traits and women with another; second, in terms of so-

cial categories, in that (as far as Mae Enga were concerned) attributing of hostility and lethal influence to women could be associated with men's experiences of marrying wives from enemy groups.[8]

The word antagonism combined it all: Highlanders were typified by "prevailing aggressiveness" (Meggitt quoting Read) and a significant manifestation of this aggressiveness was sexual antagonism. What was reported about male-female relations thus tended to turn on the antipathy between the sexes—hostility Langness openly called it. Apropos Bena Bena he observed, "Male solidarity involves the residential separation of the sexes, and a complex of beliefs and sanctions . . . that exist to buttress the social distance between males and females." He went on to note that while the beliefs and sanctions were functional in terms of group survival (in a context of warfare), they were at the cost of individual sex and dependency needs and thus "ultimately promote hostility and antagonism between the sexes" (1967:163). Like Meggitt, Langness widens the whole issue of male-female relations to warfare and political confrontation. These ethnographers are not relegating women to some subsidiary status: they are integrating beliefs about the nature of women with the wider so-called 'social structure'. But the tension is imagined from the emotional demands of that structure: Mae Enga demands for group solidarity in the face of clan enemies, Bena Bena demands for warlike behavior on the part of warriors.

The sanctions and beliefs to which Langness refers included restrictions arising from fears of pollution and from ritual and cult activity. Cults that mobilized a male membership were largely secret affairs; they excluded women and might be in conjunction with or necessitate the initiation of boys into their congregation. They captured the anthropological imagination.

ANTHROPOLOGY IN THE HIGHLANDS: SEXUAL ANTAGONISM

The debate over the nature of Papua New Guinea Highlands descent groups has all but extinguished itself; the sexual antagonism model has endured long beyond.

Read's 1950s interpretation was seminal.[9] He described the then extant cult of the sacred *nama* flutes in Gahuku-Gama in the Eastern Highlands. The sociological functions of the cult, especially in the context of men's initiation rites, are understood as follows:

The initiation rites serve primarily to introduce the younger members of the community into the men's organization. . . . They express unmistakeably the rigid sex dichotomy of the culture, the community of male interests and their essential opposition to the sphere of women, and also designate successive stages of physiological and social growth. . . . [They] are the supreme expression of the community of interests between men. (1971[1952]:223, 225)

A 'community of interests between men' is embodied in a conception of 'the whole subtribe', and men are specifically concerned with male growth or maturation, so that there is a gamut of associations here from community to social category to sex identity. When Read refers to the cult as "preeminently both an affirmation and expression of the enduring order of established forms of male relationships" (1971:226), we understand the designation at once sexually and socially. In this context, it seems self-evident that the sexes should be segregated.

Not just segregation of the sexes but male domination is at issue. The cults are described as an "artificial and consciously contrived mechanism through which men hope to demonstrate and preserve their superior status" (1971:226)—the *nama* cult is both an index of male dominance and an institution maintaining male hegemony. Male ascendancy is thus taken as men dominating women, with women spiritually dependent on men's control of the flutes and the ancestral past. *Nama* is represented by Gahuku-Gama men as a channel of supernatural force upon which the welfare of the group depends, men's activities being clearly written into those institutions which uphold groups. Male superiority is thus vested in what is recognized as 'society'.[10] In addition male superiority has a status in this account as a manifestation of 'cultural' behavior. It became a commonplace to follow Read's other observation that "the superiority of the male . . . has largely to be achieved" (1971: 228). He emphasizes that Gahuku-Gama men labor under an initial "physiological inferiority" that leads them continually to "assert their dominance in cultural terms" (1971:228–229). As he put it later (1982: 68), the edifice of male superiority was, in fact, erected on a male secret that women were biologically superior. Men's cults are thus seen as at once an embodiment of society and of culture: of society, since male collective life has ends of its own, particularly in promoting a community of males who endorse Gahuku-Gama social values; and of culture, in so far as it rests on deliberate artifice.

There is a slippage here, then, between the way in which the observer conceives social structure and Gahuku-Gama men's notion of collective

life—its manifestation in ancestral connection, the promotion of general welfare, and the specific defense of subtribe and tribe.

Read says at one point that "[w]omen are not present at any of the ceremonies . . . yet the festivals are for them, no less than for the men, the climax of social life" (1971:235). He concluded his 1952 paper as follows: "The force which the *nama* symbolize is the power of society itself" (1971:238). Although reflectively Read approves of Langness's (1971) interpretation that the *nama* cult represented a peculiar kind of Durkheimian religion in which society apparently worshiped only men (1982:68), in fact, Langness challenges the idea that the cult symbolizes the power of society itself. If it does, it is a society that excludes women. But the point is lost in that additional equation. The original equation between male collective life and 'society' anthropologically conceived is sustained by the parallel one between the description of Gahuku-Gama men's creativity in designing and performing the cults and the anthropological concept of 'culture'. Read himself prefaces his approval of Langness's remarks by stating that Gahuku-Gama culture was stridently masculine.

To the Western European view, culture is production, it makes things; it is artifice, it builds on an underlying nature; and it is an agent, a manifestation of power and efficacy, for in what should power and efficacy be shown but in the taming of the natural world and the products of the created one? And here in the heart of Papua New Guinea are Gahuku-Gama men recognizably doing what anthropologists call cultural activities. For it is reported that their own dogmas suggest that they must overcome what they see as an imbalance in nature. Women pose to men a problem of 'nature' in the eyes of the actors and observers alike.[11]

In the intervening period since Read first wrote, much fresh ethnography has added to anthropological knowledge of ritual as is found in the *nama* cult complex in the Eastern Highlands. Generalizations run the recognized danger of assuming that there is a single genus of 'male cultism' (Keesing 1982:5); and in reference to any one area there is difficulty in deciding from a range of rituals which should be counted as part of 'male initiation' (Newman and Boyd 1982:243). But quite apart from ethnographic discontinuities between bachelor cults, secret fertility rituals, puberty sequences at marriage, and so on, as well as the linguistic and sociological differences between different congeries of Highlands societies, one can discern common interests on the part of

the investigators. By and large, they sustain theoretical continuity with the descriptions first developed for the Eastern Highlands societies and the form that sexual antagonism takes there. Continuity is provided by the premise that where cults involve the initiation of boys, as they often do, then their purpose is to make boys into men. It is worth considering how this proposition is made convincing.

Looking back on his research, Read (1982:73) stresses that one cannot dismiss the understanding of 'subjective experience' neither in accounting for why the cults have since disappeared nor in understanding Gahuku-Gama culture at a time when it was dominated by men's need to be warriors. Thirty years after Read's initial studies, Herdt properly questions "the conventional anthropological view that New Guinea male myth and idioms only represent the collective assertion of male superiority and solidarity over women" (1981:263). He gives a most interesting twist to the physiological doubts that Read reported in Gahuku-Gama ideas about maturation. Among the Sambia, who are located on the very edge of the Eastern Highlands, Herdt suggests what myth and ritual really disguise are men's deep doubts about their maleness. Myth converts the fear that a man has feminine attributes into a positive conviction that he is masculine. He describes the fear as a transsexual fantasy in masculine behavior.[12] Indeed, one of Herdt's contributions to Melanesian ethnography lies in his extensive exploration of the manner in which Sambia individuals perceive their identity.

The sexual antagonism model emerges in Herdt's work with refinement. For instance, the volume edited with Poole develops the point not just that women are a problem for men but that men are a problem for themselves: "Male sex role dramatization and male incorporation in solidary adult groups are problematic phenomena" (Herdt and Poole 1982:23). One must agree when they (1982:24) write as follows:

> We can no longer 'read' behaviour from the specifications of ideology, and we must recognize that men and women may formulate different ideological versions of each other. . . . both men and women must be allowed to 'speak' in our ethnographies on their condition and view *of each other* [my emphasis].

Yet the next sentence reads:

> Our understanding of the *experience* [my emphasis] of self, gender and sexuality, and of the informal tenor of inter-sexual relations, must now come to the foreground of our analyses.

Ideology in this account is thus seen to 'cover' behavior and experience, and the experience of self is merged with that of gender and sexuality.

Subjective experience was always central to the sexual antagonism model in the prominence given to the attachment of sex roles to the individual. It contains a theory of socialization. Hence, the psychosocial processes of initiation ceremonies "provide a means for assigning statuses and roles to individuals" (Herdt 1981:295–296).[13] Indeed, Herdt deliberately characterizes recent developments in Melanesian ethnography as paving the way for "a new anthropology of ritual experience" (1982c:xix) with its specific interest in affect and the self. The anthropology of experience is especially sensitive to the emotional correlates of these socialization processes, thus serving a theoretical postulate about "social conditioning" (1981:3). Masculinity and femininity are embodied in individuals as a dimension of their experience. Social categories become the framework within which men and women behave in certain ways, but behavior is ultimately manifested by the individual, whose ontogeny therefore becomes a focus of interest.

The individual in this view is a source of action, an embodiment of sentiment and emotion, author of ideas, and one who reveals the imprint of culture. This is not a simple matter of personality but shows in complex phenomena—attachments, dissociations, trauma, fears with respect to 'others'. Since the individual as an agent is also conceived as a single entity, many of her or his problems are presented existentially, as boundary ones. Read (1984:213) appositely cites Geertz's observation about the peculiarity of the Western conception, of the person as bounded and integrated, and set contrastively against other such wholes and against a natural and social background. Yet the conceptualization of the person as individual, as a being that worries about its boundaries and searches for a unitary identity, remains an unspoken premise in the anthropology of experience. Thus, in his first volume on the Sambia, Herdt states that for him the anthropological task is to

> explain a puzzling pattern of culturally constituted development in which Sambia heterosexual manhood emerges only after years of normatively prescribed and prolonged homosexual activities. (1981:2)

The puzzle must become the nature of Sambia 'masculinity'. Sambia men, he writes, "need to sense themselves as unambiguously masculine" (1981:305). This formulation, of men as individuals needing to experience a unitary identity, is both attributed to the New Guinea culture

and adopted by the observer.[14] I suspect it underlies the description of men's interaction with women in terms of antagonism. Characterizing relationships as antagonistic captures the individual actor as agonist and records the imprint of encounter with others in terms of the feeling subject. Others pose problems for the self.

Herdt is critical of the concept of sexual antagonism itself. He and Poole (1982:21) list nineteen different theoretical contexts in which it has been used. They point out that in the history of Papua New Guinea ethnography the concept has done three things: (1) it enabled observers to pin down a sense of cultural pattern over a diverse ethnographic area; (2) it metaphorically covered a linkage between individual feelings and social behavior; and (3) it belonged to and contributed to a debate over the extent to which sex and gender could be interpreted in the light of taken-for-granted norms. Yet whatever revolutions there have been in our interpretations of sexual behavior, the parallel concept of 'experience', which was part of the 'sexual antagonism' model, continues to tie us to certain perceptions of gender. In this guise, the model endures.

There is for Western Europeans a persuasive element to the presentation of subjective experience. I cannot, for instance, read Poole's (1982) account of Bimin-Kuskusmin initiation without making a fascinated/repelled connection with the horrific traumatization of the boys.[15] To give less than full vent to the emotional impact on the anthropological observer would be to diminish the range of phenomena, including the emotions, that require comprehension. What I wish to unearth from the presentation of experience, however, is an approach to gender relations, particularly through the equation between gender relations and sexual identity, which does another kind of violence to the material. Hagen has no initiation practices of significance; therefore, it is not possible to juxtapose 'my experience' of Hagen ritual with that of others. At my disposal is only a suggestion of an analytical nature: that the kinds of interpretations of male ritual discussed so far have a prefeminist cast to them. This is not because they deal primarily with men, but because of the theoretical way in which indigenous gender constructs have been treated. The antagonism model, in so far as it endures, promotes a self-contained approach to gender that pushes the problem of individual identity to the fore. The assumption is that the creation of masculinity is first and foremost conceptualized by the actors as a matter of sex-role acquisition. On neither anthropological nor feminist grounds should we, in fact, be content with the formula that male cults are in this sense self-evidently concerned with 'making men'.

THE PROBLEM OF GENDER IDENTITY

Individual sexual identity is a cultural issue in Western society. Preoccupation with sexual performance, heterosexual or homosexual, turns erotic behavior into a significant source of self-definition. Yet the notion, for instance, that homosexual behavior might involve an exclusive orientation to one's own sex would seem to be comparatively recent in Western Europe.[16] It is a point Herdt stresses in postulating that Sambia homosexual behavior does not produce 'homosexuals', that is, a "single identity type" (1984a:x). His argument is that outward sexual behavior is not necessarily formative of internal identity—"feelings, ideas, goals, and sense of self."[17] And it is this internal identity that is the subject of his delineation of masculinity, namely men's sense of their own gender—"the developing boy's sense of himself and his maleness" (1981: 14). It would be unfair to make too much of a term that he situates within psychological discourse; but Herdt's specialized use of 'gender identity' confines gender within the psychodynamics of individualized personal experience, even if it includes experience of the world and of others and is regarded as developing in response to specific cultural demands.

Melanesians make considerable imagistic use of gender. But we cannot assume that individual identity is at the heart of what is going on. Concern with identity as an attribute of the individual person is a Western phenomenon—it is we who, as Wallman (1978) said, make sex into a role. The sex-role model derives, in turn, from certain cultural assumptions about the nature of 'society'. To assimilate Melanesians' understanding of initiation and puberty rituals to sex-role socialization supposes the actors hold a similar model of sociality. This may cloud appreciation of Melanesians' own preoccupation with these issues. For it is important to be clear about the extent to which we do or do not wish to make their preoccupation ours. Even if we de-intellectualize them as 'experience', I am not convinced that we have understood everything about their gender concepts in understanding people's orientations towards being men or being women.

The sex-role model does not, of course, assume that identities are only their own point of reference. A relational view is built into it. Masculinity may be described as a psychosocial dialectic (Herdt 1982a:74). In addition, the solidarity of the male community exists at the expense of females (Herdt 1982a:48), and the initiation system is fraught with internal contradiction in the relations it supposes with women (Keesing

1982:36).[18] Langness explicitly argues that it is in the face of cross-sex ties that men construct their exclusiveness: "Boys are naturally attracted to their mothers and must be removed from them by the community of males" (Langness 1977:18). Herdt bases his analyses of Sambia men's beliefs and rites on the transsexual fantasy that men began as a composite of maleness and femaleness. "It is my hypothesis," he says, apropos the most secret of myths, that it "helps convert a man's nagging fears that he has feminine attributes into a positive conviction that he is masculine" (1981:263). There is no doubt, then, that these analyses incorporate a relational view, so that the construction of solidarity along sexual lines is regarded as inhering in power relations between men and women as well as in the stereotyping of their differences. But at the same time the sex-role model assumes that the focus of ritual concern is the individual who is in some sense the responsive self.

There are a number of interesting affinities here to feminist discussions. However, internal feminist debate also leads to radically divergent views about gender identity. For some, what has to be explained is 'gender identity' in Herdt's sense, the sexed self. But this position, in turn, is split between those who regard the sexing as a prior state, and those who locate it in discourse.[19] A further constellation of views dwells on the ideological origin of the categories through which the sexed self is thought, and thus their relation to cultural and social formation. This view, which may be claimed for and by Marxist/Socialist feminists, has come under attack for its presumption of the arbitrary nature of gender ideology and for the supposition that the primal state of being is genderless, gender being acquired through socialization.

Gatens made one such attack. She argues that the body is always imagined and thus is always "the site of the historical and cultural specificity of masculinity and femininity" (1983:152); the situated body has to be the subject of analysis, and it is a historic fact if it is situated in a society divided and organized in terms of sex. But such specificity is not to be regarded as after the event: there was never "a neutral, passive entity, a blank state, on which is inscribed various social 'lessons'" (1983:144).[20] Her view is not a biological essentialism, she makes clear, but an account of the (conscious) subject as a sexed subject. Such a view attacks the alleged neutrality of both body and consciousness found in some socialization theory and in the suppositions of some Socialist feminists that a de-gendering of society is possible. The neutralization of difference would entail normalization, part of a rationalist program, she

objects, which itself invests heavily in the idea that gender is ideology and ideology is malleable.

This particular account focuses on sexual difference as an organizing device in the construction of subjectivity. It entails a view of the person as an individual 'subject', as opposed to those concerned with an ideological view of 'society' and of the self as an ensemble of social re-lations.[21] Either may claim to account for the other's position. The de-bate teaches us that we require a theory of unitary identity before we construct a theory of unitary gender identity. From there one might ask which societies do indeed foster a concept of a genderless, neuter per-son upon which gender difference becomes inscribed, and which so-cieties throw up the idea of there being no persons as subjects who are not sexed subjects. Given that both positions are claimed simultaneously in the context of Western feminist debate is a fascinating 'feminist' con-tribution. Neither can be taken for granted. Consequently, the confla-tion of gender and identity, the notion that gender difference is first and foremost a matter of the integration of the person as self (against an other), must be examined as a specific historic form.

It is clear that a sex-role model of socialization cannot be taken in an unexamined way as the base line for exploring gender difference. For all their emphasis on real experience as opposed to symbolic anal-ysis, in seeing gender as a matter of identity, as experienced masculinity or femininity, it is those anthropologists concerned to record how indi-vidual persons feel who also, in fact, give indigenous symbolism an autonomy in their analyses. This could be put in ideologist terms. Ideol-ogy acquires autonomy *in their accounts* in so far as they argue that the cause of the symbols (of masculinity) lies in the parameters of these symbols themselves (making men into men). For in appealing to how men and women think and feel, they allocate the whole woman or the whole man to a gendered status. What women and men do can be un-derstood as exemplars of what 'women' and 'men' do[22] and thus as the subject matter of the difference between maleness and femaleness. Lost in all this is Mead's (1935:301) original caution that there may be so-cieties in which it is not possible to "feel like a man" or "feel like a woman." It remains a matter of ethnographic verification whether or not 'being a man' or 'being a woman' occupies an organizing—represen-tational, systematizing—place in the classification of behavior. Lost in all this too is a grasp of what the differentiation—the oppositions and exclusions—may be about.

In failing to see potential grounds here for relating such issues to feminist discussions of gender, either on points of agreement or disagreement, those concerned with identity confine themselves in the end to a limited view of what is being constructed in these relations. Indeed, one encounters a muted antagonism to feminist-derived interests. Read finds it necessary to make a valedictory disclaimer:

> I find no reason to revise anything I said about the character of male-female relationships among the Gahuku-Gama in 1950: the economic, social, political and ritual subordination of women and the presence of 'tension', anxiety, ambivalence, opposition and conflict in inter-sex interests, attitudes and behaviour. I do not think this paints a one-sided picture influenced by any bias I may be assumed to have had as a male. (1982:67)

He goes on to say that men cannot know or experience fully what it is to be a woman and that Gahuku women never told him "how it felt." He describes interaction between the sexes but makes no reference to feminist issues except in the context of women's expression of identity. His envoi states,

> I have no quarrel with those *women* anthropologists who suggest that their male colleagues have tended to be neglectful if not cavalier in their scholarly treatment *of women* [my emphasis].

But he chides them for overenthusiasm in their "worthy aim of trying to demonstrate that women are persons in their own right" (1982: 76–77).

A feminist view is recognized but is de-intellectualized. It is not held to impinge on the analysis of the interaction between the sexes but simply comprises an essentialist equation between 'women' as subjects of study and 'women anthropologists'. Moreover, the essentialism is compounded by his insisting that what one needs to counterbalance an analysis of how Gahuku men feel is how Gahuku women feel!

The point is underlined heavily by Langness in the essay which follows:

> I cannot imagine trying to answer . . . fundamental questions of sex and gender relations without further information about what individual actors *feel* and *think* about what is going on [original emphasis]. (1982:79)[23]

In other words, feminist scholarship is caught by its practice of bringing into prominence women as a social category. Interest in women's point of view is the field within which intellectual feminist debate develops, yet the scholarship is bypassed in such cursory treatment. Feminist

thought is assimilated only to its own political position. The search for identity that Read so easily assumes underlies the intention of 'women anthropologists' is, in fact, a matter for internal debate. Taking it for granted leads to a curious analytical lacuna in these accounts of initiation ritual and cults.

In spite of the relational frame suggested by antagonism and its synonyms, analysis boils down to the conflict between the values of manhood or masculinity and the values of womanhood or femininity. Thus, differentiation from women is seen to serve the purpose of making men into men. Across Melanesia, it is argued, there is a broad spectrum of 'man-making' rites, connected by the ideology "that men are a cultural artifact and women (in a far more fundamental sense) are simply what they were born to be" (Read 1984:221). Men's image of themselves is insecure, so that questions of identity appear pressing. Such arguments equate gender as a role with sexual identity: the problem presented by the opposite sex is what your own sex is, viz., male dominance is about preserving maleness in encounters with females. Again, Langness had made an important break with these arguments. While he agrees that male ritual makes warriors, he questions whether "it is designed to make them men in the sense of somehow solidifying or transforming their gender identity" (1982:80). Yet his own emphasis on the primacy of experience supports the assumption that representations of male-female relations concern only relations between men and women.

The lacuna lies in the failure to ask what the nature of the relations is. If the relation between men and women is conceived in a contrast, then what is the point of contrast? What form of power is framed by the exclusions and oppositions?

Analyses concerned with gender as identity—with how women and men experience being women and men—take the relationship between the sexes as axiomatic; it is the site at which masculinity and femininity fight it out. This is indeed 'antagonism', where the tenor of the relationship is seen as arising from the need of each sex to carve out an antithetical definition; in particular, men carve out their masculinity from the 'natural' identity of women, subjugating women and natural process itself to their control. Keesing writes,

> Once we anthropologists take seriously the challenge of fitting partial explanations together, further connections come into view. Thus the male political solidarity stressed in sociological theories is fully congruent with a neo-Marxist emphasis on male appropriation of women's labour and control

over their reproductive powers. . . . [He goes on:] the sexual symbolism of
phallic power and pseudoprocreation. . . . becomes compelling in a society
where men are created, not natural, and where they must control women,
whose essential nature is dark and dangerous and beyond male regulation.
(1982:33)

If women's threat to men emerges as a problem that Papua New Guinea
men conceptualize, then we are dealing with statements about relations.
It is the business of 'we anthropologists' at least to ask what kinds
of statements they are. Should we be satisfied with a self-reproductive
frame—with a view of dominant males producing males needing to be
dominant?

Many feminist scholars would concur in the project of elucidating
categories principally by reference to the perpetuation of the categories
themselves. They would find nothing exceptional, for instance, in the
observation Bowden makes of Sepik gender symbolism in art, that if
one is dealing with artifacts as the creations of men, then one's study
must be complemented by women's views and values. Yet there is a flaw
in this dualistic approach. In seeing men's creations as likely to repre-
sent a "man's view of the world," the analyst assumes that what men
ponder upon is themselves, so that the artifacts that visually express
"ideals relating to masculinity" represent an idealized expression "of
what it is to be a man" (as distinct from a woman) in this or that so-
ciety (Bowden 1984:447–448). The flaw lies in not making explicit the
underlying theory of representation, here a naive correspondence be-
tween the sexed individual and the autonomy of 'male' and 'female'
viewpoints.

Since there are clear parallels between (for instance) Bowden's ar-
gument and certain feminist positions, these latter could be dismissed
as redundant. Indeed, the internal conflict between feminist positions
could be thought to negate all of them. However, my intention in re-
calling feminist debate was to point precisely to the internal diversity
of stances. Constructed in relation to one another, these positions can-
not be apprehended axiomatically. Far too axiomatically, I believe, has
the sex-role model held sway in anthropological analyses of Highlands
initiation and male-female antagonism. Individuals are regarded as re-
cruited into their sex rather as clan groups recruit their members, and
the boundary problems of group identity and the boundary problems
of individual (masculine) identity become merged together. Among the
drawbacks of such an approach is the further assumption that identity
consists in the possession of qualifying attributes, in whether an indi-

vidual 'has' the characteristics that make him unambiguously mascu-
line. It is important to contextualize these assumptions by juxtaposing
different ones.

From within feminist debate, one might turn to other positions, such
as those that regard images of the sexes as referring neither to autono-
mous, bounded entities distinct from one another nor to the relation
between them (Shapiro 1979; 1983). Idealized masculinity is not neces-
sarily just about men; it is not necessarily just about relations between
the sexes either.

One could consider, for instance, Barrett's critical treatment of rep-
resentations. She examines the position that ideology does not reflect
'reality', a criticism of other feminists that could also be applied to those
Melanesianists who take gender constructs as reducible to the affairs
of men and women. She quotes Adams (1979):

> as long as feminist theories of ideology work with a theory of representa-
> tion within which representation is always a representation of reality . . .
> the analysis of sexual difference cannot be advanced. . . . [W]hat has to
> be grasped is, precisely, the *production* [original emphasis] of differences
> through systems of representation; the work of representation produces dif-
> ferences that cannot be known in advance. (1980:86, 87)

At the same time, Barrett insists that representation is not free floating;
it is contextualized ("linked to historically constituted real relations").
Yet the constituting nature of symbolic strategies needs no introduction
in anthropology, nor does a theory of their necessary contextualization.
It is all the more surprising that anthropological accounts of gender
symbolism remain so narrowly focused on men and women themselves.

And it is tantalizing, then, that in his own reflection on earlier anal-
yses of the Bena Bena version of the *nama* cult, Langness should care-
fully observe that none of the rites seemed (as he put it) primarily phallic
or primarily uterine. "There are, to be sure, both phallic and uter-
ine symbols in relative abundance; but these are inextricably mixed
together" (1977:114). About the same time, Dundes (1976:232) pro-
vocatively raised the old question about whether male initiation ritual
feminizes or masculinizes the participants. His answer, that it may do
both, invites further questions about how, in that case, difference is
established between the two processes. And however much the differ-
ences affect the way in which women and men 'think' and 'feel', that
experience cannot in itself provide the grounds for the process of dif-
ferentiation as such.

4
Domains: Male and Female Models

Whereas in the Eastern Highlands male collective life outside warfare once focused on cult activity of various kinds, including the all-important initiation of boys, ceremonial exchange takes that place of prominence in the Western Highlands. In opening his study of Wola,[1] Sillitoe refers to exchange as "the sociological principle which forms the backbone of Wola society" (1979:1):

> The premise of this study is that to understand Wola society it is necessary to appreciate how these people resolve a universal paradox which faces mankind. This paradox concerns individual freedom and the restrictions which society places upon this freedom. That is, how does society curb the self-interested drive of the individual, and control behaviour so as to allow social co-operation between people, without detracting too much from the individual's freedom of action. (1979:4)

Exchange mediates the paradox, he says, because it contains within it two opposing features that complement "the opposed forces inherent in man's nature," namely "individual interests versus community interests" (1979:5). It both encourages sociability, as he puts it, and rewards self-interest. It enables men to act at once considerately and competitively towards one another. This he presents as true of exchange in general and of ceremonial exchange in particular.

Sillitoe's account is interesting as an attempt to get away from an equation between social structure and groups. Indeed, he criticizes those writers who have argued that ceremonial exchange in Western

Highlands societies such as Hagen "functions to maintain the integrity of groups" in competition with one another (1979:293). But substituted for groups in his account is simply the other half of the society— individual antinomy. His explicitly individual-oriented approach places emphasis on exchange as the key principle of "social organization" (1979:292). Relations between individuals sustain it, and it in turn sustains them. Social life is thus recognizable in the balance between individual autonomy and social order, to use Sillitoe's phrases. It consists in this account in the manner in which individuals manage relations between themselves.

In similar vein, Feil closes his analysis of the *tee* system of ceremonial exchange in Tombema Enga with a paean to its role in connecting individual persons to one another (1984b:240):

> the *tee* for Tombema people and society . . . is a model of and a model for their humanity. Without the *tee,* there is no community, no sociability, no reason for people to congregate. The mutual, reciprocal interests of the *tee* bind men into secure, cooperative partnerships of trust. Without the *tee,* Tombema believe such relationships are impossible.

One has to understand that Feil subsumes under exchange relationships the work of production and the domestic economy: "all production and exchange decisions have the *tee* as a backdrop" (1984b:7), and I return to his arguments on this point in chapter 6. He stresses that the *tee* is carried by individual partnerships, and indeed is opposed to warfare which mobilizes group behavior.[2] Since these individual relationships are constituted by ties through women, and since production is, as he puts it, geared to extra-domestic exchange, women are in his account crucial participants in both production and exchange. Feil purposely takes women's affairs as seriously as he does men's. But his emphasis on women's participation seems to incorporate an assumption, like Sillitoe's, that sociality is (collective) sociability. Hence the *tee* is "the central institution of Tombema society" (1984b:237).

Identifying a key institutional backbone is itself a theoretical residue from older anthropological analyses of 'social structure' as the bony articulation of 'life' and other processes. It thus leads to a dichotomy, as became apparent in the previous chapter, between what is social structure and what is not. A consequence of having identified a central institution, then, is that in order to pay attention to women as well as men, one is required to show how women as well as men 'participate' in this institution.

Consequently Feil must argue that we should not be taken in by group rhetoric, as he also argues that we should not be taken in by the kind of dichotomous categorization into domestic and political domains as is found in societies such as Hagen (Feil 1978). In order to bring to the fore the preeminence of women in Tombema Enga society, he states that the politics of individual exchange partnerships obviates any such dichotomy, for politics penetrates every domestic decision: "the political is inseparable from the private" (1978:268). Valuable as this criticism is, it fails to broach the issue of where and how Tombema, or any other Highlands people, deploy gender difference as constitutive of other differences.

> Tombema say that two men 'come together' or are 'joined' in the *tee* by a woman, that they base their relationship on a female link, and that when it no longer exists, the incentive to maintain the relationship disappears. This view is, I think, a recognition that women alone can guarantee the integrity of men in *tee* dealings, and without that guarantee, the relationship may flounder. (1984b:103)

Tombema say that two men come together linked by a woman; they do not say that two women so come together. As he notes subsequently, the chief channels for prestige "distinguish and elevate the names of men, not women" (1984b:117). Quite aside from the respective powers or influences that each sex possesses lies the unexamined nature of the opposition and exclusions symbolized in the Tombema difference between men's and women's activities.

However unfortunate an analytic idiom, the image of 'domains' captures part of a global categorization that (in the case of Highlands people) extends a difference between the sexes to differences in their scope for social action. Showing that men and women both participate in political and in domestic activity does not negate the gender categorization itself: it simply relocates its focus. In the Tombema case, it seems rather clear that 'men' are exchange partners, while 'women' guarantee or are in some sense a cause of their being so linked. We need to know how 'men' and 'women' are so categorically and so differently placed vis-à-vis each other.

If there has been a single advance attributable to feminist anthropology, qua anthropology, it has been in bypassing questions about the essentialism of sexual identity and opening up an adjacent range of issues widely known as the social and cultural construction of gender. What is laid open to scrutiny is the relationship between constructs of

maleness and femaleness. This goes beyond considering how the experiences of individual persons are molded by cultural prescriptions about male and female behavior. Where whole areas of social life ('domains') become the apparent concern of one or the other sex, then their relationship or articulation must be investigated. This position constitutes a significant critique of analyses that take the coexistence of such different areas for granted.

Those dealing with the social or cultural construction of gender are not required to take a decision as to the prior or derived sexing of the body, in terms of the debate briefly mentioned in the last chapter. Their concern is rather with the relationship between the very categories male and female. The concern itself derives from specifically anthropological interest in elucidating the metaphoric basis of classification systems. A presumption of social or cultural holism is thus combined with a demonstration of the plurality of interests at work. Let me give a sense of this intertwined history, which will put some of the observations made in the previous chapter in a rather different light. At the same time, it will also traverse similar ground.

The feminist-anthropological critiques about domestic and political domains which dominated the 1970s originated in premises similar to those that informed the earlier sex-role model of gender identity—taking the 'relationship between' male and female as the focus of inquiry takes these entities in turn as fixed points of reference. However they are defined in respect to one another, the task is seen as connecting two terms or concepts that can also stand independently of that relationship. 'Male' and 'female' become reference points for its elucidation, despite the interdependency of the cultural characteristics associated with each. The strategy was inevitably to fall foul of the previous accumulation of ethnographic data that interpreted maleness and femaleness as referring to what men and women are and do. It also joined with general anthropological thinking of the time in its interest in models of society, in which one can discern the tension between holistic and pluralistic premises about the nature of interrelations between the sexes.

I wish to draw attention to two features in the social constructionist formulations, versions of some of the assumptions already encountered, and presaged in the citations from Sillitoe's and Feil's works. One concerns the axiomatic way in which the individual, like the categories of male and female, is taken for granted as an autonomous reference point. Sociality is uncovered in the investigation of relations between individuals, even as social and cultural constructions are uncovered in

the investigation of relations between male and female. Second, to see male and female attributes as reflecting men's and women's positions establishes a further parallel with the way in which the individual is also presented, in that these suppositions rest on an intriguing presumption about the boundedness of such entities. Individuals are imagined to have boundary problems similar to those that afflict 'groups', almost as though sociality consisted in substituting group boundaries for individual ones. If men, women and individuals qua individuals are seen to be subject to the kinds of 'socialization' processes sketched in chapter 3, then they also appear to have autonomous interests of their own that they must negotiate. In the case of men and women each acts with respect to the opposite sex, and in the case of individuals each must maintain relations with other individuals.

Indeed, the feminist-inspired concern with women as 'social actors', as persons in their own right, can be directly attributed in anthropological accounts of the period to the conceptualization of male/female as the social or cultural construction of 'men' and 'women' on the one hand and to the haunting equation of sociality with collective life on the other. Both were caught up in the arguments about public and domestic domains, and in Melanesian ethnography both belong to that same intertwined, though not completely merged, history.

THE 'SOCIAL CONSTRUCTION' OF MALE
AND FEMALE

Studies of gender symbolism over the last two decades have been dominated by the concept of gender as a social or cultural, that is, 'symbolic', construction. What is being constructed is understood as sex-roles themselves, and as the everyday world which normalizes them as well as ideal or stereotypical images of relations between the sexes. In Melanesia, one might start the historical account with Mead's (1935) and Bateson's (1958 [1938]) works. They saw cultures as variably determining what was acceptable male or female behavior in men and women. This was the beginning of an explicit social construction theory, though the object of study remained the sexing of personal identities. It was Mead who enunciated so clearly, in her overview of New Guinea initiation rituals, that while women make human beings, only "men can make men" (1950:103). Thus, the great problematic for her was the relationship between sexual stereotypes and people's personalities, and from this approach came an analytical vocabulary of normalcy and

deviancy. Bateson focused on the way in which Iatmul culture promoted a conventional ethos that affected the sexes' interaction with one another: each sex had its own ethos, experienced as a range of emotional responses. Nevertheless, his classification of types of relationship—complementary and symmetrical—and his concern with the 'cultural logic' of pairing, opposition, and divergence, made modes of relating a theoretical problem.

As a category term carving out the study of male-female relations, 'gender' in its modern sense came to embrace more than the sex stereotyping that interested Mead. The popularity of varieties of structuralism within anthropology generated techniques for the decoding of symbols. Sexual symbolism could be understood not just as stereotype or preferred personality but as metaphor.[3]

We have seen how Read's early papers connected the symbolism of inter-sexual conflict to the demands for male solidarity, and that sexual antagonism was interpreted largely in behavioral terms, as a matter of relations between the divergent situations of men and women. Male-female relations, in the phrase of the time, thus encompassed attitudes and stereotypes about the sexes, but it also broached the symbolism of community ('male') life itself. It is of a piece that in addition to its interest in solidarity and group structure, Meggitt's (1964) article was an exercise in symbolic analysis (after Needham). Meggitt laid out the relationship between a series of terms by analogy to the underlying logic of male-female opposition. 'Male-female relations' now covered a symbolic universe of polarized equations, a social classification, and when 'gender' gained currency, the constructions were grasped as 'metaphorical' ones (see Buchbinder and Rappaport 1976:33; see also Kelly 1976; M. Strathern 1978). Relations between the sexes were images for the organization of ideas about other things, about life-forces or general values. Categories constituted a social classification, and the modelling (in the term of the times) of the relationship between male and female was there for decoding. The concern was with processes of signification and the relations between terms.

Feminist theory of the 1970s, as it entered anthropology, did not take these classifications at face value but further regarded the lexicon as part of the power positioning of the sexes in relation to each other. It thus took as axiomatic the reference of male/female symbolism to the affairs of men and women. Its own critique addressed gender as an ideological construction and addressed the issue of whose models the analytical models appropriate. This critique was particularly pertinent

when a divide between public and private or between politico-jural and
domestic domains became represented through a male/female polariza-
tion. The pertinence of feminist theory lay in its implications for the
definition of society as somehow first and foremost structured as the
social world of men.

In Britain and the States these interests defined the emergence of a
feminist anthropology through the publication of *Perceiving Women*
(S. Ardener 1975), *Woman, Culture, and Society* (Rosaldo and Lam-
phere 1974), and *Toward an Anthropology of Women* (Reiter 1975).[4]
Many of these collected essays illustrated the contemporary concern
with models, and the bias of models, and began the debate on the
universal nature of the dichotomy between 'domestic' and 'public' do-
mains.[5] The spheres were presented both as demarcating domains of
action and as corresponding to people's evaluation of the significance
of men's and women's activities. By focusing on these constructs as
embodying cultural evaluations, it seemed possible to distinguish be-
tween differently structured systems. In some, men and women partici-
pate equally in public and domestic matters; in others, boundaries must
be crossed or subverted. Rosaldo suggested that women gain "power
and a sense of value when they are able to transcend domestic limits,
either by entering the men's world or by creating a society unto them-
selves" (1974:41). With its implications for the study of kinship and
politics, Rosaldo's was a powerful holistic formulation that seemed to
allow comparative analysis across a range of situations.

Gender thus was taken to comprise an indigenous model of duality,
discriminating between categories and constructs of all kinds, often to
asymmetrical effect (one of a pair valued, the other denigrated). Such
symbolic asymmetry seemed to resonate with perceived inequalities be-
tween the sexes. At the same time, then, a dualism was also identified
between their interests. The ethnographer had to look for dual models
of the world, reflecting the differing perspectives of men's and women's
lives.[6] This meant that the asymmetry could not be taken for granted;
it might well turn out to be a property of a dominant model, creating
an ideological hierarchy of values. It could reveal an indigenous bias.
To avoid replicating such bias, the ethnographer's task had to rest on
a dual approach of his or her own, both taking into account the sexes
as interest groups likely to have their own visions of the world, and
showing up sexual stereotyping for the ideology it was. The significance
of the public/domestic debate was derived, in part at least, from this
contemporary concern with male bias (indigenously and as part of the

ethnographic account) in the description of social structure (Quinn 1977:183; Milton 1979).

That less than ten years on the debate should be dismissed as having outgrown its usefulness, or as addressing "anything more than an ideological distinction that often disguises more than it illuminates" (Atkinson 1982:238), is testimony to the scrutiny and theoretical 'work' the capture of domains engendered. What had been captured was the interest-based dimension of cultural categories, and thus an internal pluralism. Where men have a special interest in seeing themselves as the authors of collective life, the argument goes, then it also becomes their interest that the nature of this life be described through sexual differentiation. If what men do becomes public and visible, a counter-part domestic domain becomes identifiable with a noncollective and female realm. It was turning these categories to analytic use in describing men's and women's spheres of action that proved troublesome—the extent to which women were made invisible via this very categorization. The debate foundered on the tautology of the association between women and domesticity: domesticity could only be identified by the presence of women (Harris 1981:64).[7] Indeed, feminist commentators complained about the way in which those who interpreted or incorporated into their accounts an explanatory division of this kind ran together distinctions between public/private, political/domestic, social/individual (e.g., Tiffany 1978; Rogers 1978; Yanagisako 1979; Sciama 1981; Yeatman 1984). Yet in terms of Western classifications, of course, these form coherent ideational sets.

The same is also true of the equivocations themselves. We might contrast the tension between the holistic and pluralist critiques in terms of their own (Western) symbolic devices. On the one hand, the domains are interpreted for other cultures as their symbolic device for the internal ordering of society, the male capacity for 'group' behavior being set against the refractory individualism of 'family' life symbolized as female (Rosaldo 1980:394: "Male dominance . . . seems to be an aspect of the organisation of collective life"). On the other hand, they may be taken as revealing that in actuality men and women themselves constitute 'social groups', each with its own spectrum of interests. Indeed, the symbolic domains may cross-cut 'real' oppositions between these groups. (Commenting that gender symbolism in Hagen male cult activity should be viewed as a discourse on the state of power relations, Hawkins refers to women as a group: "The interdependence of male and female as expressed in the . . . cult is thus an express rationaliza-

tion, an orthodox view, of the state of power relations between men and women . . . between two groups for the monopoly of power" (1984:222).)

Although the debate might have exhausted itself, one of its highly ethnocentric motivations remains. This was an insistence, in the face of a frequent cross-cultural association between women and domesticity, that women should be treated in the anthropological account as full social actors.[8] The equation with domesticity suggested that without a degree of conscious effort then women might not be so considered. At an early stage in the debate, Rosaldo located the problem in cultural evaluation:

> I have tried to relate universal asymmetries in the actual activities and cultural evaluations of men and women to a universal, structural opposition between domestic and public spheres. I have also suggested that women seem to be oppressed or lacking in value and status to the extent that they are confined to domestic activities, cut off from other women *and from the social world of men* [my emphasis]. (1974:41)

Interesting in this formulation is the perception noted by La Fontaine (1981): the possibility of classifying some areas of life as 'more social' with respect to others that are 'less social' (cf. Ortner 1974).[9] Continuing insistence by feminist anthropologists that women appear as social actors in their accounts responds to a similar tension. It is an important political tenet of scholarly practice; at the same time, the tension must also be understood as belonging to the anthropological interest in models of 'society'. The point is worth comment.

The accounts of the 1970s treated the public/domestic divide as a tool for analytical discrimination with a universalizing potential. What had been advanced at a previous stage of anthropological theory[10] as an interpretation of the manner in which jural authority is constructed, and the relationship of politico-jural citizenship to authority within domestic groups, appeared analogous to the manner in which men claimed to be responsible for 'society'. For feminist commentators, the politico-jural domain was the place where social values were promulgated, from which social power was exercised. As we have seen, criticism (as in Feil's 1978 article) was also made of those who adopted the essentially normative division implied in such ideas as an analytical one. It was regarded as an ideological instantiation, in so far as the very modelling of a divide perpetuates a claim, viz. that certain areas of social life necessarily subsume and thus regulate other areas, which are consequently characterized as requiring regulation or as not having in-

dependent interests of their own. This critique led to attempts to rewrite a political dimension into domesticity itself. Indeed, it was rapidly accepted that the study of 'politics' should be separated from the study of 'public' life. As a recent summary puts it,

> No longer does it seem useful to equate politics with 'public' institutions, statuses, and social groups previously considered as a predominantly male 'domain'; instead, politics should be seen as a system of power relationships and value hierarchies, which necessarily includes both women and men. When male activities, groups, and ties are studied. . . . it must be recognized that these are gender-marked phenomena and do not constitute the 'human' social universe. (Tsing and Yanagisako 1983:512)

That there was reason to question these constructs arose from the parallel conflation of domesticity with the affairs of women. In so far as the domestic domain was interpreted as inward-looking and removed from the wider society, so too, it was objected, were women regarded by prefeminist ethnographers.

In their critiques, feminist anthropologists remain divided among themselves. In some cases they are concerned to analyze how these cultural constructs work 'really' to contain women; in others to show the inappropriateness of mapping what they claim are Western-derived concepts onto systems that do not discriminate along these lines. Even where it is regarded as analytically appropriate, the fact of so organizing social life to the exclusion of women and to their domestic containment is interpreted as an instrument of power on men's part. The construction of power, it is argued, depends on promoting values that underline the axiomatic nature of the division. The divide thus incorporates a partisan self-description, a particular representation of society. This may be understood either on the holistic premise that one is dealing with a coherent ideological set that confines women to a particular position or on the pluralistic premise that women are not really to be encompassed by such categorization; evidence for their models of the world have to be found elsewhere.

These equivocations were in the end dominated by an idea feminist anthropologists shared with other anthropologists of the time—the assumption that symbolic strategies such as domaining afforded a model of 'society'. Yeatman regards this assumption as intrinsic to modern social science:

> Because the [Western] gender ascription of the differentiation of public and domestic socialities operates to make these socialities appear not as a difference within the same kind of life, but as a difference of kind, between

different types of life, the equation of 'society' with public sociality tends to exclude domestic sociality from 'society'. (1984:135)

The anthropological compulsion to identify what is crucially 'social' in indigenous representations assumes that the indigenous models promote a split between a society so perceived and elements that might be regarded as asocial, antisocial, subsocial.

For the inherently plural character of Western images of society underwrites the identification of collective life and the public/political world of men such that a domain metaphorically categorized as male is taken to reveal men equating themselves with society tout court. In this Western view a 'male' domain must speak to men's interests. And a domain conceived as public and collective in character is assumed to oppose individuating, noncollective areas of life as society opposes the individual. When such domaining activity is encountered in non-Western gender symbolism, it is easy to imagine that it speaks to similar concerns.

Instead of arguing it away, I suggest it will be important to the Melanesian case to investigate the distinctive nature of domestic sociality, that is, to take seriously the distinctiveness culturally attributed to it. One might thereby avoid doing violence to indigenous differentiations. The important aspect of the debate to pursue, then, is the realization that boundedness between areas of action—private set off against public affairs—is itself an image (La Fontaine 1981). This image creates a value difference between types of action. Where the values are mapped, as they appear to be, onto a distinction between things to do with men and to do with women, an ideational boundary between the sexes becomes the medium through which the possibility of action itself is presented.

MODELS OF SOCIAL LIFE*

I turn briefly to three studies carried out in the 1970s, two from the Western and the Eastern Highlands with a third illuminating study drawn from right outside this area. They all reveal a boundary that appears to run contrary to expectations. It is not men who emerge as specifically 'social' in their orientations but women. The ethnographers who have documented these cases have made a point of consid-

*These accounts are adapted from material I have presented elsewhere: the Hagen case from O'Brien and Tiffany (1984); the Daulo case from Hirschon (1984).

ering women's perspectives; however, these are not simply negative instances. On the contrary, the cases are drawn from societies (including Hagen) whose traditional 'public' institutions were male-dominated. But changes that have been taking place in these societies in recent years are revealing.

The spread of wage labor and cash crops in Melanesia has had an effect upon subsistence work. By and large, horticultural activities continue intact; yet with men becoming involved in migrant labor or 'business' of one kind or another, women are more prominently concerned with the subsistence base. In this context they come to be associated with a range of public values. As men move into a world opened up by colonial and postcolonial trade and politics, women become visible reminders of enduring norms of social conduct. For all three instances, women's past activities were confined, by contrast with the wider activities of men that set the definition of public life. It looks almost as though women now come to stand for 'society' itself, as it appears in the contemporary world. However, the question shows up the construct of society for what it is: an anthropological equation between collective activities and the society of Western discourse. What is revealing about these ethnographic examples is the challenge that they offer not only to an association between 'social' values and public, collective activity but to the characterization of domesticity.

Internal migrants: Hagen. The system of ceremonial exchange between political groups, involving each man in a wide network of exchange partners, has expanded and escalated in Hagen since contact, absorbing monetization and with the then (1970s) abeyance of warfare being a focus for men's public displays. Men's collective endeavors continue to be highly valued as such. In drawing a contrast between ceremonial exchange and things concerning household production, men hierarchize what in other situations they value equally. Thus they may claim that renown and prestige are to be found only among men in the sphere of public life, concretely presented as a matter of men being prestigious, women rubbish. Men's prestige comes from their collective activity, which includes travelling to exchange partners and drawing in wealth from exotic places, whereas women are confined to a restricting domesticity, to 'the house'. Production is not publicly valued in this context: certainly it is not presented rhetorically as the basis for building prestige. And men constantly use the contrast between male and female as a metaphor for the difference. Thus men encourage one another not to

behave like women but to invest in public life. Women's exclusion from
this sphere is also read as a kind of irresponsibility (which it would be
if it were men withdrawing themselves). They are portrayed in dogma
as wayward, capricious, with small, private concerns at heart. In other
situations, men also make positive evaluations of productive work, in-
cluding their own and women's work. But when men state that women
are 'strong things' on whom they depend, this acknowledgment is
muffled by all their other assertions that men alone are strong because
of their public presence. It is, therefore, illuminating to note what hap-
pens when men remove themselves from the arena of local politics and
ceremonial exchange.

Hageners, mostly young and male, have been migrating to the coast
for some years (see M. Strathern 1975). Urban migrants recreate an
adolescent culture: they avoid ceremonializing public occasions; they
downplay oratory, the supreme political art; and they reject any serious
application among themselves of the epithets, 'prestigeful' and 'rub-
bish'. In removing themselves from the world of politics they may
jokingly say they are 'all rubbish' by contrast with people at home. But
they would never use the image frequently used of rubbish men at
home, that they are 'like women'.

To those left at home, the absent migrants show much of the irre-
sponsibility said to typify female behavior. Yet in terms of the frame-
work crucial to such evaluations, migrants confound other aspects of
femaleness: far from being confined to the house, they are mobile and
free. Yet mobility is prized only when it is to a purpose. Ostensibly the
migrant travels to gain money; it is when he fails to return or to send
money back home that kinsfolk start to label him rubbish. Like the
migrants themselves, however, they do not resort to male-female meta-
phors. People at home continue to judge migrants' behavior in terms
of prestige, but they too abandon female/male idioms. The reason, I
suggest, is that with the passing of time, the most crucial issue becomes
mutuality. Relatives become increasingly restless as the optimum mo-
ment for the youth's marriage comes and goes, and they are unable to
discharge their obligations. This feeling is matched by concern at the
absentee's lack of feeling for them, the inadequacy of the gifts he sends.
Interdependence is gone, and its restoration emerges as the first need.
Interdependence may be thought of in terms of reciprocity embodied
first and foremost in successful domestic relations.

For their part, if migrants de-politicize their urban affairs, they *also*
de-domesticize them. They ignore the passing of time which at home

turns a feckless adolescent into a responsible adult. And where a contrast between male and female is not used to evaluate public and non-public orientations, the female comes to stand for something quite different. To the migrant, women—sisters, mothers, potential wives—represent adulthood and its demands, social responsibility, the return to relationships formed through reciprocity and interdependence.

Youths at home enjoy considerable freedom. Most migrants are unmarried or only newly wed and continue to think of themselves as untrammelled by social obligations. They constantly remind one another that they are free to do what they like. Some say they ran away from home to escape marriage, for the idea of matrimony is bound up with a man's feelings towards his elders, foreshadowing an explicit interdependence with the woman who will be his wife. Much more potently than other Hagen men, women visitors who travel to town or female relatives who send messages, remind the migrants of the binding nature of relationships they pretend to have shaken off. Indeed, migrants become excessively embarrassed by the presence of female visitors, apologize when they give them gifts, and may express bad feelings at having abandoned their mother or sister. Women's requests lead them back into the responsibilities they have half discarded. Here, then, we have women associated with responsibility, with social obligation, as people who direct the youths' thoughts not only towards themselves but towards home society in general.

Overseas migrants: Vanuatu. Exhortations to participate in public activities or to meet domestic obligations are appeals to action. They do not also presuppose a sense of a particularly 'Hagen' way of doing things. The next example, however, reveals an ethnic-like modelling of a culture or society as a holistic entity, conceptualized through a contrast between places that adhere to 'custom' and those that follow new ways. It comes from a region that has experienced migration for a much longer period and on a much larger scale than is true of Hagen.

The Sa-speakers of Pentecost Island in the Vanuatu archipelago inhabit an area that has known European influence since the 1870s; Pentecost had its own first ethnographer in 1916. Villagers nowadays divide themselves into custom (*kastom*) and into school (*skul*) villages, signalling their orientation to the now postcolonial world. The polarization is clearly a politicized one and affects a range of activities—subsistence patterns, ceremony, knowledge, dress—so the alternatives are total. Sa-speakers perceive a connection between reliance on subsistence

production and the performance of traditional ceremonies in the same
way as securing money by cash cropping or wage labor and diminishing
traditional ritual by substituting Christian worship are also held to go
together. In appearance and habit, persons are identified with one social
order or the other.

Jolly, on whose account I draw, worked in a *kastom* village.[11] The
Vanuatuans here contrast themselves with Europeans. Europeans are
regarded as floaters, like driftwood, stringy and flabby because they
have no enduring relation to the earth but are compelled to move about
in search of money. Vanuatuans describe themselves as belonging to
ples (having a home), rooted to the earth, and their persons in self-
evident good health, for they are strong by producing, exchanging, and
eating their own food. *Kastom* does not just depict tradition, then, but
a moral and material order.

Enduring sociality is traditionally symbolized in things to do with
men. Thus the rootedness they see as characteristic of their whole
society is modelled in the rootedness of men. Rights to land are held
by male agnatic descendants of a founding ancestor. "Land is not so
much owned as part of one's human substance," the "precondition of
human culture" (Jolly 1981:269). Attachment to land is conveyed in
the Bislama (Pidgin) term *man ples* ('man place'). The form of the
generic *man* resonates with the fact that men who are typified as having
enduring rights to the land also relate to it collectively.

Sa grow two main crops, taro and long yams. Taro is cultivated
continuously, production being by the household; all household mem-
bers, male and female, may cooperate to grow it. There is no rigid
division of labor: if necessary, a person could complete the whole taro
cultivation on his or her own. But with yams it is very different. The
seasonal growing of yams is part of a male cult, and they are eaten as
sacred food. Here there is an explicit division of labor between the
sexes, men's and women's deliberate cooperation being likened to sex-
ual intercourse, an image in which the yam is equated with man or with
penis. Yam cultivation is communal—often entire villages work to-
gether—and in this collective work men have a dominating role. They
organize the labor, possess the magic, and it is in their name that yams
are circulated as gifts in exchange. In short, the organization of yam
production and distribution is in the hands of men. In fact, they control
all public prestations of food. In the process, Jolly reports, women's
work is systematically devalued. Men appropriate the yams (and pigs),
treating them as their own rather than as "shared creations" (Jolly, in

press). As with a number of similar cases reported by Rosaldo (1974: 34–35), the manner in which men's and women's activities are allocated establishes a distinction between a collective public life focused on male cult and male exchange and the private life of the joint household.

Although Sa in the *kastom* villages maintain an ideological opposition between themselves and the followers of European ways, this does not mean that they ignore everything European. They turn European things to their own ends rather than seek to encompass European ends; in other words they Vanuatize things derived from the European world rather than Europeanize themselves. Sa have been synchronizing labor migration with yam production for the fifty years that men have been leaving the island to work on plantations elsewhere. Men go off in groups, rarely alone because leaving the island to work abroad involves risks, especially to men's health. An important element in the link between people and the land is the food they eat; indeed status differences between social categories are marked by rules of commensality. Taro, for instance, is regarded as a female food and is specifically fed to a newborn baby, whereas yams are the food fed to boys at circumcision to signify their masculinity. There is thus an intimate equation between the food one eats and one's bodily and social state, as there is with the circumstance of eating[12] and the classification of foods with parts of the human body. The contrast with Europeans is made in terms of the way lifestyles, including the kind of relationship involved in the production of food, are evinced in body substance. Yet migrant laborers have to subsist on imported rice, tinned fish, and corned beef. Men are thought to be weakened by this exogenous food. But the weakening effect is apparently limited to the personal body (that can be replenished in the yam harvest); they do not see themselves as also compromising traditional society, the *kastom* through which their village defines itself. And how can they sustain the paradox of moving away like Europeans and eating foreign food when *kastom* is founded on rootedness to land? By having women stand for rootedness?

Jolly tells us that men actively discourage and prevent women from seeking migrant work. They thus inhibit women's contact with outsiders. This action sustains claims to male dominance (men are regarded as more able to withstand dangers than women); and men appropriate access to the outside world just as they do a leading role in ritual and exchange. Yet there may well be a further dynamic to the relation between gender and the conceptualization of traditional society. Thus in the context of male migration, not in others, women at home can repre-

sent the enduring relationship to land that is held to characterize a *kastom* way of life as a whole. This possibility perhaps lies behind the novel paradox noted by the ethnographer that the ideological commitment to *kastom* and to *kastom* food has become predicated on women: "in the end, the tenacity and rootedness of *man ples* depends on the tenacity and rootedness of *woman ples*" (in press).

The modelling of a social life on notions of male rootedness or the mobility that has displaced it, and on their superior organizational skills, could be taken as an ideological set fashioned by men to further their own interests, including the domination of women. Indeed, in striking comparison with Bloch's (in press) description of circumcision among the Merina of Madagascar, Jolly (in press) suggests that in the manner in which the contrast between taro and yams is engineered, these tubers do not merely mark difference between the sexes but convey the mastery of men over women and the encompassment of female by male symbols. Or one could argue that the differentiated spheres of male and female activity afford a framework for the conceptualization of dual processes in social life. In truth, these are not necessarily alternative approaches: the latter models motive, as well as justification, for domination. I return now to the Eastern Highlands of Papua New Guinea where, as we saw, male domination is frankly asserted in the interests of promoting public benefits.

Business: Daulo. Eastern Highlands male cults were described in the last chapter as asserting masculine superiority. They not only promoted social solidarity—on the single sex model of male cohesion in the face of female threat—but were, according to the ethnographic reports, an instrument of domination. Numerous constraints were put on women's behavior in the name of men's various cults. But the cults have since disappeared, as has warfare in its traditional form. What effect has this disappearance had for men's proclaimed domination over women?

Read (1984) suggests that giving up the cults and the symbols of male community (the flutes) has released men as well as women, that men in the old days were traumatized by their painful initiation into manhood, and that the present regime is welcomed with relief. Men have also abandoned their fears of biological inferiority: they are no longer afraid of female pollution and no longer attribute superior physiological powers to women. Although they still control the basic sources of production, interpersonal relations are reported to be freer and easier.

Men still sustain, however, a distinctive domain for themselves. Over this period, modern business enterprises have developed with great vigor, and there is no doubt that it is men who are dominant in this sphere. Yet although they continue to rely on women's domestic labor, it is hard to see their dominance as geared simply toward the domination *of* women. The involvement of Eastern Highlands men in development projects has to be interpreted more generally as a manifestation of their visible agency. They are seen to be active in the new world. It is interesting, therefore, to record the emergence of a kind of 'business' run by women, on a smaller scale than men's but often with male assistance for skilled work. Men's commercial involvement has produced a response from women not to participate directly in men's enterprises but to match what they see men doing.

The Eastern Highlands are entering a phase of incipient stratification. Development projects have created a local elite, and what began as collective commercial enterprises by groups of clansmen have become in the last decade the empires of individual men. To some extent, these empires are built on a traditional subsistence base where women's work is still very significant. These male projects are also, it would seem, devoid of much ritual content. Indeed, it is arguable that when the male cults were abandoned, they did not simply remove men's fears of women and men's domination of them: they also removed certain avenues to collective life and to social and physical regeneration. Breathe more easily women might—the extraordinary thing is that women have taken up the ritual slack. They have created new rituals of regeneration. And this they see themselves doing in the name of general public welfare, since at the center of their endeavor lies an equation between nurture and the production of money. Money is now essential to the reproduction of life, Sexton argues, and women have made themselves the ritual nurturers of it.

Sexton has described such women's rituals for the Daulo area in a northern region of Eastern Highlands.[13] The major source of cash is the locally grown coffee. Partly in response to men's control of cash at the household level, women here have developed their own savings and credit system, with features deliberately adopted from what is known of banking procedure. The system is called in Pidgin English *wok meri* ('women's work/enterprise'). Groups drawn from the co-resident lineage wives of a village protect their savings from the depradations of their husbands by banking them collectively and using the capital for business ventures and for lending to similar women's groups. The or-

ganization of a *wok meri* group is based on a preexisting collectivity (the wives of patrilineage mates) that cooperates on other occasions also. Established groups sponsor 'daughter' groups in other villages by making them loans that are eventually repaid when the latter become 'mothers' themselves. A complementary set of symbols turns on affinity, so that mothers and daughters also see themselves as bride-givers and bride-receivers to each other, the bride being the *wok meri* expertise itself.

An important point to be drawn from Sexton's analysis concerns the idioms in terms of which this activity is conceived. Women emphasize the collecting together and saving of wealth but not as a form of gift exchange in the ordinary sense; instead, debtors and creditors may remain unknown personally to one another. Women regard themselves as safeguarding their cash incomes, while men are cast into the role of spendthrifts, concerned only with individual goals and short-term consumption.[14]

Despite competitive demands on household income, men respond to the women's efforts; many husbands respect wives' claims to dispose of some of the cash crop income and support the groups with expert advice, acting as bookkeepers and truck drivers. A man ('chairman') may also act as a group's spokesman on public occasions. The focus of such occasions, however, is the women's transactions, and money is given and received in their name. Although some women's groups disintegrate in the face of male disapproval, Sexton (1982:190) reports that after one women's ceremony in which thousands of participants and thousands of dollars were mobilized, men of one clan were so impressed that they urged all their clan wives to join the movement. From time to time in such ceremonies, a group calls in its loans, and with the accumulated capital may purchase wholesale trade stores to supply small local trade stores or trucks licensed to carry passengers.

These women save and invest considerable sums of money, then, through operations staged from time to time on a public scale. The concept of nurture is central to this organization. Each new group stands as daughter to the mother (*oraho*) sponsor. In *wok meri* mothers give loans to make the work of their daughters grow, and the transactions are accompanied by birth and marriage rituals. Sexton gives the following account:

> As a mother cares for her child, so does an owner look after her property; as a child grows, so ideally does property. Pigs grow and reproduce; coffee trees mature and bear fruit; money is invested to earn a profit. By the use

of the term *oraho* ('mother, owner') *Wok Meri* women not only base their relations with other groups on fictive maternal ties but also claim control of money by describing themselves as its 'owners'. (1982:173)

The ownership exercised by mothers is a special kind, with parthenogenetic overtones reminiscent of Gillison's description of the Gimi far to the south. There "the vigour and fruition of all nurtured life is believed to depend upon exclusive attachment to, or symbolic incorporation by, individual female caretakers" (1980:147). The identification between the nurtured thing and its maternal source leads to Gimi men both separating themselves from the female body and sustaining the depiction of women as cannibals who will envelop them. Possibly the attitude of Daulo men towards these investment associations revolves around a similar tension between extracting the products of nurture and actively encouraging women's continuing nurturant role.

Since money invested is seen to grow, it is appropriate that women, promoters of growth, should see themselves as nourishing and guarding their money that is both evidence of their work and part of the productivity of the lineage. Sexton writes:

> In rituals like the symbolic marriage ceremonies . . . *Wok Meri* women claim responsibility for the communal welfare. An accepted interpretation of traditional male cult activities in the Highlands is that they enable men to take on symbolic responsibility for the fertility of women, crops and pigs, and for the well-being of the human and animal populations. . . . In the Daulo region . . . male cults have not been practised for some time. It is of major importance that women have developed *Wok Meri* rituals in which they symbolically shoulder the burden of insuring the 'fertility' or reproduction of money which has become a requisite (as a major component of bridewealth) for the reproduction of society. (1982:197)

This is no narrowly conceived image of maternity. In the context of men's withdrawal from collective rites, Daulo women have taken over the modelling of a productive, public life, on the whole with men's support. Important to this promotion is the exploitation of single sex ties, the all-female character of the internal rituals. At the same time, the particularity of the integrative idioms—mother/daughter ties across groups—indicates that these women are not simply imitating men's rites; they are drawing on other symbolic sources for the representation of social welfare and productivity. By recreating the rituals of marriage and bridewealth, Sexton argues, *wok meri* women reaffirm that women are the source of wealth. More than this, they give birth without assistance; they "create and reproduce society by themselves" (1982:197).

Warry's (1985) account of similar rituals in the nearby Chuave area emphasizes the potentially subversive character of these claims. Women's fabricated transactions do not sociologically replicate the structure of traditional exchanges between kin and affines; the fictive relationships created among women often link strangers, and actually disrupt the interpersonal networks men sustain.[15] Kin-based prestations revolving around births, marriages, and deaths were formerly channelled through what Warry calls men's corporate and competitive efforts, an engagement of their group identity. The new women's activities do not respect these boundaries. On the contrary, Chuave women's complaints about men's wastefulness include male investment in ceremonial exchange activities that promote the clan or lineage prestige. Women construct a new collective dimension to their 'growing' activities. In their creation of female to female ties, they endorse collectivity but challenge the group formation on which men's collective activity was based.[16]

SOCIAL ACTORS

One question presents itself: is it simply that a boundary between public and private or political and domestic domains has been redrawn? In each case, is it men's encounter with the encompassing world of 'development' and commerce that has led to women taking on the values of 'traditional' life? Perhaps the whole of traditional society thus becomes encapsulated, its central values represented by the category of persons traditionally encapsulated by men's collective efforts. But if this is so, there are some interesting qualifications to be made.

Most important perhaps is the highly contextualized nature of women's association with social responsibility, rootedness, or ritual regeneration. Indeed, in the first two studies, the association appears a matter of situational rhetoric made explicit only in certain circumstances. Nor is it true that the whole of 'traditional society' is conceptually located in an external world like a domestic as opposed to a public domain. Men's own external relations do not necessarily provide scope analogous to the dominating part they played in home politics. On the contrary, local political action remains a largely male domain. For all the public, cultural, collective nature of women's new activities, in none of the cases here do they also come to signify active political engagement, neither in the sense of promoting the solidary interests of groups in confrontation with one another nor in exclusive claims to the avenues of prestige.

Western spatial idioms that depict a public/domestic divide in terms of geomorphic external and internal orientations would be misleading if one used them to suggest that values internal to indigenous society were now somehow set off against those of the external world. Indigenous politics certainly have not been domesticated in this way; on the contrary, men see their activities here and in the external world as continuous evidence of their public efficacy. Hagen women may be regarded by migrants in town as the repositories of all social obligation, but that does not mean that at home they are more prominent. The Vanuatu women on Pentecost might stand for rootedness in relation to men's going away, but that does not mean they actually take over men's ceremonial life. The Eastern Highlands women may mount collective rituals of regeneration but that does not mean they have shifted the basic structure of control over household resources. I say new activities, but what is new in these accounts is the way in which a certain kind of sociality becomes visible. What is made visible is that special sociality characteristic of domestic kin relations.

This generalization holds across the differences in the three cases. Hagen women embody 'public' values in so far as the responsibilities and duties of which they remind the migrants receive general acknowledgment and are openly recognized. They are not 'private' values in any sense. Yet at the same time these are not values related to concerted, collective action but are embedded within the interdependencies of close kinship relations. From men's point of view, relations with women stand for particularistic cross-sex ties, including domestic relations with other men.[17] On Pentecost, it is arguable that a holistic model of both 'society' or 'culture' is being built; not only does *kastom* (culture) comprise habitual ways of doing things, but certain productive relations internal to the community are seen to uphold a general sociality by which Sa-speakers identify themselves. This holism seems to be a specific ethnic artifact: Jolly describes *kastom* as a strategy for responding to, modifying, and sometimes resisting European 'custom'. In Daulo, women are involved in concerted activities, at certain points private (internal to themselves) and at other points public (brought into the open) but throughout of an emphatically collective nature. The all-female ties parallel all-male ties, in other contexts. At the same time, the crucial relations between *wok meri* groups are modelled on interpersonal kinship among women.

The fully social nature of women's involvement in local affairs is made visible. Yet these formulae do not obliterate differentiation be-

tween men's and women's activities. Women come to occupy a public space but still do so in contradistinction to men. The resultant divide may not be satisfactorily matched with all that is connoted by the Western formula of public/domestic domains and its variants; but that realization does not take away the divisions that exist in indigenous life. At the same time, the divisions cannot possibly be construed by the outsider in such a way as to suggest that Melanesians associate one sex with sociality and the other with some lack in this regard. Chapter 3 queried the description of Highlands men's attitudes that suggested these men saw boys as incomplete in their biology; the corollary of this Western-derived suggestion that women completely endowed by nature must somehow always be seen as socially incomplete does not follow either.

The public/domestic issue has figured so large in the debate taken up by Western anthropologists interested in gender relations because of the extent to which apparently similar evaluations are encountered in the lives of other people. All three cases here provide a patent disjunction between men's and women's activities. But I have been arguing that what must be examined is the form of the disjunction not only the fact of it. There was ever only a limited point to asking if women 'really' are confined to a domestic sphere, a strategy that inspects the terms of a dichotomy and ignores the relation. Perhaps these cases can assist in understanding the further general problem, that so often the symbolized activities of women appear to be focused on physiological reproduction or on involvement in household provisioning, to the extent that these appear to constitute female domains. Is not domestic sociality still a diminished sociality?

The question of households invites return to the Hagen materials, for it seems the weakest. It looks as though women simply remind migrants of their limited 'family' duties. Yet if this appears derogatory from a Western viewpoint, it is because of Western assumptions concerning domesticity. At *their* base is the notion that domesticity makes women less than full persons, so that they do not qualify as proper exemplars of social actors.

Hagen domesticity. Within Western society, it is possible to conceive of certain categories of persons being rather less than persons. In an early paper, Ortner thus suggests that women appear closer to nature than men in societies where they are associated with children who must be moved from "a less than fully human state" (1974:78) to full human-

ity through the offices of men.[18] The acknowledgment of reproductive power might compensate for lack of cultural creativity, but domesticity confines women to a low order of social integration. Whether or not such formulations can be found in the thought systems of other cultures, they certainly are in our own.

Western women run the danger of appearing as less than full social persons, either because their creativity is in natural rather than cultural matters or because they belong to the narrower world of the domestic group rather than the wider 'social' world of public affairs. We entertain the idea of incomplete social orientation, insofar as Western notions about personhood evoke ideas about evolution (see chap. 1). Industry and culture are conceived of as a break away from nature and suppose domination over it. Within these terms, to be a full person one must be culturally creative. Such notions are also set within a politico-economic formation that assigns autonomy to the workplace, to a public sphere away from the infantilizing home. At home, the nonwage earner is dependent upon the wage earner, even as the whole household depends for subsistence upon institutions outside it. To be adult, one must break out of the domestic circle.

The Hagen view of the person, by contrast, does not require that a child be trained into social adulthood from some presocial state nor postulate that each of us repeats the original domestication of humanity in the need to deal with elements of a precultural nature. Society is not a set of controls over and against the individual; human achievements do not culminate in culture. And to whatever extent female domesticity in Hagen symbolizes affairs opposed to the collective interests of men, it does not thereby entail the further denigration that women are less than adult. For women's identity as persons does not have to rest on proof that they are powerful in some domain created by themselves nor in an ability to break free from domestic confines constructed by men. The Hagen denigration of domesticity is located within a specific evaluation; only with respect to activities that lead to prestige are things 'of the house' rubbish. That female concerns are thus denigrated does not touch on women's stature as social persons.

Hagen women exert an influence more limited in range than men; at times they are forced into humiliating positions of powerlessness; they are 'political minors' (M. Strathern 1972:293). Yet it is also true that women are credited with will, volition, and the capacity to put things into a social perspective. Elsewhere I have glossed these as autonomy, in the sense that the self and its interests are acknowledged

reference points for action. Hagen women are always held responsible
for their actions, and it would be inappropriate to conceptualize their
status as child-like. Women quite as much as men are credited with
minds, a capacity for judgment and choice, an ability to entertain as
points of reference both a consciousness of selfhood and a consciousness
of social relationships. There is no single term in Hagen to describe
these attributes, unless it is that of being human, but if we regard them
as amounting to a concept of personhood, then it is clear that the public
power women exercise (the political content of their decisions) is irrele-
vant to their definition as persons. Indeed, women often go their own
way, following the dictates of their minds, in the very act of refusing
to acknowledge what men would classify as appropriate public goals.
But this connotation of autonomy must not be overstressed. Women
are also credited by men and believe themselves able to set their minds
on ends that benefit both sexes. The most regular context in which
women's minds are engaged in social endeavor is household production,
domesticity itself.

The mind (will, awareness), I was told in Hagen, first becomes visible
when a child shows feeling for those related to it and comes to appre-
ciate the interdependence or reciprocity that characterizes social rela-
tionships. The relationships always take a particular form. They present
themselves initially in a domestic context, for example when the child
acknowledges that its mother needs sticks for the fire quite as much as
the child needs food to eat. A gloss of mutuality is put upon the un-
equal, asymmetrical relationship. The child is held to have a further
model of interdependence in the figures of his parents. As adults, hus-
band and wife are portrayed as mutually dependent upon each other,
and because of the difference between them. The difference is absolute.
This interdependence turns upon the value put on work, in both the
productive sense and as an index of intentional endeavor, a mark of
maturity. Reciprocal activity within the household comes to symbolize
other-directed intentionality. Husband and wife each contribute their
work and effort to the household; such work is particular to the rela-
tionship and is not given measure by the outside world. The male prep-
aration of gardens is not esteemed more highly than the female tending
of crops or cooking of food. The domestic context of women's efforts
does not reduce them—as it does in industrial societies—to something
less than work.

The transformation of work into prestige belongs to another realm
of discourse, for it remains true, as we have seen, that labor (production)

is devalued in relation to activities surrounding ceremonial exchange (transaction). This should not be confused with the status of domestic work in a capitalist, wage-earning economy. The domestic unit is not seen to depend on wider institutions, as the Western household depends upon an outside workplace, but is in the local view viable on its own. Men's public affairs and the pursuit of prestige among themselves may belittle the value of domestic work in the rhetoric of collective interests, but this only reminds them what they also know—that as men they must be effective in their own domestic obligations. Above all, then, the domestic household is the place where people show themselves to be proper persons engaged in reciprocal transactions. The converse, as later chapters will make clear, is that persons are also created in that context as the object of their relations with others. Crucial to this conceptualization is the construction of differences and asymmetries between those so related.

The male migrants who went from Hagen to Port Moresby not only de-politicized their view of their own position but also de-domesticized it. In the general Hagen view, they were not shaking off the confines of an infantilizing home. These actions held a profound threat: male migrants forego the framework of mutual interdependence, established within the domestic sphere, which creates the mature person. They in turn might be able to ignore the politics and rhetoric of senior men, but find it much harder to denigrate the claims of women. It is easier for them to cast themselves sardonically into the role of rubbish men than it is to deny appeals to that interdependence with others which both constitutes and symbolizes sociality itself.

In Hagen eyes, women's association with procreation and children renders them polluting and weak, yet these symbols are to be distinguished from Western symbols of social evolution that classify the house-bound woman as child-like and dependent. As agents of socialization, in this latter view, women are associated with its earliest phases, especially the preverbal training of infants in whom must be instilled certain habits. Socialization reproduces the social evolution of man and the creation of culture: children become persons as they begin to manipulate artifacts and learn social rules. The mother, in the Western world view, is gatekeeper to the outer world—hence our paradoxical concept of independence to refer to entry into this world. The mother is tainted by this state of dependency, reinforced in her role as wife.

This rendition of Western stereotypes is spelled out in order to dislodge Hagen notions of domesticity from such a matrix. Those con-

fined to the domestic domain are not in Hagen regarded as less than adult, as incapable of autonomous action. A woman's contribution to the household is seen as a matter of her emotional and rational commitment. Hagen notions of human nature posit that self-identity and social consciousness mature over time, so that the mind is nurtured, showing evidence of itself in a child's growing self-determination and its awareness of others. There is no concept of childhood prolonged through continued dependency, because there is no equation between adulthood and independence. On the contrary, rather than grow away from them, the child grows into sets of particularized social relationships, predicated on that asymmetrical relation between itself and its parents. Childhood dependency upon parents is imaged as a matter of mutual feeling between them. Finally, these ideas of personhood do not turn directly on dominance. It is not the case that a person can be him or herself only through freeing the self from constraints imposed by others, an idea that shadows certain Western constructs.

Whatever use is being made of maleness and femaleness in ranking activities of one kind or another, for Hagen it is not necessary to erect a model of personhood predicated either on extradomestic domains of power or on a politicization of domesticity. In so far as the division of labor between spouses stands for mutuality in general, it is the domestic domain that produces full persons. Under no definition of the term could an anthropologist working with a concept of 'society' regard Hageners as supposing this domain to be infrasocial or outside society.

TWO TYPES OF SOCIALITY

The analysis of initiation ritual in the Eastern Highlands can be subjected to similar scrutiny. If we label as social the kinds of relations people establish with one another, their capacity to influence and be effective, the obligations and constraints and powers these interactions set up, then from our point of view men and women emerge equally from these studies as social actors. And from the Papua New Guinean point of view, they equally impinge upon one another. It would be false to read off from the ritualization of physiology a symbolized contrast between social actors and natural individuals. There is no reason to suggest that, any more than in Hagen, Eastern Highlands peoples imagine a 'nature' upon which society and culture work to impose their rules and classifications. Indeed if social relationships are taken for granted, a Melanesian model of the person would already incorporate

the fact of connection or relation. The person is not axiomatically 'an individual' who, as in Western formulations, derives an integrity from its position as somehow prior to society. We cannot then argue that what males claim to dominate are female elements conceptualized in extra-social terms, viz. physiological powers as attributes of an external nature. On the contrary, their concepts of collective and bodily activity are more simply understood as tantamount to a theory of social action.[19]

When powers are defined in an oppositional way such that one set seems lethal to the other, a consequent rhetoric of antagonism may become attached to a perceived asymmetry between actors. Thus it may seem to be 'men' who feel threatened by 'women', that is, their collectivity by the particularity of dependency relations. Antagonism consequently appears, as the early fieldworkers argued, to involve unilateral domination and anxieties about domination. Yet the apparently inexplicable question of motive dogs the question of male domination.

An institutionalized desire to dominate implies the construction of concepts that link domination to a perceived benefit. As Ortner (1974) observed, there has to be a grounding imperative to categorize difference before the differentiated 'other' is constructed as an object to be subdued. This remains unexplained in the sex-role models of gender relations that suppose women present themselves to men as a self-evident ('antagonistic') category. Nor can this model account for the kinds of shifts, described earlier in this chapter, which lead to the positive association of women with the responsibilities of ritual life. The formula that I prefer is that gender demarcates different types of agency.

Persons differentially impinge upon one another, and imagining 'male' or 'female' ranges of efficacy becomes a way of eliciting these diverse types (Wagner 1974:112). On the one hand efficacy derives from collective action, based on the sharing of identity, and on the other hand from particular relationships, based on interdependency and difference between persons. Gender imagery thus differentiates sociality,[20] which is consequently conceived as always taking one of two forms.

Biersack offers a comparable argument for the Paiela, a Highlands people to the far west of Hagen and Enga. She analyzes the gendering of a public/domestic dichotomy as a reflexive discourse on social life. The most salient feature of human life is diversity and variability, and "Paiela use a very simple discursive device for talking about diversity and variability. They employ a physical difference, . . . sexual dimorphism, to signify a polarity that is thought to characterize the species as a type of moral and social being" (1984:134). The superior/inferior

axis of gender ideology she relates to its reflexive character: it could never be nonevaluative. It is the question of evaluation that triggers what I earlier described as Western theories of social constructionism.

The Western European notion of society, as it informed anthropological and feminist accounts of the 1970s, grasps collective action, whether in an integrative or competitive mode, as binding entities different from itself. Sociality is seen to rest in relations between individuals, in the social and cultural constructions of the individual or of sexed persons (men and women) whose individuality or sexing lies beyond the construction.[21] Elevated to academic discourse, we may call such a concept positivist or bourgeois. It by no means has a monopoly on Western ideas of society, but through its counterpart in widespread folk models (e.g., Schneider 1968), with their own gender symbolism, in this sense enjoys hegemonic status. The power of society is shown in its control of the extrasocial individual. Subordinating 'nature' or socializing the 'individual' provide images for one another. In the same way as descriptions of systems produce the idea of events, such a notion of society produces the concept of presocial (biological) entities, like so much raw material, and the relationship is forever a source of speculation. This particular model of society employs—as do similar versions in the history of European thought (Lloyd 1984)—a distinction between male and female to symbolize that relationship. The model cannot keep the polarization steady but switches between suggesting that society is the source of creativity and energy and that the individual is, or between seeing females as instinctual, natural beings and seeing them as refined end products of civilization. Such concepts have profound consequences for the way in which Western Europeans think about relations between men and women. However much willpower is applied to reversing the terms of evaluation or adjusting them in favor of one sex rather than the other, the fact of evaluation remains. This, in Rubin's (1975) words, is our political-economy of sex.

The implicit culture-nature dichotomy becomes highly relevant to the hegemonic Western formulation of public-private domains not only as a matter of content (the domestic domain is regarded as the site of biologically based activity) but in terms of the structured relationship between intractable, given units and the working of social forces which (through exchange or the division of labor between households, for instance, see Harris 1981) creates superordinate ties and thus sustains sociality between otherwise autonomous entities. Thus the domaining activity itself—the separation of public ('social') affairs from private,

domestic ones—holds an analytical place like that of the incest taboo, a separation that creates 'culture'. The division is posited as a model of the creation of society itself.

This kind of argument further takes for granted a reflexive function in social classification; people are bound to describe their relations to one another in such a way as to create a second-order modelling that subsumes a first order one. There is the double imputation here that the *operation* of ordering, the indigenous organization of ideas about social life, will show in the *product* of such reflection, viz. as an internal analysis of social life into more ordered and less ordered parts. Thus, the public domain may be understood as an exteriorization of or a socializing process brought to bear upon familial atomism. For significant to the constellation of Western concepts concerning the notion of society is consciousness. Gatens (1983) remarked that socialization theorists had to work with a body-consciousness split. Gillison makes the point in relation to specifically anthropological theorizing about the construction of models as acts of consciousness: "The opposition between culture and nature represents an externalization of the relation between mind and body or between consciousness and instinct" (1980: 171–172).

The terminology of 'construction', as in the social and cultural construction of gender, reminds us of the close conceptual relationship in Western thought between consciousness and reason, with reason evincing itself in system and systematics.

> The ideal of an ordered realm of thought to which intellect can retreat from the confusion of passion and the sensuous has dominated Western intellectual aspirations from the time of Plato. From their earliest origins in Greek thought, our ideals of Reason have been associated with a flight from the particular; and associated, too, with the idea of a public space removed from the domestic domain. Reason is the prerequisite for, and point of access to, not just the public domain of political life but also a public realm of thought—a realm of universal principles and necessary orderings of ideas. In the highly influential picture of morality which found its fullest expression in Kant's ethics, this realm of universal principles was seen as the proper locus of moral consciousness; the picture is in many ways still with us. (Lloyd 1983:490–491)

It becomes easy for the Western observer to assimilate indigenous model-building to a second-order activity, to a type of systematization, the product of consciousness, which replicates the organizational forces of society itself. 'Models' and 'representations' are conceived

holistically. At the same time, any organizational principle can also be construed as 'a view'. Because the image is of self-reflective activity, a pluralistic hypothesis is also possible: that any one set of rationalizations comprises a view from a specific vantage point. The concepts of models, representations, the imposition of systems, ultimately predicated upon assumptions about nature and culture, thus enable the feminist anthropological critique of ideology to take the form it does.

For the Melanesian cases, I am not sure that the indigenous modelling of domains, in the vocabulary of the 1970s, is helpfully regarded as second-order self-reflection. I suggest we regard their evaluations as predicates for action, and that what is made visible are differentiated competences. This disposes of the supposition that a gendered domaining necessarily represents different points of view. The idea of domains corresponding to men's and women's worlds is not a dualism that needs be sustained in the Melanesian context. Domaining itself is not simply a male description of the world imposed upon a preexisting heterogeneous nature; nor do the values ascribed to the domains simply stand for men's and women's intrinsically opposed perspectives. The very questions about the articulation of domains that were so important to the anthropological-feminist critique turn out to endorse a model of a society that must code its own and not other people's gender constructs.

One must, in fact, get away altogether from the model of a 'model' that takes symbolic representation as ordered reflection.[22] Domaining is better taken as an activity, the creation/implementation of difference as a social act.[23] This repeats the conclusion to chapter 3. There it was asserted that the vehicle of symbolism should not be seen as its cause (that gender imagery is about men and women); here, that a differentiation into domains of activity is not necessarily explicable in terms of their character. But one might ask: why is so much energy thrown into the act of differentiation itself?

There is certainly a strong Melanesian interest in evaluating the way in which persons affect and influence one another. Different types of relationships are made visible in transactions between persons. Indeed, to imagine these interests as tantamount to a theory of social action rather than a theory of society might bring one closer to being able to adjudicate on issues of inequality or at least to address the premises on which the actors perceive their power. For the cases discussed in this chapter still leave us with questions about the nature of the boundaries drawn through sexual imagery. In essence, there is only one boundary. There are not an infinite number of types of sociality but basically two:

for the moment we can continue to call these 'political' and 'domestic', if what is understood is a contrast between collective action (based on shared identities and aims) and particular relations (based on the difference and interdependence between them). The one can thus be construed as 'opposed' to the other. But in what sense does one also appear as subordinate to the other? For the Eastern Highlands case especially has raised the issue of male domination. Women's *wok meri* rituals did not emphasize domination; women claimed superior financial skill in order to circumvent male irresponsibility but not to control men as such. Men's traditional cult activity, however, seems to have involved emphatic assertions of superiority as the basis for domination over women. That claim remains to be examined.

5
Power: Claims and Counterclaims

Interpretations of sexual antagonism in the Papua New Guinea High-
lands have never taken men's claims at face value. I do not mean as to
whether their domination over women is effective but in reference to
the way the claims as such are promoted. For these are seen to express
anxieties on men's part about their 'real' control of women's powers,
and hence indicate both the extent to which these powers present a
challenge and the extent to which men's social institutions fail to ac-
knowledge an ultimate dependence upon women. Withdrawal into all
male activities, it is held, by denying also asserts the power of the ex-
cluded sex.

A conundrum runs through anthropological analyses of male and
female initiation/puberty rites: when a category of persons claims ritual
powers (through secret knowledge, cult engagement), is it because they
have or because they do not have comparable powers in other terms
(in daily life, in politics)?[1] The conundrum takes many forms but is
most perplexing in relation to the initiation of boys into all-male associ-
ations or cults. Do such male rituals imitate female capacities ('envy')
or supersede them ('superiority')? Are men compensating for what they
lack or appropriating what females possess? Do ritually made state-
ments reflect distributions of secular power or are they a sop to lack of
power? Beliefs may be regarded as simultaneously exaggerating and
reversing social realities, but such equivocations also accept certain of

the actors' definitions. It is they who propose a difference between male and female capacities.

The conundrum comes from joining these propositions to the anthropological habit of thinking of society in terms of domains. Consequently, it touches on the very structure of anthropological explanation, on the manner in which different areas of social life are symbolized. This operates in two modes that were encountered in the last chapter, and both apply to the analysis of initiation/puberty ritual. The first regards ordered, institutional life as imposed upon a reality that both presents it with its reasons for existence (controlling nature, harnessing resources) and confronts its orderliness (in the recalcitrance of individuals). The second divides up areas of social life into different levels or spheres; one talks of public and private levels or political and ritual spheres, with an inbuilt ambiguity as to whether these are adjacent to or encompass one another. When social life is regarded as motivated by the need to integrate the one with the other these analytical divisions come to assume a taken-for-granted or innate status as part of the data. The much used metaphor of 'articulation' aptly summarizes the problems posed by this second mode. I take the two briefly in turn.

First, imposition upon reality. The claims Highlands men make in the context of their rituals have been interpreted as strenuous assertions by which they at once dominate women and mystify themselves. To suggest that a set of ideas has a mystifying effect also suggests, of course, that a real situation exists beyond them, that the actors are incorrectly apprehending reality. Consequently there exists an interesting asymmetry to these accounts. Men are regarded as deluding themselves, but what they attribute to women is taken by the observer as real. Where Gahuku-Gama or Sambia men stress, as they do, that one of the achievements of their ritual is making boys grow, the ethnographer may point to the supporting evidence that the men also adduce— that by contrast with boys, girls mature rapidly at puberty—and locate the evidence for him/herself in real nature. Read writes,

> It may be a simple observation [i.e., common sense reality], but I think the Gahuku-Gama noted that the signs of sexual maturation are more obvious (visible) in females than in males. . . . They did not hesitate (without any prompting) to liken the nosebleeding rites of the nama cult to menstruation, explaining that both were necessary to complete the process of maturation, and also acknowledging that men had to simulate (ritually induce) an event that occurred naturally in women. (1984:227)

What 'they' mean by growth is assimilated to what 'we' would mean (compare Lindenbaum 1976:57). Men are thus seen to be grappling with problems which lie in (real) physiological processes beyond their (real) control.

The rapidity with which girls grow is often noted to be part of indigenous commentary on male initiation. Female 'initiation' may celebrate or strengthen this growth or be regarded as a further device for bringing such power under men's control.[2] Where such suppositions are attributed to or voiced by the people involved, they feed into a general set of theoretical assumptions (on the part of anthropologists) about the intrinsic and visible value of women, particularly in terms of their fertility. It is of a piece to take it as self-evident that men should organize social life so that they are able to exchange women between themselves. In the case of marriage disposal, it is argued that men's domination of women is institutionalized in their right to allocate their claims to other men; in ritual, that men strive to come to terms with the idea of women's natures. Women confront men with a natural or real superiority in their biological functions which propel men into social action. In the course of harnessing and organizing the natural resources embodied in women, the argument goes, men's claims to an esoteric counterpower support concrete acts of domination over real women in other areas of life.

Such interpretations imply that women, because of their natures, do not 'need' to exercise the ritual power by which men mystify themselves. Indeed, it is rather easy for an outsider to achieve some distance from male pretensions when they are embedded in activities (as in cults) that the outsider does not take at face value. Yet when the observer is confronted with social realities he/she does take at face value, the argument about exclusion proceeds differently. When it is a domain of political or economic action that men create, bolstering their interest in warfare, individual acts of violence, or their extraction of women's labor, it is often treated as significant that women are without the political and economic resources to protect their own interests. To be excluded is to be deprived. In ritual activity, however, men's 'power' may be interpreted as complementary to, as compensating for, or as controlling other 'powers' that women evince of themselves. Their exclusion from ritual thus also appears natural and obvious. Men may be regarded as simply attempting to overcome a "fundamental disparity between the sexes" which arises because "women are naturally endowed with reproductive capacity" (Newman 1965:80).

Second, ritual as a domain. The staging and sequencing of acts sur-
rounding particular ceremonies lends concrete support to the anthro-
pological perception of ritual activity as a domain separate from other
'areas' of life but nevertheless reflecting upon them. The analytical
separation seems further justified by the actors' own distinctions, for
example in women's exclusion from all-male ritual activity. We have
already encountered this kind of thinking in the assumption that a male
domain must speak to men's exclusive interests. The conjunction of this
assumption with the first—that an organized social life points to a
reality beyond—leads to the prevalent anthropological supposition that
it must be in men's interests to dominate women. Domains are not
merely adjacent to but potentially encompass one another. For these
explanations inexorably produce the view that men's energies are de-
voted to controlling something beyond themselves. In the case of exclu-
sive all-male activity, that beyond must be women or what women
stand for; in the case of ritual performance, that beyond must be a
mundane sphere of a political or economic character.

Explanation of male ritual thus frequently turns on an 'articulation'
between domains. For those ethnographers who take men's assertions
about superiority as grappling with real issues of women's power,
men's exclusive cult actions are revealed as supporting actions outside
the cult context. While they might have their own internal logic, the
cults are not regarded as achieving their ends exclusively within their
own framework but as having an effect on mundane (real) areas of
social life. It appears that men are able to justify individual acts of dom-
ination by reference to their collective superiority, and to sustain the
domination of their particular constructions of reality. It may even be
assumed that as a rich cultural activity, the social life men create for
themselves in the cults is in itself of value, so that women's exclusion
is to their deprivation. In this view, women are excluded from an arena
of importance. The argument supposes female envy of male social life,
which directly contradicts the earlier supposition that women somehow
do not need ritual life.

These two potentially conflicting modes of anthropological explana-
tion between them conceal the conundrum. For the two modes can be
run together in the analytic imagery of control: the rites are to be
understood in a double sense as men expropriating women's powers
and controlling them by excluding them from a domain of social activ-
ity. At this juncture the naive might ask, since the men are doing this
all for themselves and since women are excluded, in what sense are

men's activities of relevance to women? And should we give weight, for instance, to an observation Ledermen (in press) makes of Mendi women who just did not seem to care very much about their exclusion from group (clan) concerns?

It is the concreteness of images such as domains, in this case the ethnographer's geophysical metaphors, that leads to an analytical conflation between a sex and its attributes. Male ritual must be about men's interests, for the object of men's activities lies 'beyond' them, as exemplified in the idea that they desire to dominate women. This kind of supposition is intimately bound up with those Western explanatory modes that regard one 'area' of life as imposed upon or as an exteriorization of another, and force as applied to something beyond and external to the acting subject. As we have seen, such metaphors may further be attributed to the intentions and motivations of the actors.

The extension may be apposite in the hierarchical systems of the kind Bloch and Parry (1982:6) have in mind when they point to certain specific contrivances of the idea of social order. The mortuary rituals with which they are concerned comprise "an occasion for creating . . . 'society' as an apparently external force [original emphasis removed]." Yet more pertinent is a further argument Bloch (1985:40) presents about Madagascan (Merina) initiation ritual: the picture of the world created by the ritual is not a guide to or map of people's cognitive system. No such guide or map exists.

As I understand Melanesian concepts of sociality, there is no indigenous supposition of a society that lies over or above or is inclusive of individual acts and unique events. There is no domain that represents a condensation of social forces controlling elements inferior or in resistance to it. The imagined problems of social existence are not those of an exteriorized set of norms, values, or rules that must be constantly propped up and sustained against realities that constantly appear to subvert them. People are subverted by the actions of other people. Or they are attacked by nonhuman forces forever beyond their reach. The world is not mapped into spheres of influence, into adjacent and competitive empires. Nor do people envision a hierarchy of levels whose final battle ground is the subduing of the human body. Consequently, initiation rites are not, I think, imagined as presenting the individual with the power of society/culture as an external force, and one which in male hands is also an instrument of a mundane power they have the prerogative to exercise. It is not external forces that are, so to speak, the problem at all. Melanesians set for themselves the problem of in-

ternal efficacy: how to draw out of the body what it is capable of. The rites construct ways of knowing what these capacities are.

This chapter is concerned to dismantle the concreteness of certain other anthropological metaphors that are so often ascribed to the minds of Melanesian participants. It introduces my further argument that the powerful Western image of control depends on concepts of ownership and property. These, in turn, have often had a drastic effect on how Western anthropologists deal with the question of gender identity. They are also bound up with the conceptualization of power, an inevitable adjunct of any attempt to understand men's emphatic claims to superiority and domination as they are reported in the ethnographic record.

POSSESSION AND IDENTITY

What is arresting about male initiation cults are the apparently conflicting idioms of exclusion and appropriation. From some of the supporting mythology of the Eastern Highlands cults, men clearly construe their exclusive activities against the interests of women, as when boys are said to be torn from the mothers who want to retain them. Whereas in the case of the extraction of labor, the ethnographer has to supply an interpretation the actors do not necessarily admit, here are encountered blatant *claims* of extraction. In fact, the logic of cult activity is constituted in such claims. The very necessity to perform the rituals is given by an original act of theft from women. Across the Eastern Highlands, society after society is reported in these terms. The ritual paraphernalia—especially the flutes that are a central secret of many initiation cults—holds power for men because at some point in the past they wrested it from the power of women. Something women previously possessed is now in men's hands, an apparently simple and effective statement that women are a source of power and that men control it.

Women are consequently construed by observers as doubly deprived. They are prevented from exercising the ritual power by which men appropriate their fertility. This lack of ritual power is further interpreted as indigenous justification for their (real) lack of (real) social power. Yet in spite of indigenous metaphors of extraction, it is important not to extend the image of possession too far. Certainly we should not merge these Melanesian formulations with the Western concept of private property.

Such property notions pose another conundrum: who really 'has' the

power? Is it those who say they have it or those who do not have to
make such statements? For ultimately power is known, in the positivist
view, by its attachment as a resource to the possessor, who evinces 'it'
in interaction with others. Yet this definitive Western image of posses-
sion occludes the very question of interaction. Possession implies a
finality and thus holds out hope for the observer of an ultimate adjud-
ication about which sex has power. The rituals referred to here, of
course, never come to completion; they involve constant and repeated
assertions about the significance of the theft. The impression derived
from these accounts is not that of an ultimate victory commemorated
but of contemporary battles freshly engaged. As Read points out in his
retrospect, if women were 'enemies' they were nevertheless enemies "as
necessary to the ideal of masculine strength as the traditional enmities
between adjoining tribal groups" (Read 1984:233; Tuzin 1980:313).
This necessary confrontation is not illuminated by our thinking that
Melanesians conceptualize power as a possession, as something that
one person 'has' and another 'does not have' in this or that area of life.

An idiosyncratic feature of popular Western concepts of property is
that singular items are regarded as attached to singular owners. The
fact of possession constructs the possessor as a unitary social entity,
true whether the owner is acting as an individual or a corporation.
Property is construed as a relation between persons and things, and the
person is an entity to which things are external. Whether property is
'private' or 'communal', the possessor is the singular author or pro-
prietor. Thus communal property would be owned by a community
and in this sense would be analogous to private property so-called.

Anthropological theories have for long provided a critique of such
ideas through the analysis of multiple interests. This was prompted
largely by investigations of African kinship and politico-economic sys-
tems that had to deal with equations between persons and 'things' (as
in bridewealth) or the 'ownership' of persons by other persons (as in
certain authority structures). The terminology of ownership came to be
abandoned or at least modified, in anthropological analysis, being sub-
stituted by a flexible interpretation of 'rights': rights in things and
against persons can be shared or structured in such a way that the item
is never exclusively allocated to one social person. Interpretations of
non-Western property systems, including the disposition of rights with
respect to persons, are thus advanced in specific critiques of private
property as a universal category, a point to which I return in the next
chapter. Nonetheless, a proprietorial premise continues to inform an-

thropological interpretations of people's conceptualization of power. Power is regarded as attached to a person in such a way as to define the person's identity. There is an either/or, have/have not quality about it, which also holds for Western gender constructs. Now if it is not, in the end, going to be helpful to regard power as held like a piece of property, the same may be true of sexual identity.

This would release the analysis of initiation/puberty ritual from Western sex-role assumptions about the unitary nature of the entities constructed in Melanesian gender concepts. For to assume that male initiation cults simply make boys into men is to assume that the boys have an incomplete sexual identity. It is supposed that they must become endowed with the appropriate attributes, that they must find their real identity. There must be a point at which a boy's perception of himself matches the social expectations of the category role he is to play as a full adult. In short, at issue is a figure whose constitution must show internal consistency—'male' in terms of maturity, sexual characteristics, inner feelings, and outward social attributes. These he all owns as part of himself. Women and their powers, or associations and relations with women, could only compromise a masculinity constructed in such a totalistic fashion. Femininity is interpreted in a similarly totalistic manner, especially in the extent to which Highlands ethnographers dwell on female pollution as marking out a definitive sexual identity. It is taken as Melanesians' signification of intrinsic female nature.

These latter assumptions have been to some extent disturbed by two sets of reports from the Eastern Highlands made in the 1970s. Faithorn and Meigs both observe that prevailing anthropological suppositions about unilateral pollution—that it is always women who pollute men—reflect patchy knowledge on the ethnographer's part. Faithorn (1975) argues that we should attend to contexts in which men are a source of pollution.[3] Meigs (1976; 1984) emphasizes that we are mistaken in seeing pollution, a particular capacity to harm, as an attribute of men or of women; rather, for the Hua people, it is a quality that inheres in substances which may be passed between them.[4] Indeed, these substances are powerful because they are transferable.[5] Thus she identifies various disconcerting facts, as she calls them, that suggest that Hua "attempt to neutralize or obscure the male-female opposition through a sharing of characteristics and flow of membership between the categories of male and female" (1984:49).

> If pollution is a substance that can travel, then perhaps elsewhere in the highlands, as among the Hua, the polluted class of persons cannot be defined

in terms of the genitalia, which are not in and of themselves polluting.
(1984:69)

As the substances associated with sexuality (menstrual blood, vaginal
secretions, semen) are "transferable between the two genital classes,
this classification permits crossovers: a genitally male person may be
classified as female through his contamination by female substances,
and a genitally female person may be classified as male through the
transfer of pollution out of her body" (1984:70–71). However she
implies that the transferred attributes then become possessed by the
new owner, so to speak, so that the condition of the total person be-
comes reclassifiable as male or female.

For Meig's description of Hua suppositions about the theft of flutes
from women remains committed to a style of analysis that assumes that
a "belief in the natural superiority of women" is what motivates men's
rituals. The position is worth illustrating at length:

> [T]he view that women are by nature superior to males is implicit not only
> in the metaphor that relates sex and feeding but also in the origin myth of
> the flutes. In this myth . . . females are represented as the original producers
> and owners of the flutes, and consequently the original rulers of the society.
> When women played the flutes, males hid their eyes and bowed their bodies
> to the ground in an attitude of submission. At some point in the distant past
> men stole the flutes from the women. With this theft of the symbol of
> political dominance they gained actual preeminence as well. From this time
> on it was women who had to prostrate themselves when the flutes were
> played.
> Male supremacy was thus achieved either by reversing the natural order,
> in which the female act of feeding is identified as good and the male act of
> sex as bad, or by overthrowing it, when the men seized power from its
> original and natural owners, the women. (1984:45)
> It is consistent with these male feelings of superiority to female powers
> that initiation among the Hua as well as other New Guinea highland people
> is perceived as a compensation to males for their natural physical disadvan-
> tages. The flutes revealed to initiates represent, Hua men say, the male
> counterpart to menstruation. Rites of initiation, they add, represent the Hua
> male answer to the challenge posed by the more rapid female growth and
> more dramatic female manifestations of maturity. (1984:134)

Suggestive as the above qualifications are, it is patent that we require
insight into the epistemological bases of these acts of classification.
What is the status of a person's attribute? To this end I introduce three
accounts that have as their focus the elucidation of indigenous practices
of knowledge. None is written from an explicitly feminist perspective,
although they would be germane to one.

The transfers to which Meigs draws attention can be interpreted, it seems to me, as an instrument of knowledge for the actors concerned, how they make certain powers and conditions known to themselves. Melanesian perceptions of power are in turn elicited in the methods by which people come to know about themselves and others, for people's bodies are significant registers of their encounters with one another.[6] Here Meigs's language is blunt but apt. Much male ritual concerns definitions of masculinity in physiological/genital terms. Images of nurture and conception distribute different powers between sexes: either sex can claim reproductive capacity of a kind. Discarding the social-control-of-nature paradigm will free one to think of this concern with physiological process in another way—as a matter of what people discern must lie within their bodies including, of course, within their minds.

I follow Gillison's theoretical lead. Gimi ideas of male and female yield to men and women different kinds of efficacies. But the results are not images of a totalistic sexed identity of a Western type. On the contrary, maleness and femaleness seem defined to the extent in which persons appear as detachable parts of others or as encompassing them. In the end, it is not male or female substance that flows between the sexes, as Meig's description suggests, but visible signs of the alternating conditions of persons in their ability to separate themselves from or contain one another. The question, then, becomes how people such as the Gimi make known what is 'male' or 'female'.

Running through the practices in the cases that follow are concepts of a proprietorial nature. I have emphasized that we should be wary of the metaphors that creep into and constitute exogenous analysis, in particular Westerners' easy idioms of control. Making explicit the practices by which people 'know' and classify their attributes, including knowledge of sexual identity, will be some kind of preparation for composing a description of those indigenous assertions of possession and appropriation.

MAKING POWER KNOWN*

The three cases are drawn from roughly the same areas considered in the previous chapter. Here I begin with Vanuatu, specifically with Rubinstein's work on the island of Malo, to the west of Pentecost,

*These accounts are adapted from material I have presented elsewhere: all three appear in the volume edited by Fardon (1985).

where women substituted for men's sense of being rooted. The second case comes from the Eastern Highlands of Papua New Guinea with its development of women's rites of regeneration. The Gimi, whom Gillison studied, are on the southern borders of the *wok meri* area. Her study is very much an inspiration to my general analysis. Finally, I return to the Western Highlands. The Paiela of Enga Province share some features with Hagen. I have chosen them both because (unlike Hagen) they perform puberty rituals and because I wish to draw on Biersack's explicit attention to the presentation of information. In the first example, ritual surrounds men's entry into a system of public grades; in the second it is performed at both girls' and boys' puberty ceremonies, and in the third in the context of a male bachelor cult.

Graded society: Malo. Types of knowledge can be conceptualized as attached to, detached from, and transferred between persons (Rubinstein 1981).[7] Traditional Malo knowledge is divided into two components, conceived as distinct sensory operations. The first component, 'understanding' (from 'feel', 'hear'), refers to emotional response, the impact that interaction with others has on the inner person. The second component, 'knowing' (from 'eye', 'examination'), refers to a much more automatic response "existing at the boundary between an individual and his environment" (Rubinstein 1981:150), and thus encompasses perception, recognition, and factual knowledge. Knowledge of either type may be converted from an internal state to an external fact. Words are its vehicle, being considered as objectified units of expressed knowledge.

Malo do conceive of sourceless knowledge, but generally it is 'part of a person', connected to its bearer. Over his or her lifetime, each individual amasses a specific array of knowledge—the physical landscape is littered with items commemorative of events under the proprietorship of particular persons. Understanding is not privileged over knowing or vice versa. Both understanding and knowing are personalized; they are also both capable of being objectified. Both have their source in specific persons—how this felt, who saw that—while at the same time being potentially detachable things to be communicated to others.

Rubinstein ponders on what he describes as the relationship between personalized and objectified knowledge, which is paradoxical in terms of the Western antithesis between subjects and objects. Malo envisage a special relation between persons and knowledge, which establishes an

identity between an individual and what he or she understands/knows, but also detaches that sensory reaction as a resource transactable in encounters with others. Knowledge is like a gift. From its characteristic as a resource (objectified) it can operate as a token in the external world; but precisely because it is also part of the person (personalized), its deployment is an immediate vehicle for statements of that person's power or standing.

An individual may be the origin of certain facts or act as a channel for them. This perception takes three forms. (1) 'Understanding' or wisdom is a record of the way events have been experienced by someone. People's conception of the order of things can be shared with others, thereby creating a factual world on the basis of personal experience: what is understood comes to seem objective and depersonalized. Rubinstein gives the example of the cargo cult leader who impresses his vision on those participating in his experience. (2) The kind of knowledge ('knowing') possessed as custom (skills, spells) can be transferred to others through payment: the transaction detaches the knowledge from the original owner and reattaches it to the new. It is possible to purchase another's bodily gesture or idiosyncratic speech form. The relationship between person and knowledge here is that between owner and disposable, but not alienable, item—the item retains its value as a resource from being simultaneously in another's possession. (3) Where knowledge of either type is enunciated through words, factual value is measured directly by personal source. For example, validation of what people say must come through reference to the person who 'saw' it. Disembodied information is discounted. Here the personal reference is crucial for establishing the objective status of a fact in the eyes of others. Only when information has belonged to a particular person can it have social currency, that is, affect what others see or feel.

There is an intimate relationship between the attachment of knowledge and the structuring of power relations in men's political life. At the institutional heart of the traditional political system were fifteen ranked grades, entry being restricted to men and achieved through the killing of tusked pigs. Rubinstein (1981:139) refers to the pig-killing sequence as a "progressive determination of masculinity." Women and those who had not gained initial entry were grouped into a single low-ranking class. Membership involved consubstantiality: men of the same rank ate together. Leaders, who purposefully 'walked', attained high rank at the head of others who 'followed'. Such successful men held a monopoly on esoteric knowledge, and its value was related to

the status of the individual who claimed it, for the success of the individual was proof that the knowledge was true.

The three modes of linking persons to one another through knowledge transmission structure the acquisition of rank. Thus (1) creating a factual world on the basis of shared personal experience: members of one rank share a common life, ingest the same food. (2) Transactability of skills: partaking of the power of a higher person is accomplished through purchase[8]—a young man can only succeed by following an elder who shows him the pig-killing techniques. The elder disposes of his asset in this sense but with no loss to himself; through the purchase, rank becomes attached to the junior entrant. (3) The measuring of factual value by personal source: powers of accreditation increase with rank—the more highly ranked, the more comprehensive is a man's feeling and seeing; the facts of his success are testimony to his internal state of understanding and knowing.

Rank must be exclusively enough perceived in order to define interpersonal behavior yet open enough for its values to encompass everyone who is eligible. The Malo structuring of everyday knowledge establishes the conditions for its attachment as a personal quality. For the (male) person's processing of response (through knowing and understanding) is construed as a set of assets, the value of these assets being reflected in the eyes of others and thereby determining his own value. Secret knowledge becomes a reflex of the fit assumed between the skills and enterprise by which high rank is gained and a man's superior but invisible internal processing capacities. Anyone's realization of his qualities as assets—in objectifying them or claiming their personal source— brings confrontation with others. In turn, assets are made out of one's position in life, such as sex, age, accomplishments, which are seen as inseparable from the power of self-knowledge (understanding) and of grasp of the social world (knowing). This differential evaluation of persons constitutes their ranking.

Intersexual transactions: Gimi. Malo women are discounted as a category in exchanges between high-ranking men. My second case concerns exchanges between the sexes themselves and is pivotal to my general argument. Gillison's (1980; 1983) analysis of Gimi perception turns us away from both social constructionist and proprietorial views of gender relations.

The Gimi live in an isolated southern region of the Eastern Highlands of Papua New Guinea. To them "the surrounding rainforest . . . is re-

garded as a male refuge from women and from ordinary life within the settlement. The Gimi wilderness is an exalted domain where the male spirit, incarnate in birds and marsupials, acts out its secret desires away from the inhibiting presence of women" (1980:143). A special kind of knowledge leads to the realization of men's ambitions to identify with the nonhuman world and to be revitalized by its "limitless, masculine powers." This identification is achieved through initiation rituals where male initiands are likened to birds of paradise and hornbills and male potency to tall trees and flowing rivers. Yet the knowledge imparted during the stages of the ritual makes it clear that this is no realm definitively cut off from things feminine. On the contrary, these features of the male natural world turn out to be female characteristics detached from women, 'appropriated' by men (1980:147, 170). At the center of male self-identity, then, lies a statement of their power with respect to women.

The female identity of elements central to male ritual in Melanesia is frequently the subject of ethnographic reports, to the greater or lesser surprise of the ethnographer.[9] Gillison draws explicit attention to an underlying premise: the transactability of what we would regard as sexual attributes. These are exchanged between men and women, attachment and detachment visualized in terms of gain and loss. Such attributes are not purchased in the Malo fashion but are mythologized as having been seized with violence. This interchange is reenacted in the contemporary world through the deliberate staging of shifts of meaning. What was one thing is seen to have been something else. At different points of knowing, different origins and thus different identities are attached to the actors' sexual parts.

Gimi rituals involve flutes. Mythically stolen long ago from women, they are sounded during the male initiation sequence in the all-male forest preserve. This decisive separation from women is dramatically dissolved at one point and re-presented as encompassment. Maleness is revealed to include female features, knowledge of which is imparted through verbal commentary on what the initiands are 'seeing'. Perceptions are altered:

> As the climactic moment of revelation of the flutes to adolescent male novices approaches, the symbols of the body in men's initiation songs, which up to this moment have been unequivocally masculine, now become bisexual. Trees are phallic projections which not only have 'heads' that feed birds (symbols of the erect penis, the gorgeously befeathered initiates and the transcendent spirit of dead men) but they also have hollow trunks inside

which nest 'female' marsupials (symbols of women's pubic hair, initiates
when they are called 'new vaginas', and the ancestral spirit-child). Headwa-
ters are not only clear streams of male effusions but are also, according to
the singers, the issuances from fissures in rocks and from inside mountain
caves. The dark cavities of trees and rocks, Gimi men say, are like vaginas;
the rivers, like menstrual blood. (1980:170)

A special kind of self-knowledge is thus imparted. The initiate is not
being endowed with attributes; rather he learns that what he already
has (his genitals) are signs of encounters with women that already have
taken place. They commemorate men's theft: the beard he will grow
originated when the first man played the flute not realizing it was
plugged with his sister's pubic hair. The flute was simultaneously the
woman's child and the woman's birth canal, and possession of it as his
penis means that the initiand has both been successfully separated from
women (his mother) and contains within him vital reproductive power.
"Masculinity is wholly achieved when the married Gimi initiate succes-
sively assumes the ritual identities both of female (menstruator) and
male (flute-owner) and of mother (supplier of uterine food) and child
(eater of uterine food). To attain full male status the initiate symboli-
cally acts as his own creator. He is mother to himself" (1980:164,
emphasis removed).

The impact of these equations is built up through stages. The true
man is defined as pan-sexual and capable of reproducing himself with-
out women. The power to create is itself defined in male form—the
hollow penis is womb; menstrual blood is semen as it emerges from
real or symbolic (noses and arms of male initiates) penises. How is this
made to stand as knowledge?

The truth of this knowledge about men is established, I would argue,
by the evidence of what happens to women. First, men have extracted
something from a source thus made external to themselves. Men own
the flutes, and women bear evidence to the theft in their bleeding from
the wound. Second, by masculinizing female attributes (womb, men-
struation) men imply that the effective reproductive capacities of real
women are male in origin. Parallel to male initiation is a rite for girls.
Gimi girls are betrothed before puberty, and at her first menses the
bride is 'initiated' by men of her husband's clan. They take male spirit
from their forest and deposit it in the female. She drinks ancestral semen
(river water) and eats a spirit child (a marsupial encased in sugarcane
and vines, a penis). These objects are forced on her. If she does not eat

these foods she will not bear her husband's children. Childbirth becomes testimony to male efficacy.[10]

But there is equivocation here: if men are self-reproducing, then women may be self-reproducing too. Since men's capacities are sustained by ritual, it becomes this ritual alone that prevents women from being parthenogenetic. But once they were and so they could be again. If men possess now what women no longer have, their current claims to being self-reproducing block women from making the same (male) claim; at the same time, because of the cross identities set up, what is possible for the male sex is perpetually recreated as possible also for the female. Men's fears "suggest that female and male have too great an affinity, are too easily brought together" (1980:150).

I have followed Gillison's exposition of Gimi men's views. She argues that women generally concur in giving credence to their underlying assumptions, though where men orchestrate ritual, women orchestrate the growth of plants and pigs. It would be an error, however, to interpret men's intended definition of themselves as reproducers as also taking away women's reproductive powers. On the contrary, their own reproductive activity is evinced in women's. What they take away is women's ability to plant or implant the new life that the women must grow for them. The new life must be conceptualized as part of their male selves. In constructing this image, they momentarily extend the claim to the ability to encompass and grow the new life itself, in unitary identity with its (male) source. But there is no prior stasis in the respective powers of the sexes: "separations in existence (self/other, male/ female, human/animal, etc.) are repeatedly destroyed in order that they may be repeatedly created" (1980:171). The product of this tussle is an image of power itself. The contexts in which now male and now female is seen as the encompassing agent together constitute the possibility of encompassment as such. It takes a singular form. "Sexual antagonism is a conflict over who controls the *indivisible* power to reproduce the world" (1980:171, original emphasis). The indivisible flute is symbol of a thing that "cannot be shared," but "is wholly possessed by one sex or by the other"; it is "transmissible but indivisible" (1983:49).

In daily life, Gimi men claim superiority over women: they shun them through fear of contamination, and Gillison refers bluntly to Gimi women's debasement. Yet the ritual cannot be said simply to validate male power. Rather, it is an elaborate commentary on the nature of

power. That there are parallel rites for girls and boys is significant. Gimi have produced a double system of knowledge that rests on the claims of one sex being forever defined by the claims of the other; yet there can be no resolution in terms of the claims. The product of this dialogue is also its context, not that one or other sex in the end encompasses but that Gimi have created in the idioms of sexual reproduction a model of power as encompassment, a totalizing condition, and either sex may evince it totally.

I wish to argue, moreover, that this power lies more in 'being able to do', in its evidence of an internal capacity, than in 'control over' others. We are misled in that evidence of 'being able to do' is reflected in external others, through *their* changed state.

Gimi see people's fears and desires as the basis of the contest between the sexes. Men are held to be motivated by the fear that women want to retain their children inside themselves rather than releasing progeny into the world. Indeed, women's songs imply that the female body can be sealed, retaining menstrual blood in the form of its own lineage's semen. Against this, her husband's lineage has to force the bride to eat the foods symbolizing the entry of male spirit from a different source. It is important also that women's anthropophagy—their absorption of men's bodies when they die—be construed as entirely 'women's idea'. This crucial processing of body enables male essence to be released into the wild forest as a spirit/bird, and the futures of unborn men depend on it. But the custom is held to have begun spontaneously. The first act of consumption is attributed to female appetite. Men's accounts of such events in the recent past present them as chaotic and orgiastic, whereas women recall the orderly distribution of the corpse's parts and say they had too much compassion for the dead to let it rot in isolation. Such compassion is congruent with the nurturing intentions mentioned in the last chapter. Women tend the plants and pigs whose growth so depends on their care. Men's fear that spirit will again be trapped within the female is resolved by them at the end of the absorption process: for each part of the corpse that a woman ate, she is given wild marsupial meat. By replacing the (male) substance within women's bodies in this way, the men force it outside and thus compel the women to release spirit.

Evidence of women's driving motivations was structured through the device of secrecy.[11] Women were supposed to trick their husbands who did not realize what they were eating, so that in effect they stole the corpse (as men stole the flutes). What was not secret in actuality was

thus made out to be so. Women were secluded during the greater part of the mortuary meal, within the men's house where the wrapped flutes were kept that at other times tricked them by their sounds, and were not allowed to emerge until ingestion was complete.

The containment of women and the concealing of acts are central to these rites. I noted in chapter 4 that the *wok meri* sequence was structured through both private and public episodes. Indeed, it is a feature of cult life in general in the Highlands, and of all initiation ritual, that a contrast is staged between acts which remain 'hidden' and their effects which are brought into the 'open'. There is nothing individualistic about the privacy: it is a collective privacy. I would also note how often a ritual enclosure is the focus of these activities; initiands or cult members are secluded in 'houses' that may be specifically designated as such.[12] The house image recalls (for myself) the character of domestic interactions rather than of public life of a political nature. A collective domesticity: but instead of a cross-sex pair, the house is filled with persons all of one sex—the opposite sex is represented through the artifacts and paraphernalia deployed in the course of the rituals and even perhaps in the gender of the enclosing house itself.

Gimi women's secret devouring of flesh, like men's secret blowing of the flutes, does not successfully dissemble information; it does orchestrate secrecy as an event. The sexes claim that details of their own ritual performances are 'unknown' to the opposite sex, notwithstanding Gillison's photograph showing young men dressed as female initiates for a mime of female secret rites to be presented during the course of male ceremonies (1980:166). Gimi secrecy does several things. It allows process to occur: revelation will be evidence of a changed state. Secrecy 'fixes' motivation: in the same way as people's intentions are locked within themselves, so the 'real' desires and impulses that are held to drive this or that category of people are locked within a portion of their ritual; secrecy indicates that those excluded do not share these drives. Finally, it acts out encompassment: the stretches of secret ritual establish what the actors are claiming on a wider stage, that they have sole control over the meanings they give to their internal actions. This kind of claim to power is self-fulfilling, a matter of power to do, of evincing what the body is capable of.

In Gimi politics at large, the handling of motivation provides a divide between those who claim prestige and those who remain rubbish. Big men can subordinate impulse and appetite, while little men give in and become like women. Gimi say, for example, that little men could not

refrain from watching women prepare the cannibal meal and would even join their secret orgy and share in the meat also. Generally, in the Highlands, big men are able to shape the management of events because evidence of management is fixed first in themselves. In this positive feedback system, prestige leads to prestige. For if a big man can align the intentions of little men with his own, it is because the big man internally aligns himself in accord with ideal male behavior. He literally makes himself capable and thus embodies power to do.

Male puberty rights: Paiela. This last case concerns a Western High-lands society, Paiela, also rather isolated but related linguistically to the large populations of Enga-speakers to their east.[13] I took a cue from Biersack's (1982) analysis of Paiela puberty ritual in suggesting that one mechanism by which Gimi men know the meanings of their own sexual parts is the perpetual information before their eyes of what happens to women—because of men, women bleed (semen) and give birth (to male spirit). Paiela men also see evidence of themselves in women but through individual relationships between particular men and women and with respect to nonrepeatable short-term events. The definitive actions of women as a category are less important than how this or that woman is behaving here and now. The example suggests intentionality skewed in the reverse direction: what happens to Paiela men is evidence of what women have done and of how women are motivated.

Biersack is concerned with a rite whose purpose "is to grow the boys who participate in it so that they might mature and marry" (1982:239). The participants are thus oriented towards a particular relationship with the women who will become their wives.[14] In the rites, they are made dependent upon a female spirit, as in nonritual contexts husbands depend on wives. A married man needs his wife to perform secret growth magic for him every time she menstruates, to make his skin look large and beautiful. First, however, a man has to become marriage-able, and it is by entering into a relationship with the female spirit (the Ginger Woman) that he is initially grown as a man. Biersack emphasizes the transactional nature of the relationship he thus enjoys initially with his spirit wife and then his human partner. People and animals do not grow by themselves, but transactionally, "as the beneficiary of some-one's actions" (1982:241).

Here, the sexes do not differentiate themselves through substances whose identities can be exchanged; they are exchanging with substances already differentiated and whose identities therefore remain constant.

There is no changeover of gender and no place for girls' puberty rites in such a system. But that does not mean that the sexes are bounded off from one another. Rather, Paiela accomplish through ritual what Gimi take for granted; Paiela men must compel women to grow them.

Biersack points to the trivial material content of the initiates' gifts to the female spirit (the ginger gardens planted for her). Nevertheless, the transactional monopoly that men hold over ceremonial exchange thereby appears to create its counterpart idiom: women's transactional monopoly over personal male growth. Male growth has political connotations, in that the strength of a clan depends on the strength of its members.[15] Strength and health depend in turn on the success with which men influence the motivations of others. Intermarrying groups may either fuse or polarize in respect of potentially joint activities. Those who are related may or may not support one another, may or may not exchange pigs, and perhaps the intentions of wives in this sense present a categorical problem to men. As in other Highlands societies, intention is 'unknowable' except in so far as it can be read from behavior. I wonder if in their rituals Paiela men attempt to resolve a further political uncertainty—that dependency on a female caretaker will actually 'grow' them and keep them healthy.

Female intentions are certainly at the heart of the ritual, and since intention always remains hidden, only the outcomes being known, secrecy is important for its organization. Biersack's theorization of communication codes points out the opposition Paiela set up between what is visible and what is invisible. Transactions are classified as overt or covert. Overt transactions are witnessed by both parties, as in the open exchange of wealth. In covert transactions, the donor's intentions are kept out of sight, and his or her gift is only known as a condition subsequently produced in the recipient. A husband cannot observe his wife's menstrual magic; he knows she has performed it properly through the appearance of his skin. Growth itself is thought to occur in the invisible inner layer of a person's body, below the surface of the skin, so that the "size of the epidermis is the consequence of an action that occurs offstage" (1982:241). This action is thus perceived to be a (covert) decision-making process on the part of the man's female caretaker, and only after the event can a husband reconstruct his wife's intentions—whether she meant help or harm. Hers is the crucial and hidden decision whether to perform the correct menstrual magic, neglect to do so, or even perform it maliciously with injurious specifications.

The Paiela political system, predicated on sustaining relationships

between kin groups through exchange and/or war, is intensely con-
cerned with the structure of intentions. Relations between whole sets
of people can shift according to intentions revealed. If gifts are given,
are they adequate (good intentions for the future) or inadequate (bad
intentions)? If a fight takes place, is it a cover for something else (allies
playing a double game) or the hostility it appears to be (enemies acting
as enemies)? Indeed, there is uncertainty about even overt transactions.
In spite of people 'seeing' the material embodiment of intention in a
gift or blow, this knowledge must rapidly regress on itself. What re-
lationship does a single gift or blow bear to wider social and political
issues? By contrast, covert transactions can be apprehended in a singular
encompassing form. Invisible, ritually-enacted decision-making, as in
the growth rituals, substitutes uncertainty about the act (the transaction
between initiate and spirit remains secret) for certainty about its out-
come. The visible effects of these ritual transactions are located within
the confines of a single body.

In communicational terms, Biersack argues, the secrecy of the boys'
seclusion is necessary to structure a relationship between observer and
observed. The audience waits in uncertainty to see what will have hap-
pened to the boys. When they emerge, handsomely decorated, out of
the forest enclosure, uncertainty is replaced by certainty. Those watch-
ing now decide whether they are being informed that the boys have
indeed grown or whether they are still small and puny. The observing
witness is crucial, because what he or she receives is what is being
imparted. A boy either does or does not make a favorable impression.
Thus growth "is a product of a recognition of difference" (1982:250),
whereas imperceptible change produces no information. But the evi-
dence is self-contained, the relevant criteria being displayed for each
initiate in his own body. It is also uni-dimensional; only physical growth
is at issue and not the open-ended parameters of public renown, wealth,
prestige.

In this sense, perhaps, the audience's decisions about the success of
puberty rituals—the affirmation of male growth—is a constrained deci-
sion, for there will be a tendency to agree that the boys have indeed
grown since that was the purpose of the ritual. Male growth is categor-
ically assured; it is undermined only for individuals. It is known that
rituals were carried out for all the initiates; it is not known if each has
had satisfactory transactions with the spirit. On display, the initiates
compete within themselves for audience favor, for only the beautiful
give evidence that their transactions were successful, and only some will

be admired. This discrimination is also witness to the relative powerless-
ness of the secluded boys. They may try to compel reciprocity in making
ritual gardens and a tiny house for the female spirit, but whether in
turn she makes them all large and beautiful depends on her.

COLLECTIVIZING DEPENDENCY

Whether people perceive power as a piece of property, estate, a
personal attribute, an ability, or an effect revealed in the reactions of
others, power also has the status of a proposition. Propositions evoke
their context, and in being context-dependent are inherently contest-
able. An extreme example is a proposition framed as a claim, for a
claim derives its character from the adversary context of counterclaim.

Claims are being made in all these cases. These may be based on
information about facts or experience, as on Malo; or be seen as the
outcome of a particular moment of revelation, as in the Gimi ritual
cycles that constantly supplant one proposition by another; or in the
Paiela mode inhere in a transaction between cult observer and observed.
But for power to be distinguished from other propositions, it must have
a content of a sort. A notion of power as enablement (Fardon 1985)
directs us to the definition of internal capacities. These may be made
visible through the acquisition of qualities (Malo), the changing identity
of body parts (Gimi), or a staged uncertainty about whether particular
values have adhered to the body or not (Paiela). For Malo, reputation
is established through convincing others of the standing of the knowl-
edge that one has processed; people thus evaluate themselves as more
or less convincing processors in terms of their knowing self. Gimi create
alternating universes by switching the meanings attached to their sexu-
ality; access to these meanings sets up an evaluative divide between men
and women, pre- and post-initiates. Paiela men define themselves as
having a problem that Paiela women do not share: an acute bodily
susceptibility to the motivations of others, to how they appear to their
audience, for they know their own capacities through this reflection. In
all three sets of practices, people are construed as depending upon
others for knowledge about their internal selves. They are not in this
sense the authors of it. It is on the two Highlands cases that I now
concentrate.

Gimi men appear to voice strong concepts of proprietorship and
appropriation. Yet to metaphorize those into the kind of 'control'
redolent of Western property ownership would be quite limiting. Imag-

ining that people conceptualize power as an exclusive possession leads to the conundrum with which I opened. If a set of rituals is about the power men have, they must also be about women's lack of power; or else the property analogy supposes that one must really have the power and the other is either making mystifying claims or compensating for its lack at an unreal level. It cannot be the case that men have exclusive power, and that women also have exclusive power, as Gimi appear to claim.

The Western paradox is not, of course, a Melanesian one. The actors may state that now one sex and now the other is all-encompassing, but we miss the point if we take sides: like flutes blown in pairs, the pair of statements offer a single proposition about the effects of encompassment. One such effect is growth. On the part of Paiela men, by contrast, power lies in compelling others to make decisions favorable to oneself. Here it could be said to exist in the control of others only in so far as transactions have successful outcomes. Power is thus measured against the risk of unsuccessful outcomes. These two Highlands practices consequently differ as to the significant corollary: where force has to be applied. In the sequences that have been described, Paiela men force transactions on others, as do the boys on the Ginger Woman. They have to compel an engagement, or else there will be no productive outcome. They must make her grow them, be a grower on their behalf. Gimi men and women, on the other hand, take growth for granted in these rituals: rather, men must force a differentiation between the grower and the grown in order to extract the (grown) product.

An important indigenous metaphor is singularity or boundedness, also an effect of encompassment. Throughout Highlands societies, descent constructs of varying degree of emphasis establish boundaries for groups of men who know themselves as clans or lineages. Clan life becomes collective and public by definition. Here in these cults, with their physical enclosures of houses and fences, I suggested that we might imagine the procedures as creating instead a 'collective domesticity', recalling its crucial kinship and cross-sex interdependencies. Collectivization is effected through single-sex association. But at every turn, through emphatic assertion or denial, dependency on the opposite sex is at issue. The excluded sex is thus 'present'. Presence constructed through deliberate absence has been noted by a number of ethnographers. Herdt and Poole (1982:13) make the point nicely, citing Tuzin's (1980; 1982) studies. The additional question of women's cooperation in apparently all-male enterprises was initially raised by Van Baal (1975) in 1970 in

the context of "The part of women in the marriage trade: objects or behaving as objects?" The opposite sex is not, however, simply there in the sense that every performance needs an audience, nor in the sense that leaders need followers: they are there as vital processors of the information the actors are seeking about themselves.

The resultant interdependence I take as defining domesticity, hence the particularity of the gender designations of the actors. They are, in external appearance, all-male (or all-female in the case of the Gimi mortuary rites) with reference to the crucially 'absent' sex. Expanded, my suggestion would read that the cult context collectivizes the condition of particularity. Relations that rest on the differentiated *particularity* of identities, as between men and women, imply that the distinctiveness of the parties is never submerged. Each is known by its separation from the other. By contrast, the *collective* character of relationships is created through replication—the gathering of persons of like sex. Each knows him or herself in the image of similar others (Schwimmer 1984). Yet neither the single-sex identity of the participants nor the replicable nature of their activities can be taken as givens. On the contrary, interdependence of a domestic nature, involving the division of labor between spouses and debts between kinsfolk, denies autonomous identity to either sex alone.

A later chapter returns to the apparent contradiction between a single-sexed collectivity (which is how the multiplication-effect of persons is achieved) and the fact that its concerns may be those of domestic kinship. Here I observe how the contradiction is established. Unable to be present in person, the excluded sex is present in artifacts, and these may include artifacts that also appear as personal appendages. A person's own body parts can embody the other sex. A man's genitals may be revealed as artifacts of this kind, as may the contents of a woman's reproductive tract or of her mind.

In order for the distinctive gender of these artifacts, like the particular and distinctive gender of the participants, to be made apparent, bounding mechanisms are necessary.[16] Seclusion and the secrecy surrounding stretches of the ritual momentarily contain the participants and their acts. I would also suggest that the body is constructed for a duration as a parallel unitary and singular entity.[17]

A person's outer skin can be organized, so to speak, decorated and doctored, to produce a single effect, to indicate unambiguous masculinity or femininity. Actors present themselves through a single image, as all-male or all-female. The individual body is then perceived as at once

singular and momentarily total in its identity; it follows that the replication of like bodies multiplies this effect but does not modify it. Modifications take place internally.

One of the best known Melanesian axioms must be that appearances deceive, and the unitary identity sets the stage for the revelation that it covers or contains within itself other identities. At certain moments in the kinds of revelatory sequences described here, a separation may be seen between the body's enveloping skin and its internal substances. In gender terms, the single sex figure will have parts or appendages 'belonging' to the opposite sex. These are imagined as encompassed or contained within the single body, for it is only a unitary form that can appear to 'contain' an internal differentiation of this kind. A male body encompasses female parts. This proposition then prompts the further conceptualization of the female parts taking a male form, continuous with, rather than discontinuous from, the enveloping male body.

The unitary perception is thus highly contextualized, like the deliberate conceptualization of single-sex collectivities in all-male or all-female events. The corporeal body is presented as exclusively male or female for specific ritual effect: persons are not axiomatically conceived by these Highlanders as single sex. Rather, an alternation of sexual conditions, two modes of gender constitution, is displayed. In the same way as these rites deliberately juxtapose the separation of particular identities from one another along with the replication of like identities, so they juxtapose different relational perceptions of gender. Homomorphism between persons, or between a person's constituent parts, produces a same-sex relation, while dimorphism produces a cross-sex relation. Either relation may be made evident within or beyond the body.

A same-sex identity, then, is effected as a deliberate contrivance. In fact, in those societies with puberty rites for both sexes or rites celebrating homosexual nurture, these are the occasions at which the androgynous or cross-sex character of personal identity is revealed as a premise underlying efficacy and interaction. Claims of all-maleness or all-femaleness are transient and temporary definitions of power. In the Gimi case, claims of all-maleness are laid to powers of fertility that at other times may be conceptualized as all-female. Men momentarily construe themselves as totally responsible for reproduction by encompassing exogenous powers.

To us it is a paradox that men should flaunt their maleness by

revealing that they contain within themselves what is also female. This seems a confusion of properties. Western formulations of identity of a unitary kind would lead one to expect that men become more male by associating with things definable as exclusively male; an intrinsic attribute (maleness) would be elaborated with extra attributes of the same nature (more maleness). The more removed from female matters, on this Western model, the more permanently male is the identity: hence the interpretations of male initiation sequences which take as their culmination the achievement of manhood (a single-sex social identity that finally matches an intrinsic physiological one). This could not be further from the Melanesian case.

There is an additional point. If it is the body's capacities which are made known, then the evidence for these must lie in the effectiveness of action. In Melanesian terms, this implies interaction. While separation marks off one sex as distinctively male against the other's femaleness, each makes itself known through the nature of the transactions between them. That is, the specifically male contribution to this or that enterprise is created through its effects on female enterprise. Paiela transactions thus depend on the differentiation of the partners, or there is no effect. Or the effects may be the very constitution of the opposite sex, as when Gimi men compel childbirth: women's capacity to give birth to the appropriate offspring is proof of male efficacy in the matter. The presence of the other sex remains crucial, then, not simply as a cognitive device, that what is male is defined by what is female, but in terms of demonstrating external efficacy and thus by the same token internal capability.

Barrett found startling the suggestion that sexual differences cannot be known in advance (see p. 65). I repeat her quotation of Adams (1980:87): "what has to be grasped is, precisely, the production of differences through systems of representation; the work of representation produces differences that cannot be known in advance [emphasis removed]." Gimi ideas appear sustained by the premise that the differences between the sexes cannot be known in advance of the interaction between them. The Paiela cult, however, presents a variant case. Here sexual difference is known in advance and is not redefined but itself made productive through the transactions between male and female. As we shall see, there are concomitant cultural contrasts in the way transactions are constructed. It will, in fact, turn out to be significant whether, as far as the sexes are concerned, the differentiation between

them is regarded as prior to their interaction or as constituted by it. The one schema creates anxiety about their productive combination (growth), the other about their productive separation (creativity, birth).

Distinctions must be made (Harrison 1985b:419). Some Highlands gender constructs take as a starting point, as it were, that when they transact with one another each sex retains its discrete identity and jointly creates products—the children and food they grow—which carry the identity of both sources, newly combined. Although this interpretation comes from my understanding of Hagen, it would also apply to Paiela. The discrete identity of men and women (there is no ambiguity about sexual ascription) is the basis for the transactions between them: the one is not axiomatically encompassed by the other. In such a context, where the transacting entities are by their prior nature already differentiated, their transactional engagement has to be forced. Activity mobilizes the differentiation and makes it productive. If the transaction is successful, it will have a product—in the Paiela boys' (husbands') case their own growth as well as the gardens and children that husband and wife produce between them. Such intersexual transactions consequently result in an outcome that combines the work and identity of both, and in this sense has a dual or multiple and thus cross-sex character. In turn the reproductive construction of the joint identity of such products takes the separate sexual identities ('male', 'female') of the sources or origins of the products as given: they are combined only as the result of the transactions themselves. Paiela 'descent' formation is pertinent here. Although the consanguineal units that intermarry and make exchanges are cognatically structured, Biersack makes it clear that the separate origins of the intermarrying groups remain relevant: the unit that now regards itself as 'one' is a "transactional corporation" (Biersack 1984:123),[18] predicated on sustaining internal cooperation. The original groups are combined but not conflated.

However, Gimi gender constructs, and this may also be true of Daulo, elaborate the premise of androgyny. Taken as given is a conflated cross-sex identity. Reproduction—the harvested crops women nurture, the children to whom they give birth—is achieved through momentarily distinguishing the product from its source. The distinction works through gender. The 'maleness' of children which emerges from the 'femaleness' of mothers, derives from the fact that it is a male feat to have effected the separation at all. As Gillison argues, the female characteristics that men appropriate have become male in the decisive act of being detached from women. Separations thus occupy a different

symbolic place by contrast with those of Hagen and Paiela. The separations are crucial at particular conjunctions in the staging of effects—as in effecting birth—but once separation is accomplished, the distinction between male and female agency collapses, each being presented as a form of the other.

In the Hagen/Paiela instance, the separate identities of the sources remain as a pair; they are merged not in each other but only in the product of the relationship between them. That multiply-composed relationship is thereby made productive, and the androgynous product is thus differently constituted from either of the sources taken alone. Gimi (and Daulo?) sources of growth are not paired in the same way. On the contrary, growth is taken for granted as an effect of encompassment. Encompassment is made evident in turn as a same-sex state. In one mode, it may be regarded as emphatically female. The 'spontaneous' growth that so many commentators report as a focus of attention in the case of females is evidence of this homomorphic capacity. Its male counterpart is creativity, the spiritualizing effect of men's association with the spirit world, axiomatically productive of both health and welfare. Released from the female, the "male soul had the capacity parthenogenetically to bring forth every kind of life" (Gillison 1980: 40). It is in cross-sex contexts that force is necessary to induce the complementary effect: males have to be forced to grow in their bodies, as females grow; females have to be forcibly injected with spiritual essence in order to produce life, as males give birth to spirit. Encompassment imagery thus construes sources of growth and creativity as all-male (male encompassing female parts in a 'male' form) or as all-female (female encompassing male parts in a 'female' form). That imagery also indicates the form that separation will take. The momentary realization of opposed single sex identities appears as container distinguished from contained. Thus either container or contained can be seen as at once distinct from and merging with the other, a conjunction of dimorphic and homomorphic possibilities.

Instruments of androgyny. Suppose in some nightmarish moment we were forced to make up our minds about another Highlands conundrum—not who has power but who is male and who is female. Images from a quite different area of Papua New Guinea are suggestive in this regard. In the course of analyzing the art of the Abelam in the Middle Sepik, Forge (1973:189) observes that the paintings in question are not "a picture or representation of anything in the natural or spirit world,

rather [they are] about the relationship between things [emphasis re-
moved]."[19] The facades of men's houses are covered with multiple de-
signs representing male clan spirits and other beings; the figures have
various appendages. Though graphically they appear similar, Abelam
exegesis distinguishes some as breasts and some as penises. This raises
an initial query about the meaning of the apparent phallus, which Forge
concludes is an organ of nourishment.[20] But what is imagined in this
fused representation of nurture, with its male and female elements, and
what kind of relation or identity is being claimed between the two? It
is almost as though male and female were variants of one another. But
are types of nurture being differentiated or conflated?

There are two stages here. It is necessary to know what maleness
means in the configuration within which it is presented, and thus what
kind of relationship is supposed with female elements. Yet if the houses
are decorated with figures whose appendages can be read as both
breasts and phalluses, then what is 'male' and what is 'female' in the
first place? Is the phallus a male breast? Is it to emphasize its maleness
or femaleness that the breast is imagined as a female phallus?[21]

Now this equivocation is not simply a piece of Sepik esoterica; it
runs through much gender symbolism in the Highlands and in Mela-
nesia at large. Men's houses may be equated with wombs. Penile bleed-
ing may be identified as menstrual. The flutes men blow in their se-
cret cults may be described as 'mothers' or as 'wives' or be paired as
male and female; Herdt (1982:88) gives a number of examples. At
one point Gillison (1980:167–177, n. 19) observes that the Gimi flute,
'mother's penis', can also refer to mother's breast. Where male flute
pairs are given a same-sex designation, do we imagine two brothers as
two breasts? To pursue the case of flute symbolism, I note that Herdt
suggests the instruments are thus eroticized, and Dundes (1976) that
their feminization is in the interest of subverting heterosexual depen-
dency by homosexual independence.[22]

Yet to conclude that men wish to live without recourse to women,
or that what is at issue is male control over female reproductive power
(men simply encompass within their affairs things to do with women,
and thus appropriate them), encounters that original difficulty: how is
it made known what is distinctively male and what was imagined as
male and female before the act of appropriation? Lewis, writing about
another Sepik people to the far west of Abelam, asks how we come to
recognize representations of other things. He considers the phenome-
non of penis-bleeding.[23]

To see it as symbolic depends on our choosing to classify penile bleeding apart from menstrual bleeding. The idea we have of menstrual bleeding is that it can be applied correctly only to something which happens to women. This is an essential attribute, an intension, of our definition or understanding of menstruation; real or true menstruation can only happen to women. Therefore male bleeding must be apparent menstruation, symbolic or mimic menstruation. (1980:112)

In what sense, then, might we understand real or true and therefore also 'symbolic' gender designations? Are the Sepik figures with their breasts/phalluses a mimicry of one or the other? Or do they embody some variety of bisexualism, as entities of ambiguous or fused sexual status? Is an androgynous ancestor depicted on a male cult house the sign of victory, that men really have won their battle over women in encompassing all forms of nurture within themselves?

All such questions would require the assumption that breasts belong to women or that phalluses are the property of men. However, if people say that phalluses were stolen from women or if a phallus is treated like a fetus, it is not at all clear that we can be so certain in our evaluation on the Melanesians' behalf. Even if we were to allow that phalluses are male, when they are offered to women (in their physiological embodiment or in the form of bamboo tubes) are they being offered as instruments of masculinity; or will they change in the process into something else (into fetuses perhaps); or is a thing, as Schwimmer (1974) argued in another context, being rendered to women that belongs to women anyway? In which case, is a phallus on a man some woman's 'property'?

It is clear that our metaphors of possession have exhausted themselves. Were we to draw on metaphors of interaction, the formulas might seem less tortuous. Perhaps persons give parts of themselves to others or yield to others what is already owned by them, because it is owed to them. A transactional idiom might afford a way out of the conundrum. And that goes for notions of possession in relation to one's bodily parts, where property idioms make for such difficulties in symbolic analysis. As Westerners we feel, as Lewis remarked, that we should be able to identify things by their attributes: to decide whether flutes are 'male' or 'female'. It is not necessary that they are one thing or another (we can envisage a dual or ambiguous identity) but we do imagine that identity inheres in the thing, as it does in people. However, the Melanesian material indicates that knowledge (what is made apparent as male or female) cannot be derived from inspection alone.[24] Iden-

tity is an outcome of interaction. Yet stated like that the conclusion seems trite; let me therefore give it some cultural substance.

If people define their relations through transactions with one another, then perhaps among the things that the Sepik characters display, with their dual appendages, is the fact of transaction. In the timeless dimension of a portrait (to borrow from Harrison 1984) appears the figure of an interchange between elements that simultaneously indicate the relation between them.

One can supplement this suggestion sociologically, for cult ritual associated with the men's house is invariably conducted between two parties—between sponsors and their supporters—with alternate initiation classes in specific reciprocity.[25] Androgyny personifies the relation created by a transaction, the juxtaposition of elements that in the dimension of time were first separated then joined. The indivisible Gimi flute is such an androgynous instrument. 'Male' and 'female' at best discriminate points in a process, how it is played and what is emitted, or rather, who plays it and who is emitted.

Gimi symbolization establishes the male or female character of a person as an incident, an event, a historical moment created in time. Such character does not inhere in attributes of a fixed kind, in the exclusive possession of particular items, not even in possession of genitals, for the origins of those are ambiguous, always the result of past transactions. What differentiates men and women, then, is not the maleness or femaleness of their sexual organs but *what they do with them*. Whether a tube turns out to be a penis or a birth canal depends on how it is and has been activated. And how an organ is activated is shown in its effects, whether it works as container or contained. Knowledge about this is therefore simultaneously knowledge about internal capacity or enablement, and about external efficacy in interaction with others.

At one juncture in his overview of the diverse approaches through which anthropologists have examined assertions of single sex identity in male initiation rites, Keesing (1982:22) draws attention to what is often taken as the clinching rationale: "what men produce—as women cannot—is *men* [original emphasis]." If the assumption is that like must produce like, then this is a profound misreading of male creativity. Certainly it would not hold for Gimi. On the contrary, one could say that men have to be 'produced' by women because the whole difference between men and women lies in their respective enablements in produc-

tion. Men break away from the endo-anthropophagic cycle of women's nurture. They are, in this sense, produced only by women: they do not themselves produce in like form. Rather, they transform themselves into the agents who coerce women to so produce (and thus produce them as agents). What women grow they create. A drastically differentiated capacity lays the basis for male identity.

Coercing women to give birth seems to me a very different statement from saying that men control women's reproductive powers. It also abandons the paradox of the power of the weak.

This chapter opened with a reference to those analyses of male cults that turn on the idea that women are powerful because of their femaleness. Yet women are supposedly weak for the same reason. Herdt notes the "culturally constituted contradiction" that "men's mundane idioms tacitly assume . . . that . . . women . . . are inherently powerful because of their very femaleness" (Herdt 1981:17). The contradiction only arises if it is assumed that women are intrinsically 'female' and that men have to be established as intrinsically 'male'.

For Gimi, ultimately what differentiates the sexes is not things possessed. Sexual organs can appear androgynous, like the flutes/bamboo containers, at once breast and penis, both hollow and penetrant. They do not have a unitary character in themselves: such a character is determined by how they are used, caused, or completed by the opposite sex. Male and female sexual organs 'in themselves', then, stand for a composite relation: if one is male and the other female, it is because one is completed by or derived from the other. They do not in themselves indicate a differentiated thing; instead difference is constituted relationally by men's and women's respective agency. The one grows, the other is grown; the one is forced to be creative, the other creates. Women grow in their wombs what men grow in their cult enclosures; men make women yield the penis-child that they thus separate from themselves. Gimi men are not afraid of having their masculinity swallowed up, enveloped by women; the very fact that they are enveloped and not the enveloper saves them from absorption. Their fear is not to be released at the proper time, for were they not released they would no longer be male. Again, it is at the point of interaction that a singular identity is established. Gatens (1983) argued that women are different from men because their bodies are different; even if women 'do' the same things as men, the context provided by their own bodies genderizes their acts. For Gimi at least, it would be truer to suggest that it is the

other way around. It is because women 'do' things differently from men, because they evince different capacities in the way they act, that their bodies are gendered.

Yet Herdt's supposition might seem to fit cases of the Hagen/Paiela type, where sexual differentiation is taken for granted. However, it is clear that even here men and women do not so much possess sexual qualities as attributes as deploy their gender capabilities in transacting with them. The maleness or femaleness of the objects of transaction comes from their source in the actions of men and women. If the capabilities of the sexes are taken for granted, nevertheless their interaction has to be deliberately promoted, and this gives a political dimension to men's and women's relationship. The concurrent political dimension of Paiela cult activity is, in fact, best understood through its analogue with ceremonial exchange, a topic developed in the following chapters.

Biersack offers a striking depiction of Paiela domestic sociality which brings us back to the collective context of knowledge: "That sector of 'inside' [the realm of human action] that Paiela designate 'gardens and houses' signifies a relationship and its moral connotations, the relationship of nonunion and insularity and the immorality of 'selfishness'" (1984:134). In her terms, the inward-looking character of domestic relations contrasts with the outward-looking character of households in the public domain, where collective activity—including the cooperation at the basis of consanguineal groups—is interdomestic, where pigs are not eaten but exchanged. She stresses the noncommunicative nature of productive activity: "the only relationship a human being can establish with gardens is a relationship of noncommunication. . . . On a daily basis the producer operates alone and in silence" (1984:121). The transactions by which wives 'grow' their husbands, and husbands 'bind the blood' of wives in conception, are also covert and secluded; they would fall into the Paiela class of noncommunicative relations.[26] If the bachelor rites do indeed collectivize such domestic relations, we may comment on the significance of a communicational element in the accompanying omen-taking. The boys attempt to communicate with the spirit woman, to compel her to reveal whether she will grow them or not. They force a visible, overt sign from her.[27] This communicational possibility in the collectivization of otherwise 'silent' intradomestic relations is the central achievement of the ritual.

In their dependency upon others to evince capacities in the self, Paiela, quite as much as Gimi, locate the sources of their internal efficacy beyond themselves. The sources do not constitute some other

realm or domain but another type of person. For 'men' they lie in the acts of 'women'. These sources are not to be controlled or overcome but sustained in order to give perpetual evidence of this very efficacy. They are at once a point of origin and a reference point for demonstrating subsequent historic moments. Thus they may also be rendered as 'appropriated'. They are perpetually preserved since they are required to elicit, in Wagner's phrase, the body's capacities, to externalize and make known its internal composition. But the difference between internal (intrasomatic) and external (extrasomatic) relations has itself to be made known, and this is done through the imagery of replication, through the collective character of the events by which what is made known about one body is repeated for many.

Indeed, disparate as they might seem, the three ethnographic cases addressed in this chapter show parallels in their practices of knowledge. Information, sexual organs, and a capacity to grow are all made known or valued by reference to their source. Yet the source lies beyond the person who displays it, by the same token that its efficacy must be registered in another. For a Malo man acquiring the idiosyncratic behavior of another, value lies in the origin of that behavior in another. The donor does not lose what he gives away. In the instance of Gimi reproductive creativity, violent extraction is imagined as gain and loss. Yet here, too, the original source (women's possession of the flutes) seems to be capable of regression or regeneration (namely, return to another moment in time), such that loss or gain is ever only temporary.

We may put the point another way. These Melanesian cases delineate the impact which interaction has on the inner person. The body's features are a register, a site of that interaction. Consequently, what is drawn out of the person are the social relationships of which it is composed: it is a *microcosm of relations*. In this sense are the capacities of the body revealed. And if the body is composed of relations, if it shows the imprint of past encounters, then the relations are not in a state of stasis. Awareness of them implies that they must be attended to. These internal relations must either be further built upon or must be taken apart and fresh relationships instigated. The kinds of initiation ritual to which I have been referring stage just the awareness or acknowledgment of the necessity of so taking further action, and of the possibility of doing so.

Although I refer to the body, the effect of the rites is to bring the body to consciousness and, in the Melanesian idiom, to show the impact of people's minds upon one another. Intention and motivation

have physiological consequences. The person is vulnerable, so to speak, both to the bodily disposition of others towards him or her and to their wills and desires. For there is more to the Melanesian 'person' than that analytical figment of the anthropological imagination that supposes the social person is a locus of roles, a constellation of statuses. In the Melanesian image, a series of events is being revealed in the body, which becomes thereby composed of the specific historical actions of social others: what people have or have not done to or for one.[28] The person appropriates its own history.

The practices of knowledge to which I have been alluding, and especially that people are construed as dependent upon others for knowledge about themselves, do not simply reside in the personal discoveries of reflective individuals: these are not existential possibilities that could apply anywhere. I refer specifically to the manner in which the cultural conventions of these societies present people with the effects of their actions. And this is not in turn simply a question of intersubjective dramatics, the personae that people proffer, the playing of their 'roles'. A distinctive feature of these Melanesian practices is the elicitation of knowledge about inner bodily and mental constitution. A set of internal relations are externalized. This may be communicated as a condition shared collectively, but the condition itself is a particularistic dependency on critical social others, made manifest in the objects of their encounters.

If the individual person, then, is the site at which its own interactions with others is registered, then that supposition on Melanesians' part must in turn shape their conduct of relations. Succinctly put, it gives social relations the form known in the literature as gift exchange.

6
Work: Exploitation
At Issue

Feminist concerns with the ideology of sexual identity and feminist anthropologists' concern with the nature of the political-domestic divide would not have quite their critical edge if it were not for what seems one pervasive and near universal fact of life: the apparently persistent misrecognition of women's work as somehow less than work. Either women's labors are hidden from sight or else, where they are visible, do not give women the social scope that men's activities enjoy and may well be overshadowed by other criteria of public importance. Such evaluations inhere in cultural arrangements and classifications. Since these are often seen as working to the interests of men, the corollary is the supposition that in gaining more than women from such arrangements, directly or indirectly, men exploit women's labor. This is certainly how the New Guinea Highlands has appeared to outside observers. Thus Leacock (1981:294) can suggest that "the ritualization of sex hostility in highland New Guinea is the acting out on an ideological level of the reality that men are competing with women for control of what women produce," and cites me as having made clear for Hagen how "control of women's labor is enormously important to men."

In turning to the issue, I wish to accomplish a number of things. The first is to bring feminist critiques to bear on the earlier discussion about power from their perception of the 'reality' of material conflict. This is important, second, because these critiques contain a pluralist criticism of the anthropological propensity to take culture for granted. A similar

133

criticism was apparent in the theorizing over the nature of the political-domestic divide. Here I consider this divide in relation to indigenous classifications of activities that do not on the surface present themselves as evaluations. For instance, the concepts of 'wealth' or 'gift' do not immediately appear discriminatory; what appears potentially discriminatory is men's and women's access to them. However, for the New Guinea Highlands, including Hagen, an important attack has been made on those culturalist formulations that fail to grasp the ideological status of 'gift exchange' and its accompanying mechanism, of 'reciprocity'.

Third, my interest in this debate stems from the use that I nonetheless wish to make of the concept of the gift. It is one of my fictions—to be deployed in its relational definition vis-à-vis its counterpart, the commodity. The pair of terms provide an axis for considering a range of contrasts between Melanesian societies and the societies of the Western world from which the analytical constructs of social science in the first place derive. One may suppose the axis as a difference between root metaphors: *if in a commodity economy things and persons assume the social form of things, then in a gift economy they assume the social form of persons* (adapted from Gregory 1982:41).

Fourth, this fictional division—as though one could thereby characterize whole cultures and whole societies—enables one to marshall together a number of disparate theoretical issues that have made their appearance in the preceding three chapters. They have been loosely tied to a running commentary on property assumptions. At the risk of repetition, I spell them out as the specific ramifications of a commodity metaphor.

Thus, in a rather ad hoc manner, I have asserted that this or that set of concepts does not apply to the Melanesian material. They include the following: the idea that persons can be less than social beings; nature as a constraint and as a resource; the kind of unitary identity implied in sex-role theory; attributes appropriated as though they were property owned; things being regarded as having intrinsic properties; the purpose of domination being control, and so on. These can all be considered refractions of a specific Western root metaphor. They belong to a culture that grasps the form of things through imagining that things exist in themselves: the use to which they are put must always entail some kind of relation with their (resistant) nature. Or, one that regards the work of society and culture as giving social or cultural value to things and persons, much as the use value of goods and products

circulates only when this has also been turned into a market exchange value (Sahlins 1976). Or, one that correspondingly construes persons as commodities, both having an intrinsic value and establishing values for themselves in circulation among others. Barnett and Silverman's (1979:79–80) exposition of Western notions of personhood, after Schneider (1968), draws the contrast in terms of 'substance' and 'contract'.

The socialized, internally controlled Western person must emerge as a *microcosm of the domesticating process* by which natural resources are put to cultural use. Hence the person is a homologue of society thought of as a set of rules or conventions (chap. 2). The only internal relation here is the way a person's parts 'belong' to him or herself. Other relationships bear in from the outside. A person's attributes are thus modified through external pressure, as are the attributes of things, but they remain intrinsic to his or her identity. A shoe is a shoe, to take a famous example, however much it costs, and whether or not it is even marketable at all, because of the way it is worn. Extrinsic modification thus transforms or controls intrinsic attributes but does not challenge their status as the definitive property of the entity in question. The refractions of this commodity metaphor suggest an image of persons standing in respect of their own selves as original proprietors of themselves.

Whereas properties 'belong' to a thing in a definitional sense, in the case of persons 'belonging' is imagined as an active proprietorship. Persons own their minds as well as their bodies, and their minds turn the proprietor of his or her own actions also into the author of them. This unitary potential demarcates the proper singularity of such authorship, in parallel to the 'individual' as a real, concrete entity. Indeed, it becomes possible to slide from conceptualizing a subject exercising control over objects at his or her disposal, including personal capabilities such as sexuality—often taken as the property *par excellence* that in its outward orientation should be deployed through the will of the possessor of it—to a society or culture regarded as turning the intrinsic properties of things—conceived culturally as utilities—into objects of conventional worth. Both the capabilities available to the person and the resources available to society are construed as 'things' having a prior natural or utilitarian value in themselves. And persons in turn, as individuals, comprise just such a resource for society. To control or exploit this intrinsic value is to raise questions about the authorship or proprietorship of the social or extrinsic value thereby created.

As a derivation from the Western concept of the commodity, these refractions receive most explicit anthropological discussion for the evidence they afford of a type of political economy. Thus it is in the "capitalist mode of production," under the conditions of market exchange, that

> any commodity, once it plays the role of [an] equivalent [in exchange], seems to possess *in itself* the capacity to measure the value of other commodities. The 'equivalent form' of a commodity does not reveal the essential value (which is a social reality, human labour); it turns the value into a characteristic of things. (Godelier 1977:156, original emphasis)

Indeed, the contrast between these Western/Melanesian root metaphors is usefully conceived in terms of different political-economy regimes. This brings us back to the feminist critiques.

The final observation to make, however, is that we are brought back in such a way as to realize how much those critiques participate in the constructions they seek to undermine. They are branches themselves of the commodity root metaphor, as they have to be. This is true whether they are, so to speak, extensions of the roots or whether they adopt a specific nonpositivist, nonbourgeois stance, in which case they are like the canopy of a tree apparently separated from but in fact feeding its root system below. I cannot, of course, remove myself from this radix: I merely occupy another position.

This is a position from which the Western metaphor can be made visible and from which it appears as an inverse of that attributed here to Melanesian cultures. I thus attempt a parallel inversion between 'Western' and 'Melanesian' cultures through extending an internal contrast (commodity and gift being concepts derived from a commodity economy) to two cultural forms external to one another. In my account, the concept of the 'gift' is heavily dependent on its antonym, the 'commodity'. The opposition would not make sense in the Hagen language. What I call gifts Hageners call by a term that we would otherwise happily translate as 'things'. But that opens rather than closes the analytical work: the question is what kinds of things are they, and, from our perspective, what social form they take.

DISCERNING EQUALITY

Feminist anthropologists who have extended the debate over political and domestic domains into considering the economics of subordination

properly challenge the manner in which one adopts indigenous for-
mulations as analytical ones. Yet at the same time, it is important to
maintain a critical distance on their arguments. This necessitates con-
structing a position, as I have tried to do, from which their own assump-
tions are apparent. It is significant to the overall concerns of this book
that from among the diverse refractions of the commodity metaphor
many such arguments ultimately turn on certain conceptualizations of
property.

The same observation was made in the previous chapter with respect
to power. It is somewhat mischievous to repeat it, in so far as those
writers who draw on political-economy theory explicitly offer critiques
of economic categories such as 'private property', which are properly
taken as specific to commodity production in capitalist economies.[1] The
critiques include the general proposition that property is a relation, not
a thing, to be analyzed as a relation between persons with respect to
things.[2] The 'idea' of property is thus not treated as self-evident at all.
It is an impertinence, therefore, to suggest that such critiques might in
turn incorporate unexamined property assumptions. Nevertheless, this
is also what one must expect. In so far as the critiques were developed
in the first place to scrutinize the social relations of capitalist economy,
they were internal to the economic system under scrutiny. We should
not be so surprised after all at the continuity. The continuity I now
wish to make evident lies in the manner in which agents and their
actions are assumed to be structured.

My remarks would be less impertinent if they did justice to the
debates over the nature of exploitation in noncapitalist, nonclass social
systems; I refer the reader, for instance, to Modjeska's (1982) overview
of inequality in Highlands societies. It is particularly in arguments
about the exploitation of labor[3] that one encounters a stubborn Western
assumption about the natural proprietorship of persons. In any attempt
to characterize the differences between various Melanesian modes of
sociality, it is to my mind an interference that the way these issues have
sometimes been aired has not only, and necessarily, incorporated certain
Western premises about social action but that these have taken a prop-
erty form.

Yet an important caveat must be entered here. Evaluation, as op-
posed to interpretation, requires a self-conscious separation between
analytical and indigenous formulations.[4] The concerns introduced in
chapter 4 underline the point. An analytical interest in distinguishing
political and domestic domains found a mirror in the myriad ways in

which indigenous Melanesian domaining mechanisms are established. This is partly and quite properly because the analytical impetus comes largely from within anthropological theory itself, and such theory responds to the ideational constructs of the cultural systems it addresses. Here it is interpretive in nature. However, the feminist anthropological argument that claims over the products of labor are crucial to the evaluation of sexual equality does not, overtly at least, rest on attempts to find justification for the analytical categories in the symbolic systems of those being studied.

In the work of those who align themselves with Marxist-feminists,[5] the theoretical basis for analysis lies outside anthropology and lies instead in a theory of social action not itself affected by situations for which there is no indigenous counterpart theory. The main strength of a Marxist-feminist perspective for anthropologists, then, is that it provides grounds for exogenous evaluation. Given that a principal goal of feminist evaluation is the degree of equality that particular systems allow men and women, the search is for measures that can be universally applied, and relations of production prompt such a measure.[6] Such relations are concretely interpreted as resting on the nature of access to productive resources, control over labor, and jurisdiction over the products of labor. None of these concepts needs rest on indigenous models and none requires them in order to remain useful. It is, therefore, a specification of and *not* a denigration of the debates over equality that they incorporate unexamined property assumptions. These are unexamined simply because they are incorporated as taken-for-granted facts about human existence.

One well established debate concerns the extent to which otherwise egalitarian societies do or do not sustain inequalities between the sexes. The debate has been especially vigorous apropos hunter-gatherer economies and is worth considering briefly here.

Hunter-gatherer societies have engaged Western observers by virtue of their apparent egalitarianism. Feminist anthropologists have with some force joined the debate over the appropriateness of this designation. It is my own view that what drives us to contemplate these systems as egalitarian is one unusual feature: contemporary hunter-gatherer communities contrast with the majority of the world's societies in that claims on persons are effected through claims on services rather than claims on goods. They lack property relations; they also lack the mediatory form of gifts. Ties between persons are not constructed through the control of assets and of persons as though they were assets, and

wealth cannot store labor; objects do not become gifts in the sense in which one would use the term in Melanesia. Value lies in things being instruments of service relations between persons. What is confusing about these systems, then, is that inequalities are structured neither through the ownership of assets nor through the transaction of gifts.

This does not mean that inequalities do not exist. The point is made explicitly in the debates on male-female relations in these systems. Collier and Rosaldo (1981) demonstrate how marriage, affinal obligations, and the division of labor between the sexes set up asymmetric relations between men and women, although they allow men to assert a strenuous equality between themselves. People exert all sorts of claims on the acts and actions of others, including work in the form of service due to another. There are inequalities, then, in claims on such labor, but although we may refer to it as labor, it is not embodied in property or gifts. Collier and Rosaldo thus suggest that such asymmetries in relations do not have to be metaphorized as the ownership or control of resources.

The position against which they argue is familiar from the works of Leacock (1978; 1981; 1982) and Sacks (1975; 1979). Both have addressed the character of sexually egalitarian systems. In their view, control (in terms of ownership) over resources is crucial; the test of an egalitarian system rests in whether or not property discriminates between persons. Leacock is especially interested in the structure of decision-making, and the relationship between production and consumption and the dispersal of authority. Consensus, she argues, is fundamental to the organization of everyday life in egalitarian band society. She writes (1981:139):

> food and other necessities were procured or manufactured by all able-bodied adults, and were directly distributed by their producers. . . . there was no differential access to resources through private land ownership and no specialization of labor beyond that by sex, hence no market system to intervene in the direct relationship between production and distribution.

She adds emphatically,

> Unless some form of control over resources enables persons with authority to withhold them from others, authority is not authority as we know it.

Sacks (1979:113) argues a case for what she calls a communal mode of production in such societies:

> All people have the same relationship to the means of production, and hence they stand to each other as equal members of a community of 'owners'.

Thus they are all in a sense owners: they share equal control. That the sexes may "act on different aspects of nature" (1979:113) is a matter of occupation not of the critical relation to the means of production. Hence there may be differences in terms of occupation at the level of productive forces, Sacks puts it, but not at the level of relations to productive means.

For both authors, 'equality' is present where persons as agents share decisions or utilize common resources because ownership does not discriminate between them. Men and women are found to be equal on this score. Control over resources is thus the significant feature by which we know such societies to be egalitarian. The self-evident nature of this position is apparent in Rogers's (1978:155) general statement that "[p]ower may be measured in terms of control over significant resources." The qualification that resources need not only be 'economic' (they may include ritual knowledge and information) does not affect the model of control.

Sacks makes careful historical distinctions with respect to the emergence of private property in class society and the definitive character of systems that are not characterized by private property. Yet she perpetuates a certain type of property thinking in her very emphasis on the significance of co-ownership (though qualifying the term 'owner', see Sacks 1979:123 no. 2). In her 'communal mode of production', everyone enjoys equal claims on productive resources. The sexes may do things differently, but they stand in the same relationship to the band's means of production: each sex owns and disposes of the fruits of its labor (Sacks 1979:133). 'Egalitarianism' thus rests on everyone *owning their own labor*. She refers to the band members as owner-producers; one could also say that she makes them into a band of proprietors. For the concept that persons own and dispose of the fruits of their labor renders them individual proprietors of it. Others cannot interfere in the exercise of this ownership. The individual's relationship to his or her labor is not imagined as that of private property, since the argument is that labor is not alienable and cannot circulate in commodity form. The proprietorial assumption to which I nevertheless draw attention is the unitary identification between persons (as subjects) and the products of their activity (work).

This is a general postulate in Western assessments about whether or not men's and women's worth is culturally recognized. It involves an ethical definition of the person as an agent responsible for his/her actions. So says Leacock: "[T]he basic principle of egalitarian band society

was that people made decisions about the activities for which they were responsible" (1981:140); others did not take that 'right' away from them. I suspect that this position includes the idea that the author of an act should also be the one to execute it and accountably so. Endicott (1981:1) is explicit: she defines equality and egalitarianism in hunter-gatherer economies as the "individual control of one's own labour, decision-making, course of action, social contacts and sexuality." Yet the Western notion that people own what they do to the exclusion of others seems hardly borne out by the evidence on how claims and ceremonial duties in such non-Western societies are often structured. Indeed, she refers to the cooperative nature of familial relations. To assume that one can take as an analytical base a condition in which people control themselves and their labor, without reference to social others, is to introduce a neoclassical economism when one least expects it.

I have touched on arguments about egalitarianism in hunter-gatherer economies partly because of feminist interest in the extent to which such systems are also sexually egalitarian and partly to demonstrate a particularly interesting property assumption in the accompanying ad-judications. The reader might be reminded of the prevalence of 'control' in the reasons Highlands ethnographers adduced for the cults and ritual presented in the previous chapter. This notion of control implies something like an exercise of proprietorship, either over attributes 'belonging' to oneself or else over attributes 'belonging' to others and yielded by them. The concept already prejudges the manner in which persons impinge upon one another. In the same way, the concept of individual ownership of the self, which these writers on hunter-gatherer systems unwittingly use, implies an exclusion of other parties; it thus prejudges the analysis of how claims are established on persons and exercised by social others.

Sacks extends her argument to what she calls the kin corporate mode of production as one might find, she says, among clan-based Papua New Guinea Highlands horticulturalists, though her detailed examples are drawn from Africa. Here she explores the crucial contradiction be-tween men and women who as siblings share the same relations to the means of production (corporate kin resources) but who as spouses stand in different relations. She notes the appropriation by husbands of what the wife produces, so that by contrast with their relations with sisters, men control their wives' labor or the labor's products.

Writing specifically of the Duna (to the west of Paiela but belonging

to a different language family in the Highlands of Papua New Guinea),
Modjeska raises the question of how the discrete ownership of particu-
lar products, such as the husband's claim to pigs, can be conceptualized
in a situation in which the different labors of husbands and wives are
combined in quality and quantity. He observes (1982:70) that it is "in
the movement from the organization of production to the allocation of
rights . . . that the primary moment of false appropriation" must lie.
He dwells particularly on the appropriation of wives' labor in pig pro-
duction: "the interactive and social character of domestic production
is not matched by *equal rights* in determining the allocation of pigs
[my emphasis]." He continues: "Women are granted equal rights in
consumption, but their rights in determining circulation are flatly de-
nied. This denial is mediated by ideological justifications" (1982:82).
In fact, most interestingly he proceeds to offer an observation that
compromises too close a parallel between the political economy of the
Duna and the corporate kin mode systems described by Sacks; Duna
kinship corporations are structures made and perpetuated by the cir-
culation of pigs under male control. The modalities, as he puts it, of
exchange, which include bridewealth and compensation payments de-
finitive of group action, are effected through the circulation of pigs in
their appropriated form.[7] Even as siblings, relations between men and
women are not equal. But that is not why his argument is introduced
here. Rather, it is to draw attention to the assumption that there can be
some independent determination of what a person's 'rights' should be.

A vocabulary which turns on the deprivation of 'rights' must entail
premises about a specific form of property.[8] To assert rights against
others implies a type of legal ownership. Does the right to determine
the value of one's product belong naturally to the producer?

The postulate that equality exists where agents exercise control over
their activities, based on the assumption that what they do belongs to
them in person, is itself part of an ancient European critique of property
and inequality. Work is regarded as just such an activity. The internal
critique of Western capitalism that draws attention to alienation—to
the separation of a person from his/her work—rests ultimately on the
notion that persons somehow have a natural right to the products of
their own work, since they are the authors of their acts.[9] Such intrinsic
possession of one's own activity (work) means it has a value in the first
instance for the self (and thus may we also speak of it as labor). It is
the person's *own* appropriation of his or her activity that gives it value,
in so far as the person is a microcosm of the 'social' process by which

exogenous appropriation by others, by 'the system', also gives it value. Not only is internal proprietorship assumed (Barnett and Silverman 1979),[10] but a one-to-one relationship is imagined to exist between a producer and what he or she produces. Ownership of what a person does properly rests, it would appear, in that person as a singular individual. This notion, already mentioned in chapter 5, is one to which I shall return.

Comparative analysis does not in the end turn on the applicability of single concepts but on the comparison of whole systems. To isolate the idea of 'equality' is a case in point. No one would suggest that in Melanesia relations between men and women are egalitarian either in fact or ideology. Indeed, Josephides (1982) points to the significance of an overt ideology of inequality between the sexes as concealing the combination of their labors. But, following Godelier (1976), this observation can also be reversed. It is through gender imagery that concepts of equality and symmetry or inequality and asymmetry are fashioned. The connection between this imagery and relations between men and women as such cannot be assessed without some grasp of the overall system within which equalities and inequalities are generated. On this point, all those writers whose work has been mentioned agree. It is necessary to specify the nature of the political economy that produces these formulations of gender. This task requires an evaluative decision on the observer's part about what kind of system it indeed is.

A CRITIQUE OF THE GIFT

Adopting the concept of gift economy to apprehend the political-economic form of Melanesian societies avoids certain prejudgments. Specifying the products of economic arrangements as 'commodities' and 'gifts', rather than referring to different ways of producing and circulating 'goods', avoids assumptions about values. For instance, Gregory (1982) argues, the category goods implies a subjective relation between an individual and an object of desire—goods are pre-defined as things that people want. Categories such as commodity and gift refer instead to the organization of relations. Commodity exchange, as he (1982: 41) puts it, establishes a relationship between the objects exchanged, whereas gift exchange establishes a relation between the exchanging subjects. In a commodity oriented economy, people thus experience their interest in commodities as a desire to appropriate goods; in a gift oriented economy, the desire is to expand social relations. For in a clan

(rather than class-) based society, production and consumption are related in such a way that consumptive production, the consumption of things for the production of persons, predominates.[11] This is close to Modjeska's formulation that Duna social practices concerning pigs as objects with a mediating potential ('gifts') confront one "not with a system of commodity production but rather with a system for the 'production' (or social reproduction) of persons as lineage and family members" (1982:51). The self-replacement of clans, in Gregory's scheme, involves turning things into persons, a process of personification that is predominant over what he calls objectification, persons' production of things. By predominant, he means that this process determines the social form of things and persons.

'Gift economy', then, is a shorthand for describing a relationship between production and consumption in which consumptive production shapes people's motivations and the form in which they recognize productive activities. To so refer to Melanesian economies entails as much a cultural as a social categorization.

But such a decision is bound to entail prejudgments of its own. The questions posed about the ideological states of 'property' and 'ownership' as Western cultural idioms raise counterquestions: perhaps terms such as 'gift' and 'exchange' have a similar cultural status. Chapter 4, for instance, axiomatically adopted the concept of reciprocity in defining the domestic production of persons in Hagen. The exegesis of the last chapter depended upon an interpretive resonance with Melanesian ideas about the interchange of sexual attributes between the sexes, thus adopting a model of exchange to describe the way relations are set up between persons. But what is the status of these Melanesian ideas? If the idea of property as a thing conceals social relations in a commodity system, then what is exchange concealing in gift systems of the Melanesian kind? We require in turn a critique of the ideology of exchange rather than adopting it unexamined into analysis.[12]

The concept of 'reciprocity' in particular has drawn recent anthropological fire. Among many commentators, from among and beyond Melanesianists, A. Weiner has supplanted interpretations that rest on notions of reciprocity derived from *The Gift* (Mauss 1954) with a modelling of Massim exchange as a species of reproduction. Exchange, she argues, feeds the way in which "transactions allow for the build-up and the embeddedness of wealth and value in others" (1980:73; see also 1978; 1979; 1982). Reciprocity in exchange cannot be taken as an independent social form.[13] As will become apparent, my later arguments

dovetail with hers in so far as I attempt to elucidate different types of productivity. However, the impetus for the present chapter comes from Josephides (1982; see also 1983; 1985a), a Highlands commentator who tackles reciprocity in terms of its ideological dimension.

Although to some extent independently conceived, Josephides's argument can be related to those offered by feminist anthropologists addressing the issue of sexual inequality in terms of class relations and exploitation and the comparison of political economy types. As we have seen, there are advantages to such a position: namely, it distances itself from cultural categories. In conventional accounts of gift exchange indigenous formulations are captured for analytical purposes; it is not necessarily the case that the theoretical frame is derived from them, but the kinds of data fed into it are. Actors' concepts about transactions or indebtedness in gift relations are selected as the essential data. In the Melanesian systems, these also involve assumptions about reciprocity and equality. Josephides queries the ease with which they have been taken on board. On the one hand, her critique of gift ideology derives its force from considering gift exchange as constituting relations of production; on the other, she discusses the way in which the 'equality' and 'reciprocity', on which the exchanges appear to rest, disguise the nature of these relations.

For my part, I regard the argument about equality as something of a detour: the crucial observation to which her thesis leads is that gift exchange conceals the conventions of reification. All the same, the detour is worth making briefly, if only to dispose of a number of questions that lurk by the way.

'Gift economy', as a shorthand reference to systems of production and consumption where consumptive production predominates, implies, in Gregory's terminology, that things and people assume the social form of persons. They thus circulate as gifts, for the circulation creates relationships of a specific type, namely a qualitative relationship between the parties to the exchange. This makes them reciprocally dependent upon one another. Some dependencies are conceived of as prior to transactions, while others are constructed during the course of the transaction itself. In the latter case, parties may come to the transaction as independent social entities, a condition for the kind of reciprocity that ceremonial exchange partners in Hagen, for instance, sustain between themselves. The outsider may establish these points through the examination of social arrangements (political and kinship) contingent on the circulation of persons and things; but it is the actors, of course,

who construe the qualitative nature of the relationships in terms of an 'exchange' or as a matter of parties to the exchange being in a state of 'reciprocity'. As Sahlins (1972:134) warned, "everywhere in the world the indigenous category for exploitation is 'reciprocity'."

Josephides's critique of the gift is directed specifically to the manner in which the sphere of ceremonial exchange has been thus described for Hagen. She writes:

> the ideology of reciprocity, and especially in the form of ceremonial exchange in traditional Papua New Guinea societies like the Melpa of Mount Hagen, Western Highlands, serves to disguise actual inequalities in the distribution of social, political and economic power. (1982:1)

In other words, ceremonial exchange and its attendant norms of reciprocity are presented in a form that mystifies power relations. She argues that they both hide inequalities between men and cover up the productive base on which men's prestige-gaining activities rest. They thereby facilitate men's exploitation of women's labor.

Her view of the systemic ('ideological') nature of this facilitation is a subtle one. Disguise is at issue in so far as these ideas present a version of the relationships in question which promotes the interests of some of the actors at the expense of others; thus she raises the question of divisive interests. But she does not imagine that they belong to another order of reality. It can be argued that relations based on 'gift exchange' quite as much as those based on 'kinship' function *both* as relations of production *and* as ideologies, in Friedman's phrase (1974:445), upon which mythologies are built. These relations disguise features of themselves.[14] Josephides argues that "What is concealed . . . in these [ceremonial] exchanges . . . is the relationship between the prestige gained there and productive labour; in other words the role of *moka* as the mode of appropriation, and, in a wider sense, as relations of production" (1982:32). Consequently,

> to say that at the core of *moka* [Hagen ceremonial exchange] transactions is exploitation and domination, and all the rest is mere waste of social energy in converting and reconverting economic capital, is not to present a true picture of the economy; rather, as Bourdieu warns, it is to strip it to its final, material effects; in fact to impoverish and caricature it. *For within a definition of economic activity is included also the activity that conceals its function*—the relation of 'misrecognition'. . . . We have to penetrate to the 'deeper logic' to understand the economy; but at the same time we must realise that this 'deeper logic' would not be visible if it had no overt structures to support it [my emphasis]. (1982:32)

The crucial domination, she argues, is of big men over little as well as men over women. Her analysis suggests that it is big men's inevitable interests in prestige and group aggrandizement and its converse that no strong group could exist without a strong individual, which are the source of the misrecognition. Her insights rest in turn on a fundamental premise about the nature of social life:

> I arrive at an irreducible socio-economic activity which I see not as culturally relative, but as being present in all societies and ordering power differentials. This is unequal access to the pool of human labour in a community which enables some people to control the labour power of others. Whether the control is direct or indirect, . . . overt or covert, enshrined in institutions or practised surreptitiously, it establishes and reproduces relations in which some social actors may exercise political dominance over the community. (1985b:18)

Most widely conceived, Josephides's argument is that to concentrate on gift exchange is to overlook the vital sphere of production, a procedure that participates in indigenous evaluations:

> While the exchange sphere is said to be egalitarian, the productive domestic sphere is one of interdependence. Yet the egalitarianism of exchange is false, precisely because of its unacknowledged relationship to production; and the interdependence in production really supports hierarchical domestic relations. (1985a:1)

But in saying that I regard the issue of equality as a detour, I would comment that it is with respect to adjudications over equality and inequality in the course of examining this 'egalitarianism' that she implements the same kinds of property assumptions encountered in the discussions about hunter-gatherer economies.

Since Josephides addresses herself to Hagen, her comments have a special interest for me and I first re-present some of the Hagen material to suggest how her very pertinent criticism of gift ideology incorporates certain property ideas. It is this aspect of the root metaphor that importantly establishes the exogenous viewpoint from which the criticism is made. But at the same time, it limits the criticism to its own premises, viz., productive work and the disposal of its products. Let me repeat that the problem here is not the bias of the criticism (the criticism is properly conceived of as drawing on a different frame of reference from indigenous formulations). The problem is rather the form the bias takes—that it entails specific assumptions about proprietorship that interfere with our understanding the indigenous premises of Melanesian social action.

THE EXPLOITATION OF FEMALE LABOR

Aspects of Hagen domestic organization were introduced in chapter 4. The division of labor in subsistence horticulture involves men clearing and fencing the land which women plant and harvest; pigs are raised, tended and fed by women, to be used as wealth items in exchange transactions. These include bridewealth, funeral and compensation payments, and also that class of gift giving, ceremonial exchange (*moka*), that promotes men's prestige and political interests. Kin-based exchanges tend to be completed fairly quickly, and any enduring transactions based on them develop a *moka* format. Shells, and nowadays money, circulate alongside the pigs. Public ceremony is in the hands of men, and I coined the epithets 'producer' and 'transactor' to distinguish women's and men's places with respect to these activities (M. Strathern 1972). Whereas men are both producers and transactors, women are by and large only producers. As one polygynist declared: "Women are on our hands; they are not strong enough to do things themselves and we men look after them. We men work with our hands, and women are on our hands and eat the food that comes up."

'Looking after' typifies relations between political allies and help given between clansmen as well as between parents and children. It also typifies relations between husband and wife in so far as they contribute to one another's enterprises. Thus, women are said to look after their husbands and sons. Both spouses may plant their own patches of the cash crop coffee and may declare that each harvests the trees they have planted and keeps the proceeds without regard to the other. Here a unitary relationship is conceptualized between the planter and the yield, which applies also to the planting of foodstuffs. Such claims are exercised especially by women, who jealously guard their crops against all comers (including husbands and children). And then, in the same breath, they will also say that the husband 'looked after' his wife and gave her some of the trees he had planted, or the wife 'looked after' him and picked coffee for him. Men's and women's labor is not contrasted here; what is contrasted are the ends to which the labor is put.

Whereas husband and wife both look after each other, the husband is also in a position to acquire a name, that is, public prestige. The help his wife gives him assists him in this, and in turn she may thereby participate in his prestige. So, for instance, in the name of his potential prestige, a man may ask for monetary help from his wife to buy a vehicle that will bear his and not her name. But the reverse transaction

is traditionally inconceivable. The same holds for the disposal of pigs. Husband and wife together rear them—the pigs are tended daily by the wife, fed her food from land belonging to the husband's clan—but only the husband can transform the pigs into gifts and dispatch them in ceremonial exchange. He makes a name for himself; later he returns stock to his wife's care or allocates her pork; she gets more pigs, and/or pork but not a name.

A small illustration may make the point, in relation to preparations a young man and his father were making for ceremonial exchange (*moka*) in 1981. They had collected together cash sums from various female relatives. The youth commented that the women were just helping them both, and it would be their own two (the men's) names which would "go inside the ceremonial exchange." Pigs were also involved. There were various pigs of the house which his mother and father would put in the *moka*. Both parents had looked after the pigs together, but the father would, of course, transact with them. There would also be pigs gained from his exchanges with other men.[15] However, in talking to me later, the mother herself used the unit model that suggests an exclusive relationship between a planter and what she plants. She said that she was going to contribute to the exchange apart from her husband, in the name of one of her immature sons. They were her own pigs, she had tended them, and they would go in separately from others that the husband had acquired from elsewhere.

These are not to be understood as conflicting property claims but rather as glosses put on differentiated sources of production. Pigs may be seen as cared for by the wife, as the product of the spouses' joint labor, or as ultimately derived from earlier transactions of the husband's. Yet the situation seems ripe for an analysis of exploitation. Indeed, it is reminiscent of the Barotse case from central Africa scrutinized by Frankenberg (1978). The notion of reciprocity in the division of labor between Barotse husband and wife, and the legal fact that they have equal rights in the crops she has worked, serves to hide inequalities in their access to productive resources. Frankenberg refers dryly to the wife's labor as rent for the land she works. A wife's control over the fruits of her labor is restricted by her obligation to feed her family, and her claims to land depend on her marriage to her husband. Her labor does not establish any independent entitlement. These observations parallel Josephides's.

Josephides worked among the Kewa, to the south of Hagen. She describes Kewa ceremonial exchange in which men distinguish, as Ha-

geners do, 'house pigs' that the wife has reared from pigs obtained by
the husband's transactions and over which the wife has diminished con-
trol. Because of all the coming and going of animals, in fact at any one
time most pigs can be shown to be the result of the husband's transac-
tions, and are claimed by him as 'his'. Thus Josephides argues, trans-
actions mystify women's continuous input of labor. A wife must feed
all the pigs to which a husband lays claim, wherever they have come
from, yet her labor does not necessarily establish any entitlement to
them.[16] Rather

> transaction upon transaction creates a smokescreen in which a woman's
> labour in the acquisition of exchange pigs is irretrievably lost. Women's
> labor receives official recognition at the pig feast, but this is exactly where
> the products of that labour are appropriated. The husband distributes pork,
> creating debts in his name. The wife may still enjoy the fruits of the returns
> if she remains with her husband, but if she separates and remarries she
> forfeits her investment. (1983:306)

Although Josephides points out that Kewa have no elaborate ex-
change cycles with a momentum of their own, it is from a similar
vantage point that she mounts her critique of the Hagen data. She
argues that the ethnographers had overlooked the ideological force of
Hageners' rhetoric of reciprocity, which perpetrates the myth that gifts
create gifts. To regard items used in transactions as coming from trans-
actions with others obscures two things. It obscures inequalities in
men's access to productive resources among themselves, since the ability
to obtain gifts is seen not as a matter of number of wives or size of
gardens but of skill in transactions. And in the case of pigs it obscures
the considerable female labor that goes into their maintenance. Since
only men gain a name, they convert material into symbolic capital while
excluding women in the process. Relations between husband and wife
might be represented as reciprocal (when they speak of 'looking after'
one another) but, she argues,

> it is the relationship *between work and its product* [my emphasis] that the
> system disguises. Formal reciprocity espouses a strict division of labour
> which is intrinsically unequal. . . . The exchange is fetishised as creating
> wealth, whereas in reality wealth is merely *appropriated* [author's emphasis]
> there [in exchange] by being transformed into [men's] prestige. (1982:32)

Exchange, and not the labor that creates the product in the first place,
is presented as creating wealth. This sets the conditions for what she
calls 'relations of exploitation'. Production is appropriated in the in-
terests of men. In raising pigs, women produce a man's most strategic

resource. For this reason, Hagen "men cannot allow their women rights of disposal over their products" (1982:30). Appropriation is understood as inhering in the conversion of the products of work into material capital (wealth) that can be converted into symbolic capital (prestige), excluding the producers as producers.

Ceremonial exchange, with its myth that gifts create gifts, thus hides the underlying fact that such exchange is the means through which wealth is appropriated. The dogma of 'reciprocity' pretends that men come as 'equals' to their exchange partnerships; "what is suppressed is inequality of access to resources" (1982:3). The domination of some men (those with the most productive resources) over others is covert. Domination of women by men, however, is overt. Men and women must be conceptualized as different for the sexual division of labor to operate, and as unequal since the work of one sex is accorded more social value than the work of the other. The value is itself constructed through the disguise of economic capital by symbolic capital, by the dogma that it is not the products of labor that are put into circulation but the result of transactions, viz., gifts. Reciprocity between spouses glosses over the inequalities intrinsic to this division of labor.

> Every transaction must be euphemized as a gift, because what is formally stressed is always the relationship between people transacting, rather than the acquisition of goods. This cultural emphasis covers up the unequal exchanges which take place between husband and wife, married man and bachelor, big man and his agnates. . . . Gift economy, then, disguises unequal exchange and mystifies transactions as free gifts, yet at the same time presents them as wealth creators. (1985a:218, 220)

Inequalities are created, Josephides argues, in the relationship between production and exchange. The ideological separation of production from transaction renders the producer's position inherently exploitable. It may be a gentle rather than violent exploitation, the big man hiding behind kinship ideologies in order to reproduce the relations of domination,[17] but we must recognize it as such. However, I build on Josephides's insights through a gentle deconstruction. Two things interest me: first, the assumption that it is work which is the subject of value conversion, so that one can speak of the appropriation of labor; and second, that persons ought to own and retain control over what they do.

Domestic labor and the question of alienation. There is certainly a Western sense in which all value-conversions are regarded as exploit-

ative, that is, the value that people acquire for themselves is seen to be at the expense of others. With respect to wage-labor, extraction is envisaged in the form of alienation, because it is supposed that what lies at the basis of value-conversion is something being done by other agents to the work people do or to the products that embody their work. The worker does not determine their value. In effect, he/she has given up control over the use of his/her labor. When Hagen men make gifts out of pigs, they do indeed transform value: the animals have been reclassified. By turning pigs as food to be eaten into gifts to be exchanged, the husband relocates their social origin: the pigs are now seen to be the result of other previous gift-transactions by which they entered his household. As gifts, they circulate only to enhance men's names. Any credit that comes to the wife is secondary. The case would seem to present evidence indeed for labor alienation in a noncapitalist context through "the concealment of the economic in a non-economic form" (Bonte 1981:39).

However, we cannot dismiss the fact that the concept of alienation is in the first place connected to particular critiques of Western capitalism and class relations, as noted at the beginning of the chapter. In the long term, this connection will prove relevant to the manner in which we apprehend modes of symbolization and, in the immediate term, to the kinds of questions we ask about labor.

It is axiomatic to this critique that interests are advanced through the mystification of social relations. Par excellence, the representation of commodities as 'goods' promotes them as objects with self-contained value, capable of being owned and circulated as property, without reference to the social sources of production. Goods are created with particular persons' concrete labors, but that labor is embodied in them as abstract labor, so that their origin in the work of particular laborers is rendered irrelevant. They can thus be appropriated as the new owner's 'property', attached to the owner by virtue of the owner's own actions: ownership implies control over the alienability of things. This is possible in so far as labor and/or its products may itself be construed as alienable property and put under the control of another. Here we have a description, then, of the internal rationality of relations of production *and* of its constituent ideology by which the separation of worker and product is taken for granted. However, another dimension tends to take center stage in both feminist and anthropological arguments that draw on such critiques, and that is the substantive question of control over domestic labor.

One issue facing the analysis of noncapitalist systems is that typically labor is not made abstract—it remains concrete—that is, it remains indicative of its social origins and cannot be measured or quantified by criteria common to all labor. The proposition applies, for instance, to the production of knowledge on Malo; knowledge there has value because of its reference to specific persons and thus specific social sources. It also applies to basic subsistence activities. If a division of labor between the sexes defines their relationship, then the labor has no abstract value outside it (if a wife's job as a wife is doing X for her husband, she cannot sell doing X to someone else). Indeed, in subsistence technologies of the Melanesian kind, the status of domestic labor becomes relevant to the characterization of the whole economy.

As it was debated in the 1970s and early 1980s, the issue of domestic labor turns on the extent to which, in a capitalist economy, domestic relations lie outside capitalist institutions or contribute to them. It also turns on whether the very notion of concrete labor in the domestic context—the way in which members of a household are locked into rendering services to one another—is not itself a mystification. The question is the nature of the work being done. It has no 'social' value, not because the sources in particular persons are not acknowledged but because it remains private labor. Not abstractable in terms of an average quantity, it has no currency and thus no visibility outside the domestic sphere.[18]

There is an interesting equivocation here: the Marxist-derived epithet 'social' refers to an abstract value (e.g., the socially necessary labor time inherent in the commodity), the anthropological epithet to particular, nonquantifiable relations of all kinds. Thus Harris and Young (1981), agreeing that where production is not for commodity exchange labor will not be abstracted but allocated by social criteria, add that the circulation of goods and people must form part of the account of social reproduction as a whole. This nonetheless prompts one, as Josephides was prompted, to ask the same question about concrete labor in noncapitalist systems: what interests are served in the way the mobilization of labor is embedded in structures of kinship or politics? If one relocates the question of production as the production of social relations through circulation (of items, food, women, children, and men), by what mystifications do people represent these structures? Can one regard gift exchange as analogous to exchange (i.e., 'distribution') in a commodity system that separates such exchange from production and consumption as part of its own self-descriptio' ? If the social circulation of products

is consequently regarded as distinct from production, conceived as a self-contained process, the separation is an ideological one in capitalist representations, concealing the process of alienation. Yet can we concomitantly extend the argument that the gift, an appropriation of items produced by domestic labor, also conceals the nature of these productive relations?

The argument has been extended in negative form: were such concealment not to take place, and the productive base of exchange activity to be openly recognized, then exploitation based on alienation would not occur. Feil (1984) takes this view in his study of Tombema Enga.[19] Relations of exchange, he says, are equally relations of production, and since production and exchange are linked together, then men's and women's complementary efforts are recognized (1984b:79–80, 232). Women's labor is not alienated from them, because the labor is never extracted: it remains embedded in the pigs that circulate as 'produced' items. Thus although Feil (1984b:80) says that "only by exchanging them, by giving them away, does 'social value' accrue to the producer of the pigs," he also regards exchange and production as a continuous process, so that production is not thereby devalued. In other words, he denies that there is any conversion of value, or, if there is, that at the point at which social value is created, it continues to bear reference to the joint activities of both sexes. Significantly, women are seen as central to the very constitution of the exchange partnerships (created through affinal and matrilineal links). Women's essential role in the formation of exchange partnerships means that "relations of exchange are equally inalienable from them, for . . . men cannot form partnerships without women" (1984b:232).[20]

Feil adduces historical reasons for the rather different developments in Hagen society (see 1982a), which he sees as leading there to women losing "their crucial role in and partial control of the exchange system" because "[t]hey no longer helped produce the items of highest exchange value, pigs" (1984b:98), since shells had become the most esteemed item. In Tombema, women's crucial role remained intact, and he refers to husbands and wives as partners in ceremonial exchange. Prestige is to be gained for both. One basis for this, he argues, is that "[p]igs are the inalienable *property* of the woman whose labour produced them [my emphasis]" (1984b:118). A woman thus has rights of disposal over 'house pigs', that is, those produced within her own household as opposed to those that come along the exchange 'road'. A property relation constitutes rather peculiar grounds for arguing that women's labor is

not alienated! One may also note the asymmetry in his argument, that such pigs of the house are not also classified as men's 'property', in spite of the complementary effort that went into their production.[21] Nevertheless, Feil's general point is that labor is not misrecognized; it does not undergo a value conversion that renders it as something else, as Josephides suggested is the case in the Hagen conversion of the products of labor into wealth and gifts.

The historical argument is to some extent a red herring. In a context where, as Feil correctly notes for Hagen, production as a category of activity is devalued in certain situations, I want to argue *both* that labor is not alienated *and* that there is nonetheless a radical value transformation that sustains the distinction between production and transaction. There is a concealment, but it is not best grasped as the concealment of the economic in a noneconomic form. There is domination but not domination through the exploitation of labor.

The Hagen ethnography (e.g., M. Strathern 1972) apparently gives the unfortunate impression that domestic labor is women's labor. It was never the case, of course, that domestic production in Hagen was described as engaging female labor alone. Men and women are both producers;[22] it is in the rhetorical context of evaluating transactions that men distinguish 'male' transaction from 'female' production, thereby feminizing their own productive efforts. They eclipse their *own* productive activities as well as women's.[23]

I use the metaphor 'eclipse' to draw attention to a special feature of this concealment. It is not the case that transforming pigs into gifts re-'produces' them, re-authors them in terms of production. It is not their own (male) labor that is made the basis of their claims, as appears to be the case among the Sa-speakers of Vanuatu. Sa men claim certain products "as incarnations of themselves, of their labour, thus obscuring the interdependent nature of co-operation and the sexes in their production." Jolly adds: "although the ideology correctly represents products as congealed human labor [it is not misrecognized as property], there is a partial misrepresentation in that particular products, namely yams and pigs, are seen pre-eminently as the creations of men"; this supports her analysis of relations here involving 'partial exploitation' (Jolly 1981:286–287). By contrast, the evaluation of Hagen pigs as male wealth entails the apparently paradoxical corollary that female labor as such is not concealed. The creative work of producing pigs is not denied; on the contrary, the work that women do in their gardens and in tending the herds is fully acknowledged.

There is a puzzle here: Hagen work is not disguised as something else. The value switch does not affect the products of work in the Sa sense, making out that the work belongs exclusively to one of a pair. Nor does it affect it in the manner in which in the production of goods which as commodities every input of labor is made more useful by the addition of further labor—at each stage of a manufacturing process, the prior stage is regarded as yielding a raw product, in a relatively useless form, which the manufacturer of the moment turns into a more useful one. Hagen gifts in no sense make useful objects out of useless ones. On the contrary, that use remains embedded in the domestic cycle and in the pigs' eventual consumption as food. It is when they are consumed that the labor in producing them is recognized. The creation of a gift makes a quite different entity out of the animals. Indeed, as gifts, there is an embargo on them being consumed. The gifts create debts, and the debts sustain the circulation of pigs; they are re-transformed into use items only by the original person who put the gift into the system and who decides to kill the pigs he gets back in return for his initial investments. Both husband and wife eat: no one else can take the spouses' joint interest in the animal out of the system.[24] Whatever work went into the production of the pigs, others cannot appropriate it as work; they acquire the gift as a debt to be repaid.

Modjeska (1982:85–86) has a comment on this process.

> Women find themselves labouring within a structure of social relations created by a flow of pigs in circulation, produced at least half by their own labour, and yet it is a world they never made. The surplus product can be returned completely to its producers without altering the alienations of a social edifice constructed by male-dominated circulation.

That the demands put on women are a consequence of men's operations should not be underemphasized. Given the way work is oriented to social others, power lies in the effective definition of the scope of relations that such work can create. It is scope about which Hagen women complain: they too would like to be able to travel around all day visiting others.

Work as such is not being transformed. Rather it is a sphere of agency. Men who, like women, are produced out of domestic households eclipse that social source in arrogating to themselves a domain of political action. They do not encompass domestic relations, but they claim that their activities are not determined solely by them. For instance, in the relationships created with exchange partners through

debts, it is dependency between kinsmen that is eclipsed. Hagen practice tends to make matrilateral and affinal relations the basis for (further) *moka* partnerships and to set to one side the essential asymmetry of such relations conceived in terms of domestic kinship. Elsewhere in the Highlands, through an elaboration of kin-based exchange, the work of nurture and procreation does indeed create unilateral debts. Return gifts acknowledge that work, although as we shall see there is more than acknowledgment of work at issue; such exchanges also have ends of their own. Consonant with the last fact, Hagen ceremonial exchange displays the exertion of male agency in creating a special set of effects. But, as in a lunar eclipse, for the effects to be registered, there can be only partial concealment and not obliteration. It is in deliberate contradistinction to domestic sociality that political life is created. Definitively, political life does not re-'produce' the interdependencies and asymmetries of kinship.

This is the point at which to refer back to the supposition in the exploitation arguments that persons naturally own what they do, that is, they own their own capacity to labor. Western proprietism inheres in the way relations between persons and things are conceived through the metaphor of the commodity. Persons are assumed to be the proprietors of their persons (including their own will, their energies, and work in the general sense of directed activity). Hence commodity thinking supplies two sets of formula variously present in the analyses considered here. We might imagine them (see pp. 134–136) as the roots and branches of one (Western) system of thinking.

The ideology and its critics occupy alternating positions. One is the thesis of market exchange, which supposes that a product can be separated from the producer with no loss to the self (it can be freely bought and sold). The antithesis is that every such separation in fact alienates the producer from part of him or herself, namely his or her labor. The second thesis concerns private property, namely that proprietorship instantiates an identity between owner and thing owned, between producer and product. Its antithesis is that such a state is realized 'naturally' in the enjoyment of the use value of things but cannot be realized under the conditions of labor alienation. What brings these ideas together is their resting on a common (cultural) notion of a unitary self, the "possessive individual" (Illich 1982:11).[25] It was noted earlier that this holism supposes an internal relation of a rather limited kind. Either the unitary self is an autonomous agent with control over things external to him or her, but which, in his or her possession, is part of the person's

identity (thesis one and two), or else (antithesis one and two) the person is indissolubly linked to his or her own activities in such a way that this unitary self is split apart when the products of activities are appropriated by others. None of these Western propositions allows for the intervention of social others except in the guise of a supplanted authorship or proprietorship. As long as things are 'owned' or the 'use value' of labor is enjoyed, the one-to-one relationship between proprietor and product is assumed. The visibility of such a one-to-one relationship gives the person's subjective autonomy with respect to others its recognized cultural form.

The common proprietorial metaphor of an identity between the person as agent and the agent's acts/products implies they are his or hers before they are appropriated by another. Specifically, the identity is that between an act or product and the source of the act or product *in an agent*. For the postulate that people own themselves is linked to the notion that they are the authors of their own actions. Authorship combines two elements in this constellation of ideas—the property-derived conceptualization of legitimate ownership and the critique based on a metaphysical definition of the conscious individual agent who is the singular source of his/her own acts. Persons 'are' what they 'have' or 'do'. Any interference in the one-to-one relationship is regarded as the intrusion of an 'other'. This other may supplant and in effect re-author activity by being the source of a different value for it.

Now this looks, for a moment, rather close to what Hagen men are doing. They claim singular responsibility of a kind: as wealth pigs are freshly conceptualized as the results of men's transactions, and thus their value in exchange is the value that men have given to them. Indeed, men's collective identification with the exchanges they create does produce a kind of unitary measure. There is a one-to-one relationship between a man's performance in *moka* or public life in general and his name or prestige. But this identification is a specific creation of male political life. In fact, men only achieve this state through a set of systematic separations that render the sphere in which they claim prestige apart from domestic activity, where they are, quite emphatically, not the singular proprietors of their own persons.

It is no surprise, then, that the paradoxically conceived contrast between root metaphors should yield further paradox in turn. In a gift economy of the Hagen type, men lay singular claim to a sphere of political activities, creating as artificial a unity that in a commodity

economy is supposed as a natural relation between the individual sub-
ject and his or her activities. Inversely, the commodity supposition that
it is culture or society that pluralizes and diversifies the values of things
runs counter to the supposition of the gift economy that persons are
intrinsically plural and diverse in origin and in their acts. With this in
mind, let us return to the issues of exploitation and alienation.

TRANSFORMATIONS

Ceremonial exchange activity of the Hagen kind is set off from
domesticity and from production and reproduction in household re-
lations, as it is from the demands of personal kin ties. In this latter
domain, work remains concrete, specifiable by its social source. More-
over, since products are seen as constructed from multiple sources, sus-
tained as multiple, the products themselves remain multiply authored.
Where work is combined (as in the reproduction of children), one type
of work cannot establish a claim over the product to the exclusion of
others. What is true of children is also true of foodstuffs and pigs pro-
duced by the household. Indeed, whether we are dealing with kinship
systems of the Hagen or Gimi type (see chap. 5), such products repli-
cate the discrete input of no one author: the child has neither the moth-
er's nor father's social identity but combines them both in an entity
that in this sense is unique. It exists as a specific combination of other
identities. When wealth circulates in this domain (through bridewealth
and child payments, for instance), it will also carry a multiple identity.
In Hagen, it is emphatically the achievement of men's ceremonial ex-
change system that they transform this into a singular identity for them-
selves: wealth comes to stand for that part of themselves which is then
construed as their whole self, their prestige.

To emphasize the achievement of singular identity, I prefer to call
this dynamic a transformation rather than a conversion, because rank
is not an issue.[26] 'Subsistence wealth' and 'prestige wealth' are not to
be measured against one another. The two domains do not simply
comprise different spheres of exchange: the concept of wealth is freshly
constituted, and it is this symbolic constitution that I wish to capture
in the term 'transformation'. Conversion may well typify the mutual
translation of gifts into words or into blows, and vice versa, all within
the domain of political action. Transformation consists in a switch from
one domain to another; it results in the very creation of wealth items

and their messages about the donor's and recipient's prestige. There has been a dramatic alteration in the perception of the joint products of domestic interdependence.

In other words, it would mislead to present the case as the supplanting of one proprietor by another, or as though the conversion from economic capital into symbolic capital substituted one relation of unitary identity for another. The transformation in the Hagen case is the creation of a unitary identity (for men) *out of* a multiply constituted identity.

This being so, perhaps one should abandon the term labor altogether. If we follow the distinction between work (purposive activity in the production process that creates use value) and labor (which is apprehended as having social value) as Ollman (1976:98) elucidates it in his discussion of Engels and Marx's terminology, one would have to say that in the Hagen case 'labor' is not an instituted category.[27] That is, there is no objectification of work apart from its performance. It is social relations that are objectified in pigs and gardens: work cannot be measured separately from relationships.

This is highly pertinent to the way in which the multiple identity of persons is evinced in the sphere of domestic kinship. I take the Hagen division of labor between spouses as the principal relation out of which the values established in ceremonial exchange are constructed. Between husband and wife, we have seen that the work each of them does demonstrates both motivation ('mind') and intentionality as well as commitment to their relationship. When people consider the work that went into producing pigs, neither the woman's nor the man's work can encompass that of the other partner. The pig is multiply produced, and I say multiply rather than dually in order to retain a reference to the open-ended transactions with (multiple) kin of all kinds in which any particular set of transactions, including those between spouses, is enveloped. As a product of the relationship between the conjugal partners, the pig is not reducible to the sole interest of either party. Now the work of feeding pigs is not part of them in the eyes of its recipient in *moka*: what is in his eyes are the animals he will eventually match (his debt). The donor, on the other hand, cannot recall such work independently from his domestic relationships. To think of the work embodied in the pig is to think of the value husband and wife have for each other. A man takes a fattened animal as a sign of his wife's care (it is when he does not that conflict arises). Conversely, the wife is not an owner of the pig who can transfer that ownership to someone else or who has

it wrested from her control, because there is no one-to-one relationship between her and her working capacity or between her working capacity and the products of her work.

Here is the crucial factor that makes it impossible to speak of alienations in the gift economy.[28] Gregory stressed that it was particularly between exchange partners that a tie was created by the transfer of inalienable things; the point may be extended, with qualification, to spouses. Inalienability signifies the absence of a property relation.[29] Rather than talking about 'inalienable property', I prefer to sustain the systemic contrast. Persons simply do not have alienable items, that is, property, at their disposal; they can only dispose of items by enchaining themselves in relations with others. Whether between exchange partners, spouses, or between kin, the circulation of things and persons in this sense leads to comparisons between the agents. Items cannot be disposed without reference to such relations.

Enchainment is a condition of all relations based on the gift. The inevitability of enchainment reveals a continuity between kin-based relationships and those of ceremonial exchange. Indeed, I would argue that it may extend to barter and indigenous market transactions (Godelier 1977; Gewertz 1983) in so far as people are tied to a perception of traders as enemies, victors, strangers, or whatever and thus to comparison between themselves and these outsiders. And Hagen men might attempt to transform domestic sociality into political sociality, but they cannot do it by freeing themselves of enchainment altogether. On the contrary, they establish new forms of dependency in the reciprocity that defines exchange partners. Partners compare themselves with one another. This dependency in turn is a condition for the accretion of prestige; in this sense, the wealth objectifies persons, that is, their relations with others.

The difference between gift exchange and commodity exchange is systemic; it is hardly admissible to decide that this particular transaction results in alienation, while that particular one does not. One cannot tell by inspection. For sometimes it is suggested that all that is at issue is the continuing 'ownership' or, if not that, 'control' exercised by the producer or transactor.

Thus I understand Feil's insistence that Tombema women's 'ownership' of the pigs they produce means that their 'labor' is not alienated.[30] This assumes that alienation occurs where the original person loses control over what happens to the item in question. The evidence now to hand suggests the following objections, among others. First, it is not

of course the relationship to the item which should be considered but relations through others with respect to the item and thus to the kinds of debts that are created. The cultural form of relationships becomes pertinent. For instance, the Melanesian idea that work is evidence of and governed by the mind precludes its appropriation: one person's mind cannot be put to another's use; instead, it is through appeals *to* the mind that people try to exert influence. Second, one cannot argue that women's work is not alienated as long as women are looking after pigs, but it is once the pigs are disposed of. Either work is alien*able* or it is not. Alienation occurs at the point at which its objectified social value, as labor, is determined in such a way as to preclude it as a value for the laborer. One might envisage that alienation occurs when the products of work are classified as wealth, but in fact, if work is not in a technical sense labor, we lack the crucial middle term that makes sense of the shorthand that work is simply converted into wealth. Finally, in a commodity economy where all objectifications are alienable, if one's own products are enjoyed as (private) property, this does not mean they are not alienable from one's person. Even if it is the person's own labor that created it, the item now stands in contradistinction to his or her subjective agency. Simply owning what you have made does not preclude its alienability. On the contrary, what is owned, so to speak, is control over the conditions of its alienation. For the possibility of (future) alienation has already created a division between the self and its products.[31]

Hagen wives are clearly put into the position of 'helping' their husbands to gain names while they themselves gain none. Yet the character of this domination is not to be grasped by assimilating it to the exploitation of labor in commodity economies.

The Western concept of exploitation rests ultimately on the idea that violence can be done to a supposed intrinsic relation between the self as subject and its realization in the objects of its activities. I have stressed that this entails a view of agents as single entities, as singular authors of what they make and do. The partibility of persons under the regime of a gift economy is very different from the positive or negative, but either way 'unnatural', dividing of the 'whole' self in a commodity regime. In a society such as Hagen, persons do not have to strive for singular identities in the domain in which they are produced, viz., that of domestic kinship. Other items are also produced here. As we have seen, these products are multiply created. That is, food fed to a pig by the wife is grown on land of the husband's clan, cleared by the husband,

planted by the wife, and only an exogenous theory of labor extraction would hierarchize these mutual investments. Neither husband nor wife can claim sole ownership vis-à-vis one another, because the relationship between them is constituted on a differentiated input of work into joint products. Sole 'ownership' is claimed by the husband only vis-à-vis other husbands, in the sphere of ceremonial exchange.

The situation is not closed to manipulation. Individuals wanting to make claims in one context will force their cross-sex partner to enable them to put the claim forward. It may well be against his wife's wishes that a husband takes off a pig for a particular purpose; yet though she may be screaming out her objections, he has not extracted it from her to dispose of without further regard. Removing the pig from the house stalls to display on the ceremonial ground does not remove his obligations. As far as that pig is concerned, the husband is still obliged when the time comes to yield her part in it, by handing over pork when, at the end of a chain of transactions, pigs are killed, or by replacing that pig when live pigs come back in return. In fact, women are likely to receive something both ways, and on the basis of a pig being sent away, will get back both pork and more pigs and in the interim may lay claim to other pigs that come in to the household from unrelated transactions.

If work produces relationships, men's own work embedded in domestic relationships, as between husband and wife, is eclipsed. From the point of view of the collective activities of ceremonial exchange, particularistic domestic relations come to appear subordinate. Yet what is transformed is not the work which the husband contributed towards joint production, any more than it is his wife's work, for that input remains intact in the relationship between the spouses. What is transformed is the part which this source of his social identity plays in relation to his (multiple) other identities. There is a switch in the way items are attached to the person. Thus the relationship established by the mutual contribution of work within the household is differently constructed from the relationship established between exchange partners. One person cannot 'give' work to another, in the way that a donor gives a gift (or 'thing' in the Hagen language) to a recipient. Such 'things' appear to be created by transactions, not by work.

One consequence of the division of labor is that a husband or wife does not transform the work of the other into use for her or his own self. The relationship between work and motivation is important. Items produced for the use of another are not subordinated to some overriding purpose that redefines the ends for which they are conceived, and hence

their value to the advantage of one rather than the other, as in the classical sense of exploitation. Each acknowledges and consumes the products of the other as such.

Under a commodity regime, purposive activity results in artifacts; hence 'work' can be equated with 'making things', and hence a crucial relationship to investigate, as Josephides indicates, is that between producer and product. Hagen work is also purposive activity but is directed towards effectiveness in relationships. Work includes making things, but things are instruments of relations, and the creation of relations is not disguised. Work produces or makes visible a relationship, for example between husband and wife. A person's activities become overt evidence of their intentions. Consequently, the products of work are expressive of the person's own mind, what she or he decides to do. But a person's mind is known not only by its singular location in the chest; there it lies hidden. The mind is made visible in the context of multiple social relations with others. Evidence of a child's growing mind lies in its capacity to see its duty towards others. A person may thus intend to do things for another: the intention is her or his own but is directed away from the self; its social object is another.[32] A pig a woman raises is evidence of her effort; but her effort flourishes in the context of an orientation towards her partner, and in that sense its outcome belongs to him as well. That a woman may regard a pig as under the direction of her energies is not at all incompatible with the context of her regard, rearing an animal the husband will use in his exchanges. If she wants to make a point of dispute against the husband, then she will reclassify the social orientation of her work, not by saying that it was for herself but (in the instance cited earlier) that it was for a son.

The example recalls an awkward point. I have neglected an observation introduced at the beginning—the unitary nature of the relationship women assume in claiming total control over the crops they plant. Although men also claim similar control over sugarcane and other luxury crops, it is women for whom these claims are especially important. (Indeed, men's parallel 'control' is perhaps built on an analogy to women's, much as women's help in ceremonial exchange gives them an analogous 'prestige' to men's.) It is significant that this control is exercised during the growing of the plants and to the point of harvest. Subsequently, claims on the woman's caretaking take the form of claims on the harvested food she has at her disposal; but during the growing time, while the crops are in the ground, they are uniquely hers as their planter.

Hagen views are not as developed as the exclusive proprietorship claimed by Gimi women who assimilate growing things to their own substance (chap. 5). In fact, the Hagen identification of the crops with the woman's person lasts only as long as they are also in explicit relation to the ground with which her husband (or son or sometimes brother) is identified. The link between herself and the crop is via her particular concrete work. One could suggest an analogy here with men's contrivances in ceremonial exchange. The unitary connection— the identification of the growing plants with the woman who watches over them—is a deliberate achievement in this sphere. It operates to a precise effect to bring the plants to maturation. Once the crops are taken out of the ground, they are no longer the woman's own. Instead they are reactivated—like the pigs that return to the household—in terms of their multiple social sources. (The plants cared for by the wife were nourished by the husband's work on his clan land.) Thus a husband has irrefutable claims on a woman's harvested food, where he would never help himself to her planted gardens.

If we were to argue that men's deployment of pigs in *moka* exploits female 'labor', in so far as women are never in a position to realize the full 'social' value of their work, we would have to argue a counterpoint for women's claims over the crops they grow. When women prevent men from helping themselves to food growing in the gardens, they could be said to deny the productive input from men's preparation of the soil.

However, I have labored the characterization of gift as opposed to commodity economies not simply to conclude with an equivocal evaluation of the inequality between men and women. Rather, I have wished to formulate the basis of the transformation that men effect in creating wealth items 'out of' the products of domestic relations. The general enchainment of relations means that persons are multiply constituted. There is no presumption of an innate unity: such an identity is only created to special, transient effect. The transformation is made visible, then, as one which turns multiple into single sources of identity. Exactly the same process occurs in the association of women with growing crops. A multiple identity is overridden by her exclusive claims. At the heart of domestic relations, then, as well as beyond them, an effect depends on eclipsing the multiple or composite character of persons and things.

A theme intrinsic to these four chapters has been the relationship between collective and particular relations. The relationship is evinced

in the contrast between two types of sociality, which for the moment we may consider in their shorthand form as characterizing political and domestic domains. One comparison between ceremonial exchange and male cult performances can be made explicit in this regard. It holds for both that in transforming domestic (multiple) sociality, men eclipse this sphere of *their own* identity. It is an operation they perform upon themselves, for they consequently refashion their own visible qualities, and their own minds.

That being the case, we might ask what form domination takes in a gift economy. A preliminary answer can be given through pointing to an interesting lacuna in the present discussion—there has been no reference to surplus. Since it is the appropriation of surplus product that is held to lie at the basis of capitalist exploitation, an obvious comparative question is how surplus is realized in a gift economy. Surplus is a problematic term:[33] a relationship between input and output tends to be confused with the scale of production, so that it may even be argued that technologies of themselves lead to surpluses which can then be appropriated (e.g., that some horticultural systems produce an excess over subsistence needs). There is no doubt, as Brown (1978) and Modjeska (1982) make clear, that within the Papua New Guinea Highlands considerable differences exist in the levels of horticultural and pig production. I would follow Modjeska's comment that magnification of pig production is to be associated with the magnification of mediated forms of relations, that is, relations based on wealth exchanges. But what needs explaining are the conceptual categories (wealth, mediation): the quantity of goods is after the fact.

Sahlins (1972: chap. 5) proposed an answer to the question of domination by treating gift economies literally as economic systems. As systems for the redistribution of goods, the extraction of surplus takes place at the point of distribution, not production. The extractors are those who gain advantage for themselves in controlling the flow of goods. But we can add here a twist concerning the classification of that advantage. No conceptualization of 'surplus' is required. In transforming subsistence items into wealth items, men are not in the first place performing operations on these items. They are performing operations on themselves and thus on their relations with others, much as initiators/initiands do in the course of their rituals. They are altering the manner in which objects are attached to them and the meaning these objects hold for their identity. This can only be done if they are seen to create one type of relationship out of another. Concomitantly, every-

thing turns on how the items that objectify these relations are attached to and thus mediate between persons. The number of pigs would not matter so much if increment in ceremonial exchange were not defined as evidence of one's capacity to make relationships.

The appropriation of surplus product is central to a commodity economy; those who dominate are those who determine the manner of appropriation. In a gift economy, we might argue that those who dominate are those who determine the connections and disconnections created by the circulation of objects.

Indeed, if we follow through the inversely formulated root metaphors of commodity and gift economies, then we might recover an important implication of Josephides's argument.[34] Commodity exchange involves a process, to quote Godelier (1977:156) again, by which the essence of the commodity's value "disappears in its mode of appearance." Its value, social and therefore abstract human labor, "can only be expressed in a form, the 'equivalent form', which conceals it by making it appear a natural characteristic of things." Gift exchange, by contrast, involves a process in which human value *is* made apparent. Social relations are alternately eclipsed and revealed, but the partial concealment that results makes a drama out of their potential visibility.

If that process of eclipse and revelation conceals and thus mystifies anything, it is the conventions of reification. And thus concealed, as we would see it, is the extent to which the things that people make stand over and beyond them. We apprehend things as imposing their own material limitations on the management of human affairs, including relationships between men and women. There is an analogy or metaphor here for what we might wish to know about such management. If analysis can make explicit the social relations contained within the reified nature of the commodity, then it can also make explicit the dependency of the relations of gift exchange upon the nature of things. One would understand as constraints, then, the symbolic conventions by which social relations are indeed the overt objects of Melanesians' dealings with one another.

Part Two

7
Some Definitions

Speaking of the regenerative power that Tubetube people in the southern Massim, off the coast of Papua New Guinea, ascribe to shells, Macintyre observes,

> [w]hereas commodity fetishism abstracts the human activity that produced an item from its producer and ascribes it to the product, the ascription of reproductivity to shell valuables ideologically reaffirms the centrality of human agency in production. (1984:113)

To the far east of Tubetube lies Sabarl. The wealth items that there flow between people are said to look like people, the shadow they cast being linguistically classified as animate (Battaglia 1983a:291). Battaglia's description of wealth items does not stop at discerning anthropomorphic form. Hafted axes and shell valuables do not simply depict human beings but depict the relationships between persons. The 'elbow' of the ax represents the vital turning point in a person's relations with the father's kin; the strands and colors of red shell necklaces not only refer to their procreative powers but to the relationship between maternal images of corporation and paternal images of individuation. To state that these wealth objects are 'personifications' is not to set them *against* 'objectifications', for that implies an unwarranted double participation in the equation between subjects and persons, and the separation of subjects from objects, promoted by commodity fetishism. Objects are created not in contradistinction to persons but out of persons.

171

Objects are so created through various overt indigenous equations
(such as the connection between elbow and ax) and separations (mater-
nal kin disconnected from paternal). From a Western point of view,
thereby concealed is the conventional nature of such 'symbols'—what
we normally recognize as their 'expressive' character. In our own world,
whether symbols take the form of people or things, they are, like all
other things, regarded as the products of society and culture. For a
commodity world view sees work as producing things and regards re-
lationships as created through the social or collective ownership, dis-
tribution ('exchange'), and consumption of things (Sahlins 1976:211).
Symbolic interests are set against material ones (Bourdieu 1977:177).
This holds also for symbolic 'relationships'. Relations between symbols,
whether or not they are reducible to an infinitude of binary oppositions,
are regarded as composing a classificatory system that orders its compo-
nent units like so many segments of a society. The relation between a
symbol and what it stands for thus occupies a position analogous to
that of the commodity with its dually derived values (Reason 1979) or
of the person who is a microcosm of the domesticating process. Conse-
quently, one thing can stand for another thing, we hold, as a cultural
expression relates to what it expresses, and one thing can be converted
into another under appropriate circumstances, as concrete into abstract
labor.

But in a world *where social relations are the objects of people's
dealings with one another,* it will follow that social relations can only
turn into (other) social relations, and social relations can only stand for
(other) social relations. Thus might we imagine, for instance, the two
types of (political/domestic) sociality to which I have referred, the one
created out of the other. Indeed, although it may sound counterintuitive,
it is also possible to regard the one as an alternative form of the other.

The contrast imagined here between Western and Melanesian worlds
applies equally to the nature of symbolic constructions themselves. I
doubt if the people of Tubetube and Sabarl speak of one relation
'standing for' or even 'turning into' another. We know that on Sabarl
Island it might be more appropriate to use the concepts of 'support'
and 'complementarity'.

Supports (*labe*) are of different identity but assist one another: "one
item structuring or positioning an analogous one without essentially
changing it"; complementary relationships (*gaba*), however, stress "the
oppositional aspect of paired elements and the process of completing,
or bringing to potential, one of the pair through the other" (Battaglia

1983:292). The Sabarl terms for the two types of relationship clearly distinguish them by their functions; at the same time, the one may be used as a metaphor of the other (so that complementary relationships may be said to be supportive). It is no surprise that the same items (ax blade and shaft) or the same social persons (husband and wife) may be connected by either relation. The fusion is not accidental: both principles are said to underpin Sabarl growth and health. When maternal and paternal food are considered as 'supports' for one another (*labe*), "pigs provided by affines support the yams from the matriclan" (Battaglia 1983a:292), each positioning the other without changing it. In a *gaba* relationship, which entails an internal relation of opposition, "fat complements the bones and flesh of the fetus, completing the physical person" (1983:292–293). Mortuary ceremonies transform support relations between certain kin into opposition ones, and the terms can thus refer to the same items in different states. The result one might note is that "paired complementary items are neither in balance nor ever unequal *in any fixed sense* [original emphasis]" (1983a:293).

We do not necessarily need to adopt the Sarbal formulation. We do need to pay attention to the fact that it is the capabilities of relations, not the attributes of things, which are the focus of these operations. And since we have already encountered the proposition that persons and things have the social form of persons, we know in what form the objectification of relations so appears in people's dealings with one another. The objectifications are realized in persons.

This, in turn, constrains the manner in which difference, and thus the basis for connection, can be registered. Connections between social relations, like connections between persons, have to be experienced in terms of their changing effects upon one another. Relations and persons become in effect homologous, the capabilities of persons revealing the social relations of which they are composed, and social relations revealing the persons they produce. But revelation also depends upon the techniques by which one entity—a person, a relationship—is seen to be differentiated from and to have an impact upon another. Persons appear as individuated women and men with influence and power at their disposal; relationships appear to contain or extend people's potentialities.

My account is thus lured into considering ideas about cause and effect. The constitution or capability of one person becomes externalized by he or she drawing out of another a counter condition. This response in turn, of course, provides the actor with the very evidence of his or her own internal capability. And the other is not necessarily

another human being. Munn observes of men from Gawa Island, to the
north of both Tubetube and Sabarl, that although "they appear to be
the agents in defining shell value, in fact, without shells men cannot
define their own value: in this respect, shells and men are reciprocally
agents of each other's value definition" (1983:283). In lieu, then, of a
theory of symbolic construction, as we would reckon it, we find a
Melanesian theory of social action. Action is understood as an effect,
as a performance or presentation, a mutual estimation of value. Such
presentation we might be tempted to call 'representation'; in indigenous
terms it is perhaps better apprehended as 'knowledge'. "A symbolic
expression is the actualization rather than the representation of people's
shared understandings" (Clay 1977:3).

This description accords with recent re-thinkings of the nature of
symbolic activity, in critiques of the supposition that we can understand
symbols simply as expressive instruments of meaning (e.g., Bloch 1980;
1985; Sperber 1975; and among Melanesianists, Harrison 1985a;
Lewis 1980; Schieffelin 1985; Wagner 1972; 1975; 1978; J. Weiner
[in press]). A performance is not necessarily a performative.

I take an example from about as far from Sabarl as one can travel
in Papua New Guinea. Writing of the Mianmin, a Mountain Ok peo-
ple near the western border with Irian Jaya, Gardner (1983) criticizes
analyses of initiation and other rituals that regard them as simply
instantiating by their acts a known state. The aim of Mianmin ritual
action is to change states and create effects, but not in the constitutive
sense by which performatives are defined. Mianmin so act in a context
of uncertainty about outcome, which makes every performance also an
improvization. A successful outcome may be judged in the display itself,
but this is only then to be judged by subsequent effects, in the long term
affairs of the community. Magical and practical techniques "are not
intended to be 'performed' [qua performative] or followed as a 'code',
but rather used as the basis of inventive improvisation" (Wagner 1975:
88, emphasis removed).

Indeed, Wagner's is the most elegant formulation of this theoretical
position, for it encapsulates both Western and Melanesian proclivities,
the idea of a symbol *both* as a conventional, artificial expression of
something already (invented) existing in itself, *and* as the inventive
desire to draw out of relations and persons the innate (conventionalized)
capacities that lie within them. Where the one rests on a linking notion
of arbitrariness (culture), the other rests on a notion of uncertainty (and
thus of power), of a state not being a state in any fixed sense.

The status of these constructs must be specified. In the same way as the root metaphors of the commodity and gift economy were grasped as an inverse construction, so we may also grasp these differences in symbolization. I present them in terms of a self-contained contrast. Consonant with the fictions through which my account is composed, the relationship between invention and convention is like that between person and thing, or between consumption and production; the one concept contextualizes the other. And like gift and commodity, they necessarily derive from the symbolic practices of a commodity economy. But the predominance of one or other term may serve to capture the distinctiveness of an intrinsic cultural form. I quote Wagner:

> Convention, which integrates an act into the collectivity, serves the purpose of drawing collective distinctions between the innate and the realm of human action. Invention, which has the effect of continually differentiating acts and events from the conventional, continually puts together ('metaphorizes') and integrates disparate contexts (1975:53). . . . *And because both kinds of objectification take place in every cultural act* (one in an explicit and 'masking' role, the other in an implicit and 'masked' one), it follows that every such act involves the interplay of invention and convention. (1975:45 my emphasis)
>
> If Americans and other Westerners create the incidental world by constantly trying to predict, rationalize, and order it, then tribal, religious, and peasant peoples create their universe of innate convention by constantly trying to change, readjust, and impinge upon it. Our concern is that of bringing things into an ordered and consistent relation. . . . and we call the summation of our efforts Culture. Their concern might be thought of as an effort to 'knock the conventional off balance,' and so make themselves powerful and unique in relation to it. (1975:87–88)

The contrast is, of course, a technique of our own devising for making the suppositions of others 'appear' with some autonomy in our accounts. The chapters that follow draw on a number of Wagner's own techniques as well as allude to his Highlands ethnography. For the necessity for such devising continues, as must critiques of this kind, because of the tenacity of our own intervening metaphors. The chapters of part 1 were intended to give some sense of that tenacity and in places one would least expect.

It is both interesting and incidental that it was a Melanesianist (Leenhardt) who in 1947 formulated the notion of a mode of thought that juxtaposes but does not classify, and an historian who unearthed this prescience with a comment on that significant "break with common habits of closure and wholeness, structures of the intellect and the body" (Clifford 1982:181). But the break never became one.

OBJECTIFICATION

Where objects take the form of persons, actions and activities neces-
sarily reveal the person in turn as a microcosm of social relations. What
become hidden are the techniques of reification, the conventionalized
assumptions through which revelation works. Yet such conventions
have wide ranging consequences for the conduct of people's lives. Let
me try to make these consequences appear by continuing with the set
of contrasts I have chosen for myself.

Critiques of commodity ideology, which supposes that labor is a
thing, point out that labor in fact originates in the work of persons. If
gift ideology supposes that work produces relations between persons,
then the countercritique might point out that while relations are sus-
tained through the mediation of things, these things have an indepen-
dent existence and character which will also determine the manner in
which relations are structured. But as we shall see, what is crucial is
not their materiality as such (Sahlins's 'practical reason'), the fact of
them having substance that may be consumed/utilized. It is the specific
form or shape they take that matters.

By objectification I understand the manner in which persons and
things are construed as having value, that is, are objects of people's
subjective regard or of their creation.[1] Reification and personification
are the symbolic mechanisms or techniques by which this is done.

These terms refer to nothing other than relations between concepts:
they embody certain concepts of relations. My recursive formula is
deliberate—an internal play on the terms of a metaphor derived from
one component of commodity thinking, namely its analogy between
things and persons. If these concepts thus refer to anything it is to the
forms in which persons make things appear and the things through
which persons appear, and thus with the 'making' (-ification) of persons
and things. That in a commodity economy things and persons take the
form of things (p. 134) is encompassed in the proposition that objects
(of whatever kind) are reified as things-in-themselves. Concomitantly,
in a gift economy, objects act as persons in relation to one another.

In using objectification as a basis of comparison between the two
'economies', I make the assumption that one can so perceive similar
processes in each. At the same time, one perceives their difference.
If we take symbols as the mechanisms through which people make
the world known (objectify it), these mechanisms themselves may or
may not be an explicit source of their own knowledge practices. The

commodity logic of Westerners leads them to search for knowledge about things (and persons as things); the gift logic of Melanesians to make known to themselves persons (and things as persons). For the one makes an explicit practice out of apprehending the nature or character (convention) of objects, the other their capabilities or animate powers (invention). If I call these practices reification and personification then, in the first case people are making objects appear as things, in the second as persons.

Personification: separation and exchange: A helpful starting point is a commentary on Marx's views of the objectification of capitalist labor. A summary of his position goes as follows: "[B]y transforming the objects of his environment, man not only satisfies his needs and gives them value, but he also separates the objects and makes them his own. The transformation of objects into possessions is through labour" (Ortiz 1979:210). The process of objectification here establishes a relation between subjects and the objects of their regard that is known through the separation of one from the other. Reification is its overt mechanism. And the reification of objects is created through commodity exchange, through the equivalence of forms that Godelier notes. Thus do the objects of people's relations with one another appear to be things, as may indeed the objects of a person's creativity, both encapsulated in the Western idea that work produces things.

The Melanesian personification of objects is also established by separations. But the separations are constituted in discrete social identities. It is the (social) separation of persons as distinct from one another that provides the precondition for objectification. Work ('production') thus appears to produce relations—to give the orientation of a person's activities value in the regard of a differentiated other. Transactions, as in ceremonial exchange, may be considered in the same way. Here a relationship is objectified through items (such as valuables) which pass between donor and recipient. In so far as they are 'transacted', they have a social identity different from the transactors. This 'separation' is accomplished in turn through the way in which the relationships are defined.

Thus items become separable under the following condition: they are separated from the donor in so far as they are transacted with another whose social identity is not that of the donor him/herself. The very fact that the item is received by another means that its significance cannot be the same for the donor as before the transaction. In so far

as it mediates and thus has an effect upon the relationship between them (donor and recipient), it stands for that part of the donor invested in the relationship, appositely to some other aspect of the donor's identity. Thus 'objects' are created out of what these persons can dispose of because of the social separation of the interests of the parties to the transaction. In sum, relations are objectified by persons and things being separable or detachable from one another, and this condition of separation is known, in turn, from the relations that ensue. In this sense, the possibility of producing or creating relationships, of taking some action with respect to them, is itself a precondition to separation or detachment.

The processes just described, however, commence at different conceptual points. The result is two symbolic modes that we can call modes of exchange. And using persons as the form in which objectification is made visible seems in Melanesian cultures to be limited to drawing on one or the other mode.

First, as in ceremonial exchange transactions, things are conceptualized as parts of persons. Persons or things may be transferred as 'standing for' (in our terms) parts of persons. This construction thus produces objects (the person as a 'part' of a person—him or herself or another) which can circulate between persons and mediate their relationship. As parts, then, these objects create *mediated* relations. They are not, of course, apprehended as standing for persons: that is our construction. They are apprehended as extracted from one and absorbed by another. Donors and recipients are consequently regarded as distinguished from one another by the way these items, such as valuables, are detached from or attached to their persons. The second mode I call *unmediated*. It characterizes the work of production. Persons do not detach parts of themselves: whereas in mediated exchange a person's influence upon another is carried in the 'part' that passes between them, here effects are experienced directly. What are separately conceived as products of the activity embody the effects in a different form, as we shall see. Persons are construed as having a direct influence on the minds or bodies of those to whom they are thus related. The capacity to have an unmediated effect creates a distinguishing asymmetry between the parties.

The content of this contrast may be grasped in many ways. Through mediated relations, items flow between persons, creating their mutual enchainment. The items carry the influence that one partner may hope to have on another. Through unmediated relations, one person directly

affects the disposition of another towards him or her, or that person's health and growth, of which the work that spouses do for one another or the mother's capability to grow a child within her are examples. Or one may think of the contrast between the circulation of blows in warfare, and the harm that one body can do to another because of its very nature, as evinced in so-called pollution beliefs. Despite the absence of mediating objects, these latter interactions have the form of an 'exchange' in so far as each party is affected by the other; for instance, a mother is held to 'grow' a child because the child, so to speak, also 'grows' her.

Yet whereas the first mode of symbolization is recognizable to us through Mauss's description of gift exchange—persons transfer parts of themselves—the second would not normally be recognized as a type of exchange at all. However, the earlier remark that social relations take the form of gift exchange is meant to include both mediated and unmediated modes within a single type, for they are created within the frame of a single conceptual system. Though there are differences between them, the differences are related to each other. One cannot, out of the workings of Melanesian social action, extract one set of relations as typical of 'gift relations' and another as typical of non-gift relations: the unmediated mode takes its force from the presence of the mediated mode, and vice versa. I therefore use the nomenclature of gift exchange to cover all relations, even though this produces the semantic paradox of there being gift exchange without a gift. The paradox in fact usefully points up the crucial absence (no gift) that characterizes the unmediated mode of symbolization.

To say that work produces relations and that transactions create objects, then, captures different points of a recursive sequence of revelation (relations as the objects of people's interactions). The sequencing is itself marked by separations, as in the distinction the Daribi of the Southern Highlands act upon, between consanguinity that relates and exchange that defines (Wagner 1967), or in the Hagen distinction between production and transaction (M. Strathern 1972). Hagen gift transactions are specifically *ukl* ('creations') in which 'things' (*mel*) are manipulated (*mel* in general are wealth items. As we have already seen these objects of mediation are not produced in the course of 'work' (*kongon*), for that simply evinces an orientation of 'mind' (*noman*).[2] Work has a direct (and unmediated) effect on one's partner. *Ukl*, however, includes display, political speech making, and the mediations of magic spells. *Ukl* thus brings things visibly to one's outer

'skin', where *kongon* evinces the orientation of the inner and hidden
'mind'.

The analysis or critique of constructions such as these must be as
follows. In a gift economy, social relations are made the overt objects
of people's activities. In the direct, unmediated activity of work, the
fact of relatedness may be taken for granted (as between kinsmen), but
work makes the specific relations visible—kinsmen do things for one
another as kinsmen should, as spouses also work with each other in
mind as spouses should. Transactions, however, appear to make rela-
tions afresh, for the instruments of mediation—the gifts—appear to be
creating the relationship. Transactions are thus experienced as hold-
ing out the possibility of relationships ever newly invented, as though
there could be an infinite expansion of social connections. Hence Jo-
sephides's shrewd observation about the myth that gifts seem to create
gifts. Together these modes of exchange compose an explicit practice
of personification. From the perspective of Western knowledge prac-
tices, however, they conceal their own conventions, that is, the further
mechanism of reification.

Reification: the constraint of form. Separations are intrinsic to the
ability to perceive ('personify') relations. The activities that Hageners,
for instance, distinguish as production and transaction are themselves
composed of distinctions. In the first case, the products of work are
separable from those who produced them in that they stand for the
relationship between the producers. In the second case, the transactors
are separable from each other in order to create a relationship between
themselves. The necessity to differentiate becomes an explicit burden
of people's interactions with one another (Wagner 1975:52; 1977a:
624). But the differentiation in turn will only be apparent, made visible,
if the correct forms eventuate and the correct 'conventions' thus hold.

This can be put another way. The objectification of relations as per-
sons simultaneously makes them into *things* in so far as *the relations
are only recognized if they assume a particular form.* Indeed, there is a
very small number of (conventional) forms that will do as evidence that
relations have been thus activated. They must display certain attributes.
Establishing attributes, the nature of things, is not the explicit focus of
these symbolic operations, but it is present as an implicit technique of
operation. From our point of view, the operation thus conceals its con-
ventional base. Objectification necessarily requires the taking of a form;
knowledge has to be made known in a particular way. Now Western-

ers apprehend as symbolic a relationship between an item and what it 'expresses', as we imagine a shell valuable depicting a child, for the relationship is between 'things' each with their own form. Where Melanesians personify relations—endow valuables with human attributes and human capabilities as they do individual people—they must instead *make the form appear*. For a body or mind to be in a position of eliciting an effect from another, to evince power or capability, it must manifest itself in a particular concrete way, which then becomes the elicitory trigger. This can only be done through the appropriate aesthetic.

My argument is that relations are objectified in a few highly constrained ways. Only certain specific forms of interaction will be taken as evidence of the successful activation or maintenance of relationships. In being conventionally prescribed these are reified: they-in-themselves hold evidence of the successful outcome. We might call these things performances. Performances must thus be recognizable by their attributes. Only certain performances, then, will make the relations that they objectify properly 'appear'. Improperly done, the relations will not appear, as people dread when they take omens to establish the blessing of ancestral ghosts or tremble in their finery before the scrutiny of a critical audience. The Paiela equivocations described by Biersack (see chap. 5) make the point nicely.

In this sense, we may understand the two exchange modes of personification as 'reified': their manifestation is prescribed in either mediated or unmediated relations. The differentiating (conventional) prescription of these forms is hidden in so far as what they make apparent are the relations themselves. The two modes of reification I am about to mention similarly hide the principles of their own aesthetic. Their conventional nature is made covert in people's overt experience of these forms as invented, individuated performances, for all they perceive is their own activity, freshly instigated, that "[a]n innovation is an event" (Wagner 1978:253, emphasis removed).

Three types of event are acceptable indications that social relations have been activated through mediated or unmediated exchanges. First are two performances that one might call the external and internal analogues of one another. These both manifest *replication*. What is replicated are relations—either extending beyond the person or operating within the person. If we were to focus on the substantive form of the relations from our point of view, we might be tempted to call these respectively the flow of things between persons and the growth of things within a person. In both cases, however, the object of interaction is to

make relations visible through their replication. As an alternative, and it is the only alternative, relations may be made visible through *substitution,* the creation of a thing that embodies those relations in another form. The production of wealth or children is how we might phrase it.

Chapter Eight first analyzes the replication of relations through the kinds of mediated exchange familiar in the anthropological literature and then touches on the replication of relations made visible through unmediated growth. Chapter Nine turns to the process of substitution by which relations are made visible in a form other than themselves; the substituted effect is often staged as the transformed outcome of relations magnified through replication. These latter are thus doubly revealed, as themselves and as themselves in another form.

The pairs of analytical contrasts (mediation, nonmediation/replication, substitution) participate in each other. There are two manifestations of replication (mediated and unmediated), which I have described as the external and internal analogues of one another. There are two manifestations of unmediated relations (replication and substitution), which may be considered as alternatives to one another. These permutations are made concrete in the imagery through which the performances are contrived. This is the imagery of gender. In my account, it is the final reification, the final constraint, but in the lives of those who live it, of course, gender exists as a further enablement.

GENDER

What are the attributes to which I have referred? The distinction between replication and substitution underlies the staging of events: those events themselves must take concrete shape. That shape is their gender. And this basic, limiting aesthetic accounts for the paucity of modes that will provide proper evidence for objectification. Everything must take one of a pair of forms. At the same time, this aesthetic is the enabling condition for an infinite reduplication of the pairs themselves.

Gender is evinced through what Melanesians perceive as the capabilities of people's bodies and minds, what they contain within themselves and their effects on others. Conversely, like the differentiation of relations into mediated and unmediated types, capabilities are made manifest through an internal differentiation between male and female. But it is the capacity or capability which appears as people's concern: the conventional basis through which the attributes of maleness or fe-

maleness are established is not apprehended as an artificial, symbolic practice.

Since all persons are defined in terms of their capabilities, it follows that persons can only be apprehended in a gendered form. I note that the reference to persons here includes reference to individuals; the ambiguity is important to my purpose at this juncture.

The shape that people's bodies and minds take—whether they are seen as male or female—becomes the focus of their operations upon one another. That is not the same as saying that they are always in a sexually activated state. On the contrary, sexuality is a specific activation of a particular gender state: for a person to encounter another of 'opposite sex' means that her or his own gender takes a singular form. In this condition, one person elicits a corresponding sexual form in another. He is all-male or she all-female, strictly with respect to that other. When gender identity thus becomes homogenized in a unitary, single sex form, the person's internal parts are in a *same-sex* relation with one another. However, the outcome of such activation, conceived as a product of the relationship between partners, takes another form: it embodies within itself a *cross-sex* relation.[3] A person's gender may thus be imagined as dually or multiply composed, and in this androgynous state men and women are inactive. In their dealings with one another, persons alternate between being conceived in a same-sex state or a cross-sex one. They thus embody or objectify social relations by evincing them in either one or the other shape. And, as Clay (1977) argues with respect to the Mandak category of nurture, they can consequently *only* evince a relationship in its already differentiated form.

Sexually active, a person elicits a cross-sex relation with a partner with whom he or she thereby establishes an unmediated relation. That effect is registered in that person. Their relationship may be perceived as an outcome of their unmediated activities and take the form of its product—the results of a division of labour or procreation in which each has some interest. The product (food, a child) becomes a substitution for that relationship: a dual relation consequently appears in a singular and composite form. However, relations may also be elicited with a same-sex partner. The elicitation, the creation of an effect through bringing separate entities together, can be achieved only if the partners become differentiated as subjects, their interests thereby being separated through the relationship itself. As I have already anticipated, in the same way as donors and recipients are created by their different

interests in the items that pass between them, so same-sex relations can be created by the process of mediation, the passage of an item between parties already conceived as other than themselves. Indeed, this applies to the internal as well as the external constitution of the body. The exchange of items, which have a dual value in being differently conceptualized from the donors' and from the recipients' points of view, thus appears to effect a replication of singular persons.

Imagining a multiplicity of persons of the same singular sex makes replication visible. Similarly, the successful substitution of an unmediated relationship, as a child substitutes for its parents, is shown in its cross-sex or androgynous composition. Single sex replication provides an image of the flow and the growth of items, but at the point at which flow and growth is revealed, at the point of production (birth) or consumption (death), a cross-sex relation appears. This is the moment of substitution. Here production is analogous to consumption: the outcome of unmediated relations that substitutes for the relationship its own effect.[4]

Although it is only in a single sex form, then, that persons create an effect on others, as substitutions they also evince the effects of active others upon them. I thus regard gendering, like exchange itself, as significantly present both as a same-sex identity (male or female) and in its combination or 'absence', imagined, for instance, in the cross-sex androgyne. It therefore becomes impossible in my account to think of gender simply as a question of the relationship between male and female. That incorporates an inappropriate commodity view which, in supposing that entities exist in themselves, requires explanation as to the relationship between them. This is the sex-role model of gender which has dogged analyses of initiation rites, described in chapter 3. More generally, it underlies the current Western orthodoxy that gender relations consist in the 'social or cultural construction' of what already has differentiated form through the biological sexing of individuals (chap. 4). Melanesian orthodoxy, however, requires that the differences must be made apparent, drawn out of what men and women do.

As I understand the gift view, at certain moments male and female persons may be opposed, as discrete reference points for the relationship between them. In itself being neither, the relationship is different from them and may be imagined as embodied in its product. The (androgynous) entity so produced, the object of the relationship, literally evinces their cross-sex relationship within itself.[5] Each singular state anticipates future interaction, since it is as independent entities that male and

female persons then join together. For this joining to occur, a composite, androgynous entity has had to be reconceptualized as singular, and in being differentiated from another as incomplete. Figuratively conceived, 'male' and 'female' exist as analogues of one another, alike in that each is a same-sex construct.

This recursive formulation cuts across the commodity-derived view that it is as (figuratively conceived) individuals with intrinsic ('biological') attributes that male and female persons are in a perpetual relation of difference. We therefore have to avoid any presupposition that takes the differentiated single sex state as a 'natural' reference point. If there were such a reference point in Melanesian society, it would have to be drawn from the root metaphor—the multiple person produced as the object of multiple relationships (markedly but not exclusively from the duo of sexed parents). In being multiple it is also partible, an entity that can dispose of parts in relation to others. Gender refers to the internal relations between parts of persons, as well as to their externalization as relations between persons.

Hence I have proposed that the Melanesian gender relationship upon which we should concentrate is not between male and female but between same-sex relations and cross-sex relations. We may apprehend them as the gendered forms of persons who must appear as either singular or multiple in their composition. The one is a potential transformation of the other.

Although resembling categories belonging to the analysis of kin terminology, my terms derive here from an extension of Clay's (1977) distinction between same-unit and cross-unit relations in Mandak, New Ireland. Sex has the connotation of a unitary state. Same-sex and cross-sex relations may refer to identities held in common—an 'all male' relationship between the men of an agnatic clan (same-sex); a male-female relationship between brother and sister, in which the sister produces wealth for the brother (cross-sex). Or they may connect the parts of a person—a 'female' clan member with 'female' wealth at her disposal (same-sex), or a 'female' mother giving birth to a 'male' child (cross-sex). The encompassing relationship, between same-sex and cross-sex identity, is the subject of considerable attention. For the reproduced person conceived (objectified) as the outcome of relations is itself nonreproductive. The objectifications of a gift economy consequently require a double coercion: to ensure that reproducers will indeed interact and produce objects (persons); and to ensure that the completed object is itself transformable into a subsequent reproducer. What is true

of human beings is also true of food, wealth, and the other items they produce. Each must acquire a reproductive potency. These coercions in turn manifest the exercise of agency in the effective transformation of one gender state to another.

This applies as much to political as to ritual activities. The hazard of gauging whether or not any particular event has been successful engenders a general ethos open to change, to 'trying on' new ideas and new relationships. For only effects validate procedures. Such concepts prize us away from inevitably regarding culture as a structure of fixed points whose interrelations must be explained. Melanesian ethnography enables us to contextualize this selfsame decoding, inherent in the Western idea of explanation, as the laying out of conventional or literal (cultural) relations between figuratively conceived (natural) things. But Melanesian ideas also impose their own drastic limits on the behavior of men and women, as ideas must.

One such limitation is evident in the fact that every construction participates in another. This is true for the relationship between exchange and gender. As Battaglia noted, each can become a metaphor for the other (see Clay 1977:3). Thus, the different interests of exchange partners can be metaphorized *as though* they were male and female to one another, and as though gifts, the objects of mediation, were like androgynous children. And the combined interests of parents in their children can be split apart by a metaphorization of parenthood *as though* it were the consequence of same-sex relations among men or among women, and the child were an object of mediation like a valuable. To return to an earlier example, cult displays in Hagen are on the one hand *ukl,* performances, a type of political activity that involves the manipulation of magic things and thus creates a mediated relationship between men and the cult Spirits; on the other hand, through conjugal and domestic idioms, cult preparations may be spoken of as work *(kongon)* for the Spirit who will attend to the personal condition of the participants (A. Strathern 1982b:308).

The consequences of thus deploying people as persons, as the objectification of relations, entails their being always in a gendered condition: whether same-sex or cross-sex, their form either has an effect on others or evinces others' effectiveness. Hence Buchbinder and Rappaport's observation that in "taking gender to be a metaphor for the conventional oppositions they impose upon the world, people establish forever those oppositions in their own bodies" (1976:33). And there is a sociological consequence: sociality is always presented as an alternation between

one of two types. This becomes the precondition for the domination that men and women variously exercise over one another.

The terminology of same-sex and cross-sex relations is, to say the least, inelegant. Its repetition will make for awkwardnesses in the language I use. But I must regard that as a necessary dissonance.

I have also introduced the concept of reification with deliberate dissonance, to draw attention to what as outsiders we may legitimately regard as 'expressed' or 'constructed' in these gender ideas. Constraints exist in the way in which certain overt forms are taken as indicative of internal capabilities in things and persons which, in being capabilities, can also be externalized in relations. Indication depends on aesthetic convention. Appearance is structured: the color and curvature, hollowness and hairiness, extendability and edibility of things thus circumscribe as much as they open up possibilities. A hollow container may present itself to our Western eyes as an incongruous mix of radically different metaphors, female breast or male penis in the case of Sambia initiates;[6] but from their point of view, it *must* be one or the other or both in combination. For the participants' attention is directed to the crucial relationship of the encasing instrument and what it exudes, to its capacity. When they know that, they will know the gender of its form.

FIXING POINTS

Quite a plethora of terms has surfaced. The nomenclature is incidental: it is the differences and identifications which they delineate that count. But the plethora itself is presented without apology. The terms cannot be summarized or collapsed by privileging one of the several contrasts as the archetypical contrast. On the contrary, each is a vantage point from which to think about others. Thus, should we think of the modes of mediated or unmediated exchange, or of events as replications or substitutions, or of same-sex and cross-sex gender relations, we may also think of the techniques of personification and reification, of invention and convention, of the two types of sociality, and of the contrasts between collective and particular activities, singular and multiple persons. Any one of these discriminations affords a starting point for considering the others. But they are expansions and contractions of one another, tropes in a general sense of the term, not subcategories of a category or the species of a genus or components of any overarching classificatory system. I am afraid it will not help the reader to get out a pencil and list them as though they could be held together as two

columns of a table. In any case, a conventional table is held up by four legs, not two columns.

I do not joke. Metaphors participate in one another. The manner in which they so participate must be traced through as an act of faith in the details of the images that provide the linking thoughts—the linkages being the anthropologist's subject matter.

The plethora of steps or stages along such paths are no more nor less complex in Melanesian thought than the multitude of 'levels' that Western anthropologists discover in their descriptions of cultures, the 'structures' they devise, or the range of 'domains' into which they classify segments of society. The way I have presented the Melanesian ideas are bound to appear both too abstract and too concrete. But perhaps thus they will make explicit the nature of our own concretenesses and abstractions. Politics, economic systems, religious belief, family life, or for that matter, ideology and cognitive structures, or relations and forces of production, systems, and events all appear to Westerners as manageably distinct levels or domains whose similarities or differences we may then expound in showing their relationship to one another. It is of this order—of the order of the connection between politics and religion, say, or of infrastructure and superstructure—that we must comprehend the workings of a contrast between mediated and unmediated exchange or of collective and singular identities or of male and female shapes, and the workings of the contrasts upon the contrasts.[7]

The contexts of these operations are supplied by themselves: one 'construction' as we would have it is the vantage point from which others appear. Thus the replication of gender identity may be evinced in *either* an external, mediated *or* an internal, unmediated mode. From the point of view of making things grow, unmediated relations may be construed through *either* the replication *or* the substitution of effects. At each juncture throughout these operations a distinct condition is made known through *having to appear as one of a pair of interrelated forms*. Thus we could say that in so far as people think about sociality in general, they do so through thinking about it as either a collective or a particular set of relations: it presents itself so to speak in one or other aspect. One can act only in reference to the one or the other, and thus sociality is 'immanent' within them.

Each of this pair of terms may be figuratively conceived, that is, taken for itself. And it may be taken for itself in two ways—either as one of a pair of like (rather than unlike) entities, as the collective life of one clan or group is reduplicated in the collective life of another; or it will

be made to appear not as half a pair but as divided internally, existing in itself because it encompasses relations within, so at the heart of a clan's collective identity are its extra-clan relations with particular others. The result is that, for the actors, the clan is present only under one of two conditions. If matrilineally composed then it appears either collectively as 'one breast', 'one womb', with its own land, its own magic, or else as a matrix of particular exchanges that unite and divide brothers and sisters, husbands and wives. But it must be made present. Social action itself consists in 'presentation', in making such entities appear, and this is done through eliminating one or other of the forms. My own critique has been that what the participants apprehend as an effect of their interaction with one another depends upon the aesthetic conventions by which, in this instance, collective and particular relations are contrasted. In this sense do their actions depend on a prior reification.

All this is hindsight. What must be supplied are the details, the evidence. The multiplicity of operations creates problems of exposition, and I merely continue a set of sequences already begun. I thus make the evidence lie, on the grounds of my own argument, in the elucidation of gender relations. I have to show how things look from its vantage point and thus that gender ideas 'work' in the ways suggested. This will involve backtracking over materials already partly discussed. But there are also expository problems in the very nature of the exercise, for as one moves from one proposition to another, each will have the capacity to dissolve into its own components. The description could be ramified forever. I must therefore backtrack in another sense: to remind the reader that what is now presented as evidence was first apprehended not as an answer but as a question, not as solutions but as problems. These concerned specifying the nature of Melanesian gender relations in the first place, and the consequences for men and women.

My argument is in fact already implicated in its own sequencing. It has turned on a contrast between the overt personification of relations and the covert techniques that determine the proper forms through which these are recognized. The latter I see as analogous to reification in a commodity economy, though it holds a very different place in people's knowledge practices. I have suggested that gender works as an instrument of reification, presenting 'things' so to speak (effects, events) as people assume they ought to appear. However, this is really a particular case of the general contrast between invention and convention. Every discrimination, for example between same-sex or cross-sex gen-

der or between pigs to eat and pigs to give away, or between male and female procreation as Clay (1977:152) describes for Mandak, pivots on a relation between terms which itself remain implicit—the nature of the conventional relationships is 'hidden'. It works simply as an aesthetic; the conventions are ultimately aesthetic conventions. What people do is make the distinctions visible. And they then reveal the 'invented' effect or event, the distinction manifested in a particular form. At every juncture in the exposition that follows, then, we shall encounter forms that are revealed through distinctions, while the 'construction' of the distinctions themselves, the classificatory scheme they constitute, the symbolic relations as we would have it, remain implicit.

This interplay is an attempt to evoke Melanesians' own preoccupations with secrecy and exposure, with shape and what the shape contains. At the same time, the awkward plethora of terms is an attempt at making explicit and thus obtrusive the conventions that to them appear in the incidental and invented guise of people's actions and performances.

8
Relations Which Separate

The societies of the Massim briefly alluded to in the last chapter—Tubetube, Sabarl, Gawa—are all 'matrilineal' in terms of their kinship organization. The affairs of women and men are, nonetheless, governed by constraints similar to those elucidated for the central Highlands dominated by 'patrilineal' kinship ideologies. Indeed, the Massim will advance the argument in important respects, for it bears comparison through the nature of ceremonial exchange. Although mortuary ceremonies in many of these societies should be given first prominence,[1] my initial interest is in the exchanges that take men away from their home communities. While it by no means extends over the entire Massim, the overseas *kula* is a principal exemplar.

It is a good place to begin, if for no other reason than that the *kula* has suggested itself to anthropological inquiry as an integrating mechanism. The thought of dozens of tiny islands bravely linked by sailors who hazard the seas in order to exchange and trade with one another forms an irresistibly concrete image. Sociality, it is concluded, must be some kind of inner drive to form relationships and maintain cohesion between people who would otherwise remain strangers to one another. Anthropologists consequently stress how the circulation of gifts creates relationships and integrates 'society' (for two examples, see pp. 66–68). But we shall not get very far in the analysis of gift exchange without realizing that gifts quite crucially sever and detach people from people.

Exchange is essential to the processes of personification through

which persons are separated by the social relations between them. It is the relations (their reciprocity, Wagner 1967:85) which differentiate them, for each is defined with respect to the other and thus has his or her separate interest in the relationship (Gillison in press). I suggested that exchange takes either a mediated or unmediated form: it is known through its appearance as one or another type. The hidden convention on which these appearances rest, their reification, is that of gender replication. Replication is imagined as the infinite expansion of same-sex relations.

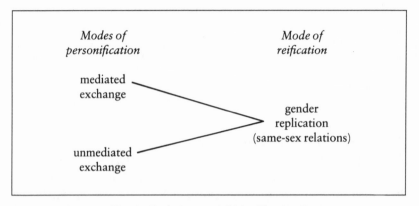

Fig. 1. Techniques of Objectification I

MEDIATED EXCHANGE: PARTIBILITY

Mediated exchange draws on the indigenous image that persons are able to detach parts of themselves in their dealings with others. Its effect is evinced in the 'flow' of items. The manner in which valuables may be detached from one person and attached to another is of consummate interest to *kula* participants. Munn writes:

> The control embedded in possession of a shell includes not simply Ego's ability to get others to act in ways that carry out his own will, but also his capacity for becoming the focus of the attempts of others to get him to act as *they* wish. (1983:278, original emphasis)

Everything turns on the influence people can exert. It need hardly be added that the detachability of items has nothing to do with alienation; the parts circulate as parts of persons. Again, however, a concrete image intervenes in our understanding. The precious valuables, after which *kula* partners hunger, disappear on the perimeter of their vision, to circulate between the partners of partners, beyond the original per-

son's 'control'. This has too much the appearance of alienation for us (see, for example, the correspondence in *Man* 1982:n.s. 17:340–345; 1983:n.s. 18:604–605). Surely, we protest, the item is no longer thought of as belonging to the original donor. But for the participants, the knowledge that the partners are always dealing with the 'parts' of other persons, anonymous or otherwise, is established quite simply and emphatically through their gender. Overseas *kula* partners are conceptually male. The condition is brought about through their own separation from females, a separation that also establishes their capacity to mobilize the parts of themselves that then appear at their disposal.

These observations are prompted by Damon's (1980; 1983a; 1983b) analysis of exchange on Muyuw (Woodlark Island) in the northern Massim. It is important that he puts his argument about *kula* transactions into the overall context of male-female relations. For the separation of males from females is a double action. Internal relations between parts of persons as well as external relations between persons are gendered, and separation is not simply a question of men taking themselves off in their canoes and leaving the women behind. They have to establish the gender identity of their activity and of the parts with which they do indeed intend to transact, and that involves transforming the meaning of their own previous actions. Damon supplies a quite necessary digression on domestic kinship.

The flow of wealth: kula. The two significant axes of Muyuw male-female relations concern brother and sister, husband and wife. The manner in which the activities of the sexes are separated and combined means that people in these relationships have different and particular effects on each other. Damon (1983a:313–314, 318) argues that between husband and wife, for instance, the man is producer and the woman distributor. The man produces food and children; the woman divides garden products into those for consumption and those for future propagation and distributes his food to the child which grows inside her. She thus completes the work the man has begun. Children are regarded as being created by the husband's work.[2] A man transforms his work, as Damon calls it, into the creation of persons. But, importantly, the products of this work are also separated from him: the children do not share his social identity since they belong to his wife's (matrilineal) subclan. The distinctness of their social identity makes his work visible in the body of the child. The child is not an extension of him but is his work in a transformed state, for it is oriented toward his

relations with his affines, and that relationship is its context. Toward the child, his relationship is unmediated: he 'feeds' it.[3] Damon's own argument is that "a woman's children are in her group because they hold the credit she receives by virtue of the loss of her brother's labour. Muyuw matrilinearity derives from the debts engendered by the process of producing people" (Damon 1983a:317). How does a woman 'lose' her brother's labor?

The separation of a sister's and brother's work from one another is crucial to the production of children, for it contrasts with the series of transactions between themselves and between their kin that deliberately combines the work of husbands and wives. A couple first meet as entities separated by virtue of their different subclan origins. But the wife's work is eventually combined fully with that of the husband. When they take up residence on the husband's land, an exchange of items between the affines establishes that the children are 'his' in so far as they are evidence of his (and not another man's) energies. They embody his work in a direct fashion, and the wife who helps her husband contributes directly to 'his' productive enterprise. The transactions that demarcate the nature of her contribution comprise what Damon calls a short circulation cycle that concludes with her death. Then, the husband's kin give at least one *kula* valuable to the wife's kin in explicit acknowledgment of the work she contributed to his enterprises. It substitutes for her work and closes the relationship by cancelling the debt her work created; that is, it substitutes for the cross-sex relation between husband and wife. From the brother's point of view, the sister's work that he lost (to her husband) thus returns to him in the form of wealth.

It is not work or food which establishes the subclan identity of the children—that is instituted in the separation of a woman's relations with her husband from those with her brother. Combining with the husband is being separated from the brother. She participates little in his endeavors, and indeed the siblings are enjoined to observe a distance between them, particularly in reference to the sexual production of those children. This separation generates what Damon refers to as a long cycle of transactions that only comes to an end with the death of the brother's children. Although she has a lien on her brother's work, it is not translated into products that the sister consumes: she is "separated from her brother's ability to transform one thing into another" (1983a:315).[4] And because her own work becomes combined with that of her husband's, she is herself unable to produce consumable products

for her subclan. Instead, she (her work) is metamorphosed into a product of a special kind.

From the woman's point of view, the completed effects of her husband's work show in the (external) facial features of his children;[5] their internal subclan identity is sustained by never-completed exchange. Her subclan alone exercises the right to recall the woman's work in the form of wealth, and this process establishes the interests of the children as separate from their father. It is they (the children) who can reclaim the mother's work as a *kula* valuable, and they reclaim it from their father or the father's kin. In this they are identified with the men who can make the same claim, their mother's brothers. Only as members of a subclan do men recover a woman's work in a transformed state, as a valuable. For 'work', of course, we need to understand the particular 'domestic relations' (between spouses, between siblings) which the work makes visible. It is these relations which undergo transformation. The husband enjoys his relationship with the woman as an unmediated contribution to his productive activities. The subclan enjoys their relationship with her in a mediated form; Muyuw conceptualize the wealth as a 'replacement' they are owed.

The valuable so singled out bears specific reference to work. It falls into the class known as *kitoum*, which are those *kula* valuables a man deploys by virtue of their standing for some part of his activity. Between brother and sister, only the sister's work can be transformed into a *kitoum*, but it is for her brother (or her children) that this is done. Thus in a 'male' form the subclan has 'female' assets at its disposal.

> An informant once told me that a subclan was 'like a bank'. When I asked him what was in the bank, he replied, '*kitoum*', and these are the *kitoum* resulting from the metamorphosis of a sister's labour. (Damon 1983a:319)

Indeed, the subclan cannot claim back a *man's* work in the form of valuables: on the contrary, the products of his work are only eventually recovered as food. And when a man's work *is* said to be turned into *kitoum*, it is not for his subclan but for himself.[6] It is not ostensibly combined with female work and thus does not activate subclan identity. Men in return for *kitoum* dispose of things they appear to have 'independently' made. They speak of *kitoum* as objects they have manufactured.

The separation of the *kula* circuit from kinship creates prestige specifically for men. Damon shows how *kula* shell valuables are concep-

tualized by Muyuw from two points of view. They are both *kitoum*, the products of male work, and *mwal/veigun*, items that compel reciprocity. The distinction lies in their relationship to men. Valuables as *mwal/veigun* circulate from partner to partner, making a name for each donor, and thus causing the donor's name to travel along *kula* roads:

> These names are produced by exchanging the valuables. But when one gives away a valuable it is said that one's name 'goes down', and one's partner's 'goes up'. Only when the article is given again to a third person does the first person's name go up, the desired result of Kula action. . . . A person throws away part of himself, his 'hand', and this self is only reconstituted as it is used to make other selves. (1980:280)

What makes the gift return to its original donor is the knowledge that every valuable is somebody's *kitoum*. What reappears in this aspect is that the valuable is a product of that man's work. As something that embodies his activities, it can substitute for the activities of others. As a consequence, *kitoum* valuables circulate outside the *kula* and may be used by men to obtain other products, such as canoes; no debt is created. Also as a consequence, only someone who owns a valuable as *kitoum* can take it out of the *kula* in the form of a return valuable classed as a replacement *kitoum*. It substitutes for the one he lost.

In the context of *kula* exchange, the contrast between the two appearances of valuables has specific content. As the product of work, an inalienable part of the male person, the detached *kitoum* brings compensation to the donor. The same valuables detached from work, from the person's particularistic social identities, carry a 'name', the "social circulation of the self" (Munn 1977:50).[7] This creates an identity for the actor conceived not as part of himself but himself as a part of a collectivity—a name in the *kula* ring. A. Weiner (1976:232) quotes a Trobriand man saying "men on Fergusson Island do not know my face, but from my *kula* valuables they know my name and my father's name." To turn a Muyuw aphorism, one has to lose (one identity) in order to gain (another).

Damon (1980:284) introduces a distinction between metaphorical and metonymical constructions in reference to the different ways in which *kula* valuables refer to the loss and gain of identities. Valuables are metaphors for persons in that their circulation in the *kula* 'is' the circulation of the person's name. At the same time, these valuables are created metonymically, in so far as *kitoum* is a (disposable) part of the male person. In despatching *kitoum* into circulation, and creating debts

and the passage of other valuables appropriatable not as *kitoum* but only as *mwal/veigun*, a man has transformed an internal part of himself (his 'work') into an external name. A metonym becomes a metaphor. And that, from the point of view of other men in the *kula* exchange, is all that he is: he is nothing but the part that he plays in keeping the *kula* moving. Parts match one another; there is no process of loss and substitution but the perpetual creation of debt. The multiple person is transformed into a unitary entity: the man becomes his prestige.

While Muyuw appreciate that all *kula* valuables somewhere are somebody's *kitoum*, they can also treat the circulation of debts between men as a closed system involving the singular identity of men as name-carriers. The internally partible or multiple constitution of men is thus eclipsed. At this point, we should recall that *kitoum* also originate in a sister's or mother's work, and it is relations between men and women which are also eclipsed.

We have seen that when *kitoum* enter the *kula* system they do so as signs of male work alone. Concealed in Muyuw saying that *mwal/veigun* is somebody's *kitoum* is that they mean somebody involved in the *kula,* a male somebody. Indeed, only in reference to a male can a woman's work itself appear as wealth. But it is a particularized or differentiated male, brother (or son) not husband. The woman's work is construed as disposable only in reference to these male kin. If men can realize their sister's work in such *kitoum*, it follows that this realization simultaneously represents her work as a 'part' of this kind of man and as 'detachable' from him. The sister's value for the kinsman is that he alone reappropriates the work as *kitoum*. Her work is an inalienable yet disposable part of his identity, by contrast with the temporary relation arising from the combination of her work with her husband's. This disposability is the basis for creating a class of items (*kula* valuables) appearing as one or other type, which can be used to mediate relations between men.

Although I have spoken of loss, the detachment of *mwal/veigun* is not the same as the detachment of *kitoum*.[8] What comes back for a man's *kitoum* is a 'compensation' (another *kitoum*) that substitutes for the cross-sex relation between the male person and the female parts at his disposal. What comes back for *mwal/veigun* is an item in a cross-sex relation to the one that was given away—*mwal* for *veigun* or *veigun* for *mwal*. The one is specifically matched with the other. But it is not in the sense of *kitoum* a substitution, any more than one sex substitutes for its pair. Rather, the matching creates a relation within a relation:

a cross-sex relation between the valuables, contained within the relationship between the same-sex partners, who thereby become separated from each other by virtue of their different interests in the transaction. The partners must appear as either donor or recipient, debtor or creditor. And thus their 'partnership' is implicit in the items with which they transact: *mwal/veigun* mediate between them as the sign of their relationship.

Young cites a man from Goodenough Island who contrasted loss through theft and injury with gift giving. "When we give something . . . maybe we don't keep it, but we don't lose it either" (1983:23). They do not lose it, I suggest, out of some mystical notion of enduring solidarity, but because of the brute and wily fact that one gives what is *extracted* from one. In the nature of mediated exchange, the donor has been persuaded, cajoled, and suffered the sorcery of another in being compelled to yield the gift. The recipient in turn perceives his effort as a matter of extracting from his partner the anticipated outcome of their transaction. The partner contains within himself what properly should be the product of a relationship between the two. What from the donor's point of view, then, is a part of himself with which to enter into exchange, from the recipient's is something to be separated and extracted from the donor. For the recipient depends on the donor for those objectifications of the one relationship which he can use as objects of mediation in further relationships; the donor in turn depends on the recipient to accept the external evidence of his internal incremental power, that of having items of which he can dispose. The recipient, with no interest in the donor's particular kin relations, sees him only in terms of the part he plays in the *kula,* in terms of his name and his same-sex gender. His task is to transform the other man's same-sex relation with these items into a cross-sex one with himself, as a partner in his partner's mind. The entity the other partner holds within must be differentiated in order to be extracted; in distinguishing his own interest from that of the partner as potential donor, the recipient thus separates a *kitoum* from him and turns it into a *mwal/veigun*. He makes it seem *as if* he can "affect the mind of the partner by making the latter's will (desires) correspond to his own" (Munn 1983:284), thus effecting a same-sex mutuality. In fact, his action subverts that ellusive symmetry.

The difference between the two transactions can now be stated. *Kitoum* stand for unmediated cross-sex relations, externally created in the contrasts between husband and wife/brother and sister, and in-

ternally between the differently gendered parts of a man's multiple activities. Separate efforts are combined in the product. *Mwal/veigun*, by contrast, conceived of as a pair of male and female valuables, are brought together by the efforts of *one* of the partners—the coercive recipient who extracts one of them. This effort distinguishes his interest and thus metaphorizes the partnership as though it too were predicated on an asymmetric, cross-sex relation (as though all *mwal/veigun* were somebody's *kitoum*). But this activation is only possible because the men are in prior terms of the same sex: it is merely the relation between them which separates.

Personification through such separations enables relations to be seen to produce relations. The circulating objects of mediation elicit the possibility that one relationship is only the starting point for others, that partnerships can constantly be made to appear. All that seems required is a capacity to extract objects. The replication of relations stretches to the horizon, for the illusion is close to hand in the replication of same-sex identity among men. And what they create in their overseas voyaging is already created at home in the manner in which a subclan residentially divides itself into its male members who stay and female members who depart: it is a collectivity of (same-sex) males that forms its community.

This gives us a position from which to hazard an analysis of Hagen ceremonial exchange.

The flow of wealth: moka. From the point of view of the Muyuw subclan, brothers and sisters are separated in such a way that the sister's activities return to the subclan in the mediated form of subclan children and wealth. As we have seen, it is with her husband that her energies are regarded as being combined. From the point of view of the Hagen clan, however, the separation of brother and sister results in a flow of wealth to it which is defined not as the recovery of its own substance but as the attraction of exogenous substance for which the sister is simply the 'road'; it must therefore be reciprocated in kind. What the clan appropriates as its own wealth, by contrast, comes from the joint activities of the husband-wife pair. As in Muyuw, wife and husband combine their activities in an unmediated form (the direct effect each has on the other was described in chap. 6). But it is out of that cross-sex relationship that *one* of the partners (the husband) creates wealth for his clan's disposal. The efforts of a Hagen man are thus directed simultaneously towards the alliance of the wife's particular interests with his

in his enterprises and the separation of those interests in the regard of his own collective relations with other men. Indeed, clanship carries a special weight in these circumstances; the respective clan origins of the spouses axiomatically guarantee the separation of their interests, as long as the clans remain separate. All clans are separated by the crucial rule of exogamy. *Moka*, warfare, and affinal exchanges work to keep particular clans apart and sustain the discrete social identities of the spouses by reference to these origins.

Since it is the 'work' of husband and wife which is combined, we can now make sense of the previous observation that in transforming his relationship with his wife, a husband is also transforming aspects of himself. For it is with respect to their joint products (primarily pigs) that their interests must be seen to be split. Pigs appear as either wealth or food. The cross-sex relationship ('food') he enjoys with his wife is eclipsed in the circulation of 'wealth'. Hence pigs are personified—that is, it is relations between persons which is seen to make different objects out of them. One relation can only be eclipsed by another relation. What displaces his relationship with his wife is a man's relations with other men. But, I shall suggest, the displacement is effective because those same-sex relations can also appear as cross-sex ones.

Relations with other men are not homogeneous; they too take one of two forms, those the husband enjoys with his fellow clansmen and those he enjoys with male exchange partners. The differences between these two sets of relations are mirrored in two separate male interests in the wealth. A man creates it for his clansman out of his relationship with his wife—the product of that relationship is his agnates' wealth, even as their (bride) wealth initiated the marital relationship.[9] But at the same time the clan only realizes that wealth through its capacity to create relations, through exchanges with other clans, who thereby provide a man with his individual exchange partners. These are regarded as sustained by his own activities: by contrast with Muyuw, when a Hagen man creates wealth for the clan, he also creates it for himself.

Hagen idioms conjure images of detachment and attachment. Wealth departs from and comes to the skin. What returns to a man in *moka* is something he made out of his relations with his agnates, but which, through his relations with his partners, he can reappropriate as individually and separately his.

This movement between the two types of same-sex relations is the crucial construction that allows the return on his gift to be conceptualized as increment. For Hagen *moka* is distinguished from the ex-

change systems of the Massim by the definitive notion of increment (A. Strathern 1983). A donor returns more than he owed: increment is conceptualized as the addition of one kind of wealth (*moka* 'on top') to another kind (the debt underneath).[10] As we would expect, the form in which wealth items appear differs from that of the *kula* valuables, matched conjugally as they are in attraction and treachery. *Moka* valuables in circulation are not in themselves 'male' and 'female': pigs, shells, and money are not gendered. On the contrary, according to its behavior, any item may take any gender. As attachable and detachable parts of a man's identity, valuables, in this guise, can be regarded as male *or* female, disposably male like the agnates (sisters) which a clan can bestow, or attractably female like the nonagnates (wives) it entices. Indeed, it is the exogamic rule rather than the love affair that makes men and women, as though they were so many wealth items, travel from place to place. At the same time, wealth items are also the composite, androgynous objects that in themselves embody a man's own other (domestic) relationships.[11] Each of these genders affords a metaphoric basis for the way in which men think about their exchange partners.[12]

Increment in Hagen *moka* appears through specific effects. Increment is 'added', like a part to a whole, a structure that supposes a difference, just as a male person adds female wealth to himself. Simultaneously, that wealth may also be conceptualized as a male augmentation of his male name, an extension of a male person. Now it is not the case that a 'female' element thereby turns into a 'male' one. Rather, in appearing in one of two forms—as male wealth, an extension of male activity, or as female wealth at male disposal—*moka* valuables bestow a gender identity on the relationship of the donor to his own disposable parts. The identity is elicited by his *moka* partner being in turn metaphorized as either the passive female recipient of the male wealth or the coeval male with whom a female item is exchanged. Consequently, the partnership itself, in terms of its outcome (the gift) may also be androgynously conceived, the wealth combining the male and female elements of the relationship between the men, like the combination of work between spouses. Yet the metaphor depends on keeping apart the connotations of 'work' as a distinctive, combinatory activity. No valuable is itself distinguished, like the Muyuw *kitoum,* as an embodiment of 'male work'.

Initially I suggested that one could regard a male exchange partner as disposing of male wealth as a clan does its agnates, and as attracting female wealth as it does its spouses; here I suggest that a male extension

of the male self may be *equated with* a male having female items at his disposal. One can complete the quatrain. The female wealth he attracts back may also be regarded as male: it comes in the form of prestige. What is attached *or* detached may take a male *or* female form. The conventional distinction that underlies these appearances is obviously that between attachment and detachment itself. Each implies the other, but an image of joint production or combination would not do: the wealth that flows must be seen as both exogenous and as capable of being absorbed, at once on the skin and evidence of the inner self. Detachability is conceptualized in the single sex form of the item (male or female), for that creates a cross-sex relation between the donor and what he gives/receives in substitution for his cross-sex relation with his wife. A man establishes an internal partibility between himself and his own activities/wealth, which eclipses the part he contributes towards his conjugal relationship.

Now the donor knows himself as a single sex person (a male with either male or female parts to detach) because his condition is replicated externally in his same-sex relations with his clansmen, and his *moka* partners. In competing with his clansmen and exchanging with his partners, he *separates* their interests from his. He thus also knows himself as a single sex person in so far as they, according to their gender, elicit that condition from him. Indeed, the one same-sex relation can be played off against the other. And because they are not commensurate between themselves, he is able to augment his own maleness, as it were, 'adding' to his name, that is, by adding relations to relations.

Through his *moka* exchanges, a man thus converts what he detaches into something very different from what he absorbs back. What is returned is 'more' than what he disposes. The constant illusion that a person receives more than he gives lies in the very difference between what he detaches from himself and what he is able to reattach.[13] Damon elucidated the switch in terms of metonymic and metaphoric symbols, to refer to how the difference is construed. Since this turn depends on the alternating definitions of donor and recipient, it also bears comparison with a situation that Schwimmer describes for Orokaiva.

During the course of analyzing how the Orokaiva, from the former Northern District of Papua, use coconut, areca, and taro, Schwimmer (1974) distinguishes metaphoric from metonymic gifts. The distinction arises in his discussion of a myth in which a man and a woman exchange various items. The objects of social exchange are male (coconut) and female (areca) sexuality. At one point, the intention is to establish

symbiosis, and here gift and recipient are identified. Thus the female gives coconut to the male, because coconut is male and appropriate for him. While it is intended for him, it is important that it is given by another. In this transaction, coconut is a metaphor for the man, and an interdependence is established between the sexes in so far as the one depends on the other for a gift that is himself. At a further point in the story, man and woman transact with each other as separate entities. Each uses his or her distinctive object of mediation as gift to the other. The female whose nature is areca gives areca to the male; his nature is coconut, which he gives to the female. Here the relationship of the parties, Schwimmer argues, is established prior to the gift and is not changed by it, and each in metonymically giving a part of himself or herself sustains that distinct identity.[14]

The two procedures are juxtaposed within the one Orokaiva myth; there is a pertinent parallel to the development of Muyuw transactions between spouses, in the course of which their work, coming from separate origins, becomes combined (Damon 1983a:308). A Muyuw man courts his future wife with betelnut, considered female, and she provides him with betel pepper, considered male; the substances are consumed together. The one is made dependent on the other for internal definition. When husband and wife are fully joined, however, the completed relationship between them is finalized through a set of external transactions. The wife's brother gives female things to the husband's kin, who return male things, each side transacting with a same-sex part of themselves. This is possible because their differentiation as sets of affines is fixed in the relationship of the spouses. That cross-sex relationship, now combined in their work, is the mediating object between the kin of each side; the discrete identity of the sides is not altered in subsequent transactions.

Transactions in which partners have a direct effect on one another (each 'completes' the other's identity) may involve a transfer of objects, as in the instance of Orokaiva areca and coconut. But I regard the exchange as unmediated. The objects establish one partner as the other's source of identity, as a 'husband' is created in association with a 'wife'. The gifts are metaphors of the act of constitution. The metonymic gift, however, creates a relationship between partners distinct in its identity from either of them alone. It is literally a mediation between them, created through their interactions, as in the Muyuw exchanges between husband's and wife's kin. This is the context in which persons, in retaining their separateness, are seen to have parts of themselves to

bestow. The husband's kin give a husband, the wife's kin give a wife. From the donor's point of view, the parts do not 'belong' to the other partner; they are parts of oneself, which in being detachable create something 'extra' for both sides. Thus the relationship between them can be 'added' to the identity of each. Both sides appear as both donors and recipients, each adding this relation to their other relations, an incremental possibility in mediated transactions not present in unmediated ones. Let me spell this out.

First, a *moka* partner disposes of a metonymic gift. The pig he gives away embodies his and his wife's work; but the pig is detachable as a part of himself, in the way the work is not, because the man has transformed his identity from that of a husband to that of a clansman.[15] The boundedness of the clan unit, like the skin of a man, enables items to appear extrinsic to it. His clan identity also guarantees the donor's prior social separation from the recipient. It is important that conjugal work remains thus defined as extrinsic to the partner's relationship because it is then made visible as a part *one* of the parties brings to the relation, in his singular state. Vis-à-vis his *moka* partners, that domestic work is irrelevant (see chap. 6); the pig comes to his partners as evidence of the donor's prestige, and for the partner it is only the man's prestige that is at stake, his standing in the circulation of mediating wealth objects. The wealth he disposes of substitutes for his person in the eyes of these men. Second, what a partner then recovers is a metaphoric gift, himself transformed in the regard of others which he attaches to himself, as his prestige. He thereby depends on these others for evidence of his own name. Their identity is in turn created as a source for his prestige.

In summary, the metonymic gift mediates in a relationship in which the partners retain their distinct identities; the metaphoric gift establishes a dependency relation that identifies the partners, in an unmediated way, as versions of one another and augmenting one another's prestige.

Secrecy in Gimi cults enabled the actors to play the parts they allocated themselves, being thus in control of their meaning (chap. 5). The ritual established an exclusive domain in which only certain sets of meanings had value; others were suppressed or rendered irrelevant for the event. A comparison with Hagen gift exchange—an arena in which the things men circulate acquire an exclusive value—is patent. Thus 'name' (reputation) encapsulates the whole man for the purposes of his interactions with other men. The wealth that circulates his name becomes an encompassing metaphor of his prestige. Things (*mel*), whether

male or female, are detachable from the male person; prestige is not. To lose prestige in that sphere is to risk losing male identity.

Hagen men's denigration of productive activity as female and things female as 'rubbish', in antithesis to the gaining of 'prestige', is a separation that can only appear because of the alternative possibility of men replicating a like identity among themselves. In eclipsing domestic relations, we have seen that the husband reclassifies his own energies and activities as a part of his replicable male self rather than as a part of the relationship between himself and his spouse. His productivity visibly adheres to his skin as an element he has the capacity to dispose of. But a condition for this capacity is collective activity, the presence of a community of males, to adopt Read's and Langness's term, regarded as equivalent of one another. It is because of replicated gender identity that the relation between partners can also be regarded as an extension of the single partner—that the relationship 'is' his prestige. Items can only be detached on behalf, as it were, of other men. Men recontextualize domestic relations as parts of themselves, as though they lay on their skin, a source of wealth in their competition with other men. By virtue of the gender symbolism, they cannot normally personify as wealth their relations with women.

I return briefly to the point that Hagen wealth is alternatively conceptualized as neither male nor female, but as an androgynous confection of both. The contrast here is between artifacts in an activated incomplete (same-sex) and in a completed (cross-sex) state. The coloring of shell valuables indicates this fusion of male and female characteristics (cf. Ernst 1978; Lindenbaum 1984). But this vivid fusion is created not only out of a relationship between men and women: rather, that intrahousehold relationship becomes a metaphor for the extrahousehold dependency of exchange partners upon one another. It is also a relationship between men that is signified in the cross-sex character of the wealth items. Perhaps this in turn gives Hagen men their sense of power, the idea that with such wealth they could create new relationships. The mediatory objects in themselves, in their figuratively complete, androgynous form, present an aesthetic anticipation of the possibility that with them alone a man could elicit more relations with other men. The illusion is close to hand in the wealth of every husband's household.

Damon refers to the Muyuw ownership of *kitoum* valuables as representing autonomy: one appears indebted to no one for them. Although there is no class of wealth in Hagen ceremonial exchange which

is specifically debt-cancelling, the mediatory nature of *moka* gives men a similar autonomy. By contrast with the dependency relations of domestic kinship, *moka* partners are definitively equal and independent in respect to one another. The enchainment (indebtedness) established by the gift is an outcome of transaction itself: only as donors and recipients are the partners unequal. Simultaneously, then, transactions indicate the capacity to create relationships and the ability to do so as an independent person. Their techniques are the same as the aesthetics of *kula*: replication of same-sex identity among men.

Replicability introduces the possibility of measurement. When men act as agents of their own domestic transformation, their agency is encapsulated in the term *ukl,* performance, creation, custom (see pp. 179–180). Whereas work remains concrete, always significant to the particular person's orientation to others, *ukl* provides a generalizable basis for comparison. *Ukl* are occasions on which the measure of one man may be taken against another; it indicates the success with which they act, precisely because it rests on the overt use of mediating objects that bring things visibly to the skin. In *moka* performance, men thereby set up a basis for inequality between themselves. The all-male collectivity provides two measures (p. 200)—the comparison may appear either between the individual members of a single group or between donors and recipients who face each other on alternative occasions. Men thus compare themselves according to what they have in common, the extent of their name, their capacity to achieve. Some fail; yet because of the gender presumption, all 'men' may be regarded as part of the *moka* system, and all participate as apparent equals differentiated only by their performance.

An effect of mediated exchange, then, is to make relationships appear as though they were accumulated and increased by the flow of things.[16] This replication rests in increasing the velocity of circulation: the more transactions pass through a person's hands, the more he can transact. The effects of men's exertions are visible in the multiplication of similar relationships, in the velocity which registers the speed and range with which gifts flow. Ever 'more' partners can be pressed into a man's network because of the common denominator that makes all men multiplications of one another. The simple categorization of male persons as potential exchange partners opens up contacts with strangers, brings distant persons close, or transforms differentiated kin-based ties into partnerships for the purposes of *moka*.[17] The strenuously defended presumption of basic parity means that partners start from a premise of

no-debt, since debts are created through the exchanges themselves and not by some prior asymmetry. A man can theoretically take any *moka* pig out of the system and consume it, and he can put any pig into it. His power to expand relationships infinitely seems constrained only by his own ability to make his relationship with his wife simultaneously of central and peripheral significance to the enterprise.

UNMEDIATED EXCHANGE: TRANSMISSION

At several junctures, the discussion of mediated relations has turned on comparisons with unmediated ones. As an exchange, an unmediated relation works through the directness of the effect which partners have on one another and, in the case of the metaphoric gift, creates a mutual dependency between them each for their own definition. They 'exchange' identities as it were. The present section focuses on unmediated exchange which appears, like mediated exchange, in the replication of entities. Here, however, it is the replication not of individuals as singular, same-sex persons which is at issue but the replication of substance. Thus we might imagine its effect as bodily growth or as the transmission of bodily tissue from one person to another.

Growth does not occur through the simple increase of material mass. The Melanesian body is imagined as composed of internal relations. The generation of substance must therefore either derive from relations or itself compose a set of relations. Indeed, both are the case: growth and transmission are caused by the interactions of persons, and occur as a direct result of interaction being duplicated within the body. I refer to the interaction as an exchange, whether or not other items such as food are present, for reasons already offered (see above, p. 179). Consonant with the earlier emphasis of this chapter on the replication of same-sex identity between males, it continues with male replication. Female replication is considered in chapter 9. Although I refer to bodily growth, the alignment of minds could equally well be taken as an example of replication through unmediated exchange.

Reference to the replication of substance as the internal analogue of the replication of singular individuals draws on Wagner's (1977a) exemplification of Daribi ideas. He argues that the Daribi exchange of detached, partible things stands in apposition to the flow of internal (lineal) substance within a single wife-exchanging or wife-receiving unit. Meat, women, and shells flow in exchange across relationships not internally unified by substance. Thus meat can be conceptualized

as an externalized partible equivalent of seminal fluid (1977a:632). In turn, semen must also flow: men see themselves as needing to sustain its internal increase through eating the juices and fats of meat,[18] and their energies are thus directed toward producing more semen. Technically, in my terms, the replication of parts of themselves, it is experienced as replenishment of what has been lost (Wagner 1983). In this respect, Daribi views echo those of other Highlands populations who regard persons as possessing a limited quantity of expendable life force (see Kelly 1976; J. Weiner 1982).

The conventional separation between internal and external relations is tantamount to the personification of the body itself. For the Melanesian image of the body as composed of relations is the effect of its objectification as a person. In the partibility of its extensions into relations beyond itself and in the internal relations that compose its substance, the body consequently appears as a result of people's actions.

Either type of exchange—mediated or unmediated—personifies the body; both depend, I have argued, upon the aesthetic of replication. We have seen how replication works to produce partibility; it also works to produce internal growth and the transmissibility of substance. What applies to human bodies applies equally to the 'bodies' of food plants and to items such as valuables whose substantial capacity to attract wealth can be transmitted to others. It underlies magic and the conveyance of qualities between objects. Here, however, I am concerned with the bodies of people. In their case internal growth beyond childhood is perpetuated through internal health. Growth and health are intimately related; both are construed as evidence that the body is indeed inhabited by a person, by the proper activation of social relationships.

If the body is thus personified, so too are its physical parts. We are dealing with the replication of substance that must assume a same-sex form. Within that context, the potential distinction between male and female is crucial, and body parts are personified in being given a gender identity as one or the other. Thus we may apprehend the apparent paradox that much ritual attention is paid to sexual organs not because the organs sex the person, as it were, but because in her or his relations with others, the person sexes the organs. They then become evidence of the successful activation of those relations.

Growing boys and marrying men. In a wide-ranging conclusion to Herdt's (1984a) collection of essays on ritualized homosexuality in Melanesia, Lindenbaum makes a direct comparison between ceremonial

exchange and the circulation of semen through homosexual practices. Indeed, she adduces "the shift from semen to shells" as accompanying a developmental "shift from involuted forms of marriage and ceremonial exchange to more expansive chains of ritual and social connection" (1984:351–352). Semen can be seen as an analogue of bridewealth. She then argues that whereas in the circulation of semen, men exchange body products as parts of themselves, with (bride)wealth, they exchange the social labors of women. Semen cultures, she suggests, simply mystify women's contribution to reproduction; but wealth items such as shells 'objectify' and make appropriatable women's horticultural productivity. Hence men in societies dominated by ceremonial exchange are interested in making wealth whereas ritualized homosexuality is focused on "the idea that men create men" (1984:349). But to my mind an intrinsic distinction cannot really be sustained between semen and wealth: semen is as much objectified as its analogue. Indeed, the analogue exists precisely because in both cases men define themselves as exchanging aspects (parts) of their own identity. In reintroducing the Sambia material described in chapter 3 to discuss the point, I also reintroduce the question of whether their rituals can be said to 'create men'.[19]

Lindenbaum's interest is in the evolutionary consequences of wealth exchange—how it creates possibilities for forms of social organization from exchange different from those based on the transfer of body substance. My own interest, however, is in the internal differentiation of social forms. At least as far as the homosexual practices of the Sambia are concerned, men move between different modes of semen exchange, transforming their identities thereby, much as Hagen men do in *moka*. However, whereas the critical contrast between mediated and unmediated transactions in Hagen distinguishes domestic from political activity, here both forms of transaction operate to major effect within the one set of ritual sequences. As we shall see, Herdt captures a further internal contrast in that between direct and indirect exchange (compare Kelly 1977:223ff.).

Male association in initiation cults, such as those found in Sambia, is marked by the overt creation of inequality and asymmetry within a body of men defined homogeneously as 'male'. Equality between male participants is achieved via a flow of mediating substances among themselves; inequality by dividing themselves in such a way that one set of men are seen to have direct, unmediated effects on the other. Equality is made evident through the replication of same-sex (all male) links, while inequality among the males is manifested in cross-sex relations.

The latter are essential for the senior participants to realize their intention to make the boys 'grow'; the former essential to their intentions that what is grown within each boy is male substance. In the all-important first-stage initiation,[20] both facts are revealed to the boys through the one device. They are made to learn that semen is a version of milk, and that the male penis is a version of the female breast.

This has been at once the significant discovery of Herdt's ethnography and the paradox that has fuelled his own analysis. Two major themes run through his presentation: the thesis of masculinization, on which I dwelt in chapter 3, and the fact that the rituals prepare men to marry and reproduce. He makes it clear that men are not fully men until they are parents. The final stages of initiation are bound up with the birth of their children; and boys must first be grown before they can, in turn, grow a new child (Herdt 1982a:54).

Herdt analyzes Sambia rites and beliefs about men in terms of their psycho-sexual transformation. The collective secrecy of male ritual, he says, disguises the experiential secret that "manhood and its supporting sense of maleness, comes not from within, but from the external, humiliating process of having been another man's sexual insertee, thus enabling one to eventually become a woman's insertor" (1981:278, original emphasis removed). Homosexual practices prepare men for heterosexual relations with women. The ritualization process forges a masculinity that is pitted against the feminine; boys have to make "the transition from maternal attachment to rugged adult warriorhood" (1981:315), but this process also prepares them for encounters with women.

The presence of female symbols at the heart of the cult has to be explained. The all-male phallic flutes turn out to be animated also by a female spirit, or they can be conjugally paired as male and female (as noted on p. 126). To the extent that he is committed to a thesis of personal gender identity, Herdt (1982a) treats the female aspect of these flutes as referring to previous relationships with real women. Men's instrumentality works, he argues, to detach the boys from their links to their own mother and fix attachment onto male objects. He documents the explicit equations made by Sambia men between flute and penis and between flute and breast. Indeed, the boy novices are instructed in the matter. Through homosexual encounters, the penis comes to 'substitute' for the breast, as a source of nurture and as a sensual replacement for the mother the boys have lost. Sambia are explicit: semen and milk flow from the 'flutes'. In accounting for the eroticism that sustains

these equations, not to say the children's emotional vulnerability, Herdt observes,

> [t]he flute-oriented behavior, releasing feelings of helplessness and fear, supplants the mother as the preferred attachment figure by offering the culturally valued penis and homosexual relationships as sensual substitutes for the mother's breast and for the mother as a whole person. (1982a:79)

In this analysis, the mother's attributes are objects that become detached and embodied in other objects that replace them. The flute acts as an erotic fetish. The equation between phallus and breast, he thus avers, is a fantasized one, and he returns at this juncture to "individual Sambia males' needs to sense themselves unambiguously and to perform competently as masculine men" (1982a:82).[21]

I would comment upon the singularity of the object (the flute that is both breast and penis, and the penis presented as breast) from another vantage point. The singular form teaches the boys that the organ may be either male or female; but it also teaches them two other things. First, whether it is a male or female organ will depend on the person who activates it: for the double penises of a 'mother' which nourished them at an earlier stage it is as though they are now confronted with the single breast of their 'sister's husbands'. Ideally, a boy is fed by many men, so this is also a transformation from a particular to a collective relationship. Second, the activation itself creates a gender distinction: substituting for the cross-sex relation a boy enjoyed with his mother, the senior inseminator establishes a cross-sex relation with him. The novice plays female to the man's male-ness. What he therefore also learns is that one cannot *act* as both male and female at the same time.

That the gender of people's sexual organs depends on what they do with them recalls the conclusion to chapter 5. The supposition was inspired by Gillison's analysis of Gimi ritual: the flute that is breast and penis, and container as well as emitter of fluids, assumes an identity in the way it is handled. In the company of other males, the Sambia initiate learns that what distinguishes males from females is not their appendages and orifices as such but the social relations in whose context they are activated. It is relations that separate the genders, male from female and same-sex from cross-sex. The boys are made to act like women and are put into a deliberately unequal position with respect to others of their own sex. The difference between male and female is thus created during the course of the rites, and it is a difference that turns on interaction, not attributes. In other words, the flutes are not simply

fetishized body parts of an absent maternal figure who is reconstructed into a male figure of desire; we must follow the second theme that Herdt offers and see the fixing of gender as concerning the persons whom the boys must become, and the relationships with women which lie ahead of them.

The singularity of the sexual organ and its semen/milk also presents an androgynous form. At one and the same time, the multiple origins of the novice are confirmed (he was born and grown of both male and female persons), while he must also know himself as eventually having a singular (male) part to bestow. This developmental sequence is played out in front of the boys. First, the older male participants of these cults embody the relations that produced *them*: senior men present themselves as combining the male and female elements of which they are composed. The flutes, the initiators, stand as both mother and father to the novices. And if one set of men act simultaneously as father and mother to the others, it is because they, too, are simultaneously the embodiment of a relation between a mother and father. The novice in turn drinks a substance he may experience as either maternal or paternal in nature. He is united with, or identified with, the duality of his own source through this dual nurture, and this identity with his male and female source establishes his own androgyny. But in order for a boy to be marriageable, he must also be able to contribute a differentiated substance to his offspring that will be the future 'father's' part as opposed to the 'mother's' part he will encounter in the person of his wife. The boys have multiple origins, yet they must come to their own wives with a singular male element to bestow.

The ritual, then, accomplishes the further demonstration that what is combined can also be separated. It is possible to detach parts of oneself. The unequal division between senior and junior[22] is also the basis for creating further difference—between male and female. Here the initiators stand specifically as 'husbands' to the novices who are their 'wives'. The seniors accomplish this through the flow of detachable substance whose social activation establishes it as male. Semen taken in by the feminized initiand is itself masculinized. In this process of personification, the substance becomes a 'male' object by virtue of the transaction itself. These rites do not make men, that is, they do not masculinize persons; persons masculinize the semen.

In fact, I wish to clear away several grounds on which the rites do not make men, in order to suggest one on which they do. First, persons are not masculinized; rather persons masculinize their own organs and

sexual substance. Second, they do that not to make the boys, as a special category, into men, but to ensure that they will have the internal capacity to procreate, to be 'fathers'. And, third, men do not in any simple way make men because men are not in any simple way men. They also have an identity as androgynous beings composed of male and female elements; and they are produced in male form only in so far as they can, in fact, be produced *out of* an opposite, female form (see pp. 128–129).

One might imagine, however, that in decomposing themselves—in detaching parts of themselves to bestow on others—the androgynous persons would thereby be feminized. That is, the senior man would detach a 'male' part and leave himself identified with his 'female' part. But what blocks this outcome is what blocks the Hagen *moka* maker, who is also able to detach a male part from his male self and sustain it as a metonymic extension of his masculinity. His masculinity is preserved by the cross-sex relation that he establishes with the recipient-insertee. His 'female' partner returns him the knowledge that he has bestowed a masculine substance, because otherwise the relationship would not have been activated. This being the case, the bestowal has a replication-effect. Semen can be added to semen, and the boys 'filled up': what is transmitted to them thus grows them. The boys can then be thought of as 'male'; thus the metonymic transmission of semen returns to the donor as a metaphor for the collective masculinity of all the cult participants. What 'grows' the female-boy can also 'flow' between the male-men. It is not as an individual or as a member of a special category but as a part of a homogeneous male collectivity that a boy appears as a man. For as a 'boy' he is already anticipated as a 'man', as I shall try to make apparent.

Apropos the analogy between semen and wealth transactions, it seems that semen is not axiomatically an extension of men, and is thus not innately male. The revelation of the cult being that male semen is also female milk, this androgynous substance is made male in the course of those unmediated transactions (homosexual relations between unequals) in which it assists the novice's growth. The relationship separates it from the donor, rendering the substance detachable. Semen can then comprise a flow of objectifications between men.

If one shifts from the initiator/novice relationship, where both semen and milk make the boy grow, to the community of senior males, it is clear that these men are also creating relations between themselves. It is the novice who becomes objectified, bestowed with a particular

value that is both the object of and product of their interactions. The boy's new growth makes these exertions visible. He is semen in embodied form. The effectiveness of men's performances as males is thereby shown in these objects; they do not transmit semen directly to one another but collectively produce the new men from their body parts. In short, the novice as a mediating object gives value to the relations between the older men.

Novices, then, like the semen they consume, are mediatory objects produced by the men's transactions. The flow sustains relations between the relatively equal seniors. By contrast, inequality between novice and initiator casts their particular interactions into the unmediated mode, and what passes between them is a substance analogous to food, which confirms the identity of the donor but alters the identity of the recipient: the one is feeder to the other being fed. But for the food to have a replicating effect—for the homosexual relations to "increase a boy's maleness and build up his masculinity" (Herdt 1981:204)—the semen must also be attached to him as an additional (metonymic) part. Hence the boys must be, as it were, already masculinized before the fresh process of masculinization is effective. This is done by making them momentarily into male vessels for the male substance.

Flutes are initially presented on the very day that the boys' noses are bled, to rid them of bad maternal blood (Herdt 1982a:59; 1982b). The boys are shown that they can detach what is within them, and are thus constituted as vessels, their bodies remaining even though the blood is expelled. The flutes are themselves vessels for the female spirit who is to be a source for their growth, and its sounds are by analogy semen/milk: the spirit woman's milk is the men's semen. The gender of this internal substance remains, however, importantly equivocal. This means, too, that the gender of the vessel is equivocal. A summary of the transactions we have been considering to this point explains why.

What the flute/penis emits is masculinized through a double set of social relations. The substance circulates among (same-sex) men as detachable parts of themselves, and to the extent that the boys become eligible to participate in this flow at their own marriage, the semen with which they impregnate their wives will also be male. However, for the men to remain in a symmetrical, equal relationship with one another, the object of mediation must itself be cross-sex, at least so one would deduce from the aesthetic of mediated exchange in the *kula* or *moka*. Simultaneously, then, the semen must indeed also be milk, an androgynous or even female confection at the men's disposal. It can thus be

.fed to the novice *either* as a single sex entity (milk or semen) *or* as a cross-sex entity (a combination of both, the spirit woman's semen). The female status of the novice elicits the semen in masculine form, and it replicates the substance that fills him up and grows him. It also reproduces, I have argued, his own multiple cross-sex identity.

One may further extrapolate[23] on the basis of some of the personifying idioms Sambia use. When the boys hear the flutes, whom they associate with the men, the flutes are said to be helpless infants crying out for milk (Herdt 1982a:78). Yet it is the boys who will receive 'milk'. Thus the boys, cavities for the flutes they must suck, are already themselves flutes. In other words, what the men detach belongs already to the boys, a metaphoric gift, in so far as the boys are constituted in a form like them. But the likeness is the likeness of both same-sex identity and cross-sex androgyny. The androgynous identity of the substance that is transmitted comes from an androgynous container (the breast/penis). It is not milk or semen, but a 'child'. The flutes are crying children. If the novice who is made into a 'new man' appears as a 'child' of the men (see above n. 22), simultaneously he is endowed with the child that he will in turn endow his wife with. He is already the child whom he will beget.[24]

This is the value that novices give to the relations between men. For in this form they make apparent the proximate paternity of the senior initiators. In having the boys receive a detachable part of themselves, these men are given evidence of their own future partibility: those close to fatherhood exercise the capacity initially on 'themselves', that is, on younger boys. The boys' ultimate paternity, and *their* capacity to reproduce, is quite explicit in what Sambia men say about having to fill their bodies up with semen, since they cannot generate it autonomously. But the paradox remains that fathers cannot directly produce fathers, for fatherhood is evinced in cross-sex interaction. Here separation is anticipated. Mythology makes it clear that the male partner (the senior inseminator) is seen as making the boy into a female, creating another different from himself, like the wife he is soon to meet. In anticipation, the novice also is put into the position of his own future wife (Herdt 1982a:70).

Lindenbaum (1984:354) notes generally for societies which practice ritualized homosexuality that "[b]rother and sister seem at times to be treated as a single unit." In Sambia, brother and sister are dependent upon one another for their identity, though they are not regarded as productive in the way that is true (say) in Muyuw.[25] This is a crucial

condition for other separations. We return to the sociological fact that a man is likely to be inseminated by the same social person ('sister's husband') who inseminates his sister, provided the individuals concerned observe the age difference between junior and senior (Herdt 1981:238).[26] Although Sambia stress the importance of homosexual partners being unrelated, in the same generation brother and sister potentially receive semen from the one source.[27] Affinity is thus anticipated in the rites themselves. The 'sister's husband' stands in an analogous relationship to both, endowing the siblings with a parallel capacity to transmit substance in turn (their respective offspring). The semen from this man overtly completes the work begun by the parents of the brother and sister; it also creates containers out of both their bodies.

For semen is transmitted to both nonpartible and partible effect. It has two forms. Some of what is ingested contributes directly to the growth of the brother's and sister's body tissue, and cannot be further transmitted: it thus augments the work of their parents. But some of it remains as semen in the boy, thereby filling his body as though it were a container: the skin and bone tissue created by primary semen is also what envelops this secondary semen. Secondary semen, in Sambia dogma, remains partible. Most that the brother receives accumulates within him as a pool, and its containment is made visible, for it is this substance that the boy in turn will detach and transmit (Herdt 1984b: 182). The sister likewise receives partible semen, but its qualities are further doubled.[28] Each type is transmissible but not for her in the form in which it was transmitted: it becomes both the breast milk (a 'male' food) with which she feeds her child and the very child itself within her which she envelops.

Perhaps initial proof of the cavity which semen both creates (in nonpartible form) and fills (in partible form) comes from the emptying of the brother's and sister's bodies when they rid themselves of maternal blood. Given marriage arrangements that encourage people to think in terms of sister-exchange, mother's blood must derive ultimately from the 'same' clan source as sister's husband's semen.[29] Indeed, a primeval brother-sister pair could be imagined as productively parallel, through the man's transmission of semen and the woman's transmission of blood. Blood might thus be, as it so appears in other Eastern Highlands societies, 'a version of' semen. But Sambia separate semen and blood. Milk, not blood, is the cognized female version of male substance.

Brother and sister are joined, not by a complementary equation of semen and blood but by semen alone, *in the single social person of the*

sister's husband whose one substance they both ingest. The crucial separation must be between the partible and nonpartible types: for children to be produced, the semen that coagulates to form a fetus must be separated from the encasing semen substance of the person's body.

Now it follows that what a man does for his wife's younger brother, other men will be doing for his own sister and himself. It is these relations that guarantee that the substance a husband passes to his wife (and her brother) will be different from what she already possesses (cf. Gillison 1980:167–168). Bodily identification with the sister establishes a man's separation from his wife. Persons cannot both act and be acted upon at the same time in Sambia cross-sex imagery. And a man's passivity towards his sister and her husband establishes his activity towards his wife and her brother. What enables them to 'produce' children is the separation which then becomes conceivable between the spouse's internal constitutions (the relation which makes each body both container and contained). Although the husband is thought also to contribute to the wife's body (the container), this is only a contribution. Her body is made largely of paternal material; instead he transmits his own partible substance that becomes contained within the wife's cavity as an entity separate from her encasing paternal body.

Given that it is milk, rather than blood, which is the Sambia female version of male substance, there is a parallel between the emptying of the male body through insemination and female breast feeding. While getting rid of milk or semen may underline the vessel-like nature of the body, blood by contrast does not have the property of further flow. It is simply discarded, and in being discarded it is 'bad', in contradistinction to the vital filling and emptying of the semen sac/womb/breasts.

Herdt draws an anology between direct and indirect semen transactions (1984b:175, 194ff.). Semen given directly to a boy transforms him in so far as he grows thereby; it is an unmediated transaction, and its productive effect is achieved through its seemingly exogenous sociality. One man inseminates another with semen from a different source (since the inseminator is an affine) than that which makes up the recipient's paternal body, hence the male/female asymmetry between them. The indirect transaction refers to the feeding of the inseminator's child with its mother's semen-fed milk, for the fetus receives the father's semen through the instrumentality of the mother's body. Herdt suggests (1984b:180) that the woman's body is thus regarded as a transformer of male substance.

As long as the maternal body envelops and encloses it, the fetus

grows. The mother's body does not nourish the child directly. (Maternal blood does not produce any body part of the forming fetus, although it is tapped during the transformation of the semen into a child.) There is no passage of substance from her—the fetus is fed only by further contributions from its own father. But its enclosure is significant. This enclosing of an object signals covert growth. In this sense, the woman's body duplicates the body of male cult members. And among them, unlike the passage of wealth items between *kula* communities or Hagen clans, the circulation of semen occurs in a context that I have referred to as collectivizing domesticity (see chap. 5). The overall result of the men's closed operations is, in turn, not expansive flow but inner growth.

The transfer of an item between units (men) who are alike (same-sex) is created through momentary asymmetry: donor and recipient become senior and junior, male and female, to one another. This asymmetry is not, as in ceremonial exchange, reversible between the original partners; the junior female can only become a senior male to other novices. Godelier (1982:14) has drawn attention to the analogue with generalized marriage exchange. But this 'generalized' exchange between men operates, as he notes, in a context where actual marriage may take the form of restricted sister-exchange. His observations for Baruya hold for Sambia. As far as the resultant kinship identities of the cult participants are concerned, there are ultimately no exogenous sources of vital substance. Perhaps this is at the root of Sambia belief that semen substance is strictly limited in quantity in the human population. Perhaps too this leads to the perception of its externalization as loss. Ultimately, kinship closure saves them. By necessity, Sambia male ritual must be oriented to the realized reproduction of children, and thus they orchestrate the initiation stages to develop from collective rites to individually centered ones related to the maturing femininity of the women assigned as wives (their menarche, first childbirth). For the marriage arrangements guarantee in kinship terms the ultimate containment of their vital resource. The containment is anticipated in their (generalized) transactions. Unlike the illusion of ceremonial exchange, there is no infinite expansion of like units, no potential to increase the velocity of flow. The illusion is that the flow of substance remains locked within the community of males. As Herdt reports (1984b:192), they hold on to the idea that semen transmitted to the boys is saved for the men.

More than the gender of the transacted item is established: its particular kinship source is also significant. Or rather, those kin relations establish its gender. Wives' husbands must displace wives' fathers as

procreators. Semen must be produced outside the woman's body in order for it to be different from the milk/semen/paternal substance of which she herself is also constituted, and the community of males detaches itself from communication with females to effect this separate production. They nevertheless construct an analogy between bodies of male and female 'siblings'. The siblings are 'affines' to the same inseminator, prepared as vessels for receiving substance from the one exogenous source. In so far as the inseminating senior males become 'spouses' to the sister-brother pair, then the future husband is also joined to his 'wife'. At the same time, men take action in order to render distinct their contributions as 'fathers'. Finally in the enclosed cult house they force upon one another the growing and extending of the boys as 'children'.

Elsewhere in the Highlands, the circulation of wealth produces prestige; here the circulation of semen produces persons in the variety of kinship relations just mentioned. Of these, fatherhood seems the most significant. Now whereas prestige can be assimilated to a metaphoric statement about the whole man, in the end fatherhood requires an opposite sex partner for its effectiveness. A flow (of semen) creates a unitary identity among the seniors, yet it itself merely replicates that identity, a trope for an anticipated but, until the moment of conjugal union, not yet realized capacity. Indeed, these imagined kinship positions are all in a sense anticipations.

THE ANTICIPATED OUTCOME

The replication of persons and substances in same-sex form is an aesthetic convention through which two modes of personification appear: mediated and unmediated exchange. Exchange makes objects (persons) out of people's relations with one another such that the ability to create or enlarge certain relationships stands for the ability to activate any.

So far I have been considering the extent to which men make themselves effective in their dealings with other men. But this is done not simply through extending relationships; it is also done through metaphorizing one set of relations to stand for another, as occurs repeatedly in these instances between conjugality and clan or cult membership. The next chapter considers more fully the way in which relations are thus turned into relations, appearing in forms different from their original manifestation. We have touched on this as displacement or eclipse.

In the further process of extraction, the agency of one of a pair of persons is asymmetrically exercised upon the other. At the point of extraction, a mutual relationship is turned into a nonmutual one, and the relationship itself becomes embodied in an object that takes a quite other form (a thing, a child, an item of wealth). The act of extraction is thus reified in the embodied substitution.

Personification entails the possibility that one set of social relations can always be dissolved into or expanded into a different set. Persons composed of one kind of relation subsequently appear to be composed of another, as Hagen men transform their identities from spouse into male, and from male into one of two types—clansman or exchange partner. The entailment is also apparent in the recursive nature of Sambia transformations. Given that persons objectify relations, I have stressed that it is their internal capacities (the activation of those relations) which is the focus of interest. But for the relations to exist, they must already be there: persons must in themselves be what they can become. The boy novice must already be a male vessel for the male semen he will ingest; the flutes/penises of the men must already be the children whom they will beget; the semen must already be partible before it is detached. The cue comes from Gillison's analysis of Gimi rites for girls—Gimi suppose that the girl about to be impregnated already has a child within her (1980:163).

To imagine that the girl is already a woman is, of course, to imagine that she has within her the capacity to bear children. Internal capacities are personalized: the potential (to procreate) takes the form of its realization (the procreator) so that these capacities embody the creations of their own creativity. To imagine that the Sambia boy novice is already his future wife is to imagine that he has within him the capacity to form a relationship with a spouse, he being dependent upon her, of course, for definition as a husband. Yet the capacity must in turn be made visible, be made to work, and it must be shown in the only form possible—as its own outcome. The capacity to bear children must appear in the form of a child who has been born; the capacity to act as a spouse must appear in the form of a conjugal union.

In English this sounds like stating the obvious. In Melanesian (as it were) people endeavor to make it obvious, to make these capacities thus objects of knowledge for themselves. They must be extracted from the body that produces them. The spirit child which her husband's kin force on a Gimi woman alters the identity of the original fetus; the men's same acts also cause the woman to give birth, the new relationship

(with her husband) separating the child from her body. Sambia con-
struct a persistent asymmetry in the relations between men; the seniors
grow the juniors, in a coercive partnership that makes the boys the
objects of men's acts. For what the men put into the boys is also what
must be extruded: the boys' (= the men's) paternal potency. As objects
of the men's relations, the boys anticipate the outcome of their inter-
action. The anticipated outcome gives the gift economy its cultural
form.

Gift exchange has always been a conundrum to the Western imagi-
nation. For it is, tout court, the circulation of objects in relations in
order to make relations in which objects can circulate. This is the re-
cursiveness of the anticipated outcome. There is nothing particularly
mystical or humanistic about it. It derives, I argue, from making explicit
a particular technique of objectification, namely, the personifying mode
in which the objects of relations are always other relations. One calls
others into existence—a sequence visible in what people seek to know
about themselves. If relations consequently appear to them in such ob-
jects, *then these objects are apprehended as both cause and effect of
the relations.* And if we take 'the gift' as a shorthand for objects (rela-
tions), then we can see how gifts pose dramatic temporal problems.
They are images of the possible collapse in on itself of any relationship
of separation between cause and effect.

The gift works as the cause of a relation as well as its effect. So
conceiving an object to be the outcome of a transaction posits its ex-
istence in the context of transaction. Both prior and subsequent trans-
actions are implicated in its value.

Objects can consequently take on the appearance of a possession to
be extracted (or stolen, Harrison 1984:392) from another. This antici-
pation is also retrospective; anything one has acquired (wealth, fertil-
ity) may appear to have had its origin elsewhere. An origin may be
acknowledged as a source of growth: what another has grown becomes
partible for oneself. A prior condition is thus transformed into its coun-
terpart. These interrelations follow from the aesthetic constraints of
gender imagery.

Transformation consists in altering the value that objects have. By
altering the objects, new relationships become visible, though where we
might perceive it is the meanings which are changed, the participants
might imagine it is their appearance. The bodily form of a Sambia boy
changes under the activity of his seniors; no longer the outcome of a
cross-sex relation between his parents, he becomes first an object of re-

lations between same-sex men, female to their male, and then a partible male entity within a male body in a potent state. The possibility of so switching the 'value' of an object makes obvious that each relationship anticipates its own transformation. What is true externally is also true internally, that the outcome or product of a relationship is already contained in the relationship itself. Thus *moka* partners are partners by virtue of the wealth that flows between them, at once cause and effect of their actions.

In this sense I interpret A. Weiner's observation that an "object is both the sign of reproduction and also the action of reproduction" (1982:64). But reproduction only exists as a discernible activity in so far as the gender of objects indicates perceptible movement between same-sex and cross-sex relations. We must return to the drastic aesthetic limit on the manner in which transformation itself is registered. Since social relations are evinced in one or other of two shapes, transformation is achieved as the movement between them; the medium that registers movement is the replication or substitution of gender identity. Basically, actors move perpetually between being the completed (cross-sex) outcome of the actions of others, and themselves (same-sex) being able to act in respect of another. To put themselves in this latter condition they thus assume an 'incomplete' gender.

The creation of a same-sex state seems a symbolic prerequisite for separating gift from giver, the transacted from transactor. Only this separation allows the detachment of an object which can then be exchanged between persons and signifies the relation between them. Detachment makes the person incomplete (Schieffelin 1980), and therefore seek completion with another. Completion is inevitably anticipated in the oscillation between creating the condition of an active reproducer (incomplete) and the condition of the reproduced (completed) thing as evidence of past action. Same-sex entities are such activated reproducers (being of one sex, they evoke their opposite), while androgynes are 'finished', reproduced beings, the sign of agency in others but not themselves agents.

Persons (relations) can only appear if they take a form. The necessity to display one or other condition—one must always *be* one or the other—thus means that to be in a present state one is no longer in the previous state: same-sex and cross-sex relations themselves emerge both as cause of and effect of each other.

In ceremonial exchange, what looks like the recipients' coercion to

attract wealth to themselves is also coercion on the donor's part. The recipients, having been donors previously, are now the passive cause (the debt) of the newly activated exchange. Activation extracts from them admission of the donor's prestige. They are forced to accept the donor's gifts, acknowledging the debt they created in the past, thereby making themselves for the present inactive.

Inequality is essential to this relation, imitating the asymmetry of those unmediated relationships by which one party grows another. For only what another has grown can become partible for oneself. (Expanded, of course, this states that the object of a relationship with one person becomes differently attached in a relationship with another.) If growth occurs on the basis of a unitary identity between grower and grown, it is apprehended as increment internal to the person. Growth is conceptualized as contained—within the clan on ancestral land, within the body of male cultists, within the size of the big man. Growth is also secret and silent, known only by its effects. But to have effect requires release of the grown entity from the body which contains it. This act of production involves both force and differentiation: the male clan detaches its female wealth in exchange; male initiates show themselves to women; a big man attracts exotic wealth as an extrinsic adornment. Objects are separated from their source by the new relationship that they signify, and a former encompassing relation (same-sex) is now revealed to be internally partible (cross-sex). Or a same-sex object—clan strength, male initiate, a big man's prestige—may be inversely construed as a product of a former cross-sex interaction: husband and wife labor to increase pigs; the initiate is junior female to the senior males; wealth comes from an unequal partnership between donor and recipient. 'Production' in either case (growth and release) becomes conceivable only in so far as the produced entity is also exchanged between persons; it exists in partible form. The relations that thus separate persons in terms of gender also give the object of their interaction its reified character.

Indeed, we might say that the anticipated outcome is the aesthetic trap of the gift economy. Relations are objectified in certain forms which leads to objects appearing as things and thus in-themselves holding out the possibility of activating relations. In fact they can activate only those relations that they can make appear. Hence the inevitability of enchainment: one can only make appear what already exists. Yet chapter 7 began with a disquisition on improvization and invention.

The further idea that things do not appear on their own but must be forced into existence by people's acts is the topic to which I now turn. Chapter 10 draws on this discussion to suggest how the enchainment works, in a way contrary to what we might suppose, to create individuals as agents and relations as the cause of events.

9
Forms Which Propagate

There is one point on which accounts of male initiation ceremonies for the Papua New Guinea Highlands seem generally agreed: boys are represented as having to be separated from the domestic sphere where they were nurtured. Separation is construed as removal from maternal influence, with no doubt about the extractive idiom. The children must be torn from their mothers. Whether or not there is accompanying female initiation, the parallel with the boys' bride-to-be is sometimes overlooked. As is clear from Gimi practices, a girl must in turn be detached from paternal influence, separated from an identification with her own father. Simultaneously, she becomes evidence of successful transactions between men. It is into this context that idioms of marriage exchange must be put. Highlanders may liken marriage exchange to the ceremonial exchange of other gifts whose effect is to create ultimate parity between male partners; but they also make the marrying of women, like the initiating of men, into a forcible process of extraction.

The parallels are mine. In the rhetorical emphasis Highlanders give to their own actions, extraction and circulation become gendered; boys have to be detached, girls have to be exchanged. Yet each act also depends on the other, and novices are made into objects of exchange, brides detached from their kin. Nonetheless, the rhetoric has had an influence on anthropological interpretations. Consequently, my account must extricate itself from the concreteness of two images as they have

presented themselves to the Western eye: the image of the boy child being removed from an overbearing female sphere, in order (as the analyses went) to socialize him into masculinity; and the image of females circulating among men like so many wealth items, their femininity or fertility (it was assumed) the instrument of callous male reciprocity. At best these interpretations captured half-truths.

Sambia tell us that there is an intimate relationship between initiation and marriage exchanges. In both cases, what is made partible is what another has grown. This is the objectified form of the process by which values are altered in the transformation of relationships; a part of oneself is seen to have an exogenous source, from the viewpoint of one relationship to have originated in another. Thus from the perspective of an all-male cult membership, boys in being separated from a 'domestic domain' are separated from the context of these men's own cross-sex relations with their wives. From the perspective of the group of males who negotiate marriages, the bride must be similarly separated. Here the relevant domain of domestic relations is male. It is her father's influence that must be altered. The difference is that the negotiating men substitute themselves (as husbands) for another male (the bride's father) rather than for a female (the initiate's mother). The flow of women can thus be likened to the flow of partible objects between men. The men's aim is to create new cross-sex relations for themselves (with the wife, with the affines); they substitute for the woman's cross-sex relation with her father their own cross-sex relation with her.

The outcome of men's transactions with one another is thus the propagation of new domestic ties. Both initiation rituals of the Sambia kind and marriages conceived as taking place between groups of negotiating men serve to establish the future conjugal and paternal activities of the men. They also turn the daughters and sisters of men into wives and mothers.

Parents of either sex are created (appear as objects of people's dealings with one another) by being extracted from their own parents in anticipation of the offspring that will be extracted from them. Beyond the conjugal union, then, lies the outcome of it—children who may be claimed by men, either as extensions of their all-male identity under patrilineal regimes or as a product of their cross-sex identity with their sister under matrilineal ones. In either case, childbirth is a powerful enactment of the extractive process itself, and women's capacity to give birth gives form to the anticipated outcome.

The idea that we cannot sustain, however, is that women are thereby symbolized as powerless. They may indeed lack power to exert influence over the individual men who arrange things for them. But they are not imagined as passive and powerless in themselves. On the contrary, there is a widespread illusion, on the part of both Melanesian women and men, that women are able to grow children within their bodies.

Again, we have to resist Western images of maternal nurture. For other ethnographic cases than the Sambia, dogma seems to have it that a woman does *not* feed the fetus within her. There, it will be recalled, the mother only 'feeds' the child after its birth, with her semen-derived milk. Within her body it is fed by the father. What is significant is the body itself—that the fetus is contained within her. This is the source of the connection between mother and child, a relationship of unmediated exchange. She has a direct effect on its growth, and in a number of societies this effectiveness leads to women's further illusion that mothers replicate themselves. Where the illusion is shared by men, then the father or mother's brother must extract what is owed him. In doing so, the men deal with what for them (as Herdt aptly noted) is the mediating effect of their affine's body in order to cause the child to be born. The difference between the regimes to which I have alluded is that in the one case the father must act on the mediating effect of the mother's body; in the second the mother's brother must act on the body of the mother's husband. Only in so far as they can bypass these bodies are men's actions seen to take direct effect.

The contrast between the two types of production mentioned in the last chapter (release, growth) presents the outcome of exchanges from two vantage points. This is true of both 'matrilineal' and 'patrilineal' regimes. In the latter, these are the vantage points of fathers and of mothers. Fathers are given evidence of their own action in the form of the born child. But it only substitutes for their actions as the outcome of them, manifesting their agency in a different form. Moreover, they must activate a cross-sex relation, since the child is only extracted in being separated from its former (same-sex) encompassment by its mother. Mothers by contrast are given evidence of their own replication in the swelling of their bodies; the cause may be a former cross-sex relation, but for them the outcome is recognizable as same-sex increment. Both substitution and replication manifest, reify, turn into things, the effects of unmediated exchange. Thus as things are persons—people and clans—grown and propagated.

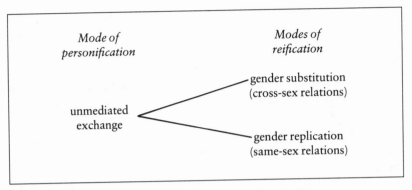

Fig. 2. Techniques of Objectification II

SUBSTITUTING FORMS: EXTRACTION

I retain the ambiguity of the term 'marriage exchange' to refer both to a reciprocity in marriages, when one partnership replaces another (as in sister-exchange), and to transactions which accompany marriages, such as bridewealth. Much has been made of the organizational consequence of their difference. My own interest is in the fact that in either case spouses are defined as extractable from their natal kin by virtue of being owed to another. I briefly comment on the marriage exchanges of the Highlands before considering a seemingly different situation in the matrilineal Massim. The ambiguity of the lineal designations is also retained, as a mnemonic for the differences by which we habitually know these systems, though it will be clear that I do not endorse this classificatory schema for my present purposes any more than I do the difference between kin-prescribed and other forms of marriage. That is, we cannot take these social forms as the basis of the very real contrasts to be made between Melanesian societies, though they certainly manifest contrast.

Creating wives and sisters. Those Highlands exchanges that take such a strongly mediated form—men circulating objects of value to create relations among themselves—have another side to them. The marriage 'rules' that so compel men to take action in relation to women simultaneously give their exchanges an unmediated form. Their relations have a direct, substitutive effect upon one another. Women are already wives by virtue of being sisters, and all that men's activities accomplish

is the moment at which their transformation from one state to another becomes visible.

Highlanders make overt the analogy between the circulation of wealth items and the circulation of women in marriage. It is they who liken marriage transactions to gift exchange, who equate women with wealth.[1] Sometimes the 'exchange' is counted post hoc: only after the event do people point out how a woman who went to that clan was exchanged for a woman coming to this one. But women are also seen to move against wealth, as when bridewealth is given; or women may move against other women, as in sister-exchange. In any case, both men and women construe the transaction in terms of reciprocity. Women's equation with wealth, it can be added, is not restricted to bridewealth but applies to the idea of valuables in general. What women reify are partible components of male identity. These partible components are not, of course, to be imagined simply as feminine powers ('fertility') that men have appropriated for themselves, but as the converse form of their own masculinity with its own maternal origins.

Like Muyuw, Hagen men say "women are our tradestores," and what they mean is that sisters and daughters bring in bridewealth, in the form of pigs, shells, and money to their clan. This transformation is accomplished at the start of a working life rather than, as in Muyuw, at its end. Hagen bridewealth is thus compensation for the detachment of a clan person rather than an anticipation of work to be lost (though this is an idiomatic element). The person of the sister or daughter is returned to her clan, then, in the form of wealth, but not as its own recoverable substance. On the contrary, the sister, already separated from her male kin by the exogamic rule, anticipates that wealth as an exogenous addition. In relation to all-male clans, then, female agnates are detachable entities, to be 'added' to other clans. This makes them equivalent to wealth disposable in social relations in so far as they stand for the relationship between units, partially attached to each.

As an aspect of Hagen men's social identities, women are personified as 'female' thereby, circulating as detachable parts of clans or persons thereby rendered 'male'. But they do so by virtue of the kinship trans-formation that turns them from sisters into wives.[2] A woman must be separated from her agnates through her relationship to a particular other (spouse), to whom her kin thus owe the possibility of separation itself. Only he can do it for them. From the point of view of the donors (wife-givers), the sister is now a detached part, but she comes to the

recipients (wife-takers) as an entire representative of her natal kin. This is a switch from metonymic to metaphoric gift (see chap. 8). It is constituted in the different perspectives that the male participants have of their interaction.[3] Hence the necessity that they are in exchange, *for what they exchange with each other are their viewpoints.* And the relativity of their perspectives comes from the demonstration of the men's respective capacities: only *one* of the kinds of males (spouse, not agnate; that is, the sister's husband, not her father or brother) can cause the woman to give birth. Again, only he does it for them, that is, convert her person into (his) children and (their) wealth. He is necessary to effect the substitution of one kind of relationship that they enjoy with her into another.

But in so far as those relations are already predicated in the exogamic rule, the possibility of substitution is already embodied in the persons of women. That outcome is anticipated.

In a number of Melanesian societies, such an outcome is construed in the prescriptive kinship claims that persons have on marriageable others. The bride is represented as already owed to the marrying unit, who assert their present claims against their former own cross-sex relations with the same people. Cousin marriage and moiety organization as found in certain Lowlands systems (the Sepik provides examples) present perfect cases of the anticipated outcome. Each unit produces for the other because it has been so produced. The gift (the bride) already exists and must be extracted, and extraction thus activates the very relation which makes the object. In the Highlands, however, it is much more frequent to find sister-exchange accompanied by a prohibition on marrying relatives, as in Sambia, or a prohibition on any replicated marriage in kinship terms, as in Hagen. The prevailing ethos that marriage is nonetheless an exchange, as it has to be to effect partition, leads to the metaphorization of marriage between wife-giving and wife-taking units *as though* marriages were substituting for one another (J. Weiner 1979, and see, for example, O'Hanlon and Frankland, in press). 'Real' or 'metaphorical' sister exchange means that a debt is established, either in the past or in the case of simultaneous double unions in the present. This latter is also the structure of bridewealth, though the debt is construed in the moment of negotiation. Transfers of bridewealth establish the claim at the same time as the claim is met. A claim is, of course, an anticipation of separable interests or viewpoints.

Separations are activated at the moment of extraction, since an object can only be extruded through social differentiation. That is, the

object of one relationship becomes the object of another: sister becomes wife, a woman's father's child becomes her husband's child. And if women subsequently reify aspects of male identity, men also reify aspects of female identity. In their cross-sex relations with different categories of males, women's female capacities are released in different ways. As far as their ability to grow children is concerned, this release is anticipated, but not realized, in the exogamic rule or in prescriptions about the kinship status of the conjugal partners. Evidence that the appropriate transformation has been realized requires the intervention of an agent who, in becoming a source of action, acts to a direct and in this sense unmediated effect. To give evidence of their own capacities, the 'things' they can yield, women need men to exert themselves on their behalf.

Creating fathers and sister's husbands. At several points in her writings on the Trobriands, A. Weiner (1976:229; 1978:178; 1980:75) notes how inapposite it would be to interpret marriage exchanges as simply defining women as objects of men's transactions. This criticism lies within her larger concern with the way women's 'power' has been overlooked in the ethnographic record. She develops a general approach to reproduction, the manner in which in her terminology persons 're-place' one another, stressing the formation of all kinds of relationships through the flow, combination, and separation of substances (1980; 1982). Exchanges sustain these flows and include transactions initiated by women quite as much as men. They are part of a general process of social regeneration, in which "women and men, exemplified in the objects they exchange, perceive the value of each other through the interface of the value of human beings and the value of regenesis" (1976:231). Women's reproductive power cannot be regarded simply as a biological resource at men's disposal. It is not the case that "women were one object among the many objects that moved between men" (1982:60).

One significant context for her perspective (1980) is provided by the small gifts (*mapula*) that Trobriand husbands give their wives, and fathers their children, particularly sons. Since there appeared no material return, Malinowski called these free gifts, even though the local term ('repayment', 'equivalent') aligns them with other reciprocal exchanges. Weiner takes, in fact, Malinowski's own position, that exchanges cannot be considered in isolation. Such gifts, from a man to his wife or his sons, initiates a much larger flow between his *dala* (ma-

trilineal kin group)[4] and theirs. Gifts to male children include resources such as land use or coconut palms. These are redeemed by his *dala* at his death: when the man's kin group takes them back it replaces them with male wealth (ax blades, pots, shell ornaments). The children's relationship with their father over his lifetime is thus finally transformed into male wealth at death. The return is a substitute for the work which the sons do for the father, in much the same way as the wife's work is also joined with his. For this, female wealth comes from the deceased's female relatives.

A parallel with the combination of husbands' and wives' work on Muyuw suggests itself. However, the ethnographers note differences between the two islands. The significant Trobriand category of female wealth (skirts and banana leaf bundles) is absent from Muyuw; people there also make minor business of the harvest payments from a brother to his sister/sister's husband which formed such a role in Malinowski's explication of Trobriand kinship. But there is more to the variations than the classification of wealth items.[5]

Distinctive to the Trobriands appears the possibility that a man can transform his 'work' (p. 195) into wealth, albeit male wealth, for his kin group. On Muyuw, a man's kin are only compensated with produce for produce—transformative power lies with the sister, whose work is compensated with valuables. (Men's work in 'manufacturing' is envisaged by Muyuw as being transferable directly into shells for their own, not subclan, use.) Weiner (1983:158–160) stresses the value Trobrianders give to stone ax blades in internal exchanges. These items of male wealth circulate to secure the replacement of individuals or property—they appear in, though are by no means confined to, mortuary distributions as final substitutions for the original marriage transactions, including *mapula* gifts. Like *kula* valuables, axes walk around and have genealogies consisting of the names of their owners (Weiner 1976:183). They are conceptualized as the property of individual men and are not *dala* property. But they can come to the men of a *dala* in completion of kin obligations, and although the axes are obtained through a variety of transactions and services, receipt can terminate relations that male *dala* members have with their paternal/affinal kin. Prime examples of male wealth, the return of such same-sex valuables cancels the reproductive potential of a cross-sex connection between a son and his affines.

The cultural weight that Trobriand men put on the male valuable (the ax) must be appreciated in relation to its counterpart, female wealth.[6] In one sense 'male' and 'female' wealth circulate in parallel in

internal exchanges. But there is also an asymmetry between them. Women's wealth bears a more emphatic connotation of inter-*dala* connection (1980:78). Female wealth is given, for instance, in reciprocity for the harvest gifts of yams which a brother sends his sister/sister's husband. Weiner (1983:157) argues that a woman is in debt to those who so provide her with yams, and she has a lien on her husband to provide her with female wealth to meet it. For one of the husband's return acts lies in his efforts to help the sister, his wife, find such wealth, including from among his own female relatives; it is part of his productive work on her behalf, which also includes making gardens and feeding the woman and her children, an activity closely monitored by the wife's brother. Weiner (1978:179–180) suggests the harvest gifts are thus a register of "the productive work effort" of a husband towards his wife.

In fact, these efforts also separate the joint work of the spouses by gender. The wife is assisted by her female affines to make a return of female wealth to her 'brother'. Meanwhile the yams also bring the husband personal prestige, and in addition he reciprocates with male wealth that includes stone axes. The significant point that Weiner stresses, however, is the manner in which the efforts of particular persons are transformed into *dala* objects. The husband's work, for instance, is returned initially by his wife's brother in the form in which it is given (yams—produce for produce) in the same way as his caring for her children is reciprocated by the wife's caring for the yams he grows for his sister (Brindley 1984:67). But when we look at the work of the siblings, it seems that female wealth is tied to mortuary contexts, for this is when inter-*dala* relations are mobilized. Thus a woman's return to her 'brother' (which is received by the brother's wife) is made on the occasion of a death in his *dala* (which is also her own) (Weiner 1976: 197–198; 1983:157). These transactions simultaneously separate *dala* members by gender into two kinds.

The brother gives the products of his work (yams) for the use of his sister's husband, while the sister provides her brother's wife with the skirts and fibers of female wealth. From the point of view of the siblings' *dala*, wealth returns to them by a double route: female wealth via the sister's marriage to her husband and male wealth via the brother's yam exchange with the sister's husband. The work of each sibling is thus objectified in these items. An asymmetry between female and male wealth has already been noted, the latter as Weiner stresses not carrying the regenerative overtones of the former. But the two kinds of wealth

could also be regarded as analogues of one another, just as there are two (different) kinds of *dala* members—female and male.

Despite the asymmetry between them, then, Trobriand brother and sister jointly generate wealth for the *dala*. That men as well as women do so may be linked to the idealized 'ranking' of Trobriand kin units, in so far as they come to be conceptualized as accumulating resources (1980:81). Male and female siblings together recoup their double 'work' in the form of the male and female wealth generated by their relationship with the sister's husband. Indeed, the husband emerges as the crucial *single* conduit by which the two kinds of wealth come to the pair of siblings. The wife holds an analogous though possibly less visible position; she is an alternative single conduit, so to speak, from the viewpoint of her husband's *dala*.

Any death—as an inter-*dala* context—generates both male wealth, which initially takes the form of compensation from the widow/widower's kin to the deceased's kin for having let him or her die (1976:74), and female wealth given by women to the kin of a deceased spouse to terminate the relationship.[7] In the long term, gifts of both forms of wealth from the deceased's *dala* make a return to the spouse for having cared for the deceased while he/she was alive, as is made to a father for his nurture of children. Marriage is the pivot for these exchanges. And without the sister's marriage and her husband's exertions, which elicit both hers and her brother's work, there would be no such flow of male and female wealth.

Brother and sister each give and receive their own type of wealth (male and female valuables) at the explicit point of termination of extra-*dala* connections. I have suggested that the parallel same-sex transfers thus separate the siblings, making them into two 'kinds' of *dala* members, male and female. Mortuary gifts, then, are perhaps a covert restoration of the cross-sex tie between them, which substitutes for the cross-sex tie of the conjugal-affinal relationship. The generative potential of this latter relationship is cancelled in the reactivation of the gender of the sibling pair. But brother and sister do not give male and female wealth to one another. Their relationship is unmediated. For it is transactions between husband and wife, as between father and children, which take the form of 'gift' giving. The cross-sex relationship between spouses and affines is the overt reason for exchange, where the substances of food and work are transformed into wealth: from the receipt of yams from her brother, Weiner (1976:197) writes, a man is obligated directly to his wife. Their exchanges are material. But while

these substances thus comprise something of a closed circuit (work/ food/wealth), the production of children is without substance. It is the absence of direct exchange in the covert cross-sex relationship between brother and sister that makes *their* joint child.[8]

Trobriand assertions that there is no physiological connection between father and child has long excited Western observers. The lack of such connection between mother and child also calls for comment.

There is an apparent ambiguity in Trobriand ideas about conception as to the relationship between the entry of the child into the woman's body, thought of as a spirit brought by a matrilineal ancestor, and the contribution that a woman's internal substance apparently makes to the fetus. Malinowski's original account emphasized that "without doubt or reserve, . . . the child is of the same substance as its mother, [whereas] . . . between the father and the child there is no bond of physical union" (1929:3). The mother contributes everything, and above all her internal "blood helps to build the body of the child—it nourishes it" (1929:149). Indeed, in conception theories where the mother's blood is bound with substances from the father (as are found in the Western Highlands), the child is said to come from the mingling of both. But here there is nothing with which the mother's blood can bind. In fact there seems to be no indication that the blood is regarded as the basis for a connection of substance between mother and child. We should query whether indeed the mother feeds the fetus with it. Weiner (1976:123) is clear on the point that it is the figure of the father who is regarded as 'feeding' a woman's children. Blood is simply the counterpart already in the mother of the spirit children who will be brought her by matrilineal ancestral beings; it is not to be thought of as food at all. Malinowski's error, if we can call it that, comes from mistaking form for substance.

Trobrianders insist that the child is implanted as spirit and by spirit into the body of the mother. The partible form that blood takes is an anticipation of the very form the (partible) child will take, filling up the mother's body as a container is filled. But ultimately the child must also be separated from the maternal container. That scenario is already anticipated in the affinal exchanges. Let me make the connections explicit.

Brother and sister covertly transact together as joint producers of *dala* wealth and of *dala* children, but they cannot overtly exchange with each other. Rather the siblings produce 'different' items (yams, children), analogically equivalent but which each must make the other

yield. In childbirth, the brother has an urgent interest in his sister's production. But he cannot interact directly with her; instead, he forces an exchange on the woman's husband. Although the woman remains titular 'owner' of the brother's yams, the harvest gifts go to him. For the husband is the man who 'opens the way', through sexual intercourse, for the child's entry into her body at conception. He creates the maternal body as container, an anticipated separation of container and contained on behalf of the woman's brother. Indeed, it is the creation of the woman's body as container rather than the extrusion of the fetus which seems the husband's significant act; he separates child from mother while it is still within, by the internal molding of its shape. The brother's harvest gifts to the husband, one may say, coerce him into so acting and hence the sister into producing an entity out of but distinct from herself. And in this it seems to be the husband's activity rather than his emissions that take effect. That activity is in turn a product of his relations with his affines.

Either spouse may be the single conduit through which flows male and female *dala* wealth. The brother's wife is as essential to the objectification of the sister-brother tie as the sister's husband is to the brother-sister tie. But what distinguishes the two relationships is the crucial part which productive work plays in the latter by contrast with the former. This introduces an asymmetry, and puts a particular emphasis on the affinal position of sister's husband/father. For the husband whose single figure is the focus, and thus the object, of the brother's and sister's overt work—he elicits it from both of them—is also the catalyst for joining their covert work in the single figure of a child.

An object of the brother-sister relationship is the brother's child whom the sister grows within her. The husband is made into a catalyst by the brother, who supplies him with yams, analogues of the child in that they are conceived of as yams that the brother grows for his sister.[9] One might suggest that it is because the husband 'consumes' the yams that he in turn gives birth to the child, which would recall the Gimi image of the women who are forced to eat the male meat that forces them to extrude male spirit. Yet the Trobriand husband who deploys the yams for his own purposes does not give birth out of his body. As is characteristic of his exchanges with his affines, he does so through the mediation of 'work', the effort of molding the fetus. The father's activity gives the child his bodily form, as an extraneous and partible entity.

Putting his face on the child is the visible act by which the Trobriand

father effects its separation from its mother. His efforts are reduplicated through nurture. Paternal feeding establishes a connection between the child and its father, but making the father's contribution very much an external 'part' of the child's constitution. He simply gives it external shape. As a contained entity within the mother, then, herself composed of *dala* blood, the fetus is fed by the father; once it is born, it is its own external and containing form that he creates, its inner form being *dala* blood. Mother and child are thus internal and external homologues of one another (compare Weiner 1978:182). It is by externalizing the child *while already in the mother*, reifying it with his features, that the husband anticipates its separation. Moreover, in so far as the husband's work is regarded as a gift to be repaid, it is kept separate, exogenous. That the neonate continues to be fed from an exogenous source (father's work) individuates it from its *dala* co-members.

Between brother and sister lies a giftless transaction that they cannot by themselves externalize. For the one impinges on the other to the extent that they engage in exchanges with their respective spouses on behalf of what unites them, their *dala* identity. It is *dala* identity that is given form in the person of the child, since the father's acts of feeding are subsequently turned into wealth objects that are not the child: as we have seen, affinal nurture can be reclaimed by the wife's *dala* who pay out wealth in substitution for it. But from the point of view of that *dala*, the woman's brother has already extracted his child from the relationship between the spouses. He has done this through the regular yam prestations, which match continuous work with continuous work. That is, he substitutes for the joint work of the spouses on the husband's gardens his singular work in his own garden, which is seen to be to the joint benefit of himself and his sister. And the sister's body duplicates the swelling of her brother's pregnant yam plots.

Trobriand mother and child are not connected by ties of substance. The woman's body, like the *dala*, is the site for cooperation between brother and sister, but only through the exertions of the sister's husband can children, and indeed yams, be reified in the proper form. The blood within the woman indicates the silent, giftless relationship between the sibling pair. This identity between brother and sister is unmediated, for each is the other's body, and by contrast with relations between spouses, there is no mediating exchange between them. What mediates their relationship is the body of the person who will objectify it—reify its products—the spouse.

From the Western point of view, there is a double paradox here. A

Trobriand man gives birth to his wife's child; a Trobriand woman does not feed the fetus within her. The child's inner identity replicates that of the wife's brother and his *dala*, conceptualized as blood and spirit—the stuff that *dala* members share. But the mother does not 'give' this blood to the fetus as though it were food, any more than the brother impregnates his sister or sister and brother exchange gifts between themselves. And only most indirectly does the mother's brother feed it; the feeding is mediated by the sister's husband's vital act as nurturer. It cannot be the case, then, that the fetus is an extension of the mother's bodily tissue and that the mother 'makes' it in this sense. Yet the fetus is regarded as growing with her, with the mother's body seen as essential for growth. This further apparent paradox is a consequence of our own nutritive metaphors. The Trobriand material suggests we should distinguish feeding from growing.

The concept of maternal nurture is so linked to the concrete Western image of a woman imparting first her own substance (milk) and then the substance she has prepared (food) to her offspring, that I suspect growing and feeding are often treated synonymously. In the figure of the nurturing Trobriand father, however, food is apparently treated like a mediating wealth item and is contrasted with the 'growing' activated in unmediated exchange. Elsewhere, of course, food may work to unmediated effect. When Gimi women eat meat, the meat is a direct substitution for the male body that the women will egest; when Sambia boys ingest semen, the semen is a direct replication of their inner substance and is held to grow them. Indeed, food should be treated to the same range of objectifying operations as indicated for wealth items and persons: I do not attempt it in full here. But I signal that we cannot know from inspection alone if feeding and growing relationships are analogous or being contrasted with one another.[10]

A Trobriand woman is regarded as feeding her child with milk in the specific context of the relationship with her husband, with whom her work is combined. It is not only her brother's yams that feed her. A wife is also fed by her husband, and her child nourished by him; this 'feeding' work by the husband is joined with the feeding work of the wife (through her milk).[11] And since the yams she eats come from both her husband and her brother, the woman's post-partum feeding continues to form a child both the same as and different from herself. After birth, the child is thus fed by two kinds of males.

As far as prenatal development is concerned, the Trobriand fetus

can, as it were, only grow within the mother. She does for the fetus, her brother's child, what he with his yams does for her. Each grows his or her product for the other. This joint work is covert because it must take place within a container. What the brother grows in the ground, the sister grows within her body. Since yams and children are 'the same', the brother's yams cannot be conceptualized as directly feeding the sister's child, for they are analogues of the child. It is in what he replicates that the brother bypasses the mediating body of the father; brother and sister grow for themselves, as a single *dala* body, in male and female form producing like bodies (yams and children).

The mother's body is an aesthetic construction: what matters is its form. It holds what is within, and this is its secret. Growth does indeed occur offstage, as is emphasized in Paiela. It is a consequence of a relationship between mother and child but one that need not be mediated by feeding or any other transmission of 'substance'. The relationship consists of form itself: a contained entity is enveloped by a container.

The image of the maternal body as a container to be filled with spiritual essence is also fashioned during the course of Sambia initiation rites for boys, though here there is a doubling of the paternal contribution. Fathers provide both spiritual essence and substance. Far from paternal substance being irrelevant, the bodies of Sambia women are the mediating receptacles for male semen that both forms and grows the fetus.[12] It is the sister's husband who, like his Trobriand counterpart, is the significant agent. But whereas the Trobriand sister's husband is coerced by his wife's brother to open the sister's body, in the Sambia case the affine inseminates a sibling pair (his wife and wife's brother) in order to grow both of them and thus evince a capacity he cannot display in relation to his own sister. I make the comparison in order to recall that the outcome of these operations is the multiple genders of the Sambia child—like the flutes, at once male, androgynous, and female. We can say the same of the Trobriand child.

The cross-sex relationship between Trobriand brother and sister results in a single outcome (the sister's child). But the capacity of that sibling relation can be realized only through the exogenous efforts of the husband who substitutes for the relationship a singular entity in proper form, that is, the correctly shaped neonate. A further cross-sex tie is thus made visible (between husband and wife) that substitutes for the one-*dala* relationship between the siblings, and in this interaction

the husband has unmediated effect on the fetus. He cannot have this effect on the wife. It is to the fetus that he gives his own male shape; and he can only give his shape to it.

First, then, I refer to the father's extractive activity as male. A man's acts have direct effect, and the form they take is the act itself. The Trobriand father extracts something that is extractable because it takes his own form, as is equally true of Gimi or Sambia fathers who are regarded as filling up the empty bodies of women with the 'male' child the woman will produce. Childbirth reifies men's actions, in so far as male acts produce male acts. Second, the visibility of the produced thing depends on a cross-sex context: the 'male' child is extruded from a 'female' body. Acts are thereby reproduced in another form: the birth is the end product of other actions, the completed or finished 'thing'. The state of the neonate's (androgynous) completion signifies that the activation required this cross-sex interaction with the mother. So the neonate is also the multiple product of that interaction. The Trobriand child puts the mother's kin in the father's debt; in many Highlands societies, the father is in debt to the mother's kin. But in either case the child within is separated from the maternal body because it is conceived as a product of external cross-sex relations. Third, until that moment, however, the child may also be conceived to enjoy an exclusive single sex ('female') relationship with the mother. In that connection, the mother's body encompasses it as a replication of its own form, and in that condition the fetus is also grown by her.

REPLICATING FORMS: ENCOMPASSMENT

It has been impossible to separate an analysis of how the objects of relationships appear as things in extracted or extruded form from concerns with growth. This is not surprising, since the process by which one relationship substitutes for another elicits a conception of the first relationship as producing something which, in being owed, ought to be relocated in a second. Substitution may, as we have seen, appear as one cross-sex relation being displaced by another just as the Trobriand brother supplants the work that joins husband and wife by his work for his sister: yams for children. An intervening mechanism lies in the possibility that a previous cross-sex relation can always be regarded as a same-sex one. A same-sex relation is one of isomorphism between a person's internal parts or a shared isomorphism with like others. In itself it may be perceived as already a transformation of sorts.

I formulate here in reverse the suggestion made in the context of ceremonial exchange, that an expectant recipient has to transform a same-sex relation (between a donor and the donor's wealth) into a cross-sex one (the other's wealth becomes partibly what is owed him) in order to extract anything. Indeed, if one thinks about it, the reverse must hold: a cross-sex relation can only work to substitutive effect if differentiable from the previous relationship. If the cross-sex relation takes the reified form of difference, then the previous relation must be construable as a same-sex one. Thus from the point of view of his relationship with his wife, a Trobriand man may regard the wife and her brother as 'one'. (They are co-members of one *dala*.)

If personification means that relations between relations are predicated on separation, reification requires that distinct forms can also be apprehended as transformations of one another. The aesthetic necessity is that every relation contains within it or anticipates (as its 'capacity') its own outcome (a 'thing'). That outcome is the previous relationship in a transformed state. But how is a transformation from a unitary same-sex condition into a multiple cross-sex condition rendered conceivable?

Without a distinction between same-sex and cross-sex relations the one cannot appear to displace the other; at the same time, the one must also appear to come out of and be anticipated by the other. Thus a cross-sex relation can be regarded as bringing together two same-sex relations, as the separate internal constitutions of (say) husband and wife are joined in conjugal union. Conversely, and this perhaps is the more difficult construction to apprehend, a same-sex relation can anticipate a cross-sex one. Its internal completeness is perceived as incomplete in relation to its prospective opposite—an all-female relation is elicited in the presence of an all-male relation. But the prospect of elicitation is already contained in its own construction. The evidence lies in the way in which people's perceptions of a same-sex relationship can be altered, as the Gimi boys were confronted with the masculine features of their universe suddenly appearing as feminine ones: one same-sex relation is revealed as the *analogue* of its opposite. That is, an all-male relationship can be simultaneously reconceptualized as an all-female one.

The switch in perception depends on people's differently placed viewpoints. The system works because *one person exists by anticipating the viewpoint of another*. Thus the Daribi brothers who detach a female agnate, part of their male person, know that the bride will appear

as a female entity to the wife-takers who regard them (the brothers, male in their own view) as female. Her transfer temporally activates the anticipation. Anticipation is implied in the contemporaneous form of analogy.

The relation of analogy does not mean that an all-male relation will 'turn into' an all-female one. Rather, an all-male relation appears as a coeval 'version' of its all-female counterpart. The other form is present at the same time.[13] From the point of view of the Trobriand husband, the wife's child is an extension of his own work in his relationship to her, its partible form being established by the fact that the 'male' child can be separated from the 'female' body. He enjoys an all-male relationship with it, as the product of his nurture. From the mother's brother's point of view, the child is extractable in so far as the 'female' body is created to extrude a 'male' form, but what the mother extrudes is the basis of the tie between brother and sister, namely *dala* identity, and it is the replication of her female form that is important, that the child is composed of *dala* blood. The same-sex tie between mother and child thus duplicates in turn his own 'same-sex' tie (via their one mother) with his sister.

An all-male entity (the child as a product of the affinal father's efforts) can be equally conceptualized as all-female (the child as product of the *dala* siblings' efforts). The two perceptions develop vis-à-vis one another, in the cross-sex context of the affinal relation. We might construe them in terms of competing claims but only to observe that the other's point of view is always part of the construction: the father knows what construction the mother and the mother's brother put on the child's identity; the one viewpoint elicits the other.

If this is so, then the one viewpoint is also contained within the other.[14] Such is the condition I call encompassment.

Encompassment may be aesthetically apprehended as a male person containing within and having attached to himself *female elements in male form* or as a female person containing within or having attached to herself *male elements in female form*. (Either an entity within or an entity attached can be encompassed—indeed, as far as body parts are concerned, or the wealth or work that people create, an appendage is the 'same' as a body organ.) In that Trobriand brother and sister are two kinds of *dala* persons, male and female, each sex encompasses the other. The woman's swelling female contour evinces the productivity of the brother's male work. Conversely, in the brother's garden a tall yam pole supporting a triangular base is erected in a corner of each

plot that is the magical focus of its productivity. Malinowski describes it as the first vertical pole introduced into the garden, "a finishing off, so to speak, of the surface work of the garden . . . [that is] now encased in a glittering framework of strength and loftiness" (1935:131, 128, transposed). To see this pole as "a symbolic projection of the pregnant womb" (Brindley 1984:37) does not seem at all fanciful. But it is a womb in male shape.

Either a male or a female same-sex relation, then, may be seen as a simultaneous version of its analogue, and this possibility is contained in the image of encompassment. A Sambia woman nourishes her 'male' child with male substance contained in female form (milk), while a man nourishes his 'female' wife's brother with female substances contained in male form (semen). Significant to the analogic relation is its simultaneity. The one form is the other at the same time. In this construction, male 'is the same' as female. Yet each is a totalizing image—and the Sambia boy, like his Gimi counterpart, is forced into switching perceptions in the way in which he thinks about bodily substances, while knowing both the forms they take.

A dual identity thus seems to the perceivers to inhere in the object of perception. This lays the basis, I would argue, for temporal sequencing: to the actor, revelation about one or other condition must be sequential. The actor may also perceive a further sequence. The same-sex relation that is simultaneously its opposite sex counterpart can appear to turn into a relationship between the two, as a cross-sex relation.

There is no paradox in considering the Trobriand mother's brother as first a female figure and then a male figure. This is how he may be construed in relation to his sister.[15] The aesthetic analogue between the female Trobriand mother who is also her children and the woman's male brother who is also his yams is the conceptual basis for the giftless relationship between them. There is an outcome to their cross-sex tie: a thing eventuates, the harvested yam, the born child. That outcome both supposes a temporal sequence, a moment of revelation, and is the relationship in another form. It is the child who is born that is the outcome, not the hidden fetus or the yams in the ground. They remain for ever tropes for one another. Indeed, the covert, cross-sex sibling tie is only productive when it is made visible in the context of another and overt cross-sex tie, namely the relation between the woman and her husband. A same-sex relation (mother and fetus) can turn into a cross-sex relation (mother's brother and sister's child) only through an active intervention that registers their temporal distinction. The once encased

fetus is now the exposed neonate. But the embryo grew, so to speak, with its birth in mind. The same-sex tie 'anticipates' its transformation into a finished thing.

Imitations. Although at several points I have referred to perception, it should be clear that mine is not a cognitive analysis but an attempt to give a cultural description of Melanesian symbolism, of gardens that swell like bellies and of milk that is male. My remarks are not intended to be taken beyond. At the same time, they try to bypass the swathe of anthropological explanations that rest on some kind of appropriative metaphor.

We may recall that the revelation that much male cult activity contains within it female elements has often been interpreted as evidence that men had appropriated or were controlling properties that belonged to women. It was taken as a sign of their victory over the opposite sex. I do not see that we require this mode of explanation. Women's bodies are not conceptualized as having a 'natural' form that men appropriate. The composition of men's and women's forms each metaphorizes the other. To make the point, I turn briefly to the question of menstruation and bleeding, for in the analyses of Highlands rituals this has been taken as prime evidence of appropriation: men bleed themselves to imitate women's bleeding and thereby (in the observer's view) show that they have appropriated women's powers. The further conclusion drawn from this is that men covertly desire self-sufficiency, that they would reproduce without women if they could. This curious fantasy, noted in chapter 5, obviously holds power for the Western observer to be so consistently read into the ethnographic record. My description is intended to put the practices into a wider context.

The collective activity of ceremonial exchange (chap. 8) sets up a homogeneity and replicability among the participants that creates the conditions for a flow of items by which men measure themselves. They dispose of wealth which refers back to their male persons yet is simultaneously differentiated from them, and conceivable in female form. The flow of such items stimulates velocity, a speeding up of circulation through like (same-sex) units, so that the total metaphoric claim is self-productive, of more wealth, more prestige. By contrast, in initiation ceremonies Sambia men, and some of their Eastern Highlands neighbors, detach and circulate objects (novices, semen) which take a male form, though there is a sense in which they derive from a female source. Here a male part is separated from the person's otherwise androgynous

constitution. This objectification of maleness in initiation activity, then, does not heighten or increase an innate maleness within persons but makes detachability evidence of a specific (male) capacity. At the same time, a partible substance cannot flow unless it is released. We also saw that the initiands are constituted as vessels through the release of blood from their bodies. This may be perceived as a female part. Yet it is not women as such that the men are so imitating: it is another version of themselves.

Sambia men bleed themselves throughout their life just as they supplement their internal semen pool by drinking the sap of pandanus and other 'trees' (Herdt 1981:chap. 4; 1984b:195–197; J. Weiner 1982:9). The sap ('milk') is covertly seen as coming from a female (the tree's 'breasts'). One would expect the blood they let to be covertly male, but this does not appear to be the case. I suggested that a relation of potential analogy between blood and semen is displaced by the Sambia analogy between semen and milk, because the origin of a man's sister's husband must be distinguished from that of his mother. Thus the blood is regarded as female not male in origin. Or rather one could say that men rid themselves of the 'same' substance in female form (blood) that they ingest in male form (semen). It is dangerous to reverse the sequencing (compare Gillison 1980:150), and this is the chief danger of ingesting women's menstrual blood, which Sambia men regard as polluting.

Women are thought to have within them both the circulatory blood supplied by their mother's womb "that stimulates body functioning and growth, and the ability to withstand sickness or injury" (Herdt 1982b:196), and that they share with men, and their own menstrual-womb blood, a pool we might say is similar to men's pool of semen although Sambia do not emphasize the equation. This second kind of blood is lethal to men in historical-temporal terms. Their mother's womb blood was an appropriate container of their person but one that has already completed them. For a person to be re-haematized, re-contained by more womb blood, would put history in reverse. Rather, historical sequence is sustained, I would argue, by blood-letting. What grew them before birth cannot grow them again but can be released in partible form. This partible substance (blood) remains something that they do not themselves transmit. Its origin in their own particular mothers is its significant characteristic.

The masculinity of blood is made apparent in other Eastern Highlands systems. Where marriage exchanges do not entail the same possibilities of reduplicated substance, it is blood and semen that may be

construed as analogies. A woman's blood is thought of as paternal substance and evidence of her paternal spirit (e.g., Gillison 1980:167).[16] In these latter configurations, the mother's brother emerges as a crucial figure, not unlike the Trobriand father/sister's husband. He is the exogenous male who makes creative the difference between male and female forms of the same substance.

In Eastern Highlands societies such as Gimi, menstrual blood is a version of semen because of its reference to paternity. Thus, ritual at a girl's first menses establishes that what flows from her body is paternal substance, belonging to the girl's father or lineage, and is explicitly analogous to the noseblood ('semen') of her brother (Gillison 1980: 149). This blood must be kept separate from male substance in its form as semen; indeed, the two are inimical. In order to receive a male substance in productive form (the husband's semen), the woman has to get rid of its paternal counterpart already within her (father's semen in partible form, her blood and thus his 'dead child') (1980:169).[17] This creates her internal cavity. She herself continues to bleed, in that her paternal affiliation can never be completely eliminated.

> [F]emale menstruation is a substitutive process in which the 'deposits' of one man (the father or, collectively, his lineage) are destroyed and replaced by the 'deposits' of another man (the husband or his lineage). (Gillison 1980:168)

In this context, women's womb blood is denied a feeding role: semen alone forms the body of the fetus. Food implies an equation with the maternal body itself, and Gimi men periodically induce vomiting (through cane-swallowing) to get rid of maternal food, including breast milk, "parts of their mother's bodies" (1980:150). Men also bleed their arms and noses to invigorate the body. What they get rid of is a part of themselves, but here themselves in female form. Menstrual blood is not food but in women a female manifestation of paternal substance. For men, its possible paternal origin is mediated by this female identity. Because it can be voided, the man's 'male' body can thus be separated from his 'female' part. It is a part that was formed during the creation of the man's own body, and as generally appears to be the case throughout this region, the voided 'paternal' substance is thus overtly described as 'maternal' blood.

On the surface it would appear that the blood is simply that of the woman's paternity (derived from the father). However, I suggest that

this also covers a further equation between a man and his own paternal substance, insofar as he reenacts his own birth. Let me spell this out.

Bleeding among men offers evidence that they can detach parts of themselves. The detachment of a 'female' part (blood) invigorates the male body, enhancing the personal health of the performer: it does not result in a product that can then circulate between men. (Men circulate their blood, so to speak, in the bodies of their sisters.) Nevertheless, it is the activity of separation—the moment at which male and female elements are visibly distinguished—which effects this enhancement. The man's person momentarily enacts its internal male/female constitution, and the results are beneficial for himself. For at the same time he is activating the already completed transactions that brought about his own (androgynous) constitution. Men thus energize themselves, one might say, in terms of the transaction by which they were born, and as an object extruded from a container are reproduced as containers. In this *they decompose themselves*. And they do so, I suggest, by detaching from their bodies both maternal (vomit) and paternal (blood) substance.

The energy that Gimi men derive can be traced through a devolution of events. First, it is a male activity to so effect detachment (Gillison 1980:147). As in Gahuku-Gama and Bena Bena, Gimi women are re- garded as receptacles for men's semen. To expand this proposition we might say that women, themselves androgynously constituted, enclose an androgynous substance (blood/semen): its masculinity lies in its state of being enclosed to encloser, and potentially detachable thereby. When he performs this operation on himself the male 'mother' voids a replica of himself, that is at once maternal and paternal substance. Second, the man's body is the single site for its dual composition through mother's body and father's semen. Men also disaggregate these two contribu- tions, thus tapping the energy that caused the original pair to unite (each parent being in a unitary, single sex state). This is possible be- cause, third, they reenact this historical event by turning themselves into a similar unitary state. In so far as they then claim this state through evidence of its maleness, the two parental substances that they decom- pose can only be envisaged as female. Thus both mother's food and father's semen must be extruded in female form (cognized as 'mother's' vomit and blood).

Decomposition through blood-letting thus celebrates different pro- creative moments. Sambia men do not reenact their historical contain- ment by their mothers but show in themselves their mother's blood in

transformed, partible (male) form. In contrast, Gimi men use bleeding to indicate their own partibility, for they were born only because their father's semen (blood) displaced their mother's blood (semen) within her body. As its analogue, blood cannot turn into semen; but blood/semen appropriately appears only in one or other form, which must be sustained as unmixed.

In certain Western Highlands societies, the distinctiveness between blood and semen is taken for granted, and it is their productive mingling or pairing that takes place within the woman's body. Menstrual pollution simply indicates the difference between blood creatively paired with semen and blood that has no creative outcome. In contradistinction to the metaphoric (analogic) equations that render semen as a type of milk, Western Highlanders who do not let blood may perceive semen and milk to be irreducibly antithetical substances (e.g. Meggitt 1965: chap. 7).

For Paiela, the crucial contrast lies between 'bound' and 'unbound' blood. Biersack argues that the Paiela wife's blood must be properly bound with semen in order for her to procreate. This deliberate combination of distinct substances produces a mediating object (the child), the wife's 'return gift' for the bridewealth (1983:96). Biersack suggests that it symbolizes the alliance of kin groups mediated by the marriage; but more than this, "it presages as well the consummation of a transaction that the husband himself has initiated. It is he who has given bridewealth and placed his wife under an obligation to reciprocate" (1983:97). The substances are the basis for a transaction between the new couple: blood and semen hold the possibility of the future transaction within themselves (each a same-sex substance) rather than, as in the Eastern Highlands cases, holding within themselves the androgynous record of transactions completed.

I return to these regional contrasts in the final section of this chapter. A remaining observation concerns the Highlands, which one might conceivably resurrect in terms of men's appropriation of female powers. Cognized as female substance, neither milk nor blood is directly reified into objects of mediated exchange; they circulate only through their analogies as semen or wealth, as metonymically parts of men rather than parts of women. Is it only 'male' substance, then, that supplies the reified form for the objects of collective relations? Does 'female' substance not circulate? One riposte has already been given: female substance is circulated already embodied, that is, in the persons of sisters and wives. And a consequence of this embodiment is that the mediatory

objects at women's disposal comprise what they have grown within, the products of their own same-sex relations. This holds true for the plants and pigs women grow, a capacity that may be abstracted as the capacity for growth itself, as in the enterprises of Daulo women. In Daulo, it even looks as though women deliberately 'appropriate' the products of cross-sex household relations in order to make them grow properly in an exclusive all-female environment.

Sources of growth. The Eastern Highlands Daulo were introduced in chapter 4. Warry underlines the different structure of women's collective *wok meri* activities from the ceremonial exchange networks of men:

> Men join together to give away massive amounts of food, money and beer in order to build group and individual reputations. Kafaina [*wok meri*] women gain public recognition by receiving and 'tightly holding' their wealth so that development and business will prosper. . . . Men 'waste' wealth in search of political status; women gain status by guarding resources necessary for development. (1985:35, 37)

The collective nature of women's activity has some precedence in women's horticultural cooperation and former rituals involving their participation as a body. Warry emphasizes the cooperative as opposed to the competitive tenor of women's and men's exchanges (see p. 86). Indeed, the new dogma of the *wok meri* movement sustains a contrast between men's propagation by 'flow' and their own by 'growth'. But, then, on Sexton's analysis the analogue of *wok meri* is men's initiation ritual not kinship-based exchanges as such. The women come together on the basis of a same-sex tie, but their indifference to extant social relationships between the participants (created largely through kinship) means that the mediatory possibilities of their transactions are played down. They obliterate the mediating element by which wealth is seen to flow between differentiated (cross-sex) social persons, and create instead a vast replication of same-sex relations. There is a singleness about women's efforts, revealed in the ideas about retention. And in their external relations this collective work by women to grow wealth gives evidence of itself in further 'internal' enlargement, as in the model of proliferating daughter groups.[18]

While momentary differentiation between *wok meri* groups is encapsulated in an affinal idiom, that they are bride-givers/takers to one another, this potential cross-sex image is juxtaposed by the companion image that redescribes that relationship as one between (same-sex)

mothers and daughters. Only on the occasion of public display, when they make their products visible, are donors and receivers of money radically separated, and this occasion is cast into a cross-sex framework: the mediating interventions of men (as bookkeepers, spokesmen) are required.

Until that moment, one group's growth is seen to lie in another similar group. As long as it grows, it is emergent from but not yet detached from its body. The enveloping maternal body is thus perceived as growing the daughters. It is in the anticipation of an eventual relationship between source and outcome—each of which is defined by the other—that their interaction can be called one of unmediated exchange. For in being grown, the daughter group also grows its mother. It does not look for autonomy until its own 'coming out' ceremony.

In describing Daulo women's activities, I evoked the enveloping maternity of Gimi planters and growers of crops. As long as the plant is in the ground, Gimi women claim a totalizing relationship: they are the plant's caretaker; the plant is evidence of their capacity to grow things. In fact, this equation appears necessary. Unless the woman is seen to take care, growth cannot occur. And the "silent growth of the human foetus encompassed by its mother" (Gillison 1980:148) is an image upon which garden spells draw, in tender encouragement of the young plants.[19] The milk and food she later gives her child have effects internal to its body; the food is nourishing because it is the mother's food. But the mother's feeding role develops only once she has externalized the child, and it exists as a thing apart from her. This separation seems to be a prerequisite for the child's body to grow or swell from its own inside. Outside the maternal body, then, the effects of growth are accomplished through the one person (mother) being seen as the origin of the other (child). But the temporal sequencing is important: one person must exist in a form prior to the other.

This symbolization appears general throughout the Highlands, if not Melanesia. Indeed, the widespread 'identification' of women with the growing crops or with the pigs that they nurture is to be juxtaposed to those rather few contexts in which women engage in (external) collective activity. The maternal relationship between a woman and her products appears in an image of internal multiplication and replication. The image is one of a body and its as yet undetached parts. It is the mother, as it were, who grows. Once grown, however, the detached things (food and children) can be used in either a mediating or nonmediating manner.

Food which a mother provides may be regarded as a female version of male food, as in Sambia (where breast milk is derived from semen), or it may, as in Hagen, be regarded as a distinctive product of maternal work that is combined with but not identified with paternal work. The latter construct gives rise to the possibility of food becoming a mediating object. These possibilities (mediatory and unmediatory) will be differentiated by social context.[20] The food which, in being intended for a child, creates an unmediated exchange between mother and child, acquires a potentially mediatory character at the moment mother and child are seen to be distinct social entities.

Feeding and growing relationships do indeed have to be distinguished. For a further Eurocentric image to be discarded lies in the idea, often imputed to Melanesian cultural practice, that food creates identity, with the implication that food contributes directly to the substance of persons, and that substance is always an inner condition. Rather, the relationship between the internal and external forms of a child depends on its location internal or external to the maternal body, and one cannot assume continuity between the causes of fetal growth and the causes of growth after birth. (They are separated in time.) The Sa-speakers of Pentecost (chap. 4) certainly posit a direct connection between the intake of certain foods and agnatic identity in images of internal substance. But there are other situations, such as paternal feeding on the Trobriands, where substance remains on the surface. What is within has no substance. Or one might think of Muyuw where a mother distributes her husband's food to their child. It is not the food as such that must be analyzed, but the feeding relationship, the question of whether food is 'given' (mediated exchange) or 'shared' (unmediated) (O'Hanlon and Frankland, in press). The effect of the food will vary according to the source from which it comes. What will vary is its potential to cause growth.

Their assimilation to specific social sources is a correlate of the personification process by which persons are made socially distinct from one another.[21] The distinctiveness of the source rests on the anticipated detachment of the outcome. Food, plants, people, and animals are all persons in this sense. They are 'identified' with others who provide a base or support for but who are not themselves equivalent in social identity to what they nurture. The overall result of this partial or metonymical identification as far as people are concerned is their location with respect to unique and particular social others. But in 'produced' form they are also things, the outcome of these others' acts.

Propagating People, Propagating Clans. I return to the Western High-
lands and to Hagen where, in their different ways, both male and female
parents are regarded as growing *and* feeding their child, even as their
substances combine in conception. A child grows in dual form, nour-
ished by both. Although food produced by the mother from the father's
land has an androgynous character, each parent may also be conceived
as a separate and unique, unmediated source for the child's identity.
But whereas the father establishes that identity after birth, planting the
child's umbilical cord in a fenced enclosure on his clan land (A. Strath-
ern 1982b:119–120; Bloch and Parry 1982:30), the mother establishes
it before birth. The child grows her, contributing to 'her' growth be-
fore it grows the father and his clan. The temporal distinction separates
them.

A unitary identification between Hagen mother and child holds most
powerfully while the child is as yet unborn. Much as the harvesting of
food activates multiple claims which extinguish the woman's exclusive
identification with it,[22] so birth extinguishes this prior conflation, bring-
ing into the world a child with a multiple identity. There is an analogy
in the way pigs that have circulated as exclusive male wealth are re-
turned to the multiple claims of the domestic household. But by what
devices is this unitary maternal construction achieved?

The claims a woman has on the crops she has planted offer another
analogy. A Hagen woman is not regarded as a container to the plants,
any more than she is a container for a child. Rather, her progeny be-
come identified with her particular contribution to its eventual multiple
identity, the work through which she tends the crops. It is with this
part of her that a plant is unified as long as it is growing in the ground.
The same-sex identity between a Hagen woman and her plants, then,
is an identity less with her total body (as their 'mother') than with the
part she brings to the conjugal relationship (her work). In relation to
that part, however, her claims are total. This is explicit: a wife's ex-
clusive connection is established by the very activity of planting.

A Hagen wife is conceptualized as one of a pair: male and female
work from a conjugally productive union, an image repeated in the
fertility ritual of Hagen Spirit cults that proclaim the productivity of
pairing itself. She encompasses her own capacity to create an alliance
with her spouse. Her efforts are her partible contribution, and it is as
a 'part' that the woman's work is publicly celebrated. Women are not
in a position to create for themselves a self-contained domain of value
like men's ceremonial exchange sphere. Rather, women's autonomy is

exercised in relation to the parts which they thus have at their disposal, both mental and physical. This gives their autonomy a political cast. Wives and husbands are like allies; wives exercise choice, their work is voluntary, and there is always a question of loyalty and commitment and thus the internal relationship between parts of their mind. If anything makes things grow in Hagen, it is a detachable component of the 'mind': the wife's effort as a matter of her intellectual and emotional commitment towards what she is doing.

It is with a part of her, then, that the growing object is (totally) identified. In the case of children, this identification lays the basis for relations with maternal kin, who are so essential for its healthy growth: they are only an element in an overall social identity, yet in relation to them the person experiences drastic bodily dependence. This bodily dependence has its analogy in dependence upon clan paternal ghosts, who also oversee health. Parallel to the maternal nurture is thus the 'part' contributed by the father. Clan land, clan food, and clan ancestral support are all equally essential for growth, and kinship exchanges give these paired sources of growth equal recognition. A component of kinship-based transactions is invariably pork (by contrast with the circulation of live pigs in *moka*). Pigs intended for maternal kin are initially killed at the donors' homesteads, an act that simultaneously involves sacrifice to their own, primarily paternal, ancestral ghosts.[23]

The political emphasis of the Hagen regime appears to foster men's fears about women's misdirected minds or their succumbing to an overweening desire to consume what they should be growing (A. Strathern 1982b). Such fears are perhaps produced by the contrived nature of the unifications. Unity only partially conceals an anticipated dual or multiple identity. And it is only appropriate for certain stages in the development of the child/food. Thus the Hagen woman's claims to the growing crops she has planted depend for their effectiveness on the fact that her work is also part of the joint work of the spouses, and it is conceived as separate only in relation to the husband's. If she simply 'took back' her own food, that is, reabsorbed it into herself as though it were not joined with another's, she would negate her own capacity for growth.

A comparison can be made here with those Eastern Highlands peoples whose construction of the maternal body as a container nourishes the eschatological fear that the mother will forever retain the products within.[24] There must be some guarantee that internal differentiation (between mother and child) will occur, for there has to be an anticipation

of it. That guarantee lies in the contrivance by which enveloping mater-
nal growth is in turn enveloped by a *male* container. This is an analogue
of the enveloping femaleness of the male body essential to the unitary
construction of males within the 'body' of a cult house.

Male containment of female nurture is, I suggest, crucial to its pro-
ductive character: the external differentiation ensures the internal one,
that the outcome of the necessary unity between child and mother will
be the development of a necessarily distinct social entity. Its potential
separation (maleness) is signalled.

The structure is evident in horticultural practices. "Ideally", it is
observed of the Gimi, "men organize and construct the boundaries
within which women care for children, pigs and sweet potatoes, while
men alone venture outside those limits. . . . men compare their freedom
to enter the unfenced, outlying orchards of 'wild' (semi-cultivated)
pandanus with the confinement of women to individual plots inside
fenced gardens" (Gillison 1980:145–146, transposed). The same device
of enveloping the enveloper is found in Hagen. The Hagen man who
explained how women were on men's 'hands', indicated an image of a
fence within which a wife is enclosed and thus encompassed by the
work of her husband. Containment is also implied in the social identity
of her husband's clan land on which the woman resides, where she
grows her chief crops, and which to the child is paternal land. Indeed,
throughout the Highlands, territory is associated with men's collective
organization. Men's collective activities also serve to contain, then, and
must be taken as a general adjunct of maternal agency. Thus it is by
virtue of the bridewealth he gave that a Paiela husband is said to have
'planted' his wife 'in the middle of the garden'—"in that center of
exclusivity the garden fence creates" (Biersack 1984:126).[25]

In Hagen, the male identity of the husband's/father's land is repli-
cated: it is also thought of as his own father's land. Whether a woman
resides with her husband or is back at home with her brothers, the very
territory is conceptually agnatic. Her partaking of its products (via the
food she grows) invests her own body with its strength. For these
'patrilineal' systems, the idiom in planting is very clear: the wife's plants
are enveloped by soil classified as the husband's.[26] The territorial source
of nurture is specific (MacLean 1985:112). Like the particularity of the
tie with the mother, it would seem that the particular agnatic identity
(this clan as opposed to that clan) is critical. Hageners do not think of
soil itself as inherently 'male'. What is significant is its social identity,

and 'clan' claims are mediated through the gardens a man cuts on his own father's or immediate lineage's particular land.

It has always remained something of a comparative puzzle that in Western Highlands societies such as Hagen, where stress is placed on bigmanship and achievement, systems that seem to produce a heightened sense of personal autonomy on the part of both men and women should also display the most firmly established 'descent groups'.[27] Yet we tend to take as self-evident the equation of the clan with the male person. We should also ask what kind of unitary identity this is. Like the unity established between a woman and her growing plants/children, it makes a totalizing statement about what is only a part of a man's social identity. A clan has unity in the context of its extraclan alliances and enmities. It is hardly fortuitous that allies, like husbands and wives, are canonically paired.

Hagen clans compete in terms of the strength and resources they have drawn into themselves rather than through the recitation of histories or knowledge of secret names or some aspect of apparently intrinsic identity as is practiced elsewhere in Melanesia. Clans compete in numbers and numbers not just of born members but of added members. To attract nonagnates is to swell the clan body by men whom it can 'take and plant'.[28] The autonomous, unitary clan puts things on its skin. Not only is the wealth that comes to it a sign of its external relations with its allies, but it also regards itself as thereby enabled to propagate crops, pigs, and women internally. All these are detachable entities, as we have seen, the clan being thus a source of something that both stands for and is different from itself. In so far as men do the detaching, they instigate the flow, and what they add and detach are 'female' things. Their external relations with allies and partners may thus be envisaged, at certain points, in cross-sex terms. The returns as prestige come as 'male' additions. One could say that prestige is female wealth in male form. By contrast, there is no hidden metaphoric relation to be established between the clan members and the same-sex identity of the clan. That is overt. A clan increases, accreting to itself entities not of its own origin, and its singular actions are thereby made visible. This visibility is the revelatory process I have called 'production' or 'extraction'—the drawing of one form out of another. In the same way as a man depends on his exchange partner, a clan depends on its allies to make itself visible.

The clan also regards itself as a source of internal growth, a growth

that swells its contours and replicates its form. The unitary construction depicts men as growers. Clansmen display a homogeneous identity: they are a single man. The land they exist upon and the ancestors who encircle them all replicate clanship. The specific identity of patrilineal groups means that the clan specifically grows its own agnates. This capacity is also its capacity to create external relations, for it is as agnates that its sisters and daughters are grown.

Hagen men thus grow women. And the men do it through the effort they apply to prepare the land to yield food. Food is the product of a relation (husband's and wife's work), but in its encompassing male origin, its source in the soil, can also be thought of as paternal. A cross-sex relation is converted to a unique (same-sex) capacity. And this is the sense in which clans grow persons on its soil, sometimes referred to as its bones. Hence the 'grease' in clan territory that nourishes plants and people is food in male form, though the term itself refers to semen and breast milk alike (A. Strathern 1977:504–507; 1982b:119–120).

Although Hagen women may be thought of as 'things', like wealth, they are not overtly conceptualized as 'on men's skins'. They are also persons 'to be looked after', especially so of incoming wives. And in being looked after, the subject of her husband's work, the wife becomes through time herself planted. The term that signifies a human being, a planted being (mbo), is also the term for a new shoot, a point of growth. Incoming wives give their own clan names to the growing subclans as they differentiate themselves like so many shoots from the homogeneous clan body; the women externalize them.

We must distinguish between two images of internal growth. Both rest on the replication of relations but relations conceived from two viewpoints—from the viewpoint of the overarching clan, and from the viewpoint of what appear as its constituent subunits. The one viewpoint is of a body whose segments internally proliferate, propagating themselves like so many daughter groups, to borrow an idiom from Daulo. Not yet detached, in being grown these internal segments also grow the outer body. This one might call the view from clanship. Its counterpart is a kinship view, that is, the celebration of the historical specificity of lineages and subclans, already distinct and detached through their own extra-clan ties, named after incoming wives. The former is of a contemporaneous collectivity—the men who count themselves clan members here and now—while the latter is a chronological image of a series of particular events, of specific marriages and external connections. The distinction is significant.

Clan relationships are formed on the replicability of ties. Clans are 'one shoot'; the singularity of this construct being based on the replication of its individual male members. Clans do not have overarching genealogies. They compose a series of single men. Same-sex ties in the context of collective behavior have the potential to transform asymmetrical ('kinship') into symmetrical ('clanship') relations. Clansmen only collect together on the basis of what they replicate, what they have in common. Scheffler's (1985:15) comment that Highlands group members do not appear mutually substitutable for one another may apply to the kinship representation of Hagen lineages, even subclans, but certainly not to clans. On the contrary, clans are constituted as units and as composed only of units. Severally or together their parts are always 'one man', 'one name', 'one stock' (A. Strathern 1972:18). Above all, they are one on the basis of effective collective action itself.

Scheffler argues that clan ideologies, the idioms of common fatherhood or the solidarity of brothers, appeal not to descent but simply to differentiation and obligation through kin relations, that is, by kin class ("we are all brothers") (1985:13). But indigenous rhetoric actually forces particularistic relations based on kinship to serve the interests of collective action. A Hagen clan is not simply a kin group blown up in size. It is a transformation of kin-based relations, an argument MacLean (1985) has offered for their northern neighbours, the Maring.[29]

Hagen clans are above all units of collective action, and clanship must be seen as a manifestation of male collective life, a deliberate artifact that stands over and against the particularities of kinship ties. What confuses us perhaps is the absence of domains. Kinship is not evinced in bilateral networks ('filiation') against unilineal group formation ('descent'), one domain of ('cognatic') relations against those of some other kind ('agnatic'). Rather, as has been true of so many contexts throughout this account, men transform their own relations. The kinship particularity of agnatic lineage relations are *turned into* the collective uniformity of agnatic clan relations. It is the rhetoric of collective action which presents the former as though they were simply a subset of or at a lower organizational level than the latter, as though lineage were an internal replication of clanship. The analytical conflation of descent and kinship, which Feil (1984a) noted in Highlands anthropology, has simply responded to this rhetoric.

The rhetoric supposes a segmenting continuity. Hagen subclans 'divide' into smaller units (subsubclans, lineages). Though lineage brothers are not formally differentiated as senior/junior siblings as elsewhere in

Melanesia, these lowest level groupings sustain genealogies that give everyone a specific place. The particularity of these lineage relationships gives them what I call their 'kinship' aspect. Between fathers and sons, between brothers and sisters, between older and younger, genealogical differentiation is sustained by asymmetries of obligation and reciprocity; in the case of close patrilateral kin, asymmetries are imposed by the contingencies of history (who helped whom when). Thus same-sex ties between brothers can be minutely and internally differentiated in terms of their individual histories of cooperation and estrangement. And their cross-sex ties (with affines and maternal kin) have a particularistic significance for their personal prosperity and health. The idiom of 'one blood' is used for intimate intralineage connections, a deliberately ambiguous construct, for the 'blood' so conceived may be maternal or/and paternal, and the phrase refers to close cognates as well as close agnates.

There is thus an important disjunction between the clan, defined by the rule of exogamy, and kinship units that organize marriage, normally lineages or subsubclans. This is not simply expediency or a question of management. Rather we should see the exogamic rule as a creative transformation of kinship relations which generalizes the asymmetry of kin-based relations into an attribute of clanship. As wife-giver or wife-taker the clan can make itself asymmetrical and unequal with respect to other clans; that is, it can particularize itself. This metaphoric transformation represents the clan *as though* it were a body of kin. And in that regard, the 'clan' is seen as having partible sisters and daughters to grow.

In turn, being able to grow sisters and daughters depends on the exogamic rule, on their anticipated status as wives and mothers to other clans. The clan turns the cross-sex ties of kinship relations into an aspect of its own constitution, its capacity to make external alliances.

The rule of exogamy creates the clan in one of two forms, as its own relations with its allies and as 'itself'. Like the effect of the dual flows of male and female wealth on Trobriand *dala* identity, on the one hand the Hagen clan is composed of male and female members (brothers and sisters); on the other hand, it is a homogeneous entity whose internal relations are same-sex. For internal difference is eliminated when the clan body, divided into male and female agnates, externalizes one category of these (the female) in its pairing relations with other clans. External relations, through the exchange of women, thus keep clans distinctively separate from one another. They depend on this separation

for their distinctiveness and thus on those with whom they intermarry. Allies are regarded as paired, and the productive parallel to the Trobriand brother-sister relation is that between the Hagen husband and wife. Individual spouses form a pair in that they combine their distinct parts in a single enterprise. What is analogous about the husband's and the wife's work, the semen and blood that mingles together to form a fetus, is that each is derived from its *own* paternal clan. In turn clans can thus be seen as analogues of one another. They are separated, as I have emphasized, only by the exogamic rule into potential marriage partners, giving rise to the difference between links 'through men' and links 'through women'. The rule gives a particularity to each agnate, bestowing on each his or her own external ties, which means that the wife's agnatic identity is no more compromised by marriage than is her husband's. That dual social source guarantees their perpetual distinctiveness in the same way as exogamy has already separated the destinies of brothers and sisters. Consequently, as analogues of one another, clans are also seen to encompass within themselves 'parts' of other clans.

Clansmen thus imagine themselves as a single same-sex man, the one figure simultaneously encompassing in male form two types of agnates, male and female. The single man is a performance. If clans are conceptualized as bodies of males, it is the arena of events in which they exchange with, compete with, and fight one another which emphasizes their singleness of gender. We might say that they attempt to impose asymmetries—as though between marriage partners and affines—where none necessarily exist. For the maleness of the clan shows in its own internal capacity to make external relations, and the growing of women who will become wives/for whom wives will be substituted is a dramatic metaphor for its capacity and potential power in general.[30] Each realization of this specific capacity depends, however, on a particular pairing relation with the specific affines who will elicit the external relationship.

I defined encompassment as the encapsulation of another's viewpoint, a containment of an anticipated outcome. The clan encompasses, as it were, the fact that from a kinship point of view its agnates are externally differentiated as particular persons who will make connections with this or that other set of kin. It claims these particularities for itself. In the same way, it is able to encompass the multiple exchange achievements of its individual male members as though 'the clan' were a unit of exchange. It thus *appears* to encompass 'its own' products, its things, the sisters and wealth it has grown. Appearance is all: the

construct consists in the aesthetic impact of the clan's performance on
its audience. Clansmen must induce potential recipients to elicit their
wealth, as the allies on whom they depend for wives must be made to
elicit sisters. In the way men think about the clan, they thus anticipate
the response of others. They encompass it within themselves.

Hagen wives encompass within themselves the efforts that their hus-
bands will elicit from them. Their work can only have this outcome;
yet its efficacy is construed as locked within their minds, their motiva-
tions secret and inaccessible until that point. A husband's efforts do not
carry the same weight towards his wife, for his motivations are already
externalized in relation to her in so far as his clan has its own claims
on his efforts. The parallel for him is his pairing with an exchange
partner or his clan's pairing with its ally. Here motivations are held
secret until the moment of display. Indeed, if the Trobriand yam pole
is a female womb in male form, the Hagen 'one man' who gives away
'female' wealth on a ceremonial exchange occasion is also an encom-
passing male form. But there is a difference in the images. The single
erect man is not supported by a triangular base; Hagen men paint red
triangles on their noses. Rather, the upright body itself is replicated
shoulder to shoulder, a horizontal line of vertical dancers bobbing up
and down and swaying back and forth. The amount of movement al-
ways gives an impression a little short of unison. But as a collectiv-
ity of men, the 'one man' thus contains within his singular form a
multiplicity of external connections. To meet the aesthetic criterion of
success, the clan must show its contours as a straight line,[31] and it so
composes itself in front of a heterogeneous and disparate audience who
will include the very persons so connected.

MAKING MORE RELATIONS

Differences exist between the several societies to which I have been
referring. I have used a sketchy Western Highlands/Eastern Highlands
contrast to keep the sense of difference in mind. The general proposi-
tions about personification and reification seem to hold, and all these
Highlands peoples make a distinction between mediated and unmedi-
ated exchange. But this should really be put the other way round. Thus
I have discussed mediated constructions in a specific social environment
in which they can be indigenously compared to and distinguished from
unmediated ones: exchanges between kin take place in the presence of
cult or clan or political activity of a collective nature; that is, the meta-

phors available for thinking about particular kin interactions include collective, 'non-kin' activities, and vice versa. There are interesting consequences here for comparative analysis.

Between Highlands societies, what seems to differ is what is taken for granted. The compulsion of the anticipated outcome means that one set of relations can always be envisaged from another point of view, as an outcome of another set. Anticipation is a preemption of what will happen. And with respect to the production and reproduction of children, of food, of artifacts, people seem to start with different premises about what has already happened (chap. 5).[32] Thus Hageners take for granted an established distinction between a husband and his wife's father, where Gimi work to create that distinction between them. One organizational consequence lies in the emphasis placed on kinship in collective and ceremonial life.

In chapter 3 I made a broad comparison between societies, as found among Eastern Highlanders, where collective life appears an adjunct to the way in which kinship produces more kinship, and those Western Highlands systems where male collective life appears to create (political) forms of its own.[33] Or one could put the comparison in terms of the incremental possibilities in the organization of relationships; or simply whether differentiation between kin is or is not taken for granted—not kin relations as an entire universe, because one specific set always has to be established vis-à-vis another, but at the point of their chief productive potential. By this I mean how persons (relations) are propagated as things. Highland metaphors generally seem to focus on the procreation of children; in the Massim people attend to the production of the 'finished' thing, the person at the end of her or his life.

However, within any one society, what is taken for granted may itself be questioned at certain moments, and the issue of increment is rather more complex than it looks. A summary of observations on kin exchanges in Hagen, in the Western Highlands, will remind the reader that the form in which I conceive the comparison is prompted by the internal manifestations of Hagen sociality.

Hagen work is unmediated evidence of the extent to which the person's mind is directed towards his or her own activities, and towards the part he or she plays with respect to another party. A person can show a greater or lesser commitment ('mind') towards the ensuing relationship, but its essential definition is taken as given. While domestic work thus makes relations of kinship and affinity visible, the effort appears to entail no social increment; it cannot add to the form of rela-

tions: it simply affirms or denies them. When such work is terminated at death, compensation is due to the person who has lost part of her or himself in the relationship that has 'died'. (The loss is of social engagement, of a source of identity.) Domestic reciprocity contrasts with the social productivity of ceremonial exchange where wealth mediates new relationships. Consequently kin-based transactions in Hagen simply confirm the multiple origins of persons, primarily in reference to their maternal and paternal kin. The duality of their immediate procreative origins is replicated in the origins of their parents, or through the marriages of siblings and children and the multiplicity of a person's dealings with particular kin. However, this leads to the counterfactual possibility of creating a unity or singleness of purpose, the sense of unity working against the multiple orientations of a person's mind; people impress themselves with this fact.

Bodies as well as minds are multiple. A Hagen child is created through a metonymic transaction between parents, each contributing a part of their substance while retaining their distinctiveness. The relationship is reified in the child who substitutes for it, and who duplicates the identity of neither parent but combines them both within itself. Its androgyny symbolizes a completed transaction. As an inert objectification of a relation, it cannot be further reproductive, but it can be added to a male or female person/collectivity. A part is thus also conceivable as an increment. Under agnatic regimes of the Hagen kind, wealth, children, and persons in general, incorporating an internal relation between maternal and paternal kin and thus in themselves androgynous, become visible as increments to others with whom they are related. Yet the conceptualization of the child as though it were wealth holds only to a limited extent.

The propagation of children in Hagen is also like the propagation of food. The result of an interaction between mother and father, the child does not mediate further relationships: it is not an item which can 'flow' between persons. The child exists only 'between' the particular affinal kin involved, fixed by the history of their relationships. Its fixity is established in the fact that, by contrast with ceremonial exchange partnerships, there is more to the separation of its mother and father than is created by the transactions between them. They are not reversibly differentiated simply as donor and recipient; they are *irreversibly* differentiated by their own paternal clans of origin.

The conjugal relationship is in turn both like and unlike that between exchange partners, a source of its metaphoric power in the way people

think of ceremonial exchange itself, as we saw in chapter 8. On the one hand, marriage is contingent on the performance of both partners—their commitment determines whether or not the relationship will endure. On the other hand, the commitment indicates not their exchange autonomy but the fact that through nurture each partner has made the other asymmetrically dependent on him/her. Thus, at times, stress appears to be on how spouses 'give' to each other, and sustain a relationship of reciprocity; at other times, that gifts cannot flow between them, for they 'join together' or one 'helps' the other in production and consumption. From this point of view, the Hagen child does not mediate between them, for it links two irreversibly unlike entities. Transactions focused on the child are transactions to make it grow.

Yet that historical fixity is compromised. And it is compromised by the very acts which celebrate it—when wealth is given at marriage or in the form of childbirth or mortuary payments to maternal and affinal kin. Maternal kin hold a special place as reifications of that element of the Hagen person which derives from his/her mother; matrilateral connections may be envisaged as external additions to the agnate. And whether neglected or fostered, they are not to be disposed of. When agnatic identity is in turn considered as a contributory part of the person, matrilateral connections appear not as additions but as a comparable counterpart. Maternal and paternal parts are paired as sources of growth and health to be dually maintained to sustain future well-being. Ancestral ghosts on the mother's side are particularly significant for the delivery of the child at its birth, and they privately continue to oversee its health. Indeed, unmediated transactions between kin are ordinarily covert. Persons have direct influence upon one another as far as both their intentions and their bodily health are concerned, but only the effect is visible. When intention is made explicit, however, when nurture is acknowledged through gift exchange, the interactions assume an overt form. Maintenance of fertility now becomes subject to successful exchange, one of the victims of this transformation being parturient mothers who fear that inadequate transactions will jeopardize the child's emergence.

In other words, relatedness ceases to be taken for granted. Kin relations come to be the subject of transactions, and people engage in expanding them in the only way possible—by making 'more' kinship. They increase the velocity with which items circulate and the intensity with which people interact. A child must maintain good relations with its maternal kin for its growth and health; mother's milk, the work of

nurture, becomes a Hagen reason for exchange between affinally con-
nected clans; a poor bridewealth may lead to an annulment or divorce,
and a failure to make proper mortuary payments to accusations of
neglect or treachery.

Kinship is transformed under these circumstances of overt communi-
cation. A transactional risk enters into the continuity of relationships;
for the penalties for failure are not simply the termination of relation-
ships as between exchange partners, but damage and ill health to the
person. Perhaps it is not surprising that such transactions are subject
to further activity. Through sacrifice, people attempt both to maximize
the mediatory possibilities of gift exchange, thereby molding kinship
relationships in terms of interest and advantage, *and* to restore the
domestic presumption that kin persons axiomatically depend upon and
care for one another.

Apart from the strongly sacrificial element in Hagen kin-based ex-
changes themselves (killing pigs to celebrate stages in a child's progress
for instance), engagement with ancestral ghosts mobilizes domestic so-
ciality (chap. 5), as is possibly also true of the performance of ambula-
tory Spirit cults. Earlier, I pointed to the relations of dependency at the
center of Paiela puberty ceremonies and the initiation rites of the Eastern
Highlands as well as to their collectivized nature. The collective context
of such cult activity stimulates a flow of messages about the caliber of
the relationships in question, through what appears the vehicle of me-
diating items. But in communicating with ancestral ghosts and spirits,
people may leave transactions incomplete: there is an asymmetric trans-
mission of messages, a covert return desired for an overt act. Indeed,
the incompleteness may actually guarantee the 'domestic' productivity
aimed for. The sacrificing congregation do not want an exchange of
messages; they want to be made healthy, to experience the effects of
ancestral blessing in an unmediated form. The last thing they require is
a return 'gift' from the spirits. This asymmetry partly explains the de-
structive element in sacrifice: the gift is properly destroyed, for it is not
a gift which is sought in return.

In societies where initiation and marriage rituals take center stage—
often demanding lengthy periods of time—people make 'transformed
kinship' their chief problem. They work at making visible what works
by being kept hidden; and they work at 'reproducing' themselves, at
making more kinship. Sources of growth and the possibility of substance
loss become hazards of the interchanges. By their own recursive acts,
Sambia men find themselves having to feed the food they impart. What

Hageners construct in clan form—the male body separated from others by its detachable sisters—may have to be constructed within the individual bodies of men (Sambia) or of women (Gimi). Men and women must show an internal separation of parts.[34] Differentiation between father and daughter or husband and wife is created in the course of their encounters, between themselves and in relation to specific external others, as a matter of deliberate contrivance.

In Hagen the exogamic rule combines with marriage dispersion to guarantee the axiomatic separation of spouses. This creates the possibility of mediatory exchanges between kin themselves. In mediated transactions, separation bestows a particular value on the part of himself that the donor gives away; as I have argued, he is able to reappropriate that value, so that he is personally augmented by all the relationships through which the objects have flowed. The idea of persons so bestowing parts of themselves on others entails political possibilities. Rosman and Rubel (1978) have documented generally for Melanesia the extent to which kin-based exchanges have overt political functions, and kin-ties are or are not the basis of other partnerships.[35] In Hagen, gifts between kin celebrate their dependency upon one another; the relationship is already defined and in that sense taken for granted. Although the parties to the transaction may be donors and recipients, they are also other social persons (sister's sons and mother's brothers, say) by virtue of the *one* relationship between them which is the rationale for the gift. Thus, when a sister's son gives items to his mother's brother under the rationale of a return for maternal nurture, a prior and asymmetric relationship is evoked. But the Hagen case is interesting for the extent to which kin-ties are staged to be transformed into political ones. Here nothing is taken for granted.

The Hagen maintenance of good relations with maternal kin shades off into political expectations, and these come to include the making of good wealth exchanges themselves. Child payments to maternal kin, bridewealth, and certain aspects of mortuary payments all have the capacity to be expanded into incremental *moka*: indeed, beyond initial gifts under these rubrics, *moka* is their enduring form. Nevertheless, between kin, the items also continue to refer to the values which persons have for one another not present in ordinary exchange partnerships. 'Actual' kin are involved in these transactions, a contrast with systems centrally focused on kin exchanges, where substitute kin often become channels for the flow of wealth. This is not the paradox it seems. When Hagen men expand relations beyond an immediate circle of kin, they

turn them into generalized *moka* partnerships; elsewhere, 'kinship' itself
may be generalized, and classificatory relatives stand in as recipients of
kin gifts.[36] The domain of kin-based exchanges thus remains strictly
limited in Hagen. It is less that kin debts are settled through ceremo-
nial exchange than that a new class of debts is created, since affines
who do not press their relation into the service of ceremonial exchange
may feel cheated of the political benefit their relationship might have
brought.

It is no paradox either that to liken marriage exchange to *moka* in
general, as Hagen men do, is part of the separation of domestic kinship
from political life. The rhetoric does not simply model *moka* on the
asymmetric dependencies between affinally and maternally related kin.
That visible part of men's activity in marriage negotiations which in-
volves their public presentation is assimilated to the kinds of political
confrontations which characterize participation on other occasions.
Male affines can behave as though they were exchange partners. Con-
versely, by contrast with the enduring asymmetries created in other
Highlands marriage systems, asymmetries between the givers and recip-
ients of brides are played down. Once the initial affinal prestations are
over, relations between them tend to equalize. Inequalities remain in
the background, taken for granted.

I return to an observation made in chapter 5: Paiela men have to
compel women to grow them, to force a transaction between entities
already differentiated. Gimi, who take growth for granted, have to
force the differentiation through establishing the distinct social iden-
tities of encompasser/encompàssed, source/product, grower/grown; cre-
ating the difference between these two identities makes the one yield
the other and separation is accomplished. The 'problem' generated by
the former compulsion is that even if children are separated from the
identities of their male and female parents, they must still be made to
grow. Where children are regarded as implanted within the mother, as
in the latter, they must still be detached from her body. As long as a
product is encompassed within its source it grows; but evidence of it
having grown can only be given when it separately embodies the growth
in an independent form. It is such visible evidence of separation and
growth which both ceremonial exchange and initiation cults seek to
display.

Consequently, mediated transactions of the ceremonial exchange
type define the quality of a relationship (its history of debts and credits)
during the course of the transactions themselves. Transactions then ap-

pear incremental; they appear to propagate more transactions. Unmediated exchanges typify parent and child ties or ties with kinsfolk based on asymmetry and dependence, source and product. These transactions appear nonincremental, yet there is a creative (productive) element to them, namely, the possibility of kin implanting their own condition in others who thus come to substitute for them. They propagate more kinship.

One might encapsulate these different techniques or practices of objectification in the anthropological contrast between generalized and restricted exchange. However, as Damon (1980) says, appearances are deceptive. The former technique seems to create endless potential for new relationships, for expanding the circle of partnerships before it comes back to oneself, evinced in the replication of same-sex ties. But in the end like does produce like—men only create more men, more partners. Despite the inflation of particular, kinship-derived values and loyalties to a collective (group) dimension, ultimately speaking, women and men remain locked in the restricted oscillation of debts between donors and recipients. The latter technique appears to engage people in an everlasting round of cross-sex substitutions, always reproducing the same relations, parents producing children who will become parents. But in the short term, it transforms one set of identities into others, creating new social persons, children who are not their parents. Despite the collectivization of kinship transactions, proximately speaking, men and women are locked into the nonreversible displacement of each generation by its successor. We might put it that people thereby borrow these two practices as metaphors for each other, so that each in fact participates in the other's form.

10
Cause and Effect

There is a final concreteness to be discarded in approaching Melanesian societies from the viewpoint of Western/European ones. To concentrate on the objectifications of Melanesian cultures appears to eliminate subjectivity. The acting agent is seemingly not required in my explanation of how people manage their affairs—and I write as though cultures proceed independently with their reifications, persons appearing only as the reflex of relationships. In fact, the individual subject has been present in my account all along; she/he just does not take the shape we are used to seeing.

LOCATING THE AGENT

Leenhardt (1979 [1947]) faced this problem in New Caledonia. With brilliance he charts the extent to which persons appear through their relationships. But then at their center all he sees is emptiness.

As he analyzes local symbolization, the body is simply a support for the living being ('personage'); it has an individuating effect, but it is not otherwise a source of identity. He discovered that bodies were interchangeable; they act as replicas of one another, by which he meant I think both that like persons are replicated and that those differentiated from a particular ego elicit its different roles. A living entity (*kamo*) "*knows* himself only by the relationships he maintains with others. He exists only insofar as he acts his role in the course of his relationships"

(1979:153, my emphasis). Figure 3A is a diagram drawn by Leenhardt of the *kamo* as the center of a fan of such relationships, every other *kamo* being replicas of his own body. "In the midst of these rays, an empty space is circumscribed by . . . the points of departure for relationships" (Leenhardt 1979:153). We cannot call this space a self, he argues:

> Their social reality is not in their body but in this empty place where they have their names and which corresponds to a relationship. . . . But no name can cover the whole person. The Canaque [Caledonian] is obliged to have a different name for every domain which involves his person in various relationships and participations. In all this, he is unaware of himself; he is the empty space enclosed by the circle of *a*'s [Fig. 3A]. (1979:154, 156)

One relationship is always, as he adduced, a metamorphosis of another. Yet his mistake was to conceive of a center at all. The center is where the twentieth-century Western imagination puts the self, the personality, the ego. For the 'person' in this latter day Western view is an agent, a subject, the author of thought and action, and thus 'at the center' of relationships. Some of the conceptual dilemmas into which this configuration leads were rehearsed in part 1. It has shaped our cultural obsession with the extent to which human subjects are actors who create relationships or act rather as the precipitation of relationships; this obsession fuels the individual/society dichotomy with which I began.

The image of the active agent at the creative or created center of relations is missing from my explanations. In the Western view an explanation consists of bringing social facts and events into relationship with one another. Explanation models the organization it describes. And such a resultant 'structure' or 'system' in being authored by its inventor must also show, we suppose, its effects upon the living subject in the world. The inventor then demonstrates the reality of the hypothesized structure or system through people's living participation in it as subjects. And because we can abstract subjects as individuals, the explanation often appears concrete enough, despite its having to cede all the infinities of 'levels' of consciousness or 'domains' of action and the cumbersome imagery of structuration. Social science never settles in fact on any single metaphor. Whether systems and structures are like buildings, maps, engines, bodies themselves, or even like minds that drown in their own thresholds of awareness, Leenhardt's star shaped configuration carries the one and same presumption: living within, guided by, driving, functioning as, or knowing through these structures of relation-

A

Composed by Leenhardt (1979: 154–155) to depict the New Caledonian personage: "We cannot use a dot marked 'self' (*ego*), but must make a number of lines to mark relationships" (1979: 153).

The personage located by means of his relationships.

Empty and incapable of affirming himself outside of his relationships.

B

Composed by Battaglia (1983a: 296–297), after a Sabarl man "commented that *segaiya* (mortuary feasts) 'look like *tobwatobwa*', and drew this shape in the sand" (1983a: 296):

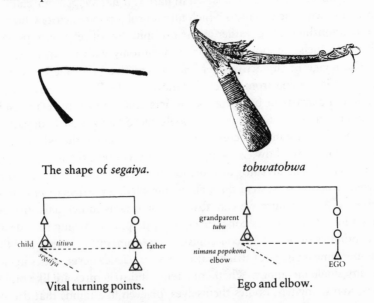

The shape of *segaiya*.

tobwatobwa

Vital turning points.

Ego and elbow.

Battaglia adds further, "We had been discussing his special exchange relationship with the patrilateral cross-cousin he called 'my father'."

Fig. 3. Two Diagrams

ships must be the individual subject. In honesty, Leenhardt could not find a corresponding entity on New Caledonia. I suggest that this upside down conclusion be turned right side up—his diagram was wrong.[1]

Possibly it is fortuitous that Leenhardt's translator used the term 'support' for the way the Melanesians in his analysis think of the body; the term recalls Battaglia's discussion of Sabarl ideas about the interconnection of relations. Sabarl imagine that it is relationships that 'support' a person (see pp. 172–173). But only certain relationships are so described; others are held to 'complete' a person. Consequently, any one type of relationship is to be contrasted with and thus seen from the viewpoint of another. The same is true for the internal construction of social relations themselves. People's positioning with respect to one another entails each party perceiving the relationship simultaneously from its own and the other's point of view. This perception is construed as a specific capacity that the person has within. For these, in turn, are metaphors, with their own cumbersome reifications. They underlie, for instance, the so-called dualism of Melanesian cultures. Imagining that the world is divided into 'two kinds of' things, relations, times, or whatever (p. 188), is to imagine the person from two different vantage points. The clan that divides its members into two types of agnates—males and females—is also perceiving itself with respect to what its marriage partners will extract from it. The woman who berates a child for taking sweet potatoes from her growing garden perceives her care of the plants in relation to the claims she must satisfy at a later point; time is sliced into before and after.

From our point of view, these are symbolic constructs; from the Melanesian point of view they are recipes for social action. They supply motivation. Perceiving another's viewpoint is also an anticipation of it; and people forever regard themselves as moving from one position to another. A wife does not, of course, become the husband whose claims she has in mind; but she anticipates the moment at which she will harvest the tubers, and that what grew because of her exclusive nurture of them will be consumed as the products of their joint work. This transformation in view, we might say that she grew the sweet potatoes 'for' her husband, since his work in fact completes hers.

Sabarl give us a diagram (in fig. 3B), a picture of relationships like joints or elbows, graphically conceived as the angle that an ax blade makes to its shaft (Battaglia 1983a:296). The ax, and particularly the direction in which the blade points, is compared to the prestations (*segaiya*) that culminate at mortuary ceremonies in acknowledgment

of the support given to a person over his or her life by his or her 'father' (a son or daughter of the father's sister). The person who benefits and consumes the food and other gifts given by the father is the pivot for these exchanges: in his or her name food and valuables are returned to the father's side. The return is finally celebrated at the person's death, when life is completed. From the point of view of his/her father's kin, the 'child' is called an 'elbow', the turning point at which valuable objects that have moved away from the village come back again (Battaglia 1983:297; 1985:430).[2] The child acts as an agent on their behalf; its shape is an angle encompassing two directions.

The acting subject or agent is construed in these systems as a pivot of relationships. I do not mean one who is an assemblage of or the locus of relationships—that is the 'person', the form of their objectification. By agent, I mean one who *from his or her own vantage point acts with another's in mind*. An agent appears as the turning point of relations, able to metamorphose one kind of person into another, a transformer. Thus from the Sabarl 'father's' viewpoint it is the 'child' who in relation to him or her is the turning point whereby transactions with affines become transformed into benefit for kin. By his or her own gifts the 'father' does, of course, compel the child to bring the transformation about.

An agent is one who acts with another in mind, and that other may in fact coerce the agent into so acting. A Hagen woman is compelled to harvest her tubers for her husband. But it would be a misconstruction to read this as the husband's superior powers, an aggrandized subjectivity overriding that of the wife's. In the commodity view, it is true, one subject acts upon another as its object. Here, I suggest, in the corresponding relation one subject acts with another subject in mind. One always acts so to speak 'on behalf of' another (compare p. 164), though the English phrase has misleadingly positive overtones. The object or outcome is their relationship, the effect of their interaction. But the two subjects are not isomorphic. If the wife is an agent, the one who acts, then her husband in this instance is the cause of her acting, though not himself active. It is simply in reference to him that the wife acts. That is the coercion.

While this will serve as a general description of Melanesian agency, I have derived it from those exaggerated forms of activity made visible in the course of public ceremonial and ritual, as with the Sabarl mortuary exchanges. Many such agents have appeared in my account: the Gimi wife who from the husband's point of view must turn her relation-

ship with her father into one with her child's father; the Trobriand father who from his wife's brother's point of view releases parallel flows of male and female wealth; the Sambia sister's husband who activates both his wife and his wife's brother; the Hagen mother who from the viewpoint of her natal clan turns her relationship with her husband into wealth for it. What deceives us perhaps (see chap. 5) is the very fact that agents do not cause their own actions; they are not the authors of their own acts. They simply do them. Agency and cause are split.

There is a distinction then between a cause and an agent: a cause exists as a single reference point for the agent, in the same way as the effect of a relationship exists as a single outcome. The cause is the 'person' with whom the agent's relationship is to be transformed, a unitary reference point for her or his acts. The one who is regarded as acting, however, is the one who in taking account of the cause—the reason for acting—*also* acts for him or herself. The agent's position is intrinsically multiple. The tubers may be for the husband, but it is quite emphatically the wife who should and does harvest them. The outcome is the food he will consume, but the activity she does of and for herself. The action remains hers.

To expound upon this point, I return to material that has already been presented. The term person, which I have used so freely in my account, must now be uncovered and differentiated into its own two types. I therefore introduce a distinction between 'person' and 'agent'.

The person is construed from the vantage points of the relations that constitute him or her; she or he objectifies and is thus revealed in those relations. The agent is construed as the one who acts because of those relationships and is revealed in his or her actions. If a person is an agent seen from the point of view of her or his relations with others, the agent is the person who has taken action with those relations in view. In this, the agent constitutes a 'self'. A corollary is that causing another to act is not to be understood simply as the manifestation of a power that some have over others in particular contexts. There is nothing contingent about it. The separation between agent and the person who is the cause of his or her acts is systemic, and governs the Melanesian perception of action. To act as one's own cause becomes an innovation on this convention. Given that persons are reified as two kinds, through the aesthetics of gender women consequently appear as the cause of men's actions, and men as the cause of women's.

Persons and agents thus occupy positions defined by different vantage points. The one and the same figure is both an object of the regard of

others (a person) and one who takes action as him or herself on behalf of these others (an agent). The person objectifies a multiple relationship but from the viewpoint of the agent is the 'one' reference point with respect to whom action is taken, for the other reference point is her or himself. The agent's social position is thus a multiple one, constituted in the different directions in which he or she is faced, but his or her consequent acts are singular. Each act is 'one' act.[3] This last perception is the single most significant metaphysical basis for the understanding of Melanesian relations.

THE PARTICULAR AND THE COLLECTIVE

The elbow image is suggestive in another regard. From the view of the agent, the persons/relations with reference to whom she or he acts have a taken-for-granted status. They are already there, one might say. As I have construed Melanesian ideas, the person is revealed in the context of relationships, for the person reveals the relationships that compose him or her as an inherently multiple construct. The plural or composite nature of the relations that make up people's interactions is thus assumed. But in chapter 1 I suggested that plurality takes two forms. In truth, one of these is assumed, and the other is not.

It is consonant with my argument about the concealed conventions of reification that the plurality taken for granted is that of the duo—the dyadic structure of the relationship between agent and the cause of the agent's acting. The externalizing duality of direction in which people's minds are turned, toward themselves and toward others, is an axiomatic context for action. As we have seen this precipitates *not* a dialectic between 'self' and 'other' but a self who in acting with respect to another alters the relations within which she or he is embedded. Consequently the effects of her or his actions may be seen in the bodies of *two other persons*. Two relationships are involved, with the agent as pivot; they form, we might say, an analogous pair. This follows from the fact that as a person the agent is always socially distinct from the cause; and in acting for or because of the cause also acts with reference to other causes. The wife who grows food for her husband does so 'herself' because she is separated from him by her own ties with her natal kin. Thus she acts with reference to 'two kinds of' men—her spouse and her siblings. In short, an agent who acts with one person in mind is also acting with another in mind. One might call the resultant angle of perspective a recursive duality. The point is that it is taken for

granted that actions proceed within a dually constructed external context of this kind.

The plurality which is not taken for granted is that I have called 'collective', homomorphic, the plurality that may evince itself homologously in singular form. This is the condition of unity, and it has to be achieved. Only under the condition of unity can the person or group then appear as a composite microcosm of social relations. Unity in turn hinges on agency: the agent reveals the unity for (as I shall argue) it is acts which unify.

The singular must also be seen with respect to the two forms out of which unity is composed—the multiple or composite person and the dividual. Here what is taken for granted are the multiple external relations in which a person is embedded, for the focus of attention is their internal manifestation in a dual form. What has to be staged is the ability to shed half the dual form: to be concrete, unity is achieved by detaching or eliminating an opposite sex part.

The propositions about plurality and singularity can be drawn as external and internal analogues of one another [fig. 4]. But like Leenhardt's, this too is the wrong diagram. In chapter 1 I used the terms singular and plural to retain contact with Western metaphors of society and individual. Finally, however, they are misleading, for the diagram creates the wrong dimensions, the nominalizing qualifiers suggesting that at issue are a collection of attributes. One has to move to the further position, that there is no intrinsic difference between 'the singular' and 'the plural'. There is, however, a crucial difference between the viewpoints of the 'one' agent and the 'two' directions in which he or she faces.

Rather than lines and arrows between attributes we should instead be thinking of the relationship between acts and the contexts of action. It is acts which take a singular form, and they produce this against a taken-for-granted background of relationships. The corollary is that *the agent acts in the knowledge of his or her own constitution as a person in the regard of others* and indeed fabricates that regard (objectifying her or himself) in activating the relationship. An agent may know her or himself as a person in the form of a dividual, potentially one of a pair, or may know him or herself as a composite microcosm, potentially bounded as a unit. The outcome of her or his singular action is in the one case sociality of a particular and in the other of a collective nature. Over time, particular relations must always substitute for one another, whereas collective relations replicate one another. The one action is so

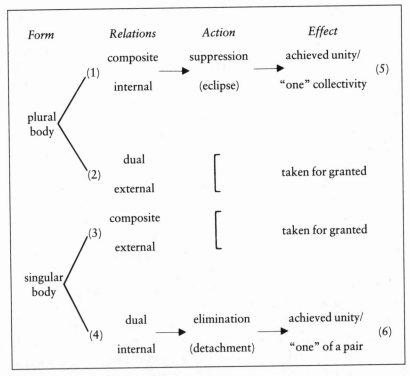

Fig. 4. Singular and Plural

Expanded:

1. Multiple internal relations among the members of the body (a 'group').
2. Encounter with a specific social other: another group, as partner, ally, etc. The context for (5).
3. The whole spectrum of relations which the person objectifies and also in that sense contains within. The context for (6) in that the other of a pair must already be external.
4. The reduction of the multiplicity of external relations to an image of internal duality, e.g., relations with mother's kin, father's kin.

The one schema can be superimposed upon the other. When we do this (conflating plural and singular), the motivating opposition emerges as that between unity and duality.

contextualized as to lead to the creation of what I call kinship; the other is not.

The unifying act. Causes are single points of reference for the agent who is a pivot, an elbow combining within him or herself multiple perspectives. But the agent reduces that multiplicity to a unity in the actions she or he takes. Thus the agent is revealed as a single conduit,

the one of a pair to whom action is credited. This singleness of action in turn establishes its reference points, for he or she then elicits the actions of others in reference to his or her single self and gives those causes ('persons') their other, multiple character. It is the one figure of the Trobriand father who releases the dual flow of male and female valuables and the one figure of the Gimi mother in which many men meet.

The elbow of relationships is single, I argue, *because* he or she is the one who takes action. Action has a unity, as Biersack describes for Paiela observations on people's behavior. She writes that Paiela social transitions require

> the operation of two principles: a principle of binary opposition whereby a set of alternatives is created, but also a principle of selection that permits one or the other alternative to become current, thereby creating temporal discontinuities. (1982:255)

Doing an act is such a selective process. Whether imagined as choosing from a pair of alternatives or choosing a single path out of many,[4] the suppression of multiple possibilities in favor of one makes relationships visible through the capacity of the self to activate them. At any point, action appears directed towards one specific relationship (the eliciting partner), which becomes the cause of the action itself. And it can only be done in one kind of way. It is done either well or badly (Biersack 1984). The criteria that I have been calling aesthetic with regard to form can also be called moral: the self is judged by the way it activates its relationships.

An action implies an agent. Conversely, for the agent to 'appear' action must take a singular form. Thus a collectivity of men wishing to act to common purpose must appear as 'one man'. Only thus do they declare themselves agents. The cause for their having to act may lie in the minds of their exchange partners or in the necessity for marriage, but the action is theirs. Unity is communicated, displayed, contrived, as it is in a performance. We may also take performance as a unified set of events, motivated by singleness of purpose and body. Oriented as participants are to others, they celebrate their own actions, and thus also their capacity for action.

Events, acts, performances are, then, presented in the singular; they both define and are defined by a single point in time. Each event thus has a historical specificity to it. Each event freshly transforms the multiple causes for it taking place into the single occasion of it having done

so. The occasion is fixed by the irreversibility of its momentary aesthetic impact.[5] LeRoy (1979:206) describes this vividly for a Kewa pig-kill.

> Let us suppose, along with the Kewa, that someone comes and observes from the sidelines. He is perhaps a visitor from another village who has come to receive a shell or some pork. Now, however, he scrutinizes the pig killers as they make their ceremonial gifts of shells and pork. His glance unifies them, and in his view they constitute a whole. This is his value: each pig killer can, by putting himself in the spectator's place, see himself as a member of a unified group. Long before the visitor arrives on the scene, therefore, local pig killers anticipate his reactions. What will he think if he sees them make a bad job of it?

In these terms we have to understand the Melanesian significance given to maternity: women give evidence of their own agency, as well as those of others, through the event of childbirth and the constitutive singleness of their own bodies. The diverse composition of these bodies, the gender of the substances or who coerced them to give birth are all irrelevant to the act itself. Indeed, in many Melanesian societies, its unity is exaggerated by the mother's isolation and seclusion at the time. The act of birth is regarded as a particular historical event. Relations merely appear as the causes of such events. For the relations are always there; what gives the event its unique character is how well or in what manner a particular relationship is made 'to appear' on that occasion. That evaluation defines the occasion. The event thus submits the self, the agent, to scrutiny in its capacity as a person from the vantage of another and thus subjects it to aesthetic judgement.

This is another way of putting the process Wagner calls analogic kinship (1977a). Relations (persons) are analogues of one another— Leenhardt's replication of bodies. But people's actions turn them into unique events so that one relation may also displace another. They become particularized.

From the agent's point of view, her or his unity is evinced in action taken. This is a generalized condition, encountered in chapter 5 as (indivisible) 'power'. It is the power to act that is indivisible. Furthermore, the agent can, so to speak, recall this generalized capacity on future occasions: it is his or her own capacity that has been revealed. But from the point of view of what caused the agent to act, the performance at that moment was a particular and irreversible event. The agent acted in relation to a specific other. The character of the other provides the context that determines whether the agent perceives her or himself as effective in a dividual or multiple mode.

Where the other already exists in prior form, its differentiation from the agent is taken for granted in the duality of an agent's orientation. As a woman, a mother knows she has the capacity to give birth; but as a wife, the woman knows she gave birth on this occasion because of the particular actions of her husband. The activation of specific relations on each occasion means that the agent's capacity is thereby particularized. Not in this sense replicated, it is elicited only with respect to a particular other, and the ensuing relationship thus takes a dual or cross-sex form. I use a kinship example, for it is such relations I would define as kin-based. The agent acts to differentiate and make these relations 'appear', but the form which the differentiation takes is already given. As a wife a woman can only act as a wife; otherwise she ceases to 'be' one. There is a prioritization to the relations that the agent can in this sense only reenact. It goes without saying that such prior differentiation is not 'innate' but is always regarded as the result of earlier, specific differentiating acts (Wagner 1977a:627). Their effect is at once cumulative and substitutive—a constant displacement of particular relations by further particular relations ('more kinship'). For a person's capacity is particularized or individualized (Gillison in press), revealed as agency, by the particularity of previous acts.

Prioritization may also have contingent rather than cumulative effect. The agent's capacity remains generalized and appears replicable; it creates same-sex relations, elicited by similar or like others. However the exercise of the capacity itself particularizes and makes relationships. In doing so, the constitutive differentiation is rendered unpredictable. There is (paradoxically for us) no determinate prioritization to the histories of intergroup relations, for instance. The instruments of their historical differentiation—warfare, competitive exchange, business enterprises, intrigues—are multiple and diverse, and are not given in advance. Consequently, anything may happen. This is the character of collective performances that occur in political contexts, creating the unique renown of clans, canoes, or leaders in relation to others like them.[6] It is in their particular historicized form (all with their own histories) that such entities are analogues of one another. Indeed, to be an analogue could be said to be their aim—groups compete, as anthropologists have long noted (e.g., Reay 1959; Forge 1972) to be equal with one another.

In other words, one must disaggregate the impact of people's interactions with reference to temporality, whether particular relations are taken as prior to an act or as a consequence of it. I remind the reader,

however, that the problem of the anticipated outcome is the collapse of cause and effect sequencing itself, and I shall return to the point.

Meanwhile, note that the verbal inversions through which my description has proceeded derive both from the interrelationship between English and Melanesian, so to speak, and from the conclusion of the last chapter about the manner in which forms participate in one another; it is after all in English no paradox to talk about the kinship aspect of politics or the politicization of domestic relations. That my argument pivots on these two concepts derives in turn partly from the Hagen-centric nature of the original problematic but also from the discussion in part 1 about the two types of sociality.

The two times of sociality. I have emphasized the substitutive effect of the cross-sex claims by which one agent extracts what is owed him or her, that is, belongs to her or his relation with the person in question. Substitution, unlike replication, can only take place once. Consequently, extraction (or production) is always a particular event. An extraction once effected fixes the parties in an asymmetric relation with one another. However many times it is reenacted in gift exchange or in further extractions, that historic shift can only be reenacted in the context of having happened.

It was argued earlier that the mother's social identity causes things in her care to grow. That identity is made overt by the events of gift exchanges and by the relationship between her work and her husband's. Under patrilineal regimes, a woman may be growing within her a fetus that comes in part from her husband's clan and be nourishing it, as she will when the child is born, with food produced by her work on the husband's land. Matrilineal regimes emphasize different constellations of significant social others. But in either case, these particularizing, cross-sex relations lie beyond her body which can thus be conceived, like a collectivity, as 'one'. Growth, therefore, has a retrospective character to it. It is in anticipation of the separation of grown thing from grower that the thing so grows, for it is only known to have done so after the event. This recursive view of time is highly relevant to my general argument.

The condition that remains hidden and enclosed, whether within a single or plural collectivity, is atemporal. It is the inert outcome of a previous sequence of events. It exists in turn in contrast to the anticipated revelation which must, in mobilizing external relations, itself always take the form of a single, temporalized event. Agents stage events,

bringing about an irreversible sequence, thereby making their relations with particular others appear. Thus a husband appears as the cause of a wife giving birth. Thus the individuating effect of Melanesian kinship: it is the act that individuates. From the viewpoint of the one who causes another to act, he or she has elicited a general capacity. But the general capacity is manifested in a particular way: from the viewpoint of the one who acts, the act is something only he or she can do. Moreover, each act appears in a unique form because it is differentiated from any other by its aesthetic effect. The quality of the performance, the child born alive and well, the things it produces, mark the point in time at which it occurred. What gives kinship relations their 'particular' cast, then, is time.

The way in which metaphors participate in one another might suggest that every such equation exists simultaneously; but that is merely the vertigo of a narrative form that has to lay out the interconnections between images. For the observer, everything seems implicated in everything else. But for the performers the whole point about performative sequence is the sequence. Actors move from one position to another. More than that, their energies and efforts are required to effect transition. Thus an anticipated effect is only *realized* as a result of action; wealth objects will only flow between exchange partners if each man takes action in relation to the other; and the children contained in the transmission of semen will only be born when the right action is taken with the right sexual partner.

Indeed, in the Sambia case we are told how important sequencing is: an older male must always play the part of inseminator (in relation to both boys and women), and no temporal reversal of the roles is permissible (Herdt 1984b:188). Age keeps apart the sister's husband and wife's brother; under the rubric of sister exchange these might otherwise be categorically fused (direct-sister exchange is always a possibility, see Herdt 1981:43). It is important that for the particular performer, for the individual agent, the sequencing is right, that his or her own inseminator is unambiguously defined. It is thus incumbent upon agents to keep the timing of their performances in order.

We might regard kinship relations as the distillation of individual acts in a necessary rather than contingent sequence. It is those acts that have produced this child of these parents, from this affinal tie, and so on. They have a particular nature to them because in kin terms each person is a microcosm of relations as they have been historically activated through individual agents. The evidence for this lies in the shape

that persons assume: their minds and bodies are thoroughly particular registers of the agents' successes and failures and of the degree to which others have properly activated their own relations. Health, stature, inclinations, feelings—all document specific action. The person as a kins-man or -woman, then, is the outcome of event and performance. Dependency in kin relations could thus be described as a priority of form: one relationship (person) must exist before another can (e.g., p. 250). 'Parents' are a prior form of 'children'. As we have seen, differentiations can be taken for granted only as the outcomes of the particularizing actions of others. Those actions in turn lay the irreversible basis for the future acts that will substitute for them.[7]

The problem of time posed by the gift's anticipated outcome, that is, by the objectification of relations, is solved by kinship, that is, by the individualization of the subject or agent. Through the singularity of his or her action, an agent keeps cause and effect apart.

An anticipated outcome means that relations must exist before they can be realized. Kinship places events in sequence, organizing the appearance of one specific form out of another, recording these sequences in the bodies of particular persons. The individual is created in the fact that these sequences—in the order they occurred, and in the success with which they occurred—are attributed to his or her motive in acting in one way rather than another. One behaves either as a senior or junior, either as a mother or a daughter. The 'individual' is thus temporalized in the image of body-time. Birth, maturation, death, decay record the history of the agent's own motives and the motives of others. The processes become highly particularized by virtue of appearing as a consequence of prior actions and thus as a consequence of people's cumulative dealings with one another.

Disaggregating the domestic domain. The Melanesian division of labor between husband and wife, seen from the point of view of one party acting for the other, inaugurates a set of particular relations focused on the household. The household appears heterogeneously based. It is constituted on dependency relations between nonequals, by contrast with those constructions of clanship where members are seen as replicating one another, a possibility that allows enumeration and the measurement of respective strengths. Relations within the household pattern the whole field of individuated kinship connections established through marriage and the maintenance of ties with affines and patrilateral/matrilateral others: they can never achieve such homogeneity. It seems

helpful to continue to refer, as in previous chapters, to 'domestic kin-ship', meaning this whole configuration of 'particular' relations. But if I do so at this juncture, it is to introduce a distinction between activities often taken together as axiomatically domestic in nature and axiomat-ically the province of women.

There are contexts in which the acts of feeding are separated from the acts of growing (chap. 9). There are also contexts in which it is analytically illuminating to separate nurture, under which we might include both feeding and growing, from the act of giving birth. (One could, of course, disaggregate further, for every 'act' is itself composed of a sequence of acts, in the same way as one can continually disaggre-gate the gender symbolism of any specific gender symbol.) I take the latter separation as a summarizing contrast of some salience in the way I think Melanesians assemble their ideas of women and men. In an-thropological analysis, these two activities are often merged under the umbrella rubric of domesticity. To do so in the case of Melanesian constructs of maternity and paternity is to obscure *the nonkinship character* of certain relations Westerners might otherwise put at the heart of the 'domestic domain'.

Childbirth is certainly constituted as a unique, nonreplicable event. It is a singular and historical act, making a specific relationship (between her and others, and not least the child) out of the mother's general capacities. For she becomes an agent activated by a particular cause seen to lie prior and external to her (the father's exchanges, envelop-ing clan land, or a brother compelling her husband to prepare her). Childbirth activates kinship. However, it is by contrast that the mother's nurturing of her child, or her crops, may be construed to evince instead a general capacity in relation to a like other (plants, the unborn child) that she thereby internalizes as 'part' of herself. Her capacity inheres as a general condition in that other. And these are the same-sex acts of growth that were described in chapters 8 and 9—hence what is in English the paradox that until it is born or harvested the growing thing within her in effect grows her. Grower and grown are unified in what could be called a 'collective' manner: like political relations, their rela-tions are of a different order from those of domestic kinship.

Into this context I would put Highlanders' remarks on the appar-ent spontaneity of female growth. Our mistake is to see this as a com-ment on a natural property that women like plants or animals have within themselves.[8] The early ethnographers claimed that it was because women were seen to grow naturally, men had to imitate them. But in

stressing the apparently unassisted character of such growth, the claims mistakenly suppose Highlanders see the process as beyond rather than constituted by human effort. Female or maternal growth is as contrived or as uncontrived as the propagation of subclans or the enlargement of men's names. Spontaneity presents an image of potential agency, of the ability to take unassisted action, precisely because the cause appears particular and external to the generalized capacities of the person/body. The actor becomes constituted as her own reference point; the woman qua woman acting with another in mind also acts from a position of her own.

At the center of women's activities, therefore, within the 'domestic domain' so-called, women's replication of same-sex relations is analogous to men's collective politics. (I write men and women here by convention. The same holds, of course, for the nurturant father in the matrilineal Massim: at the heart of lineage relations is the father-child bond.) Women's capacities for growth are replicable, generalized; their care of crops and their growing of the child within are nonspecific activities. The exercise of that capacity, as in the case of men's political interactions, is to make the resultant relationship (between grower and grown) a particular one. But that is not visible until it appears in the form of its effect: only the productive 'event' of harvesting or childbirth will reveal the relationship.

The one process leads into the other. But it is exactly time that separates them, and we should take notice of this temporality. Rather than conflating the different times of maternal growth and parturition, it is helpful in understanding the Melanesian view to consider women's bodies as evincing in themselves an alternation between the two types of sociality, the collective and the particular. The implication is that we must therefore stop thinking of women's caretaking roles as axiomatically indicative of domestic kinship: they also evince a collective and generalized capacity. Women, like men, subsequently engage in particular (kinship) relations with others through their own cross-sex ties.

It becomes unnecessary to conclude, as Ortner and Whitehead (1981: 7–8) do in gender terms "that the sphere of social activity predominantly associated with males encompasses the sphere predominantly associated with females and is, for that reason, culturally accorded higher value. . . . [Men] control the larger social operation . . . while women's social horizons are narrowed to the small range of closely related kin and their immediate needs." I appear to have been party to the conclusion (M. Strathern 1981a). But as I would formulate it now, it is not

that a male sphere permanently encloses a female one. There are no spheres in that sense: encompassment is relative. There are positions from which people act. And women as much as men are able to construct themselves as reference points for their own acts. They are not subsumed under kinship relations; rather, they equally create and enter into kinship relations at particular moments.

It also becomes absurd to think diagrammatically of the political and domestic domains as the internal and external aspects of a structure. Melanesian clanship, for instance, does not represent an exteriorization of domestic kinship, a jural order, a higher sociality. It is not a validating externalization of domestic authority, which becomes thereby sanctioned, as Fortes (1969) would have it (see chap. 4, n. 10). On the contrary, the sphere of relations I have called collective, with their contingent character, may be considered amoral by comparison with the necessary morality of domestic kinship. I would, of course, include the fact of women's generalized capacities as equally amoral.

In the context of domestic kinship, constraints on action come from the extent to which persons are construed as immediately vulnerable to and immediately able to benefit from one another's exploits and intentions, and this is partly a result of the cumulative prioritization of people's acts. The constraints are invested in the particularity of the relations themselves and their cause and effect sequencing. The resultant asymmetries may, as we have seen, be metaphorically captured in the interests of collective relations. Initiation cults blow up unmediated effectiveness to collective proportions, participants' bodies becoming the individual sites of alteration, with specific acts between particular seniors and juniors creating relations of dependency between them. Ceremonial exchange appropriates emotional states as attributes of whole social units, so that clans collectively impinge upon one another, their mutual dependency contrasting with the independence each also claims. But all this is, so to speak, a borrowed morality. Basically, men's impingement on like others celebrates a homogeneous identity which works by overcoming or resisting the moral basis of heterogeneous domestic dependencies. Hence the organization of clan events becomes an achievement and, in Lederman's (in press) observation for Mendi, "represents a hegemonic moment." Pari passu the same may be said of the act of nurture.

From the point of view of men's activities, neither politics nor ritual constitute a normative domain that abstracts and adjudicates values existing elsewhere; in transforming domestic kinship, collective rela-

tions are also oriented towards its reproduction. But they deploy an aesthetic mode that necessarily promotes not a congruent but an *alternative* set of values.

Harrison makes this point in relation to religion: representations in myth and ritual promote an 'ajural' sociality (1984:401).[9] His observations were prompted by a study of Avatip, in the Sepik River area, and by Tuzin's work on Ilahita Arapesh to the north. Tuzin's concern with ritual violence led him to note that the "felicity of domestic relations must constantly contend with ritual prescriptions designed specifically to undermine marital and filial attachment." Actors have "to pay the emotional cost of living by two contradictory, affectively loaded codes of conduct": "domestic ethos . . . radically contradicts its ritual counterpart" (1982:351, 352). One may compare Young's (1983:262) account of the antinomy in values that leads to "competing visions" of Kalauna society on Goodenough Island in the Massim. Harrison suggests rather that at Avatip "the dilemma is not between irreconcilable moral codes, but lies in the fact that religion and morality are distinct and embody values of a different order" (1985:117).

Avatip people, Harrison argues, see themselves as composed of both 'understanding' and 'spirit'. Understanding appears akin to the Hagen nurturing of the mind which chapter 4 suggested typified the dependencies created in the domestic domain. These dependencies certainly have a moral force: that is, persons so related (by 'kinship') define themselves through identifying with the concerns of others. Spirit in Avatip, however, is life-force to be augmented through self-assertion and intensification, akin perhaps to 'prestige' in Hagen or what Gillison also calls 'life force' in Gimi (1980:148). The ritual system allows men to attain degrees of 'spirit' through a male initiatory cult, giving them access to a domain of life in which moral values are replaced by aesthetic ones. "I call these values aesthetic because they are concerned above all with the power of signification. This is viewed as a capacity, inherent in [male] individuality, to produce admiration, fear, desire or other types of *affect* in others" (Harrison 1985:117, original emphasis). Avatip men gain influence over others in their self-enhancement of spirit. "Avatip religion does not celebrate moral consensus or the submission of the ego to the *conscience collective*" (1985:117).

The specific aesthetic impact that Harrison describes can be understood as the glimpsing of people's capacities in a generalized shape at the moment of their being exposed by the particularizing relations

which summon them. I have been using the term aesthetic in a wider
sense, to refer to all constraints of form.

The two types of sociality (the particular and the nonparticular or
collective) exist as alternative forms to each other because each antici-
pates the other. We might say that in the same way as an agent and a
cause stand in respective active/passive relationship, so each sociality
is suspended in its own time. The relationship has to be one of alteration
or anticipation because neither can occupy the time of the other. The
one can only 'appear' as the other in a transformed state. Whether
through the political devices of ceremonial exchange and clanship of
the Hagen type, or through life-long exchanges that focus on kin, in
neither case is the collective dimension merely a kinship 'domain' ag-
grandized. The particular relations of kinship are transformed into the
display of a generalized capacity. Conversely, nurture and growth is
not kinship condensed or miniaturized. Rather, they are generalized
capacities made visible in the context of particular relations. These
alternities become reified in the aesthetic of same-sex and cross-sex
relations.

We now see why gender constitutes an oscillation or alternation
between same-sex and cross-sex states. These give shape to a double
alternation: on the one hand between sociality in a collective mode and
a particular one; on the other hand between being the incomplete agent
who is activated in relation to another and the complete person, a
product of others' interactions. I repeat the teaching given to Sambia
boys: an individual cannot be in both an active and a passive state at
the same time, but *must behave* as one or the other. The alternations
are not isomorphic—they do not 'map' on to each other. They merely,
but powerfully, draw on the one common aesthetic. And this presents
alternation itself as a movement between states, a sequence of events.

Events (acts) entail relations. That is, relations (persons) are both the
cause and outcome of acts (not the doing of them). Take the prescrip-
tion that patrilateral and matrilateral kin have to be kept separate. This
can be achieved *in so far as they have their focus on a specific person.*
For that person is potentially an agent. Their impact is seen to take
different forms, in so far as the individual agent acts upon the fact that
her/his body and mind register the effects of these relationships. The
relationships become differentiated from one another in the one person
who internally displays the difference they make. We could put it that
the kin around him or her are not innately differentiated from one an-

other. It is the person/agent in her or his internal composition (via her or his internal relations) who differentiates them.

I now turn to the phenomenon of re-enactment, to the manner in which these internal relations are commemorated. People are also able to substitute themselves for the relationship they have with their senior kin. By their own decomposition they at once reify and individuate their persons. They do this through eating.

KNOWLEDGE IN A CONSUMPTIVE PRODUCTION ECONOMY

Metaphors of deconstitution have run through my account: detachment, elimination, division. They do so in response to the fiction of convention/invention introduced in chapter 7, and Wagner's (1978) theoretical propositions about the practices of Melanesian knowledge.[10] Knowledge is not 'built up' into a form; forms are taken apart to reveal their composition. Melanesian analysis, if one may so call it, leads to individuals testing their effects on others, trying out their capabilities, improvising and innovating, for capacities can only be known by the manner in which they are revealed. But what agents thereby reveal is their constitution as persons. Such processes of deconstitution result not as we might suppose in an array of fragments; they result in a singularity conceived as an internal unity. As I have been describing it, the unity may be derived from the dividual through the halving of a pair or may be the dissolution of a composite, multiple condition into a bounded, homogeneous state. That unity itself reveals the effects of the individual agent's acts.

Many of the social practices that a Westerner might take as ordering or aggregating activities have to be understood as deconstitutions of this kind. This should be apparent from the analysis of initiation rituals: the Sambia boy or the Gimi girl is not 'socialized' into some role or other through 'acquiring' attributes. Rather, an already existing composite entity is taken apart and produced (by their own actions as well as the actions of others) in a unitary form—the potent father, the receptive mother. The detachment of spouses from their kin through bridewealth or affinal prestations and the mortuary ceremonies that restore a singular identity to a set of kin are as much decompositions as men's differentiating acts in bleeding their bodies or women secluding themselves when they menstruate. There may well be an energizing or activating outcome, for the person is bestowed with a unity that generalizes

his or her own capacities as an agent and provides her/him with the single position from which to act in the future.

But the individual also has to get the original composition right. The logic of the anticipated outcome is quite as much one of uncertainty as of certainty. In an activated state (as agents), persons must identify the proper causes of their acts, namely the relations of which they are composed, in hoping to achieve the desired outcomes. Thus in anticipation of a child's birth, parents must secure its origin in the mediation of relations between paternal and maternal kin or between the internal elements of the parturient mother's body. The act of detachment cannot take place if differentiation has not been properly accomplished.

Possibly this explains a prevalent Melanesian attitude to human agency—at once anxious and agnostic. People say they do not know what the outcome of certain acts will be: they cannot tell. This can be institutionalized as anxiety.[11] It is encountered in the individual susceptibility of initiands displaying themselves to an audience's gaze (Biersack 1982); in the vulnerability of donors on a ceremonial ground who have brought out their wealth (A. Strathern 1975); in voiced uncertainty as to whether an event will even occur or not, as MacLean (1985) reports for Maring bridewealth ceremonies. Hence events appear both as divinations of previous states of affairs and omens of affairs to come. Such uncertainty does not arise simply from the hazard of daily interactions but is built into expectations (MacLean 1985:121). As in many dispute settlement processes (e.g., Counts and Counts 1974; Tuzin 1974), it is assumed that what is happening can only be known from the vantage point of some future event that will evince its effects. Uncertainty means that knowledge itself has to be established as having happened, as an event of sorts.

Feeding provides an image for this recursive process. For I would make a general equation between consumption and knowledge. (The equation is mine, but I offer it as a way of imagining Melanesian imagery.) The previous section dwelt on the temporal sequencing between the growing of things and their being brought out for all to see; there is a further temporal sequencing between such display and its consumption. The fact that products are 'consumed' or taken in by others creates the particular relationship between the agent and those thus affected by her or his acts. In turn, those who consume privilege for the moment that relationship over multiple others, which become suppressed or eclipsed. It may be literally momentary, as when a guest observes the canons of hospitality, or it may mark out a period of life, as a child is

fed by its parent, or recur on a daily basis, as one spouse feeds the other. The fed person is put into a passive condition. Feeding establishes the 'claim' of the agent on him or her who will register the act. What I say about food could also be said about knowledge as such.

Making effects known. In the description of *wok meri* activities presented in chapters 4 and 9, a connection was suggested between women's all-female activities and men's all-male cults. It seemed a detraction that at the juncture at which women's accumulated savings were brought out in public, men stepped in as public orators and bookkeepers. Yet male initiation sequences also end with display to a mixed audience, even with marriage for the participants; and the items that circulate in ceremonial exchange are in the long run returned to the household. Not only are pigs eaten, but Hagen husbands secrete their shells in their wives' houses with care. Production entails consumption. Production in its form as growth or flow rests on a same-sex construct: the activity is envisaged as the all-male encompassment of female or vice versa. But production is not known, not 'produced' as it were, until the point of consumption by another. The point at which items are consumed is the point at which their multiple (cross-sex) constitution is revealed to those who elicit it.

Time and again we encounter the idiomatic expression that a produced thing (Daulo women's money/the Gimi child/Hagen pigs and shells) is at some climactic moment 'brought outside'. The moment of release is at once the moment of knowledge—what was inside is made apparent—and the moment of consumption. Women's money is put to uses that also involve men, as a child is claimed as the father's work, or an exchange partner claims his debt. Hagen wives demand from their husbands pork to eat, while the exclusive control a woman has over crops in the ground is turned into multiple claims the moment they are harvested. It is through such display that a person 'knows' what she or he is made of. It becomes an event, with the characteristics of an event. It 'takes place' in time and is individuated by its aesthetic effect. Knowledge is communicated through the impact that the agent's acts have on the recipient/audience/consumer, that is, through *their* knowledge. To put it in Schieffelin's (1985) terms, it is they who complete its reality.

If action draws out of persons what they are capable of, that capacity is revealed as the ability of an agent to mobilize a constellation of relations. The agent's (generalized) capacity to make relations and the

particular relations of which a person is already made are both made known. Intent is retrospective as well as prospective. An audience may be created by the display itself, as a recipient is created by ceremonial exchange, but a recipient also exists before the event at which his preexisting claims are revealed. The recipient/consumer thus consumes what already belongs to him or her.

Hageners, for instance, speak generally of 'eating' wealth. But there is a specific connotation to this phrase in relations of domestic kinship. As far as women are concerned, the significant point at which they 'eat' wealth is on the occasion of a kinswoman's marriage. The multiply constructed child is claimed by both her paternal and maternal kin, who make apparent their relationships through eating the bridewealth. We may thus equate both consumption and knowledge with making apparent the constitution of persons and the things agents circulate. The moment at which persons and things are brought into the open is the very moment before they are taken back into a body.

Herein lies the difference between the prospective body of a general audience who is made receptive by the display and the retrospective body of those with prior claims. Ceremonial exchange proceeds with the former in view, kin-based exchanges with the latter. In kin-based exchanges, there is no expansion or multiplication of relationships: the consumer/recipient consumes an item that *substitutes for his or her own previous acts*. It is the bride's mother who above all must eat pork at her daughter's marriage, in recognition of the prior act of childbirth, and her nurture. Diverse metaphors for 'the mother's pig' (M. Strathern 1972:106) are explicit on this point.

In this ethnographic case, the process of substitution is final, and the whole bridewealth event is likened to death compensation.[12] But I suspect the comparison between birth and death is a general one; what is revealed, detached, brought out is a person (a child, a bride, the deceased) reified as the end product of a constellation of relationships, and hence a 'finished' or completed thing. Knowledge takes place at a moment of 'birth' or a moment of 'death' with equal effect. The *wok meri* rituals draw on the symbolism of birth, and women's growing of a fetus within the womb. In many Massim societies, growth occurs within the 'womb' of the matrilineal subclan; it is at death that the multiple constitution of the socially active person during his or her lifetime is displayed, then deconstituted and taken apart, the affinal ties shed so that the matrilineal body can absorb back the deceased as

clan member. The claims of a Sabarl father on the child he has fed
are extinguished when he 'eats' at the child's mortuary feast (Battaglia
1985:432–433). It is the relationship that has 'died'.

Eating is an image for the substitution of one act for another. Much
of the earlier discussion about substitution (see chap. 9) dealt with the
displacement of cross-sex relationships. But here we encounter a dif-
ferent sequence. Within the *single* cross-sex relationship—the affines
linked by bridewealth or mortuary exchanges—a difference is created
between two acts. One act substitutes for another, in the reverse flow
of food, both a reenactment and a transformation. A prior act of feed-
ing, on the part of a Hagen mother or a Sabarl father, is displaced by
a subsequent act in which the feeder is fed. This effective termination
of the cross-sex relationship may be thought of as a reduction of am-
biguity, as forming the relationship into its final mode. In the same way
as a Hagen bride's agnates become known as 'maternal kin' to her
children, the matrilineal kin of a deceased's Sabarl father are unambigu-
ously placed on the 'paternal' side. Each is composed by the new claims
of the groom's agnates or the deceased's own matrilineal subclan.

A composition from one point of view is a decomposition from
another: relationships reduced to a single strand. Perhaps there is a
sense in which all consumption involves decomposition of this kind—
what is 'seen' at any one moment, the privileging of one relationship
over others—and that eating is always at once energizing and debilitat-
ing. It creates an agent by making the person incomplete, depriving her
or him of a support base of a multiple nature. Eating is idiomatically
often equated with sexual intercourse, and sexual intercourse in turn is
idiomatically often imagined in these societies as a 'little death' (com-
pare Gillison 1983:40). Although, and strikingly in the Gimi case, we
may imagine that it is the object devoured which is killed thereby, I
wonder if there is not sometimes the idea that the devourer, the con-
sumer, also dies—losing that prior part within him or her which the
new food displaces.[13] More prosaically, the consumer as a container is
reduced to a single identity in encompassing an object produced by
another.

While the capacity for action can be replicated, acts can only substi-
tute for one another. This is as true of what an outsider might regard
as the everyday activity of eating as it is of staged performances. Indeed,
every act contains its own performative hazard: it risks its effects, so
to speak. The reenactment or commemoration of other acts—one's own

or other people's—is thus simultaneously an innovation and improvization upon them. And 'kills' or completes them (Wagner 1978:24).

Consumption and coercion. Gregory (1982:33) comments on the Melanesian idioms in broad terms. A link between eating and sexual intercourse "can be seen" he argues (1982:33), "as empirical support for Marx's conception of consumption as the production of human beings." If 'production' is making the capacities of persons (relations) manifest, then it is quite appropriately termed consumptive production for these systems, in that what is being produced is knowledge, and knowledge is only 'known' by being consumed.

One connotation of the Western notion of 'domesticity' is that consumption is an entirely passive process, a taking into the self of what has been produced with activity and energy elsewhere. Feminist arguments about the nonvaluation of domestic labor are likely to equate the self-evident use-value of an item with its equally self-evident consumption. Consumption seems to be a nonproblematic realization of attributes, a nonevent. Melanesian ideas, however, may make the process very problematic and at the least an event. In Hagen, the point at which food is consumed is the point at which work is recognized: what is significant is that recognition is a specific act. The consumer may be passive, in the sense that he or she is witness of another's agency, but becomes thereby a vital 'person' or reference point for that agent. The eating that activates that relation is also a kind of reenactment and, as we have seen, very much a performance.

In its original formulation, consumptive production involves the personification of things that promotes the survival of persons. Inspired by Lévi-Strauss, Gregory expands on Marx's account of reproduction, taking consumption to refer not only to people's need for nourishment but also to reproduction through sexual relationships and parenthood. Consumption, in this expanded view, becomes more than simply the "*using up* of materials and labour energies" (1982:30, my emphasis).

In commodity economies, consumption might be productive in a weak sense: by taking in food, the human being 'produces' his own body (Gregory 1982:31). But in gift economies, it should be regarded as productive in a strong sense—the process by which things are transformed into persons is an innovative and incremental one. This becomes apparent with the realization that one is not dealing with individuals who aim at self-replacement. It is not as an 'individual' that someone

consumes another's products but as a 'person' in that other's eyes. Persons are the objectified form of relationships, and it is not survival of the self that is at issue but the survival or termination of relations. Eating does not necessarily imply nurture; it is not an intrinsically beneficiary act, as it is taken to be in the Western commodity view that regards the self as thereby perpetuating its own existence. Rather, eating exposes the Melanesian person to all the hazards of the relationships of which he/she is composed. I recall again that one may wish to disaggregate the activities of feeding and growing. Growth in social terms is not a reflex of nourishment; rather, in being a proper receptacle for nourishment, the nourished person bears witness to the effectiveness of a relationship with the mother, father, sister's husband or whoever is doing the feeding. The recipient of nourishment is as specifically defined as the provider of it. Consumption is no simple matter of self-replacement, then, but the recognition and monitoring of relationships.

Indeed, I would argue that in these systems, people cannot be concerned with *self*-replacement at all. The whole burden of analyzing the objectifications of a gift economy (chaps. 8 and 9) has been that, if we use the shorthand at all, it is persons (relations) who replace persons (relations). These may appear as bodies, but then the body is an objectified form: the self so to speak from another's point of view.

The self as individual subject exists rather in his or her capacity to transform relations, an embodied power which reveals itself in its effects. The self is activated in so far as such relations (persons) are summoned by the agent and are revealed as the agent's supports. In effect, then, while eating is an act that only the agent can undertake for him or herself, its result is to make the agent into a person (an object) from another's viewpoint. The agent's acts consequently appear in a final and thus different form from the activity itself: the parent produces a child as the gardener produces yams. A parent does not produce a parent: the child in turn must be made to reveal parental capacity from within. An agent only ever 'reproduces' him or herself in another form.

The recipient (beneficiary or victim) of another's acts is also their effect or product; she or he is thus an object of that agent's regard. One agent does not so to speak 'produce' another. But an agent may expect that the original *act* be commemorated. This is certainly the voiced expectation of the Hagen bride's mother. The person (bride) that an agent (mother) created reenacts that act of creation. It is the bride who is regarded as bringing pork to her kin and her mother, carrying it, as

she does for part of the ceremony, on her back. In so doing, she (the bride) becomes an agent in turn, reconstituting in her own regard the person (mother) who is manifestly one of the causes of her existence.

The conditions that enable the mother to give birth to a daughter with her own separate social identity include a lifetime's history of affinal exchanges, but maternal agency is manifest in the form of the unique event of birth. A child him or herself can then become his or her own agent by commemorating that event—acknowledging the exchange relations that were the particularizing precondition of the mother's capacity. Persons may thus make overt the original relations or causes that produced them through their own transactions. They can also do again what their mothers or fathers, or mother's brothers or sister's husbands did in feeding them: they eat. Food may be of multiple origin, but it is eaten by oneself, and these relations acquire a singular site in the individual body. Throughout their lifetime, then, agents continue to commemorate themselves as persons (composed of the relationships which focus on them) through the food they consume. In so far as they attend to the social sources of their own constitution— payments to maternal kin, sacrifice to paternal kin—agents thereby activate themselves and sustain their own individuality.

However many times it is done, each act of eating is also a single event, oriented toward a single source. This has the consequence already noted. To reconstitute oneself in the regard of a particular other is also to deconstitute the multiplicity of relations that might have been commemorated. That other is privileged as a reference point (a cause) for the acts. Hence a woman is known simply as the 'mother' of the bride when she eats the pig that substitutes for her own agency towards her daughter. The particularity of that relationship eclipses or suppresses all other aspects of the woman's identity. At the same time, the substitution is anticipated: the mother acts so to speak in order to become a cause, to be the occasion for a reenactment, and thus a person—to become the object of the acts of others, as Munn (1983) describes is an aim of *kula* partners. To be a cause is to *have been* an agent. This passivity is coercive.

It is with respect to acts, then, that one may properly talk of a cause and an agent. Taking action individuates the agent as a subject, and in his/her view the cause of the action exists as an external reference point. But to be a reference point, a person to another in virtue of the relationship thereby established, is the precondition for one's own agency. In

directing an agent's attention, so to speak, one becomes an agent one-self, in the way that a solicitory gift opens an exchange sequence, or betrothal gifts elicit bride bestowal. Indeed, we have already encoun-tered this anticipation in reciprocal form, when two persons are concep-tualized as a pair, each of whom elicits a reaction from the other.

It is always one of a pair who takes action: the act of elicitation is the coming out or making known of the other's internal condition. The event is often elaborately contrived as a performance, and there is a reason for this. The physical staging of a performance is an attempt to overcome the recursiveness of time. As I described it earlier, the uncer-tainty of the anticipated outcome inheres in the status of an event itself, in doubt as to whether or not an act has taken place. For anticipation is also regression. The precondition for something to happen must be part of the happening. An event is known by both prior and ensuing events. So production is only 'produced' at the moment of consumption; knowledge is only 'known' through the knowledge others acquire; for an effect to emerge, the cause must be properly in place; there are preconditions for conditions, in short a perpetual regression from out-come to cause that is summed up in that remarkable Sambia conven-tion—though by no means confined to them—that food must be fed.[14]

Nonetheless, as a performance, 'coming out' can be staged as a particular moment with a time of its own (p. 281). A common image is the visual emergence from an enclosure. The event is simultaneously prestaged, because the enclosure has established as a precondition the unity of the agent(s). As we have seen in earlier chapters, enclosure may take the form of an envelopment by a single body, or of a homogeneous action that creates a collectivity. When men build fences around cult areas they create a unity both between themselves and in relation to the spirits with whom they are joined: at the point of bursting forth, they both detach themselves from that enveloping relationship and re-veal the association in their enhanced form. As through transactions associated with 'transformed kinship' (p. 264), the beneficiaries grow until the moment when they detach themselves in 'birth' (or 'death') from the encircling relationships. In so far as men's activity is thereby seen as the deliberate binding together of persons whose social orienta-tions are otherwise diffuse and variously directed, the unifying nature of the collective action is inherently energizing in making the partici-pants other than what they were.

But the new state must be communicated in order to be known,

hence Schwimmer's observation about the couple as the basic unit for the transmission of messages. In his example, messages are passed between men and the spirit world. A couple is formed of two moieties or two equals or by a senior/junior pair; they are alike in that each plays a flute or wears a mask, thus representing the spirits. Each is the other's source of revelation: "each knows himself to be man, but when he looks at his partner he can see a spirit" (1984:253).

The moment of bursting forth out of an enclosure is the moment at which the actors display what I have called the generalized capacity they have within before it is particularized as food or knowledge consumed by the external audience or partner who, having elicited it, is also the coercive cause of the act. The energy which agents display may be taken as a reflex of this coercion. Indeed the activation of relations seems to require energy and force precisely for the reason that persons bear evidence within themselves of what has happened to them. Whether interaction produces a relationship that in mediating between two parties 'adds to' their identities, or else an unmediated impingement by one on the other becomes registered in an alteration to the latter's body, there is a forcefulness in the way these interactions are conducted.[15] Transformation requires and is thus evidence of effort. Gifts are pressed on others; plants are compelled to grow; work is a matter of mind, will, intention: there would be nothing to know otherwise.

The visible energy is, one suspects, a result of the aesthetic requirement that acts must appear in a form other than the agent's intention, and to that extent are 'separated' from the agent. Furthermore, the subsequent outcome of actions, their effect, is always embodied in another (relation, person). If force is applied to an external object it is to display the imprint of one's own effectiveness, and in this sense to make the object part of oneself. Indeed, violence may have an assimilative effect in general; a Hagen woman beaten by her husband wears the blood or bruises as a sign of his acts; the remedy she seeks is the intervention of her kin who will restore the dignity of her separate status. Exchange partners are assimilated to the gifts that they exchange and circulate in coercing the recipient to accept them; parents implicate themselves in the plants/children they nurture and produce, violently during initiation sequences, and in reciprocal pain during childbirth. These gifts and children must register their acts, and the possibility of registration has its own precondition. Things must appear so as to elicit recognition from

others. The difference between the agent and the produced yams, shell valuables, brides, sons is only known if these things assume a proper shape. Here we return to the significance of gender.

ANALOGIC GENDER

In summary, I have suggested that ideas about gender provide the aesthetic convention through which forms are seen to appear. Relations, the overt object of people's attentions, are thereby reified in the manner in which they are differentiated from one another. In our view, what is concealed is precisely this conventional basis. That 'difference' is what we would call a symbolic or classificatory construct, contrived as we would see it either through the contrast between male and female or through the contrast between same-sex and cross-sex relations. In Melanesian systems of knowledge, however, difference is presented as an axiomatic consequence of people ensuring that recognizable forms of action occur.

Gender provides, then, the medium through which differentiation as such is apprehended. It gives a form to relations, which thereby become directed in one of two ways, as either replicating or else substituting for one another. The 'difference' between replication and substitution in turn appears in that between same-sex and cross-sex interactions. People know which kind of event or performance they witness through the gender relations it mobilizes. By the same token, they also know when one event has become another. But that puts the sequence back to front; rather, they also know that events are caused and have their outcomes, and that one kind of event must inevitably lead to another. This regression/anticipation/alternation is contained within the possibilities of a procreative gender imagery predicated on the capacity of one form to emerge from another form.

An androgyne is composed of, and can be decomposed into, male and female elements. Either element may also be construed to exist as an independent body. These constructions define a male body as having the capacity to contain within itself what it can also detach from itself, namely female body; while a female body contains and detaches from itself male body.

The imagery may so evoke the condition of 'physical' bodies or of 'social' bodies alike (and I remind the reader that one also means 'mind' in the Melanesian context). Since persons appear in male, female, or androgynous form, the possibility of one form appearing out of another

is seen to be a possibility that lies within the body. We must remember that persons objectify relations: bodies and minds are consequently their reified manifestation. And they must always take a manifest shape, that is, display a differentiated condition. On the one hand, the difference between a same-sex and a cross-sex state is that the one is a transformation of the other; on the other hand, male and female are analogic versions of each other, each acting in its own distinctive way. People's behavior necessarily reveals both their own and the condition of others: behavior is gendered. I suggested that acts individuate persons; it is thus people's acts that establish the gender of the behavior, in making apparent the condition of their own and others' bodies/minds.

Here one encounters an interesting constraint. An androgyne does not act; that is, persons are activated, become agents, only in a same-sex condition, as male or female. The gender aesthetic discriminates between the very possibility of one taking action as an individual subject and being the inert outcome of other people's acts. This has implications for the way in which people imagine the relationship between cause and effect.

An agent appears as either 'male' or 'female' in relation to the objects of his or her acts: they must appear as reciprocally 'female' or 'male'. The illusion is that coercion seems to lie in gender itself: the Paiela husbands who have to compel their wives to grow them; the Gimi fathers who force the mother to extrude the child born of paternal spirit; the Trobriand brother who induces his sister's husband to at once make and yield back the child that belongs to him; the Sambia males who impose cooperation on their younger partners. And on the other side are the Paiela wives who observe the effects of their own intentions in the bodies of men; the collectivity of Gimi mothers who consume male corpses; Trobriand sisters who create brother's sons; and the at once strengthened and humiliated bodies of 'female' Sambia novices who contain men's replenishment in themselves. These are not 'subjects' acting upon 'objects'. The intent of the act—coercion—is to establish the very relationship itself. In gender idiom, each sex elicits the acts of the other, for those counteracts are the evidence of its own efficacy. But in so far as each is also the cause of the other's acts, there is nothing automatic about elicitation; it is effected under the conditions of uncertainty and anxiety noted earlier.

It is no paradox that males are essential to maternal agency. Men assist birth; their own social productivity must be made visible in an-

other's body. Consequently they do more, in the Gimi case for instance,
than just making themselves fathers of the newborn child. Evidence of
paternity is established by the fact that their acts enable *the woman* to
give birth and herself become a mother. The early Highlands ethnog-
raphers were right: the necessity for men to act comes from what hap-
pens to women. But they were right for the wrong reason. The reason
is not because of women's self-evident nature, but because of how they
evince the capacities of men. And it is the women who have to do it.
Hence we should also pay attention to the converse; that it is women
who enable men to produce as fathers. The Melanesian child is no pa-
ternal or maternal product by simple contiguity with a parental body.
On the contrary, its assimilation to a source conceived of as male or
as an enveloping maternity or as the transactions of a brother-sister
pair must be the specific outcome of particular acts. The gender of the
activity depends on the way social relations are construed and their
cause and effect sequencing. Events do not happen if people do not
make them happen; 'things' do not appear on their own. Action consists
of compelling, exerting, impressing oneself on others. For before an
agent's acts can have effect, the agent must in turn have been caused
to act and must coerce another into being just such a reason for her or
his activity.

Indeed, people's 'causes' seem a widespread ritual preoccupation.
Melanesian knowledge practices deal with categories that are imagined
as subject neither to discovery (in the enlightenment sense of revealing
and laying bare their true nature) nor to cultural elaboration (in the
empiricist sense of rendering the natural artificial), but rather to trans-
formation. The outcome of a relation must also be the reason for it. As
we have seen, what is simultaneously thrown into doubt is not simply
whether any set of interactions will achieve anything (have an outcome),
but whether its reasons, its origins, still hold good. An effect is contin-
gent on the correct identification of the cause, health on the good favor
of ancestors. Actions are oriented to establishing the reasons for rela-
tions in order to gauge their outcome. Hence the endless search for
'origins' (e.g., Gell 1975; Barth 1975) is part of the uncertainty of all
acts—the way in which past achievements and effects are also anxious
omens for the future. At the same time, of course, to be or to evince
an effect 'is' to be or evince a cause, the source of it, in another form.

Yet because of the 'another form', assimilation to an origin is bound,
as I have indicated, to contain a measure of violence. The ancestors
are dead. Identity with a source can only be realized (known, pro-

duced) through detachment from it. The dependency of product on source is violent, so to speak, because agency, the possibility of entering into further productive relationships, requires the person to extract him or herself from prior ones. Or to displace one set of acts by their commemoration.

In the context of kin relations, certain persons (such as mother's brothers in agnatic systems) may be required to accept their place as an empowering 'cause' of say (their sister's son's) growth. But a cause is no longer active: it is superseded. The action has already taken place. The burden is on the agent to force others into being a cause for his/her extractive acts. A Hagen woman coerces her husband into making those exchanges with her kin of which his marriage to her is the cause. A *kula* partner seduces his overseas counterpart to give in order that he himself will have cause to give. Older men inflict pain on the Sambia initiates as the cause of their having to grow them—a relation of reciprocal elicitation also enacted with tenderness between the boy and his individual inseminator.

Such conceptualizations of agency find no ultimate expression in self-expression. The individual subject can only act, and in doing so, indicate its state of relations with others. Consequently, he or she is vulnerable to the premise that agency can only show evidence of itself in its impact on these others, and failure is always possible. Causes do not appear as causes should; people's minds may be diverted; it is necessary that women show that growth can be transformed into external social objects, that they do actually give birth; it is also necessary that men should complete their exchanges properly. Evidence lies in aesthetic propriety, in the gender of the act. Highlands women circulate in marriage as the objects (causes) of men's active transactions; conversely, when women actively tend children, men's transactions become the causes of that nurturing relationship. Perceived together, the sexes appear in a relation of mutual elicitation, either the cause of the other's agency.

A subject's anticipation of another's viewpoint means that a relation can always appear to be something else, that the persons or wealth items which appear to be the object of one relationship (such as between a Hagen husband and wife) can then appear to be the object of another (as between a man and his affines). Sequencing is involved: one of the parties to the original relation is required also to instigate the new one. Thus one relationship may 'turn into' another. But since that capacity has been anticipated, we can also say that one relation 'stands for'

another. That between a man and his male affines also anticipates and in this sense substitutes for his relationship with his wife. Since relations are seen to have an outcome (effect), transformed in turn into persons, outcomes also present themselves as the reason (cause) for relations. Yet this process is to be distinguished from the simultaneous or timeless encompassment of another's point of view: if male semen is 'the same as' female milk, it is already in this sense the other's view. As mutual causes of one another's acts, male and female neither turn into nor stand for each other. They are simply two kinds of, two versions of, the capacity to act and cause action. Yet paradoxically, the very activity of temporal transformation leads to this atemporal state of affairs.

As a social microcosm, the Melanesian person is a living commemoration of the actions which produced it. I have argued that a person must therefore always be a particular person, the product of specific, irreversible interactions, in gender terms an androgyne. Agents, on the other hand, individual subjects, act by virtue of their generalized capacities, that is, by the capacity for action itself, to be 'one', to act as 'one'. If it is indeed acts which individuate, they consequently make the subject (agent) appear in one of two forms, unique in gender terms. This is the same as saying the individual always acts in one of two such ways, as a male or as a female. It is only their gender that differentiates agents. Qua agents, individuals are in themselves nonspecific entities.

Maleness and femaleness indicate a difference in the agents' capacities, then, but in so far as they refer only to this difference—they distinguish what kind of agent an individual is—remain analogues of each other. This construction collapses the relationship between cause and effect. It turns a sequence of events into the context for them. Let me show how this contradiction might be imagined. It can only be done, as has been necessary all along, through rearranging the elements of the narrative.

We have seen how integral to the staging of Melanesian performances and events is the reification of the difference between cause and agent and between agent and effect; either can be presented as the difference between male and female. The one form thereby appears to elicit the other, for male and female always require the other for completion. An agent acts with respect to a cause separate from him or her and produces her or his action in a form (its effect) other than the action itself. In relation to either cause or effect (imagined as relations or persons), the agent engages in cross-sex interaction. The agent thereby 'acts' in the

context of this relationship and produces this relationship by so acting. Seen from his or her viewpoint, the causes and effects of her or his actions are other persons. But an agent may also perceive the person in reference to whom action is taken as an agent like her or himself. What makes them alike is their capacity for action, hence the reciprocal form of the pair.

Performer and audience, sexual partners, parent and child are all envisaged in reciprocal terms; each agent appears as capable of drawing forth the internal capacities of the other. While every *act* remains asymmetric (the one partner an agent, the other the microcosm of relations or person which is deconstituted), what makes the *agents* themselves symmetric is, as we have seen, their potential for action. And in terms of that potential, each remains alike: the one does not become the other. Consequently, when they are in a position for either to realize this potential with respect to the other, a pair becomes matched in a relationship of mutual elicitation. For what each encompasses within its own form is the capacity to elicit the acts of the other. This is an analogical relationship that has no time to it.

In his expatiation on types of knowledge, Bourdieu discusses Lévi-Strauss's treatment of the gift. Lévi-Strauss broke with 'native theory': it was not the irreversible sequencing of individual exchange transactions as people experienced them which was the principal phenomenon but the reversibility of the cycle of reciprocity. Bourdieu's point is that the covering mechanism that defines the agents' practice is as important an object of anthropological knowledge as what it covers. People only apparently hide from themselves the other side of that experience.

> If the system is to work, the agents must not be entirely unaware of the truth of their exchanges, which is made explicit in the anthropologist's model, while at the same time they must refuse to know and above all to recognize it. In short, everything takes place as if agents' practice, and in particular their manipulation of time, were organized exclusively with a view to concealing from themselves and from others the truth of their practice, which the anthropologist and his models bring to light simply by substituting the timeless model for a scheme which works itself out only in and through time. (1977:6, emphasis and note omitted)

He therefore somewhat misleadingly recommends

> [t]he difference and delay which the monothetic model obliterates must be brought into the model not, as Lévi-Strauss suggests, out of a 'phenomenological' desire to restore the subjective experience of the practice of the exchange, but because the operation of gift exchange presupposes (individual

and collective) misrecognition (*méconnaissance*) of the reality of the objective 'mechanism' of the exchange. . . . the interval between gift and countergift is what allows a pattern of exchange that is always liable to strike the observer and also the participants as reversible, i.e. both forced and interested, to be experienced as irreversible. (1977:5–6, emphasis removed)

We may ask how the difference between reversible and irreversible sequences are so experienced. The 'as if' practices to which Bourdieu draws attention could be considered in the nature of an indigenous transformation. But beyond the misrecognition involved in turning one kind of relationship into another is the misrecognition of the basis of differentiation itself, viz., between the one experience and the other. This is where I refer to convention. The anthropologist does not here reveal what the participants also know but creates a different kind of knowledge for him or herself.

It will be recalled (chap. 6) that it was Josephides's interest in the mechanism of misrecognition that led her to question the rhetoric of reciprocity in Highlands gift exchange. 'Reciprocity', she argues, covers up inequalities between men and women. But it is the other side of this Melanesian construction that interests me. Only the taking of irreversible 'unequal' action will cover up the analogic and potentially reversible concepts of maleness and femaleness on which convention rests. Melanesians presumably 'know' when they conceal this analogy, because they also 'know' when they reveal it. They seek to uncover the gender of things. What they do not know they do not conceal! If their practices further conceal things from the observer, then these conceal the very different kind of knowledge that the observer desires, as when she or he seeks to uncover the convention itself.

Observers of ceremonial exchange transactions have long recognized the poignancy of the completed debt. Citing Sahlins, Munn observes of Gawan *kula*: "[o]nce a shell is matched, it is necessary to create a new imbalance in order to keep shells moving along a path" (1983:282). Damon (1983:323) makes the same observation of transformations in kin exchanges. A completed relationship dies with the closing gift: it has been made apparent, reciprocally visible to both sides. Its benefits need to be hidden again in the body of either one or the other partner for there to be any cause for a future, any reason for further events to take place. The observer can see that it is the analogic conventions of gender (the matching) which subvert the temporalizing and individuating possibilities of particular events and sequences.

Imagined as reciprocal agents, as a pair, 'male' and 'female' stand in

contrast to the relationship between them, to the completed result of their interaction. Relationships ('persons') are merely the condition for action, not themselves acts. But this itself is a reason for taking action. The very gender symbolism that separates an agent from the cause and effect of her or his actions also creates male and female as timeless analogues of one another. They become differentiated only from their mutual relationship in its androgynous, nonactive form, which then appears as the simultaneous cause *and* effect of their interactions. Cause and effect become in turn conflated as the single context or condition for action. It is the aesthetic of gender, then, which reveals to the observer the Melanesian gift in its cultural form: the anticipated outcome. The aesthetic collapses time. Against it, and through their particular and temporalized transactions, Melanesians appear to be constantly inventing supports for themselves.

Conclusion

11
Domination

The as-if and so-to-speak hesitations in my account have been quite deliberate. I have not authored 'a perspective' on Melanesian society and culture; I have hoped to show the difference that perspective makes, as one might contrive an internal dissociation between the character of an author and the character of his/her characters. Consequently, I have not presented Melanesian ideas but an analysis from the point of view of Western anthropological and feminist preoccupations of what Melanesian ideas might look like if they were to appear in the form of those preoccupations.

The account was therefore not phenomenological in the ordinary sense, since it did not pretend to elucidate things as they seem to the actors. Rather, I have tried to convey Melanesian knowledge practices *as though* they were a series of analyses which afford explanations for the way things seem. Nor did I offer an emic interpretation of Melanesian culture(s) that would suppose etic were separated from emic, and so trail a positivist premise about the inherent nature of each. Rather, I have tried to expand the metaphorical possibilities of our own language of analysis. This has meant analyzing the metaphors themselves, here derived from Western social science, *as though* they could be decomposed, taking them apart in order to reutilize their components. It has also meant putting together a narrative of Melanesian life that is synthetic and in that sense a fiction.

To consider one of my chief examples: the concepts 'male' and 'fe-

male' have been understood not as motivating or mystical principles at work in society, but as conventional descriptions of the forms in which Melanesians make persons and things known. Nonetheless it may well seem to the reader that such concepts have become too reified, too abstract, in the course of argument. Or instead that they have become too personified, as though being credited with a life of their own. The presentation of abstract concepts as though they could 'do' things is, as I shall discuss briefly in this chapter, an adjunct of Western ideas about the role society plays in life.

There is a danger here, as Lewis (1980:221) observes. The anthropologist, he admonishes, is not free to speculate at will, and write his or her speculations into other people's ideas as though they had meanings in themselves. In people's lives, of course, ideas cannot possibly have a 'life' of their own. But in the context of an effort to describe such other lives, it is legitimate literary artifice to give their ideas something of an independent existence. If they are not autonomously constructed in the narrative, and thus credited as having sources independent from the ethnographer's own culture, then other ideas derived from that culture will inevitably take on that active role as unacknowledged animators of the plot. To be true to Western idiom I have tried to make the animation (the conventions) of this account explicit.

To be true to the Melanesian idiom I have tried to be an elbow, to intervene between two sets of objectifications—Melanesian and Western European ideas—in order to turn one into the other. From my single position, of course, I can only effect that in one direction, for to write about Melanesian culture as another culture is already to imagine it as a version of or counterpart to Western culture.

An agent acts, in Melanesian imagery, looking two ways from a single vantage point. This means that the agent acts from a position subsumed by neither. In this book, part 2 has been almost exclusively concerned with an anthropologically conceived difference between Melanesian and Western cultures, in turning the language of one to present the other. Yet there is more here than an exercise in dialectic; the exercise was also with a purpose, its intention existing in another dimension. The position which I occupy is also defined by exogenous feminist interests. In the same way, part 1 tried to 'turn' the relationship between feminist and anthropological questions. There I was rendering feminist ideas into anthropological ones. The independent axis for this elbowing exercise was Melanesian ethnography. But the job was left incomplete at that stage.

If I now recover at least some of the earlier feminist questions, it is to remain within the confines of Western and Melanesian idiom. One culture is only to be seen, as Boon (1982) reminds us, from the perspective of another. Indeed, no remark in this book can be construed as lying beyond them; any generalities have been specific to this double context, and no universals are intended. This is relevant to conclusions we might wish to draw.

MOTHERS WHO DO NOT MAKE BABIES

Feminism and anthropology, observes Sacks (1979:10), grew up together over the course of the nineteenth century. They were at once in collusion with and in critique of one another, alongside as she says, socialism, working-class consciousness, and imperialism. Hence, "to understand [nonfeminist] anthropological ideas about women requires reference to the complex social changes entailed by the development of industrial capitalism," where nature and biology became unconscious metaphors for social relations. She suggests that much anthropology is consequently encumbered with the following reasoning: "1. Making babies and shaping culture are incompatible. 2. Women make babies. 3. Therefore only men can make culture" (1979:25). This is the basis for her criticism of anthropological treatments of the domestic domain which persist in an innatist or essentialist equation between women and domesticity. In the company of other feminist anthropologists, she seeks to restore culture to women—"to refute the axiom that motherhood and political power and economic and personal autonomy are incompatible" (1979:66). It is an important argument, but I take a very different route to it. She is right about the reasoning. But what must also be noted is the ethnocentricity of the middle proposition, the illusion that "Women make babies."[1]

The attention of nonanthropological as well as anthropologically-minded feminists is held by the injustice of the equation between men and culture. Lévi-Strauss's work in particular has attracted comment. Objections are made to his classic disquisition on the exchange of women among men, and thus to his argument that the "act of exchange holds a society together: the rules of kinship ... *are* the society." The words are Mitchell's (1975:370, original emphasis). Feminist commentators seize on two intertwined points. First is the notion that exchange is a ubiquitous means of social commerce, the threads of social discourse, the means by which in the absence of government, societies are

held together.[2] Second is the specific emphasis that Lévi-Strauss lent
to this theory of primitive reciprocity, that marriage is the most basic
form of gift exchange, and women the most precious gift (Rubin 1975:
173; see Lévi-Strauss 1969:chap. 5). It is this 'exchange of women' syn-
drome that has attracted feminist commentary outside anthropology.[3]

There certainly seems an equivocation in Lévi-Strauss's account. On
the one hand, women are signs for relations that men create between
themselves and thus stand for parts men dispose of in dealing with other
men; on the other hand, it would seem that they are utilizable as signs
because they also stand for themselves, that is, they have a self-evident
value. One has to agree with Leacock (1981:chaps. 11, 12) that on the
latter point Lévi-Strauss lays himself open to the charge of equating
women with commodities. She cites his observation that women are
"the most precious possession" because they are not only a "sign of
social value, but a natural stimulant" (1969:62).[4] Indeed, he justifies
the plausibility of marriage exchange in the actors' eyes through the
fact that women are regarded as an essential source of life, and thus
like that 'vital commodity', food (1969:32). In Leacock's reading
(1981:231)[5] "he posits a unitary principle to explain the origin of in-
cest and of society itself, as well as of succeeding types of kin-based
structures. This principle is the allocation, by males, of the services,
sexual and otherwise, of females." She protests, as does Elshtain, that
such a formula takes away women's subjectivity. But this apparently
simple and straightforward criticism brings us back to the issue of
cultural complexity raised in chapter 1.

The anthropologist's efforts at communication are hampered by his
or her very subject matter; and indeed if they are not, if there are no
hesitations, then something is wrong. For the subject matter includes
the need to treat complexity and diversity in areas the Western reader
takes for granted, above all, in how persons impinge upon one another
as subjects. Western metaphors of social discourse and domination take
for granted an interlocution between thinking, acting beings. The rest
is 'objectified role-playing' or 'abstracted structures'. What commodity
logic promotes is a perceived diversity and complexity not in relation-
ships but in the attributes of persons as selves and agents.

Elshtain (1981:338–339) makes an interesting protest over Rosaldo's
(1974) comparison between Ilongot and American culture. To her, the
Ilongot are "a tribe which still practices head-hunting." Ignoring the
complexities of the relationship between male head-hunting and female
nurture, she chides Rosaldo for making an inappropriate comparison

between tribes and civilizations. Rosaldo was not comparing the two in holistic terms, where indeed differences of scale would be relevant; she was comparing the manner in which separations are construed between male and female spheres of activity. Elshtain, however, sees only that the Ilongot enjoy "a simpler way of life." By contrast, what diversity there is in civilization! "Human social forms and the human mind grow more complex, nuanced, and structured within civilization, filled with multiple identifications and envisagements (mind), and multiple possibilities and roles (social forms)" (1981:339). Diverse as the social forms may be, the central idea that "individuals must constitute themselves as subjects, as active agents of their own destiny" (1981:344) is, in comparison with Melanesian constructions of relationships, simpleminded indeed to say the least.

The general neglect of subjectivity is one of Elshtain's main complaints. From the perspective of a political scientist, she scrutinizes the work of Mitchell and others who have drawn on Lévi-Strauss's communicational model of culture. Indeed, she derives from Mitchell the supposition that Lévi-Strauss was referring to women as "exchange commodities" (1981:283),[6] one of the bases upon which she objects to the equation of culture with patriarchy. Yet what Elshtain offers herself is a prime example of commodity thinking. Her hope for change, she says, rests on a particular understanding of the human subject, as well as of social realities:

> A person, after all, is not merely or exclusively (if at all) an objectified role-player or abstracted object of inexorable laws, but a thinking, acting being engaged in particular relations with others within a specific historic time and place. To assimilate the public and the private [the theme of her book] into universal laws and abstracted structures requires Abstract Man, Abstract Woman, and Abstract Child in turn. Within this rarified, undifferentiated [sic] realm one searches in vain for a recognizable person. (1981:284)

She seeks to restore "the female subject." This is a very proper politics for a commodity economy.

In Elshtain's account it would seem that a person is recognizable as a subject but not as an object. In my description of the gift economies of Melanesia I have, of course, found it useful to regard 'the person' as an objectification ('personification') of relationships. In so far as people turn one set of relationships into another, they act (as individual subjects) to turn themselves into persons (objects) in the regard of others. They objectify themselves, one might say. And *this* is indeed the point

of making themselves active agents; this is their destiny. Life is not imagined to be without supports: one acts to create the supports.

Before dealing further with the issue of agency, however, it is necessary to comment on the related question of women's apparent 'object' status in men's exchanges. At the heart both of the anthropological assumptions mentioned at the beginning of chapter 5 and of these feminist questions lies an idiosyncratic Western metaphor for procreation.

Making babies. Melanesian women cannot be analyzed as commodities in men's exchanges for the obvious reason that these societies do not constitute commodity economies. The negative can take an alternative form: Melanesian women do not make babies.

In commodity logic, value lies in the intrinsic attributes of things as well as in their 'exchange' in the sense of market exchange. Both men and women may be seen as having intrinsic properties (men make culture, women make babies); but men's property in this case also has communicational functions analogous to exchange itself (men make culture because of/out of the fact that women make babies). It is thus because persons are attributed with intrinsic qualities that exchanging them creates values, so that there is an intimate, not an accidental, connection between the two parts of Lévi-Strauss's examination of women exchange. Precisely in so far as items of use are being circulated, then gift exchange appears to have the character of commodity market exchange, to have distributive and integrative functions, and thus hold 'society' together. Harris's (1981:63) critique is pertinent. She notes the ideological contrast contained in such arguments, between 'natural' relations in consumption as opposed to 'social' relations created by the circulation of commodities. It underlies the supposition that one can regard gift exchange as somehow a version of commodity exchange.

This extrapolation is especially widespread in anthropological circles when it comes to the interpretation of marriage transactions.[7] Typologies of kinship systems are based on what happens to women in marriage. Lists of prescriptive and preferential marriage rules, the fascination with the claims of cross cousins, details of the rights and debts encoded in classificatory kin terminology—in relation to the analysis of marriage arrangements and the exchange of women, these concerns remain dominated by the assumption that there is an intention to the system as a whole, namely to enable men to obtain women.

The market analogy presumably endures because it speaks so directly and strongly to Western constructions. I mean those that regard sexual

attributes as inhering in persons and thus giving them value, above all in the capacity to reproduce. It seems evident to us that other societies should be organized—even though ours is not—in terms of men having to gain access to women's fertility. It seems evident that control of fertility, embodied in women, presents itself as a problem. It seems evident that women embody fertility. When therefore people *say* that men exchange women between themselves—as they do in much of Melanesia—the obvious deduction is that what is at stake is such control. To regard these societies as attending to biology as we comprehend it thus reinforces the reality of our own constructs. It leads only to one conclusion, which is also its premise: what differentiates men and women is their physiology, and marriage arrangements across the world have as their purpose the management of female fertility. And why do we imagine that female fertility presents itself as having to be controlled? Because of something else we imagine, that women make babies.

Of course 'we' are all sophisticated enough to know that genetics requires coupling and that people do not in that sense procreate alone. But the Western imagination plays with the idea that mothers make babies in the same way as a worker makes a product, and that work is their value.[8] In spite of the input of enabling technology, so to speak, the worker joins her labor with natural objects in order to create a thing, an activity that is potentially self-expressive but whose embodiment is then, of course, extracted ('alienated') from her. Industrial production provides a model of value conversions as stages in processes; any input of labor can be revalued at the next stage. This is one source perhaps for parallel models of socialization: the child produced by the mother must be separated from her, socialized, and remolded in order to enter the world as an entity with its own value. Persons 'find themselves'. As an individual negotiating and managing interactions with others, each also thus acquires an exchange (communicational) value. Their destiny is to become autonomous agents, and this refashioning of their persons requires multiple stages, each one removing the person further and further away from the original maker, who may also be seen, of course, as outside the sphere of socialization altogether in her manifestation of biological processes.

This is the significant sense in which women appear to make babies. The baby is regarded as an extension of the mother's tissue. Women thus both provide the basic raw material and are workers at the earliest stage of society's reworking of persons. This earliest stage is forever outgrown—hence our denigration of domesticity—but at the same time

provides the basic material without which there can be no development. In other words, women's fertility in its form of maternal work presents itself to Western industrial and market minds in terms of its natural status, as the prime source from which all else comes and as a resource to be valued. It seems reasonable that elsewhere men should stake out claims to raw materials and compete to possess them. But it is this very reasoning that must be scrutinized. For a comparative question now arises. Given that traditional Melanesian reasoning does not follow these lines, then how do we account for the prevalent practice of men exchanging women between themselves? Do Melanesians not imagine that women make babies?

The second question may be answered briefly. Women do not replicate raw material, babies in the form of unfashioned natural resources, but produce entities which stand in a social relation to themselves. The Western image of part of the mother's nature being evident in the infant as also a part of nature, a theory of contiguity, hardly applies. Instead, the Melanesian mother brings forth a being already in a social connection with her and thus different from her.[9] Minimally, no child replicates the mother's kinship status. Moreover, Melanesian women are not seen as the sole agents of childbirth. If mothers produce entities already in a social relation with themselves, this is because of the prior conjugal and marital exchanges which embody the acts that other agents have also taken. Children are the outcome of the interactions of multiple others. This is what we would call a cultural construct. The objectifications of Melanesian culture(s) can *only* present them as the objects of relationships. And the aesthetics of reification mean that children, far from being corporeally continuous with their parents' bodies, embody their parents' acts in another (their own) form. This may or may not be imagined as sharing substance. As I have argued, the act of birth is taken as the point at which the multiple constitution of the child is made known. Knowledge is a process of analysis or revelation.

Concomitantly, the commodity view of women as 'naturally' objects of men's schemes because of their power to reproduce becomes understandable from certain assumptions inherent in practices of Western knowledge. Thus Western culture takes it as a human fact that since mothers are 'seen' to give birth then they own or claim the offspring as theirs, or the children are assigned to them as a matter of course. Barnes (1973:72) can extrapolate as a universal "that the mother-child *relation* in nature is plain to see" [my emphasis]! The maternal origin of the child is not at issue because it is 'visible', in the mother's giving

birth and her feeding of the newborn. The maternal relation is a patent biological fact, so that socialization must take place subsequent to it.

In the imaginings of these Melanesian societies, relations do not have such an autonomic existence. One relation is produced out of others. This has to be the 'knowledge' that a mother's acts convey. In yielding the child, the Melanesian mother has yielded what is already anticipated as a social object. Because it is in relation to the mother that the father has to act, the mother in turn is a social agent with respect to the child. Here reproduction becomes/evinces sociality. As was evident on Malo (chap. 5), to see something is not to make patent the attributes of the object of sight, but to register or consume the effects of a performance—to see is a specific act in itself. So too is revelation. What is made visible must be carefully managed. What a mother appears to produce will depend on her relation to it. She may or may not be construed as a recipient of the father's implantation of substance; the child may or may not be a recipient of the mother's nurture. But in either case if maternity is revelation, then as far as men are concerned this is accomplished not through taking away something by force that belongs to women (controlling an innate fertility), but through ensuring that the woman produces something other than herself. That something other than herself then reveals the relation between them (husband and wife; brother and sister). It also constitutes it: because the child exists in a specific social relation with the mother, the husband/brother is sustained as conceptually distinct from the wife/sister. However, Melanesians are in the end culturally agnostic: such relations cannot be seen. All that can be 'seen' (consumed) are their effects.

Yet there remains something very seductive about the Western illusion. It takes the persuasive form of a fact, of a human certainty. From an earlier vantage point, I would have concurred with the Hays's interpretation of complementarity and assertion in male-female relations. They write apropos Ndumba, a tiny Highlands community to the north of Sambia:

> [I]n recognition of their biological limitations, men must leave to women the task of bearing a child, just as they can only but acknowledge women's vital contribution to the child's physical being through the provision of the child's red, 'soft' parts and through the milk with which children are nourished. So too, men depend on women throughout their lives as provisioners. . . . Men themselves contribute the white, 'hard' parts of the fetus; they also safeguard and maintain institutions that make social life possible. *Women produce children, as men cannot; it remains for men to create society, and*

to make of children the adults that society needs. (Hays and Hays 1982:230–231, my emphasis)

But we need to hold the thought that if women do indeed produce children, it is not because they can 'make' them while men cannot. Women produce as a social act, and thus also because of men's exertions in the matter. And it cannot be on behalf of a conceptualized 'society' that men exert themselves.

SOCIETIES WHICH DO NOT NAME THEMSELVES

The first question still hangs in the air. Whatever one might argue about the production of children, it nonetheless appears from an outsider's point of view that men control society at large. This seems quantitatively apparent in the Highlands, with their elaboration of an often exclusive public and collective life. I have suggested various ways in which we might regard this activity. The point to reiterate here is that it is not men's collective activity that 'creates society' or 'makes culture', the premise upon which social values or ideologies are assumed to work to their interests at the expense of women's.

Yet while this is one premise of feminist inquiry, feminist anthropologists have also insisted that it is as much their project to address constructions of maleness as of femaleness, and that analysis must assume neither. I have consequently tried to break with the long legacy of Simone de Beauvoir's insights into Western gender relations—the assumption that femaleness is somehow always to be understood as derivative from or produced by what is established as the socially dominant form, namely maleness. The Melanesian material at least does not present us with an image of men promoting male values that also become the values of society at large, and thereby simply using female values in counterpoint to their endeavors. But this is a complex issue to argue.

I begin here with the fact that many of their endeavors are directed towards the same production of domestic kinship, growth, and fertility as concern women. In no simple sense is it the case that men and women 'have' separate models of their lives. Nor is it the case that there is a simple dualistic split between the stereotypes and images of 'men' as opposed to those of 'women'. The one is not always passive in relation to the active other, as de Beauvoir's insights imply. Men's collective life

is not to be understood therefore as a heightened or enhanced sociality that is the source of hegemonic values at once male and social.

It is precisely in the field of domestic kinship that one cannot talk of men in the abstract; they are divided by their interests and relations. Consequently, there are good anthropological reasons as well as feminist ones for not taking men's collective activities for granted. The unthinking conflation between 'their' collectivity and 'our' society leads to the wrong questions. For it is when men's collective life is interpreted as a kind of sanctioning or authoritative commentary on life in general that it is assimilated to our organizing metaphor, 'society'. It is this metaphor which prompts questions about why men should be in the privileged position of determining ideology or creating the very foundation of social order to their advantage.[10] I have suggested that the forms of Melanesian collective life are not adequately described through the Western model of a society, and that however men are depicted it cannot be as authors of such an entity. Rather, collective actions should be seen as one type of sociality, and as one type it therefore coexists with another, namely that sociality evinced in particular, domestic relations. The relation between the two is that of alternation, not hierarchy. The values of one are constantly pitted against the values of the other.

Yet what perhaps confuses us is that the one is only knowable as a transformation of the other. A further aspect of Western knowledge practices must be recalled in this context. Western views of knowledge rest on ideas of organization and accumulation (see chap. 4); we 'know' things by bringing them into relation with more things. Knowledge thus inheres in the display of a relationship between things and is convincing by its systematics. The more things that can be so correlated, the 'better' the knowledge. Indeed, we even have an economic measure of knowledge in the idea that the most efficient theory is the one which explains the most facts with the least expenditure of energy. Its power is experienced as a function of its consistency, which may be displayed as revealing an internal logic or some such. I have drawn on the metaphor myself in referring to the logic of the commodity or gift economy.

Of course, the 'logic' should be understood as a contrivance of the analytical task, of the activity of organizing. We should not mistake the productive insight that is gained for us from bringing things into relation for the manner in which Highlanders, say, juxtapose and bring into relation certain themes and values in the course of their ritual or political life. These are not arenas of reflection and discourse in which,

as it is so often assumed in anthropological accounts, people achieve a heightened awareness of their own social life and values in general. New relations may certainly be made manifest. But the participants do not simply gain further knowledge on the character of the elements so related; knowledge is recursive and cannot be accumulated. Hence may we appreciate the contingent nature of the information which initiands receive during the course of ritual—the paradoxical or upside down quality of the revelations. This is not knowledge in the sense of penetrating and uncovering truths about the attributes of things which then become classificatory schema for organizing those attributes. What has been opened out is simply what already existed, but at the exacting cost of opening it out (Wagner 1978:chap. 1). Consequently, participants do not gain privileged knowledge 'about' the essential nature of male and female, say, or the constitution of clan ancestry. Rather, they acquire another position from which to act. Each position is a particular position held with respect to specific others.

In Western terms, it would be a semantic paradox to say that relationships are not in themselves evidence of collectivity. The Western concept of society entails the proposition that relationships are inevitably plural in themselves: any single instance contributes to the wider regulating sociality of all arrangements of interactions between persons.[11] All relationships, including dyadic ones, can thus be regarded as collective in this view, in that they involve communication between separate, autonomous persons (as 'individuals').[12] It is the Western person as an individual who thus stands in contradistinction to a society perceived as axiomatically collective, for it organizes the interactions that take place between numerous such individuals. At the same time, communicational possibilities are held to be intrinsic to all social life; indeed social life may be understood as a collective act of communication.

Melanesian sociality, however, distinguishes between two types of relationship, collective and particular. The second class of relationships is noncollective. Moreover, where interactions are characterized by unmediated rather than mediated transactions, there need be no overt 'communication' between the actors. Thus when mothers are credited with an autonomous potential for growth, or through his thoughts a mother's brother curses a sister's child or a father impresses his face upon a fetus, these are noncollective and in a sense noncommunicatory situations. There is always an outcome or effect to these interactions. But communicating them is to produce them in another (mediated) form. This is the corollary of the point that revelation constitutes a

performance, is itself an act. Communication is, then, always a contrivance between particular agents, and thus has its own character. Hence, any 'unitary' condition of the person has to be simultaneously communicated as a 'multiple' one, because that is what communication does to it. The multiple, partible nature of persons' constitutions is revealed in its internal relations. In the mother's case, this is made explicit in (say) the further contextualization of herself within enveloping male exchanges. It is only in retrospect that identification with the mother can be revealed as having had an effect on the life of the nurtured object of her regard. But conflation is not an absence of relationship. And at no point are the products of relationships not conceived as themselves embodying relationships. Children are not born as natural, asocial beings. This returns us to the original point: social relationships are not constructed after the event, so to speak, through posterior socialization.

Only at highly specialized symbolic moments can the unitary identity between mother and child be apprehended. The same general supposition is true of maleness and femaleness. Initiation rituals that men stage to detach boys from the company of women are not usefully conceptualized as steps in a socialization process or as steps in the acquisition of full uniform sexual identity. On the contrary, men's contrivances appear closer to the attainment of political prestige or clan identity elsewhere in the Highlands activities. The rites do not 'make men' and do not 'make society'.

Western postulates about the gender identity of whole persons rest on a prioritization of unity by contrast to the plural or multiple composition of persons as Melanesians depict them in their kin transactions. When Westerners regard persons as having to overcome polymorphous states, this is taken as evidence of a proper (human) drive towards internal consistency; in commodity logic, the 'separate' person is also the 'whole' person. But Melanesian social creativity is not predicated upon a hierarchical view of a world of objects created by natural process *upon which* social relationships are built. Social relations are imagined as a precondition for action, not simply a result of it. Sociality is thus not to be visualized as a superstructural elaboration of other forces, and collective life does not evince sociality in an enhanced, hegemonic form.

My purpose in repeating some of these ethnographic points is simple. It is to reiterate the observation that Melanesian political and ritual activities do not constitute a privileged vantage point of commentary on the 'rest of society', and that the values they promote cannot be

understood as extendible beyond them simply by virtue of their collective character. There is an epistemological dimension to this. Collective action does not signify a superior systematization, and this is true both of social relationships and of relationships between different values or items of knowledge.

In the Western world people imagine that there exists a system or an organization of relationships that is a dominant source of values, and 'imposes' its values on individuals. The constructionist view of gender relations implies just such. The source may be seen equally as society or as culture.

This abstract entity is invested with a life of its own; its conventions are animated. Thus we conceive abstract ideas 'doing things' or 'having' a force or effect on people; indeed, I have drawn on this as a literary device in my presentation of Melanesian ideas. One can name them (e.g., 'commodity logic'). And systems can then be credited with intention, a notion from which functionalist arguments forever have to extricate themselves. We may recognize the root metaphor (chap. 6): the Western person is a microcosm not of social relations (other persons) but of social conventions. However, the further idea that persons own themselves also presents this entity in proprietary terms. For the idiom of microcosm we might substitute the more culturally appropriate idiom that persons possess social conventions, and social conventions possess them.

Western people imagine themselves as double proprietors. On the one hand they naturally own themselves, and their personal attributes, including their gender. On the other hand, their capacity for communication with one another is based on their common ownership of a culture. But if they own culture, culture also owns them. Proprietorship thus introduces a subject-object relation, in which either may become a thing in the hands of the other. Hence the social contract view of culture as the collective, superstructural values of social life to which individuals willingly subordinate themselves, in order to communicate with one another, implies that the culture is presented to them in specific, reified form. It stands as a thing over and beyond them. This is contained in the idea of common ownership. As commonly shared among its members, culture (or society) must also have a holistic character. The notion of values held in common mediates between the view of culture as the collective organization of plural relationships and as the product of homogeneous, 'shared' understandings. Thus Westerners can speak of 'a culture', 'a society'. As a singular entity that is owned,

culture or society can consequently be conceived as a thing that the owners have made or authored.

This gives rise to the further supposition that what appears as common ownership may instead disguise the fact that it was created by some and not others; on the others it is merely imposed. The illusion that culture, like society, is somehow authored does not stop at recognizing the outcomes of human action; it may lead to attributing those outcomes to a singular agent. Since quite sensibly this cannot be credited to one individual, it may well be credited to a singular category, as in the supposition that it is 'men' who make culture.

Such Western ideas yield their own double critique of other systems. First, who is the author who produces the culture and thus owns it? This is a source of feminist questions about patriarchy, the rule of the father, for he who owns culture displays that ownership as a superior regulating or organizing force. Second, what is produced is also consumed, and this is the manner in which we imagine culture to be consumed by the individual, transmuted as that individual's 'experience *of*' values and relations. The question becomes how it is consumed; to what extent are those who do not own it nevertheless forced to acknowledge ideas and values created by another? Thus persons' experience of culture, in this view, may be at odds with their subjective ownership of themselves and particularly of their bodies (a powerful source of feminist critique and countercritique over whether or not 'bodies' are held to lie outside culture). In the search for change, radical adjustment may seem possible either through altering the relations of production, that is, creating different owners and authors, or through using the dissonance of experience (consumption) to show the injustice of the impositions. These critiques arise from the same project that attempts to explain by bringing into relation, to systematize by showing interaction, to reveal the inherent logic of social arrangements, since that very consistency can appear suspiciously uniform, suggesting it could be the outcome of singular and specific interests. They are equally the grounds for our knowing that we live in a society and practice culture. We both name the owners ('the culture of the X or Y') and name what it is that they own (their 'culture' or 'society').

If Melanesian systems of knowledge do not lead to this conclusion, then they can have no name for the conventional ordering of humankind. They have no name for the origin of what we would regard as cultural constraints on the way people behave, in that they do not (cannot) *personify* that origin as this or that category of persons 'making

culture'. A person as a cause (in the sense in which I used the term in chap. 10) is only a cause of another person's acts, and cannot be conceptualized as the cause of convention as such. These ideas do not allow the possibility that men are envisaged as the authors of society/culture at women's expense.

This does not mean that there are no conventions or constraints. It does mean that convention is not seen as authored and thus perceived as a system working in the interests of some rather than others. There is neither an abstract author nor a concrete author. In abstract terms, gender is not construed as a role 'imposed' on individuals 'by culture'. Conversely, there is no problem about membership 'in society' or one's fitness to participate in the social contract. There is no anxiety, pace Mead, about whether or not one's attributes will qualify one for this or that role. Anxiety, so to speak, is not so much about the control of behavior (people's 'freedom') but about how their behavior will appear to others (their 'performance'). And in concrete terms, it is not thought that privileged roles are conferred by superior individuals upon themselves while, from their position of power, they confer inferior roles on others. In the Western view, what appears a freedom for the former is subjugation for the latter, so that men may be seen as imposing their definitions of gender on women. The constraints, as I have described them for Melanesia, must be understood instead as the aesthetic constraints of form.

People cannot help evincing gender in what they do. This means that they axiomatically succumb to the evaluations and judgments that a specific form entails. An agent can choose to act, but in acting can only act in a particular way. It is impossible in these systems to take action in a general or nonspecific manner: all acts are particular acts. By the same token, in the Melanesian view to be an agent is to deploy one's generalized capacity to a particular end.

Gender differentiates types of sociality such that the structure of same-sex bonds has a separate productive outcome from that of cross-sex bonds. Since the one is an alternative to the other, I have argued that the generalized potential for the unitary, homogeneous construction of persons exists only in relation to their multiple construction. Moreover, any one contrast can be revealed as a refraction of prior contrasts and combinations. The condition of multiple constitution, the person composed of diverse relations, also makes the person a partible entity: an agent can dispose of parts, or act as a part. Thus 'women' move in marriage as parts of clans; thus 'men' circulate objectified parts

of themselves among themselves. In the end, men's and women's domains are not socially distinct.[13] Rather, each may act in a same-sex or cross-sex way, in contexts that are always conceptually transient. Time, duration, and sequence are as important to form as they are to the gift.

Yet there seems to be a difference in men's and women's scope for action. Often men appear to derive a double benefit. In the Highlands, for example, men enjoy both a collective life and the relations of domestic kinship, whereas women appear confined to the latter. But this dualism is misleading. Chapter 10 indicated that women's counterpart to male collective life, men's unity as a body of men, was their own female unity. The generalized capacities that they evince could not be subsumed under the rubric of domestic relations. The difference between men and women conceived in these terms is that women are held to evince such capacity within the unity of their singular bodies, whereas men as often manifest it in the replication of like bodies.

We are dealing with what looks like a switch in scale then, and indeed men's replication of same-sex relations among themselves has a runaway character to it. But I have not simply returned to the idea that men's social activity imitates (appropriates) women's bodily capacity to make babies within themselves. We must get the mathematics right. Women do not 'naturally' present themselves as intrinsically single or unitary entities; we have seen that that condition involves an internal alignment of relations and is also something to be achieved. Perhaps women's bodies are perceived as unitary and singular because they metaphorize those replicated relations of male growth.[14] In the phraseology of appropriation one would say that their social activity in production and reproduction equally imitates, appropriates, and defines men's.

DOMINATION

How then are we to understand all those contexts, especially marked in the ethnographies of Highlands societies (e.g., Reay 1959; Berndt 1962; Meggitt 1965; and see Josephides 1982), in which men are reported as asserting dominance over women? They demand obedience, roughride women's concerns, strike and beat their bodies. Frequently this is quite explicit as to gender: it is by virtue of men being men that women must listen to them. Yet everything that has been argued to this point suggests that domination cannot rest on the familiar (to Western eyes) structures of hierarchy, control, the organization of relations, or on the idea that at stake is the creation of society or the exploitation

of a natural realm, and that in the process certain persons lose their right to self-expression. More accurately, men's acts of domination cannot symbolize such a structure, for it is not an object of Melanesian attention. In short, hegemony is not to be visualized in these terms.

Of course, 'we' may still wish to make up our own minds. We could argue, for instance, that alternation in fact conceals hierarchy, or that the representation of knowledge as noncumulative and recursive conceals its authoritative aspects, as indeed canons of reciprocity have been interpreted as concealing exploitation. We may still wish to regard men as creating their own lives at women's expense. Making up our own minds always remains an option; the only observation would be that one has to understand the Melanesian constructs first before taking *them* apart. And we would have to square men's assertions of dominance with the equally salient impression that many Highlands ethnographers have received that "while men hold higher status, and women may in fact be convinced of their inferiority, women command a power that belies the tenets of ideology. In those contexts which involve the coordination of male and female interests, there is, to all intents and purposes, an equality between the sexes" (Lipuma 1979:53). Yet a disjunction between the ideal and the real or between ideology and practice is in the first place a disjunction between different types of data within the anthropological narrative. This differentiation is taken as evidence for what might be judged as concealed or revealed in the culture. But again we have to be clear that we are talking about what the outsider would regard as concealed, and not about the relationships and structures that the actors deliberately conceal from themselves. To repeat an observation made earlier, people cannot conceal from themselves what they do not know.

The end of chapter 6 suggested that in a gift economy those who dominate are those who determine the manner of relations created by the circulation of objects. I now wish to divest that statement of its inappropriate personification, as though the issue were the authoring of those relations. I want to suggest a way in which we might both take into account Melanesian assumptions about the nature of social life and unpack those assumptions to indicate a form of domination that people do 'know'. There are indeed situations in which men qua men dominate women qua women, though there is great variation across Melanesia, and the grounds of domination apply to both sexes. For the moment, I observe that acts of dominance consist in taking advantage

of those relations created in the circulation of objects and overriding the exchange of perspectives on which exchange as such rests.

This is not a return to the assumption discarded in the scrutiny of the gift, that relations are somehow neutral, and that individuals merely play them off against one another in pursuit of their own exogenously defined ends. We do not have to resurrect the strategist with choice and self-interest, who simply uses 'the system' to his or her advantage. On the contrary, it seems that there is a systemic inevitability about domination and a particular advantage afforded men. But, by the same token, acts of domination are tantamount to no more than taking advantage of this advantage.

The inevitability lies in the conventions governing the form which social action takes. Acts are innovative, for they are always constituted in the capacity of the agent to act 'for oneself'. It is only in acting thus as oneself that others are in turn constituted in one's regard. This is a technicality not a sentiment: it is not altruism. Indeed, the agent is also the object of another's coercion in so acting, and an act is only evident in being impressed upon further persons. On this cultural premise, action is inherently forceful in its effects, for every act is a usurpation of a kind, substituting one relationship for another. To act from a vantage point is thus also in a sense to take advantage. This entails a behavioral ethos of assertiveness and one which applies equally well to women as men. But beyond this, men often find themselves having an advantage women lack. To show this advantage it will be necessary to dismantle certain Melanesian concepts. Since I have been concerned to despatch Western assumptions about society as an object of thought in Melanesian life, perhaps a starting place would be the counterpart arithmetic that I have been at such pains to contrive.

It will be recalled that the duo or pair is opposed to its single antithesis, the one or the many. As male and female, men and women form a pair, each capable of eliciting action from the other. I have also argued that one body is by contrast conceptually unitary, whether in a singular or a plural form, and encompasses future relations within itself. But the conceptual equation between one and many hides a crucial sociological difference. The factor that is hidden is one of its terms, namely plurality itself. Single men can take refuge in the body of men; a man sees his acts replicated and multiplied in the acts of like others. This is the basis of those situations in which men appear to dominate women. *But the domination does not stand for anything else—for*

culture over nature or whatever—and does not have to engage our
sympathy on that score. It is itself. It inheres in all the small personal
encounters in which one man finds himself at an advantage because of
other men at his back. Among the substitutions available to him, as it
were, is the replication of all-male relations in the plural form which
enlarges the capacity of each individual. This becomes its own reason
for forcefulness. In a sense, the forcefulness always has to appear larger
than the persons who register its effect. Such asymmetry turns rules
into penalties, the enclosure of domestic life into confinement, and the
cause of men's own activity into the wounds of someone who is beaten
and given pain for it.

To put it this way keeps faith with the Melanesian postulate that
it is agents, not systems, who act. The hidden sociological dimension
is that collective relations aggrandize individual acts. This is a very
different proposition from suggesting that men are thereby somehow
acting on behalf of cultural conventions or that society accords them
dominance.

However, at this juncture, I feel that I really am writing against the
grain of the language in which I write; consequently what follows is
offered with hesitation. But let me remind the reader that I have not
avoided the question of oppression and constraint per se. The rules, the
form of domestic life, the having to inflict pain: these constraints are
part of an oppressive aesthetic. They lie in the cultural form in which
people recognize the character of events and relations. If the aesthetic
discriminates between the sexes it is not because one or other sex au-
thored them. That we might think so is an artifact of the conventionally
substitutive nature of action itself, such that one sex often appears to
be substituting its own interests for those of another.

Active and passive. Men's advantage does not of itself lie in the constitu-
tion of action; men and women may act with equal assertion. At once
I encounter the literary problem. Going against the grain of a language
is going against its own aesthetic conventions: how one makes certain
forms appear. I have claimed that Melanesian men and women do not
stand in an irreducibly active and passive relation to one another. In-
deed, as the analysis of cause and effect relations indicated, since being
a (passive) cause is to have been at an earlier stage an (active) agent,
the positions are reversible. But when it comes to writing about concrete
instances, the symmetry seems to disappear.

It was argued earlier in this chapter that there is a sense in which

men's collective endeavors are directed towards the same reproduction of relations of domestic kinship as concern women. And here lies the intractable Western aesthetic. It conjures a quite inappropriate gender symbolism. If I say that men's exchanges are oriented towards their wives' domestic concerns, then the statement will be read as men appropriating those concerns and turning them to their own use. If I say that women's domestic work is oriented towards their husbands' exchanges, then this will be read conversely, not as their appropriating men's activities but as being subservient to them. I know of no narrative device that will overcome this skewing, because it inheres in the very form of the ideas in which we imagine men's and women's powers.

On the one hand it is important to appreciate just how Melanesian men and women may be seen to be the causes of one another's acts. On the other hand, in order to scrutinize the relationship between these ideas and domination as such, the one move to avoid is working into the analysis of these ideas any assumption about domination. Yet the active/passive (subject/object) skewing of Western gender symbolism makes this separation hard to sustain. I repeat the point. If I say Highlands men are regarded as the cause of their wives' giving birth, then this will imply in the mind of the Western reader that they exercise a superior agency. If I say that Highlands women are regarded as the cause of men's transactions with one another, then this will imply their inferior, object-like status, as instruments of men's exchanges or as provisioners of them.

This aesthetic impasse derives from the Western proclivity to personify convention, to seek the authors of rules, and to reduce images to dogma. Take the specific example of Eastern Highlands beliefs about procreation: indigenously women are said to be vessels for men who implant the fetus. A woman's act of giving birth is thus an act 'for' her husband; this can be read by the outsider as male dogma. Indeed, it gives rise to anthropological interpretations that are paradoxical from a Melanesian point of view, namely that the woman is acting in a passive way. Concomitantly, male dogma is *also* read into the way in which men imitate the act of birth in the course of initiating boys. Outsiders do not consider this female dogma or men as passive in this context; it may even be reported as a kind of afterthought that the purpose of the rites was to make the boys into husbands 'for' the women.

The Melanesian connection between cause and effect splits the inactive cause/effect from the active agent, who may be male or female. But

Westerners find it almost impossible not to regard the sexes in a permanent relation of asymmetry. And this is by virtue of the privilege they accord collective action that they can 'see' (men's transactions and cult activities) by contrast with that they cannot (women's internal capacity for growth). To the observer, the one appears active and the other passive. Coupled with this evident activity by men is the indigenously coercive nature of all cause/effect relations, that others have to be caused to be a cause of one's own activity. Coercion, asymmetry, and collective action all come together in the potent image with which this chapter opened: the energy that Melanesian men put into the exercise of exchanging women between themselves in marriage, and one might add all their exertions to ensure that childbirth is effected properly.[15] We find it next to inconceivable to imagine this as male vulnerability or helplessness. And if we did cede the point, it would be to regard men as made helpless by 'the system' in which they are trapped, not by the individual women for whom they do these things. Whatever is done, the Western gender difference between men and women compels the reading that the one (female) is passive to the other's (male) activity.

Van Baal courageously attempts to break out of this impasse with an optimistic generalization on the exchange of women: "All the evidence we have tends to confirm that they are exchanged because they agree to be exchanged" (1975:76). Unfortunately he reduces this to an argument about women needing protection and thus lays himself open to the charge that he is simply describing the connivance of the dominated. Nonetheless, he observes,

[B]y the simple act of agreeing to be given away in marriage to a man of another group the woman, wife to one and sister to the other, has manoeuvered herself into an intermediary position allowing her to manipulate. Two men protect her. The one owes a debt to the other and the other owes one to her. (1975:77)

The protection is in her interests as a future mother; although he refers later to women's self-selected role of care-giving, he regards this as rooted in women's natural procreative function.[16] But he has here inadvertently depicted the conditions under which women, like men, indeed act as agents, as the pivot of relationships.

Rubin pointed out how narrow it is to focus only on the exchange of women: "sexual access, genealogical statuses, lineage names and ancestors, rights and *people*—men, women and children—[are exchanged] in concrete systems of social relationships" (1975:177, original empha-

sis). Thus we should properly set the exchange of women in marriage alongside other circulations of items, including men and aspects of their relationships. An asymmetric skewing between transactors and transacted, however, remains. It continues to appear that men are still the principal transactors, even if they transact with parts of themselves. But this is back to front. Rather, as is true of much of the Highlands, it is clear that in all transactions men are in fact transacting with parts of themselves. When women objectify this partibility, they stand for a component of clanship or for assets which a body of men possesses: in short it is when they are exchanged that women are seen as aspects of men's social identities. Here is Rubin's conclusion:

> [I]f it is women who are being transacted, then it is the men who give and take them who are linked, the woman being a conduit of a relationship rather than a partner to it. The exchange of women does not necessarily imply that women are objectified, in the modern sense, since objects . . . are imbued with highly personal qualities. But it does imply a distinction between gift and giver. (1975:174)

I do not further labor the point that women are not being objectified 'in the modern sense', that is, being rendered as things alienable *from* persons. Women's value as wealth, so evident in Hagen for instance, does not denigrate their subjectivity. Chapter 4 showed how Hagen 'persons' (i.e., agents: moral entities, thinking, responsible, socially oriented and autonomous) learn the reciprocities of particular interactions within the household and do not have to prove themselves in a public sphere. Women being the 'objects' of exchange relationships are not deprived of such autonomy. Moreover, Hagen men's transformation of themselves into prestige-bearing name-carriers is not ultimately about fulfilling themselves as subjects. Ceremonial exchange works to make them objects in the regard of others. And men are also construed as aspects of women's social identities. In other words, it would be an error to see certain people as always the objects of others' transactions and equally an error to assume their natural, 'free' form is as subjects or agents. One might put it that people do not exist in a permanent state of either subjectivity or objectivity. The agent is a conduit.

One problem with the Western view of cultures or societies that would regard these entities epitomized in collective action is that a kind of permanent subjectivity or agency becomes ascribed to certain actions rather than others. Thus certain forms of activity appear as 'institutions' where others do not. Certain institutions in turn appear salient or

prevalent, the prevalence of men exchanging women between them-
selves being a notable example. Yet from the Melanesian view this is
no more nor less prevalent an activity than women feeding children or
working in the gardens. These actions all require exertions of agency
in Melanesian eyes. Where the agent is defined by gender, then it is the
one sex that 'causes' the other to act. The cause is always technically
inert or passive but with respect to that agent or that occasion and not
as a general condition. The asymmetry is always there, but men's and
women's occupation of these respective positions is always transient.

At the heart of the asymmetry is the fact that an agent is not con-
ceived as capable of appropriating another's *acts*. One can only make
another person act, and thus become oneself a (passive) cause for that
acting. Women's giving birth, as an act, cannot be taken over by men:
men can only intervene as causing the action. As we saw earlier, a
mother is coerced into becoming a mother, for herself. The antecedent
condition for such interactions as they concern the sexes must be the
ever open possibility that the one is receptive to the other, each able to
register the other's effects, 'to be made' into an agent. Each must as it
were be constitutionally vulnerable to the opposite sex.

The dependency of male ritual on a female presence, of male health
on female caretakers, can thus be interpreted as part of a deliberate
vulnerability or openness. One sex is regarded as having a direct effect
on the body of the other: what is held permanent is the possibility of
encompassment, and this may be presented in images of either male-
ness or femaleness. Thus what is enacted in the initiation sequences of
the Eastern Highlands societies described in earlier chapters is a strictly
momentary capacity; the equations involved may be effective only for
the course of the ritual itself (compare Lewis 1980). They do not neces-
sarily 'express' values to be found outside this context but are enact-
ments of a specific agency. At the same time, by virtue of the fact that
the acts are secluded, juniors grow and seniors are strengthened. Enclo-
sure here is crucial, the entire body of men being in a sense 'contained',
an entity distinct from yet encompassed or enclosed by something that
is not itself. This distinctiveness is established by those female elements
positioned as exterior and as enveloping them.[17] The absent females en-
compass the (present) male body. Their potential presence is evoked by
the men's actions.

It is pertinent that there can be no mediated exchange *between* the
enveloping and the enveloped entities: the one only ejects or yields the
other, or the other grows. Either process establishes the distinctiveness

of what is contained from the enveloping container. But the former does not derive its social identity from that exterior source: the contained entity has a separate identity, precisely because it is not a part of the container within which it lies. The independent life of the enveloped entity is evinced in the way it swells and alters the shape of the outer container. The contained element thus also appears to grow 'autonomously', as is true of the growth induced inside a cult house. Individually the participants are supposed to display a process that will have altered the appearance of their bodies; collectively, there is a swelling of the body of men; they have become more numerous as a single body, grown by what they grow. The difference in size could not be registered without a unitary construct to reveal increase as an internal fact. And an enabling condition for the unitary identity of the male participants is their categorical exclusion from women, with whom there can be no communication, no mediation. Women are in this sense a passive cause of men's actions, as well as the persons on whom the effects of men's activities will eventually be displayed.

We should not mistake this unmediated relationship between men and women as anything more than provisional. The positions can be reversed. Women's capacity for maternal growth is encompassed by the men who are excluded from the moment of childbirth. Their exchanges are analogously enveloping or enclosing.[18] And it is crucial that the exchanges remain between men. This provides a kind of outer covering of social interaction: for it is also crucial that the women do not enter into a mediated exchange *with* the men. Absence of mediation between the sexes creates the condition for women's agency as growers, of themselves/their children. A productive separation is envisaged, then, between male and female activities where male exchanges envelop women's internal capacity for growth.[19] The grown product, the newborn child, has in turn an effect on the status of those exchanges, often in Highlands societies compelling men to take further action among themselves, in making child payments or being solicitous toward their affines. Birth invariably 'causes' a fresh cycle of male transactions.

I repeat the ethnographic detail in order to emphasize that this is an asymmetry of form. The form delineates the positioning of the agent with respect to both cause and outcome. It is not that agents 'create' the asymmetry; they enact it. In summary: being active and passive are relative and momentary positions; in so far as the relevant categories of actors are 'male' and 'female' then either sex may be held to be the cause of the other's acts; and the condition is evinced in the perpetual

possibility of the one being vulnerable to the exploits of the other or able to encompass the other. The conclusion must be that these constructions do not entail relations of permanent domination.

We can now delineate the advantage that men do indeed take up for themselves in an unbalanced way and thus at women's expense. It will turn out to be created by this very alternation of vulnerability and is bound up with the aesthetics of encompassment: with the fact that in a same-sex unitary condition one body encompassed by another, which is also the other on whom its effects are registered, is held to grow thereby.

Interpersonal domination. In so far as they stand active and passive in relation to each other, the acts of men and women do not in themselves evince permanent domination. That one agent behaves with another in mind is what defines his/her agency. But a different way of putting this would be to suggest that every act is an act of domination: what is momentary is merely the experience of being in a position to act. For an act always works to substitutive effect.

As I have defined it, agents substitute one set of relations for another, and it was suggested that among the substitutions particularly available to men is the possibility of displacing other relationships with an orientation to same-sex activity itself. The possibility exists in the plural nature of their collective ties. We might imagine women's comparable substitutions in terms of their retention of food or the objects of growth, preserving their bodily integrity. But there is more to this in men's case than simply the quantity of bodies. As is true of all same-sex capacities, the unitary condition of all-male activity must be a cause of growth, and each participant male will evince that growth in himself. Men take advantage of the men at their back; but the men at their back also compel them to do just so, because the individual also contains them as it were within himself. I write with particular reference to the Highlands, but the point can be clarified from Bateson's celebrated discussion of Sepik schismogenesis.

Bateson analyzes two types of schismogenesis in relationships, complementary behavior that reinforces differentiation (as between partners playing male and female to one another) and symmetrical rivalry (as between competing moieties who prompt each other to an excessive demonstration of their similar strengths) (1958:178–179). His initial terms were 'direct' and 'diagonal' (1958:271), which recalls the difference between unmediated and mediated transactions. In direct dualism,

everything can be grouped into pairs, such as elder/younger or male/female; in diagonal dualism, one finds the oppositeness of equals. For the Iatmul context in which he was writing, he stressed how diagonal (symmetrical) relationships were imbued with aggressive display; the feature of direct (complementary) relationships that held his attention was dominance and submissiveness in behavior. Either kind of behavior could provoke schismogenic response. It is worth adding that Bateson discerned his two forms of schismogenesis simultaneously at work within the one institution of initiation. Rival moieties competed with one another in the bullying of novices, provoking each other further to similar brutalities; at the same time, between novices and initiators, each drove the other to exaggerated forms of differentiated behavior, the one 'female' to the other's 'male'.

In effect, Bateson describes the two kinds of elicitatory interactions that gender difference creates—in same-sex (symmetrical) and cross-sex (complementary) modes. He postulates that in either case one condition in a person excites a response in another, so that each partner draws apart in an exaggerated way. Either similarity or difference may be provocative. But I have suggested that there is in addition a systemic asymmetry to interactions, which leads to a third state of affairs. One could imagine it as the agent being capable of auto-schismogenesis. That is, an act *in itself* is an exaggeration of a position which an agent takes, for him or herself, in respect to others. Their passivity constitutes cause/excitation/outcome. One does not need to be provoked by the outrageous actions of others in order to be outrageous in relation to them. Their existence is sufficient provocation.

As far as relations between men and women are concerned, and especially in the Highlands, excess provoked by the inherent asymmetry between an agent and the outcome registers the effects of that agency. We must remember that a cause may be equated with an effect, that is, the same persons who compel an agent to act may also be the registers of the action. Apart from the formal asymmetry of the agent and the cause/effect of his/her acts, a quantitative inequality can arise. The person who registers those acts may be too 'small'. There ceases to be a match between the agent and the aesthetic capacity of another to show the effects of that agency. That is, the exchange of perspectives is thrown out of balance. Consequently, the person/relationship that is the outcome of the acts is perceived as an insufficient medium. And that perception of diminution is, of course, in turn a consequence of the exaggeration itself.

Such loss of balance may affect relations between men. In relations between men and women it may well be perceived as inevitable and to be most acute under those very conditions of male growth which men perform 'for' women. Women appear insufficient by the very acts that make men's growth not only something they accomplish for themselves but also for the women they have in mind. Their insufficiency is thus anticipated in the enlarged sphere of all-male relations, where each individual man becomes in himself a register of the replication of men: in this enlarged form, as a 'big' man, he is confronted by 'small' women and children who carry the burden of registering his size.[20] He is dependent on them; his strength can only take the form of their weakness. This I believe is a precondition for acts of male excess.

In a double sense, then, the plurality of men's collective life may lead to men dominating women. On the one hand they react to the inadequacy of a situation in which the growth of their self-esteem must be registered in the persons of women. They are as it were compelled to exaggerate their vantage point. On the other hand, they can exploit the imbalance they perceive with some impunity, in so far as they can count on the support of other men. The result, I would argue, are acts of domination that typically emerge in men's day-to-day and one-to-one encounters. Occasions of group vindictiveness are not special to relations with women. But characteristic of that cross-sex relationship in several societies is an assertiveness in interpersonal relations that overrides what is otherwise normally an exchange of viewpoints. The justification for men demanding submission from women is not that they are provoked by women's 'natural' or permanent submissiveness into extremes of behavior, but it is women's temporary submissiveness that reveals the effect that men, qua men, have upon them. All effects must be reinforced, because by their character effects are inevitably transient.

It would be misleading, however, to conclude that men are driven by an identity need to become 'whole persons'. It seems that Melanesian ideas pose for men not the existential problem of whether men are men but rather the problem of the multiple person—how both to act and to be the cause of the actions of others, and how thus to ensure that one's actions have indeed taken place.

The Hagen case can be taken up for the last time. What is a part of a multiple self that a man contributes to an ongoing domestic relationship with his wife, in ceremonial exchange becomes his total identity

vis-à-vis other men. In the former, he sustains a relationship with a differentiated social other; in the latter, with persons who are similar to himself, a replication that brings the possibility of a measure between them. The value of collective events becomes rhetorically juxtaposed to the value of domestic production. Indeed, that sphere may even be seen as destructive; too much time at home compromises a man's group participation. It is from this, as Lederman (in press) has noted for Mendi, that inequality creeps into daily interactions, that one spouse's interests seem more pressing than another's. The overriding nature of men's claims, the urgency of their concerns, is established in their future claims, as men, to be part of a collectivity of men.

Trivial as domestic disputes may appear to an outsider, they indicate the extent to which people suffer from one another's excesses. Men much more so than women exert force in interpersonal relations, and above all in the conjugal relationship. Men's exertions have a cost in terms of the chances of people's physical survival—as true of politics as of ritual, although in transforming themselves into agents of special kinds, the cost is borne by themselves also. The transformation is at the necessary expense of other relationships in which they engage, since such a transformation of themselves is inevitably in a gift economy a transformation of their relations with others. If we are to look for domination in interaction between the sexes, it is in the manner in which individual men in their domestic and kinship relations can override the particular interests of others by reference to categorical, collective imperatives. Women have no such recourse. The single most effective sanction at the disposal of a Hagen woman is bodily removal of her person.

Domination is found in particular acts of excess, then; in the Highlands these often involve what we would regard as violent behavior. In stressing the individual and everyday context of such acts, I have wanted to avoid making domination out to be anything more than it is. At the same time, there is a cultural reason why it is specific acts on particular occasions that become out of balance. Domination is a consequence of taking action, and in this sense I have suggested that all acts are excessive. Since in Melanesian metaphysics each action is indivisibly 'one' event, it has to be in interpersonal situations that domination is exercised. When an exchange of perspectives is denied between people who are also partners, when a 'big' man beats a 'small' woman, it has to be in such situations because it is in his male form as an individual agent

that a man is forced to find an adequate aesthetic vehicle for the ca-
pacities that have grown within him.

Given the intention of feminist scholarship to analyze the nature of
oppression and domination between the sexes, and given especially the
interest that feminist anthropologists promote in the cross-cultural 'con-
struction' of personhood, one might wish to epitomize some of the
argument of this book in a second root metaphor. The first concerned
the social form of persons and things in gift and commodity economies.
The second concerns the forms of action as Melanesian culture presents
them. If relationships are known to have been enacted by appearing in
the form of persons, acts relate persons through the will of the individual
subject.

Western culture imagines people as persons existing in a permanently
subjective state; this is their natural and normal condition, and a person
can dominate another by depriving him or her of the proper exercise
of that subjectivity. Expressed proprietorially, one's person properly
belongs to oneself. But one may be made to do things that override or
ignore that property relation, being coerced against one's own nature
thereby. Thus a person may be made to act in such a way as to deny
her or his subjectivity and personhood. A subject can be turned into an
object.

In Melanesian culture, people are imagined in contrasting modes—
male and female, same-sex and cross-sex, a person always one of a pair
of interrelated forms. Anyone can register the difference between them
as a difference of perspective. As persons, women and men are equally
the objects of the regard of others, and thus objectify their relationships.
Since persons are the objective form of relationships, the outcomes of
their acts are held to originate in and thus belong to those relationships.
In a debt idiom, one might say that they owe their persons to those
relationships, and thus to other 'persons'. But as far as acting is con-
cerned, an agent's acts always belong to him or herself. No one else
can act for one. However much she or he may be compelled or coerced
into taking action, the act is the point at which the agent exercises her
or his subjectivity. For as an agent, one also acts from the vantage point
of oneself.

There is a paradox here in Western terms. Whereas Melanesian
women and men are as objects celebrated as persons in the eyes of oth-
ers, claimed as the sources of activity and the productive outcome of

people's energies, it is as agents that they suffer domination. This does not involve deprivation of subjectivity. It is that their action must reveal the demands of others as its cause. In expanding this paradox, however, it becomes possible to see afresh the conundrum at the heart of much Western feminist inquiry: why women submit to the rules that oppress them. It is clear how and why Western scholars pose the question. But it has also become clear that the Melanesian material will not yield an answer in a familiar form.

The Western observer can understand women as the victims of men's behavior, and the Melanesian 'person' may be denigrated as well as celebrated, the inert object of activity taking place elsewhere, having to reveal in herself simply the effect of another's intentions. But it is harder to understand women's apparent willingness and their seeming connivance in situations that appear to go against their own interests. It is the nature of the willingness that seems so puzzling. Perhaps we could imagine the situation this way. As I have described Melanesian cultural conventions, an agent is made to act not to express another's dominant subjectivity but because the supports and reasons for taking action, the others whom she takes into account, are always held to lie beyond the moment of the act itself. These reasons thus appear as the acts of other persons. But since these other persons cannot act for her, only she can take her own action. In that sense, it is only her own will that she can exercise.

12
Comparison

This is in the nature of an epilogue rather than a chapter. In so far as I have been trying to make the conventions of my account explicit, the strategy of comparison has been obvious throughout. Viewpoints have been played off against one another. I do not intend to make the obvious more obvious. What possibly remains of interest, however, are the questions that have in the course of this process disappeared.

One concern is laid to rest. It is not the dreary case that in society after society we encounter example after example of men displaying dominance over women in their organization of transactions. Or even that in example after example we can discern a sphere of female activity to which men's transactions are directed. To put it bluntly, there is only one example.

In the end I did not offer any adjudication on the markedly different ways in which men and women take advantage of their situation between the different societies of Melanesia; I have not accounted for the distinctiveness of the Highlands, for instance, from which my problematic was initially drawn. What emerges instead is the extent to which the apparently numerous social systems of Melanesia can be considered as versions of one another. Some sense of the variety of social forms is sustained in the running distinction between societies whose exchange systems do and those whose do not produce more kinship. Nevertheless, this crude contrast, intended to stand for diverse contrasts within the region, in the end has collapsed.

I do not mean that the differences are not real, but that they are so to speak all the same difference: this is what has made it possible to understand ceremonial exchange through the phenomenon of initiation and vice versa. The manner in which male associations are formed, the relationship between mediated and unmediated transactions, and the images gender gives to the sequencing of cause and effect in relations, all appear as widely shared conceptualizations. Harrison has been able to describe the group organization of Sepik societies in the form of Highlands ones; they are topological distortions of what he calls the same structure. He concludes: "a single, or similar, model may underlie the social organisation of some Melanesian societies neither geographically close nor, on the surface, sociologically very similar" (1984:401). The similar conceptualizations to which I refer concern the way in which people construe social action and make known the outcomes of their relations with one another. Melanesian societies share a common aesthetic.

Such reductionism will not please everyone. For it also underlines the failure of a comparative method whose persuasion rests in elucidating a repetition of instances. That arithmetic—based on the plurality of units—has disappeared. Here we have varieties of or versions of a 'single' instance. These societies hold their conventions in common. I would draw an analogy. In the same way as one might wish to comprehend capitalist organization as it developed historically in Europe, so one needs to inject a real history into our comprehension of Melanesian gift economies. The history itself may be unrecoverable, but we surely know enough about historical process to recognize a series of connected events. Whether one retains the idea of a single formation, or breaks it down into two or three prototypical situations, is irrelevant. The point is that we are not confronted with repetitive reinventions of male domination.

This should be of interest to those feminists who turn to anthropological material, such as that on Melanesia, to explore the full range of alternative forms of gender relations, only to find the 'example after example' syndrome. I have suggested the syndrome does not exist.

Two conclusions follow. On the one hand, there is no need to account for the universal dominance of men in the Highlands; the facts of the case merely indicate the ramifications of a single (historical) set of social arrangements. There is no proof of universality here, only the inference that we are dealing with transformations at once as specific and as complex as the development of European societies over the last

two hundred years under commodity production. Indeed if one could undertake an anthropology of the nation states of Europe, one might be in a better position to undertake the anthropology of Melanesia. On the other hand, it is also the case that these people are enchained into acting out versions of their past. Despite the extremities to which some go, or the mildness on the countenance of others, they are tied to specific versions of their former selves. The sharing of aesthetic conventions is not the residue of some generalized past life held in common. That life always took its own concrete form and must have been no more nor less diverse than that of European societies before the industrial revolution.

This is the point at which to defend the fiction the reader may have found the most imprecise—the comparison of Melanesia and Western society/culture. Far from being vague, the our/their divide of this narrative is its most concrete aspect.

The notion that diverse cultural forms generate multitudinous different 'societies' belongs to a premise of commodity logic, that what people make are 'things' (including abstract things such as cultures and societies). 'Cultural' activity is the diversification of as well as proliferation of things. This lays the trap for the doubly snared perplexities of univeralism and relativity. It would seem either that elements are to be found everywhere, or else that they are found somewhere, a quest at once instigated and defeated by regarding societies as numerically multitudinous. Uniformly, so to speak, societies appear in this view to proliferate across the world; and there is no end to perceptible proliferation.

Within Melanesia we are dealing with societies that cannot be counted separately because, despite the contrasts between them, as versions of one another they are implicated in one another's histories. The versions can be compared. But if they can be compared by reference to what they hold in common, it is precisely for this reason—as outgrowths and developments of one another. Specific forms come not from generalized ones but from other specific forms. It follows that these same internal contrasts cannot be externalized to include 'our own' as a further version for comparison, a third party as it were (from the Western anthropologist's perspective, Euro-American industrialism/capitalist formation/commodity economy/bourgeois culture or whatever is claimed for the sake of argument). The people of Hagen or of Enga do not compose entities that can be compared with 'Western society', nor indeed with Wales or North America for that matter.

Comparative anthropology misleadingly assumes that all societies

struggle with the same givens of nature, so that all social formations appear equivalently and thus holistically organized to the same ends. But if we were to compare Melanesian societies to those of Western Europe, comparison would have to be directed to the overall Melanesian region as the site of diverse outgrowths of a unique historical process and not to individual peoples. This is the sense in which I would agree with Elshtain (pp. 312–313). Comparison is inadmissible not because some people live simple lives and some do not. It is inadmissible to juxtapose this or that particular historical form with what we in our imagination generalize as the single 'society' of the West. There is no such society; there are only generalizations. But from a Melanesian perspective, *this* means that there is a widespead sharing of established conventions. It is revealed as soon as one attempts to talk about Melanesian sociality in Western terms: consequently what can be compared with Western conventions are the cultural conventions that Hagen and Enga thus seem to share.

Hence I have referred in a most general way to both 'Western' and 'Melanesian' ideas. And that generality has been with specific intent. All I have done is make explicit such implicit cultural comparisons as are entailed in the incidental juxtapositions of deploying one language as the medium in which to reveal the form that another, were it comparable, might take.

Yet this also makes comparability disappear. Languages themselves are not generalized but specific phenomena. In expanding the metaphorical possibilities of the specific language of Western analysis, it can only be its own metaphors that I utilize. I have tried to make this asymmetry apparent. Taking apart the image of the commodity (things produced for exchange) uncovers the gift (things produced by exchange); but the formula rests on a Western dichotomy in the first place. The result is that the knowledge I produce about Melanesian societies is not commensurate with the form that knowledge takes there. The fact that my argument works through innumerable oppositions and contrasts, for example, is an inescapable residue of a commodity logic concerned with the value or relations between things, including abstract concepts. Were one to juxtapose Melanesian knowledge practices, one would instead be faced with the presentation of a (single) synthetic image. Relations would be made apparent not through the classification of its attributes, but through its decomposition into a series of other images. Men's body would be seen to contain the children of women, and looking at the maternal body would be looking at the transactions of men.

In striving to convey this incommensurability, I reveal the most significant limitation of this account. Practices in the West assume that things exist as information before they exist as knowledge. At the same time, it is the accumulation of information that produces knowledge—knowing the reasons for which the material was collected—and of itself thus yields the classificatory relations that make sense of it. The sense is available to anyone; expertise lies in making the relations. Consequently the method is simple: enquiry into the nature of the things. There is a timeless dimension to this Western exercise, for at issue is the effectiveness through which inherent relationships are brought to light. Hence I have presented the oppositions and analogies and encompassments described in this book as coexistent attributes of a 'system' (my Melanesian aesthetic). From a Melanesian perspective, what is missing is real time.

As I would grasp that perspective, relations only appear as a consequence of other relations, forms out of other forms. Consuming knowledge about one form means making another form appear. This requires human effort. People tie the reason for knowing things to particular sequences of causes and their effects, for knowledge only makes sense if it is consumed by the right person at the right place and time. Otherwise it is mere surface phenomena, disembodied (unconsumed) things. Information does not exist in itself. I have tried to imitate this timing in composing a narrative that depends on internal sequencing. But at the same time I defeat the purpose of the imitation because the literary plot can only make things more obvious; it cannot do what Melanesians constantly do, and subsequently conceal what has been revealed. One needs real time to do that.

We have seen that the benefits of ceremonial gift exchange must be reabsorbed by one or the other partner in order to create a premise for new action. The same could be said of Melanesian knowledge. Relationships have to be hidden within particular forms—minds, shells, persons, cult houses, gardens—in order to be drawn out of them. That is an inimitable process.

Notes

Notes

1: ANTHROPOLOGICAL STRATEGIES

1. H. Whitehead's exploration of the varieties of fertility cultism in New Guinea has since appeared (*American Ethnologist,* 1986). Within the Highlands, comparative histories are being written by both Feil and Lederman; and a region-focused collection of essays on the Southern Highlands/Papuan Plateau is being prepared by James Weiner.

2. Recent collections include special issues of *Mankind* on concepts of conception (Jorgensen ed. 1983) and studies in the political economy (Gardner and Modjeska eds. 1985); of *Social Analysis* (Poole and Herdt eds. 1982) on sexual antagonism; and the *Oceania Monograph* on history and ethnohistory (Gewertz and Schieffelin eds. 1985). See also A. J. Strathern ed. 1982.

3. The Sirians in her novel constantly conquered and colonized other planets to find a purpose for their activity. The preface to the novel begins,

> I think it likely that our view of ourselves as a species on this planet now is inaccurate, and will strike those who come after us as inadequate as the world view of, let's say, the inhabitants of New Guinea seems to us. (1981:9)

The inadequacy of the view, it turns out, is not just an incomplete conceptualization of the world but an incomplete appreciation of interests.

4. M. Strathern (1978) presents the negative case in some detail. To classify by 'cultural trait', a number of elements in Hagen life could suggest some form of puberty or initiation ritual: peripatetic cults, one of which includes the playing of flutes to keep women away; a concern with growth, fertility and sexuality in cult contexts; and a growth cult for boys reported by Vicedom and Tischner (1943–1948 Vol. II:180ff) and Strauss (1962:396ff). It is illuminating that Vicedom opens his report with a negativity: he has, he says, little to say

about the initiation of youths in Mount Hagen; people at the time (late 1930s) claimed none existed then, and the nearest equivalent to an 'initiation cult' had died out fifty years before. The cult in question involved the seclusion of men and boys, and an equation between flutes and the bird Op which was blown on them. Participants are described as living with the bird in the same way as participants of other Hagen cults 'live with' the cult stones or the spirit these embody. All the evidence suggests that this should be included among the many named cults that circulated through the Hagen region, variously promoting health, fecundity, and growth, both for the participants and for the women, children, livestock, and gardens outside.

Cults come and go, devoted to a panoply of spirits, some locally based, some passing from clan to clan. 'Initiation' into them for their duration is not to be confused with either of the two categories that Allen (1967) elucidates: puberty rites during the course of life-cycle development and initiation into a discrete social group. (Allen himself commented on the exceptional status of Hagen, along with Mendi, as evincing neither formal initiation nor the bachelor associations of some of their neighbors. See also Kewa (Josephides 1983:295). Gourlay (1975:94–96) notes areas of eastern Papua lacking initiation complexes.) The important point to my mind is not whether one can show scraps of beliefs and practices existing here as elsewhere but their contribution to social life. In contemporary Hagen society, initiation and puberty rituals do not establish gender difference.

5. By Western I always mean that the set of ideas in question derives from a social source with its own specific and singular nature by contrast to the derivation of Melanesian ideas; not that 'Western' society so designated can be understood monolithically.

6. I might note here the deliberate illusionist style with which negativities have been used to analytical effect—prominently by Needham ("there is no such thing as kinship," 1971:5) and Rivière ("marriage is not an isolable relationship," 1971:71), at the time that Schneider was asserting that kinship "does not exist in any culture known to man" (1971, in Schneider 1984). At the end of his recent book, Schneider feels others may interpret him as suggesting that in spite of all the qualifications about whether or not kinship is a useful analytical category, one should just get on and study it. He comments on the absurdity of this position. In my own account, negation is meant to set up a *relation* between sets of ideas that are, on the one hand, the social constructs of others and, on the other, social constructs as specifically deployed in an analysis not reducible to a homology with these constructs.

7. The phrase comes from Marriott. His remarks about South Asian theories of the person are pertinent:

persons—single actors—are not thought in South Asia to be 'individual', that is, indivisible, bounded units, as they are in much of Western social and psychological theory as well as in common sense. Instead, it appears that persons are generally thought by South Asians to be 'dividual' or divisible. To exist, dividual persons absorb heterogeneous material influences. They must also give out from themselves particles of their own coded substances—essences, residues, or other active influences—that may then reproduce in others something of the nature of the persons in whom they have originated. (1976:111)

Earlier he remarks, "What goes on *between* actors are the same connected processes of mixing and separation that go on *within* actors" (1976:109, original emphasis). We shall see the significance of this concept for Melanesian formulations.

8. After Harrison (1985a). I have used the epithet antisocial in respect to Hagen women's self-referring interests (M. Strathern 1980:205; also 1981a: 178). The latter article depends upon a contrast between 'social' and 'personal' concerns where I would now—for reasons that will become apparent—prefer to speak of 'collective' and 'singular' ones. Indeed, reflecting on the singular construction one might add that the state of autonomy is effective not because a person has set him/herself *against* 'social' interests, but rather celebrates his/her own self-contained sociality.

9. An equation that also has a mathematical basis in certain Melanesian counting systems (see chap. 10, n. 3).

10. In comparing 'our' categories with 'their' categories, one is of course comparing two versions of our categories, the latter being derived from what we take to be salient or relevant to them, even as the ideas gained from what we take to be 'their' categories come from 'our' encounters. To extract certain distinct ideas out of the encounter is not to judge the people as distinct, nor necessarily entail a comparison of whole societies (Goody 1977:3).

11. Ennew has drawn attention to the manner in which Bateson 'made strange' the anthropologically strange and effected a conceptual separation between his method of ethnographic description and its referent data—a device she likens to the deliberate distortions of the Russian Formalist project in literature, "which break the chain of habitual associations, and make it possible to perceive rather than recognise" (1981:59).

2: A PLACE IN THE FEMINIST DEBATE

1. Compare Eisenstein (1984:54) on lesbianism as "a theoretical position," a definition of female identity that incorporates a critique of sexual politics.

2. Emphasizing the specificity of women's oppression leads to sympathy with other forms of oppression whose victims can be identified as a similar 'minority'. Emphasizing the specificity of class oppression must assimilate other oppressions to a version of that one (that is, as resulting from the same fundamental social processes). Thus, "The materialist problematic is based on a conceptualization of human society as defined specifically by its productivity: primarily of the means of subsistence and of value by the transformation of nature through work" (Kuhn and Wolpe 1978:7). On society as a plurality of attributes, Kristeva notes how the identity of certain "sociocultural groups" may be defined according to their place in production and reproduction "which, while bearing the specific sociocultural traits of the formation in question, are *diagonal* [original emphasis] to it and connect it to other sociocultural formations"—viz. "young people in Europe," and "European women" (1981:14–15). What defines them as women places them 'diagonally' to their European origin and links them to others.

3. For example, "Feminist analyses show the existence of woman's multi-

dimensional oppression *by the social system*" (Plaza 1978:5 (trans.), my emphasis). The comment also applies to the concept patriarchy, for instance. Rubin observes the following:

> The term 'patriarchy' was introduced to distinguish the forces maintaining sexism from other social forces, such as capitalism. But the use of 'patriarchy' obscures other distinctions. Its use is analogous to using capitalism to refer to all modes of production, whereas the usefulness of the term 'capitalism' lies precisely in that it distinguishes between the different systems by which societies are provisioned and organized. (1975:167)

McDonough and Harrison (1978:131) comment similarly on Millett's deployment of the concept in *Sexual Politics*.

4. Any one of a number of texts could serve here. For example: "My purpose in writing this book has been to understand the lives of Australian women in order that we might change our conditions and subordination" (Matthews 1984:28).

5. The contrast is overdrawn, as are all the contrasts in this paragraph. The two radicalisms are combined, for instance, in Elshtain's (1982) search for emancipatory speech. But some of the ambiguity is acknowledged in critiques of women's studies. For example, apropos essays on women's studies in Britain in 1983, the editors commented thus on their work as a collective:

> four women of different cultural, national, religious and class backgrounds working together, learning from each other, accepting our differences, encouraging each other with the aim of producing something to be shared by as many women as possible, and enjoying it all—as a realization of sisterhood. (Battel et al. 1983:252–253, emphasis removed)

One of their contributors, however, later challenges the ease of this common identification:

> we bring with us to the Women's Liberation Movement a wealth of differing experiences that cannot be ignored. ... Sisterhood involves maintaining links between women with differing views on the causes of our oppressions, whilst feminist theory shows that all these oppressions cannot be contained within any one theory. (France 1983:306)

For an experientially based approach that does not take the categories of analysis for granted, see Stanley and Wise (1983); also the essays in Bowles and Klein (1983).

6. This relationship may in turn be ascribed to 'natural' origins: scholars search for the original or typical male-female relation after which all else is cultural elaboration.

7. Thus Goodenough (1970:1) opens his general account of ethnocentrism in the comparative method on a premise of similarity: "Human societies, anthropologists maintain, despite their many forms and diverse customs, are all alike in being expressions of mankind's common human nature."

8. Ethnicity is one of the forms by which people represent 'culture' to themselves in Gellner's (1982) type of growth-oriented industrial society. He contrasts the cultural homogeneity of such societies (their nationalism) with the cultural diversity of another societal type, advanced agrarian-based civilizations.

The ethnic divisions of modern society paradoxically replicate this cultural homogeneity: they posit homogeneity as internal to the ethnic unit, such that it becomes a nation within a nation. Singular attributes are held to identify singular social interests. These in turn provide cultural growth points for post-industrial aesthetic and stylistic pluralism.

9. Reason (1979) links this mode of understanding to the organization of production in a capitalist economy.

10. Anthropological art is a display of systematics, and as art displays the display by showing its conventional nature—that particular theories do not cover all contingencies, thereby demonstrating that they cover some. It deals in other words in certain conceptualizations of 'event' and 'system' that are general features of Western reflective practice. As Wagner argues, systematizing effort inevitably 'produces' events and instances, such as cultures holistically precipitated in particularistic or natural resistance to the act of systematizing. This is how the 'unique' monographs of the Trobriand Islands or the people of Mt. Hagen may be received. If individual descriptions of individual societies come to have the status of unique events only conscious effort can then 'relate' them. Comparative analysis takes such instances as the facts to be brought into relation with one another.

11. For example, "For those of us who have lived in the third world, we found that our experience of inequality in our own country gave us a particular way of focusing on the inequalities observed in the countries in which we were working" (K. Young et al. 1981:vii).

12. Hence Haraway's remark that "[w]e require regeneration, not rebirth" (1985:100).

3: GROUPS: SEXUAL ANTAGONISM IN THE NEW GUINEA HIGHLANDS

1. True at least of Melanesian anthropology. I did not initially use the term thus myself (see M. Strathern 1972; written 1969); my own first usage is in a paper written in 1973 (pub. 1978); Goodale was also writing on the Kaulong gender in 1973. A. Weiner, who was working on her Trobriand material then, refers to the "social construction of reality" (1976:12). M. Strathern (1976; written 1974) refers to "gender constructs." I recall being influenced by Oakley's Sex, Gender and Society (1972) and Hutt's Males and Females (1972).

2. These arguments appeared at a time when the new feminism was gaining ground in anthropology, e.g., Faithorn (1976); A. Weiner (1976); Feil (1978).

3. At this juncture, I refer to the division of labor as a type of relationship between persons, whether or not the products of labor (including the commodity labor power) can be compared and exchanged.

4. Leahy and Crain (1937:150). The exclamations of the explorers ("Gold!"/"Cattle!") are noted by Souter (1964:181).

5. Conflation between social structure and the study of groups is often placed at Radcliffe-Brown's door. Certainly, he defined social structure in his influential account of the social organization of Australian tribes (1930–1931) as a system of formal grouping. In his later reflections (1940), however, social

structure was "all social relations of persons to persons," and "the differentia-
tion of individuals and classes by their social role." He includes here the differ-
ential social positions of men and women. Compare Evans-Pritchard (1940:
262), and his definition of social structure as "relations between groups which
have a high degree of consistency and constancy." P. Brown (1962) made it ex-
plicit that she followed this latter definition.

6. For example, see A. J. Strathern (1969). Wagner (1967) deliberately
modified alliance theory in terms of unit definition and cross-unit relationship.
He also (1974) gave 'group' based theories of Highlands society a quite radical
critique, which did not simply rest on emphasizing 'individual' connections at
group expense (the form of most critiques of the 1970s, as noted in chap. 4).

7. Verdon (1980:135) traces this influence to *The Nuer's* preoccupation
with political relations. In the 'jural model' of descent, the problem of a group's
internal cohesion cannot be separated from that of its differentiation. He
continues:

> There seems [in this model] to be only one way of solving the question of internal
> cohesion, namely, by describing and explaining how a set of mental representations
> has a psychological effect on individual feelings or sentiments, thereby drawing in-
> dividuals together. (1980:136)

8. He delineated a homology between the relation of extraclan military
threat versus intraclan military protection and feminine pollution versus mas-
culine purity; he also adduced a set of behavioral elements, under the suppo-
sition that "Mae culture exemplifies that constellation of traits which includes
fear of sexuality and of pollution, emphasis on a male cult and frequent *conflict*
between affinally connected groups" (1964:219–220, my emphasis). Meggitt's
synthesis of analytic viewpoints was to remain a hallmark of Highlands ethnog-
raphy, with its dual British-American origins. Social anthropologists could talk
about categories and relations; cultural anthropologists about behavior and
identity. Thus when Langness (1964) challenged Barnes's (1962) characteriza-
tion of weak group solidarity, he took a construct referring in the first place to
principles of exclusive classification as referring to the viability and strength of
groups in confrontation.

9. Let me make it clear that the following remarks are directed not to the
man but to aspects of his ideas. I say the same for the pioneering work of
Langness and the more recent, and in its own way pioneering, program of
Herdt. All of them have nourished an interest in psychological anthropology
where many Highlands ethnographers have been ignorant or neglectful; have
provided a provocative corpus of material, and asked difficult questions others
have ignored.

10. I quote Read's opening statement (1971:214):

> I am primarily concerned with the sociological functions of the cult, with the manner
> in which these inter-related beliefs and activities assist in the regulation, maintenance
> and transmission of sentiments on which the constitution of Gahuku-Gama society
> depends.

Read explicitly associates his argument with hypotheses formulated, as he says,
by Durkheim, Radcliffe-Brown, and others.

11. The nature in question is nature as Gahuku-Gama conceive it; Read is not invoking biology in an absolutist manner. Thus when he says that Gahuku-Gama saw no need to promote the "biological womanhood" of girls, or that they found it necessary to finish "the biological manhood of young males" (1982:68–69), we understand he is referring to their own constructs. But the point I wish to make is the parallel adduced between the purpose of the rites ("manhood and masculinity had to be ritually induced") and a particular Western antithesis between nature and culture. In this antithesis, culture acts on and modifies nature. Although he can write paradoxically that for the Gahuku-Gama themselves, "[t]he achievement of biological manhood as well as its maintenance could not be left to nature" (Read 1982:69; 1971:228), the kind of manhood that Gahuku-Gama men promote is understood as an artifact of their culture. If ritual creativity is interpreted thus as overcoming the limitations of nature, this implies that such ideas are being accredited to Gahuku-Gama themselves.

12. Sambia are among the congeries of Anga-speakers whose languages lie outside those of the central (Western and Eastern) Highlands families. Yet noting that Sambia beliefs and practices closely resemble those of the *nama* cult, despite many institutional differences, he argues that what holds for the Gahuku-Gama holds too for Sambia: "men are, by birth, biologically unfinished compared to women. Only ritual can correct that imbalance" (Herdt 1981:15). See Meigs (1984:78) for a similar view about men's need to intervene in biological processes about which they feel insecure.

Carrier (n.d.; I am grateful for permission to cite) would find support here for his analysis of American concepts of nature and culture. He examines two American theories about learning disability, showing that one proceeds on the premise that a failure of nature leads to insufficient culture, the other that a failure of culture leads to insufficient nature. Underlying the theories is a correlation between the 'completeness' of these respective endowments. Similar reasoning seems to underlie the anthropological postulate that because boys are seen by New Guineans not to grow quickly (a failure of nature), then they cannot be socially masculine (insufficient culture). This is regarded by the outsider as a conceptual failure on the part of the New Guinea culture (since in fact the boys will grow into men) which the culture remedies by making 'more culture'.

13. Elsewhere he stresses an individual level—"the level of male gender identity and its preservation" (1982a:91)—and the psychological distancing mechanisms that give insight not only into identity but into "character structure." He refers to masculinization as "that second [postchildhood] experiential 'layer' of socialization implemented through ritual life" (1981:315).

14. Following Read and Langness, Herdt postulates that this need for unitary identity is demanded of men by their warring communities. The rites do not just make men but make warriors.

15. Compare Read's constant and important reminders of the parallel if lesser trauma of being a witness. It would be honest to note that the third-hand experience of reading the ethnographic accounts every time makes me want to abandon an aim conceived of as interpretation/analysis. Tuzin (1980, 1982)

makes a strong plea, on behalf of analysis itself, that what is being experienced matters and that the observer should not become desensitized to the cruelty that 'cultures' inflict.

16. Barrett (1980:65), quoting the work of McIntosh and Weeks.

17. Herdt convincingly shows that homosexual behavior among Sambia men is not 'homosexual' in the Western sense, that is, a challenge to heterosexual behavior. On the contrary, it is a precursor to it. Sambia homosexuality does not challenge male gender identity in his terms but rather gradually builds it up as a remedy for a problem that lies elsewhere (in the nature of the uninitiated boys' constitution).

18. Keesing stresses the fraudulent nature of men's claims to cosmic significance and points to a central structural contradiction. "By separating men's realm from women's to create male solidarity, these systems leave beyond male control the everyday lives—and minds—of women" (1982:36).

19. Within feminist theory at large, there is considerable internal debate over whether the gendered 'body' can be regarded as outside 'discourse' (history, culture), as molded by discourse or as the cause of discourse. One commentator (in the context of a translation of Kristeva's work) notes: "If it is no more useful . . . to posit the body as entirely constituted by the effects of language or discourse than it is to posit it as unitary and extra-discursive, the question still remains as to how to think the body" (Pajaczkowska 1981:151–152).

Feminist anthropology generally seeks alignment with those theorists (particularly the self-styled Marxists/Socialists) interested in aspects of gender differentiation that can be related to social or cultural form (see chap. 4) (Harris 1981; Stolcke 1981). This includes the degree to which difference is constructed. Barrett, among other feminist commentators, continues the argument that the ideology of sharply separated masculinity and femininity, of what she calls heterosexual familialism, is "deeply embedded in the division of labour and capitalist relations of production" (1980:61). That is why, she argues, the politicization of women's personal lives will not of itself eradicate women's oppression. Plaza similarly criticizes the postulate that difference (between gendered bodies) is 'really' located in nature, rather than in the discourse (or representations) that in fact constitutes difference and constitutes nature as a category. To celebrate the body as the site of difference "is already to participate in a social and oppressive system" (1978:6) and is not to criticize it from a vantage point outside. She comments on certain psychoanalytic interpretations of sexual difference that regard this difference as imposed on the infant and as (1) being a natural order, (2) requiring hierarchy, and (3) indispensable for acquiring an identity (1978:21).

20. Gatens promotes a theoretical stand contingent on a politics of 'sexual difference', carefully distinguished from former radical feminisms. Her argument about the unexamined assumptions in the rationalist view of the genderless person, as a basis from which to mount critiques of gender ideology, resonates in other contemporary debates. Elshtain (1984) criticizes theories that conflate gender difference with male dominance ('patriarchy') and lead to a counter-recipe of androgynous ideals and sexual symmetry. Like Gatens, she attacks the socialization theorists. Illich questions the extent to which we assume the

undifferentiated individual is a natural genderless entity molded by sex role expectations (1982:83). He emphasizes the social and historical specificity of that notion of the person, though responses to Illich's presentation of his views at Berkeley indicate how contentious these ideas are. (See the symposium, 'Beyond the Backlash' in *Feminist Issues*, Spring 1983.)

21. The phrase is a quote from a quote (Marx); see Kovel (1984:106), who refers to the Theses on Feuerbach VI.

22. A fallacy charged to descent group and alliance theorists by Schneider (1965:46), though it would be hard to include Fortes here (Scheffler 1985:20, n. 14). Feil raises the critique in an attack on the analysis of single sex ideology (1984a:51–52).

23. Anyone who looks up this reference will see that Langness's scorn is directed at writers such as myself who, as he says, displace concern with the underlying psychological components of male-female relations with one to do with structural and economic elements. By 'think' in the quotation given in the text, he means 'have a personal opinion on' rather than 'have an intellectual position on'.

4: DOMAINS: MALE AND FEMALE MODELS

1. Wola, who speak a variant of Mendi, live in the Southern Highlands province, but for the purpose of the contrasts I make belong to the 'Western' as opposed to 'Eastern' Highlands.

2. When it is remembered that the *tee* links individuals and, through them, their communities over a wide area, and that hostilities between groups cease to allow an approaching *tee* to continue on its way, it is clear that parochial conflict between groups was often subordinated to the universal interests of *tee*-making. Individual exchange partnerships take precedence and subdue the destructive wars of clans. (Feil 1984b:23)

3. The concept of metaphor was used interchangeably with the concept of sign, that is, referring to processes of conventional *representation* (signification), and not (as a self-contained or figurative trope) in contrast with sign (Wagner 1978). Inquiry into conventional signification rests, of course, on elucidating 'the relationship' between signifier and signified. This epistemological strategy was at one with an endeavor that saw the construction of male and female as constructed *in reference to* what men and women did/were.

4. S. Ardener consistently refers to the study of women rather than to feminist inspiration; Caplan and Bujra's (1978) collection was explicitly feminist. In the States at about the same time appeared a number of syntheses, e.g., Friedl (1975), Martin and Voorhies (1975), which address themselves to sex roles and the division of labor as a contribution to the generally prevalent interest in issues to do with male-female relations rather than to the kind of specific feminist intent acknowledged by Rosaldo and Lamphere and by Reiter.

5. Specifically in Rosaldo's challenging essay (1974). Chodorow (1978:9) summarizes the state of the argument at the time:

Public institutions, activities and forms of association link and rank domestic units, provide rules for men's relations to domestic units, and tie men to one another apart

from their domestic relationships. Public institutions are assumed to be defined according to normative, hence social, criteria, and not biologically or naturally. It is therefore assumed that the public sphere, and not the domestic sphere, forms 'society' and 'culture'. . . . Men's location in the public sphere, then, defines society itself as masculine.

This set of ideas and social forms was seen as a universal source of sexual asymmetry.

6. S. Ardener pleaded, for instance, for the careful examination of the models of both the dominant and the muted groups in any one society (1975: xxi), without implying that they would be of the same order, and explicitly denying that in the case of men and women a purposive domination by men was necessarily at work. E. Ardener (1972) refers specifically to men's and women's models, the discreteness of their views being themselves derived from the content of these models (in the Bakweri case, where men and women place one another according to the relationship between society and nature). See the discussion in Rogers (1978). The questioning of the ideological unity of men's and women's values was central to the development of a woman-focused anthropology in the mid-late 1970s.

7. On this point and others my account benefits greatly from a seminar presentation by Margaret Jolly and Christine Helliwell to the A.N.U. Gender Research Group in 1983. (See also Rapp 1979:509.)

8. Documentation of this point is given in M. Strathern 1981a; 1984a. Some of the material first presented in the latter article is re-presented in this chapter.

9. Ortner intends to draw attention to this as a widespread cultural device. This possibility of gradation—as in the related constructs that one may be 'more' or 'less' of a full person, or have 'more' or 'less' culture—is certainly a significant Euro-American construct. It underwrites socialization theory, for instance. Löfgren (in press) offers a similar view about culture from Sweden.

10. Although not a cited source for Rosaldo's account, I refer primarily to the work of Fortes, as many other commentators do (e.g., Yeatman 1984). Fortes's own words on the relationship between the public and jural dimensions of the political domain are worth quoting:

I define 'jural' as denoting certain aspects or elements of right and duty, privilege and responsibility, laid down in the rules that govern social relations. . . . It is, furthermore, distinctive of these features of right and duty, privilege and responsibility that . . . they have the backing of the whole society. That is to say, they derive their sanction from the political framework of the society. They thus have 'public' legitimacy in contrast to the 'private' legitimacy of rights and capacities based solely on moral norms or metaphysical beliefs. (1969:89)

11. The description comes from Jolly's published and unpublished work: see Jolly 1981, 1982; in press. I am very grateful for her permission to cite unpublished material and in places draw directly on her words without always signalling the fact.

12. Men and women eat at separate fires; men eat communally in a clubhouse, but there is a division based on their rank in the graded society.

13. Sexton (1982, 1983, 1984). A comparative comment is offered in Warry

(1985); the classic account of the development of 'business' in the Goroka area is Finney (1973). I refer to the response of village women; Sexton (1983) describes the activities of elite business women. The rituals spread through the Chuave and Goroka Districts (Simbu and Eastern Highlands Provinces); Sexton's work was focused on a linguistic border area among Asaro and Siane-speakers, to the west of Gahuku-Gama and Bena Bena.

14. Warry (1985:28) reports that Chuave women comment on men's failure to bring wealth into the area and say that they are showing their menfolk "the road to development."

15. Even where a prior kin relationship exists, the fact that these ties are on an all-female basis means that men are precluded from gaining status from the women's transactions; this new kinship does not include them (also Sexton 1982:174). Warry stresses that Chuave women see their own transactions, by comparison with men's, as noncompetitive. The competitive nature of men's single sex ties is thereby given fresh evaluation.

16. Although at the same time they may also claim to be enhancing men's affairs and clan reputations. Sexton (1984:146) reports that Daulo women support their husband's use of income for ceremonial payments (it is large sums squandered on personal pleasures about which they complain). Men's own attitudes vary from hostility to encouragement.

17. Thus where male migrants stressed an equalizing collectivity among themselves, which frequently embraced male visitors to town as well, women brought them back to asymmetries in people's dependence upon one another and to the specificity of particular ties. Hagen collective life appears on the surface detached from the particularities of kinship relations. In Daulo and Chuave, by contrast, kin-focused events (life cycle crises and payments to categories of kin) managed by men also mobilize clans and lineages in competitive 'corporate' activity.

18. Although I have criticized aspects of this paper elsewhere, its general orientation is one I also adopt; Ortner argues that one cannot focus upon women's powers in particular societies without understanding the deeper assumptions that accord them the value they have. Importantly she is concerned with the devaluation of women as a matter of what women stand for.

19. Paul Rabinow (personal communication) properly queried my reference to 'theory' in such a context, objecting that one would need an epistemology to know whether or not one was dealing with a theory. I was, of course, trying to seek an appropriate analogue to Western discourse. There is a hypothetical element in the way sexual attributes are classified, and the next chapter elucidates some of the grounds of knowledge by which people provide themselves with evidence of their powers and capacities.

20. 'Sociality' after Wagner (1974). I prefer 'sociality' to Fardon's 'sociability', drawn from Simmel, but intend a similar concept. Fardon (1985:134) writes: "By sociability I want to understand a framework of knowledge about the way in which people impinge upon one another. Sociability makes relationship[s] visible in their culturally constituted form and also informs these relationships normatively. Thus it bears a double relationship to social action through the social and moral constitution of relatedness." He argues that the

Chamba (of Cameroon) have "two idioms of sociability," viz. consociation (matrilateral mediation) and adsociation (patrilateral). Also see Yeatman 1984 (different types of sociality); Biersack 1984 (gender as reflexive discourse); Harrison 1985a (two organizational domains).

21. See Barnett and Silverman (1979:25) on the relationship between units and systems. The assumptions are open to radical critique. Marxist/Socialist feminism would join with those critiques that regard the individual subject as constructed by historically specific social formations, while Radical feminists posit sexed difference not as beyond but constitutive of (social) discourse.

22. This is the reflexivity of Gudeman and Penn's (1982) 'universal models'. Such models involve secondary elaboration, rationalization, and classification from a particular point of view, which thus externalizes what they 'refer to' or 'stand for'.

23. Gudeman and Penn's 'local models'. These have a nonreferential character; they do no more than 'represent' themselves. They are not a mapping of or reflection on an external world. The Western view of 'knowledge' by contrast is a model of the universal kind; this leads to problems in the matching of informants' incomplete knowledge of their culture to what the observer treats them as possessing as a unit, i.e., that culture as a whole. Lewis (1980) deals with this issue at length and recommends that we should see the symbols that others manipulate not as they appear to us as 'standing for' ideas and sentiments but how for the people deploying them they function as substitutes, as equal to the ideas or sentiments themselves.

5: POWER: CLAIMS AND COUNTERCLAIMS

1. I give one recent example of this type of argument. Bowden, on the Kwoma of the East Sepik Province, presents an analysis of art symbolism that moves through the following stages: (1) Men represent themselves to themselves as creators to ensure continuing fertility, opposing themselves to women who are seen as destructive of these powers. Yet (2) they 'surreptitiously' incorporate into their ritual and art a range of objects associated with female fertility. He notes that men say rituals were originally invented by women, and men stole them away. A problem of interpretation arises. (3) Interpretation one: "we could say that these objects constitute signs that the wider forces within which women's reproductive powers are operating have been expropriated by men and are firmly under male control." (4) Interpretation two: (presented as a contradiction to the first): "by acknowledging that women were the originators of all life-sustaining ritual . . . men may be tacitly acknowledging what, at a conscious level at least, they are denying, namely that it is women, not men, who are the prime creators, for it is only women who can bring forth new human life" (1984:457).

2. In the Highlands, female ceremonies at puberty seem restricted to the Eastern Highlands area, including Gahuku-Gama, Bena Bena, Gimi. The Gururumba celebrate female growth, where male growth has to be induced (Newman 1965:80). Lindenbaum (1976) (Fore), Newman and Boyd (1982) (Awa), and

Hays and Hays (1982) (Ndumba) describe girls' nose-bleeding rites at marriage. In the Awa case this and other pain inflicted on the girl is said to energize the bodily substances associated with procreation and to increase their strength; the Hays's account emphasizes the controlling role that men play in the women's ceremony. Outside the Highlands, Lewis's (1980) analysis of rites for Gnau boys and girls stresses that both are concerned with growth; Poole on Bimin-Kuskusmin rites says that for both boys and girls menstrual contamination must be drained from the male skull (1981:143). Allen (1967) would no doubt classify all these as puberty rites, not as initiation, since entry into a female association never appears to be at issue.

3. Faithorn worked among the Kafe, to the east of Bena Bena and Gahuku-Gama (Henganofi Sub District). Faithorn's interests were prompted by an analysis of Kafe male-female relations that showed that the antagonism model could not be taken as a description of the social reality of lived relations between men and women (see also Faithorn 1976).

4. See Meig's account of the Hua, in the vicinity of Lufa and bordering Gimi.

5. See also the account given by Poole of Bimin-Kuskusmin: male and female differ "in terms of capacities to receive, transform, and transmit the very substances that form them" (1981:136).

6. I mean, of course, as it is construed in Melanesian conceptualizations. Poole (1982:145) has a striking description of the way in which Bimin-Kuskusmin initiates become absorbed with changes in their bodily states during the course of their painful seclusion. He reports them monitoring their bodies in great detail.

7. My account draws only from this single article of Rubinstein's—an exceptionally helpful introduction to the issues which follow. Malo is a small island off the southern tip of Espiritu Santo. Details on the cultural relationship between the 'patrilineal' Malo and the Sa-speakers of Pentecost is provided by Allen 1981b. Unlike Malo, there are two women's grades in South Pentecost (Sa) but of a minimal political character (Jolly 1984).

8. Or sacrifice, since pig-killing was concerned with the orderly following of father by son, elders by juniors, ancestors by descendants. Those who progressed far up the ranks are regarded as powerful 'living ancestors'.

9. Dundes's (1976) world survey of bullroarers analyzes feminizing elements in male cults as a result of the latter's intrinsic homosexual character. He understands the 'female' elements in such cult activity as symbolizing men's desire to live without recourse to women themselves. It will become clear the extent to which this proprietorial fantasy eludes Melanesian formulations.

10. This is also a sociological issue: the male spirit that the bride has within her is paternal in origin. It must be driven out and a 'spirit child' from the husband's clan substituted in its stead.

11. A communicational analysis of secrecy, the significance of noise/silence, revelation/concealment, and the indeterminate nature of knowledge imparted during such sequencing is given in Schwimmer (1980b).

12. A striking example is provided by the Female Spirit cult in Hagen

(A. Strathern 1979): the all-male participants divide themselves into a 'men's house' and a 'women's house' side.

13. Accounts of Paiela, and reference to earlier work by Meggitt in the neighboring Ipili area are found in Biersack 1982 (my main source here), 1983, 1984. Although a small population, and with a 'descent system' described as cognatic, the Paiela speak a language related to Enga (and to that of the 'cognatic' Huli, to their south); their central male puberty ritual is similar to the bachelor cult described for Mae Enga by Meggitt (1964). On many grounds, including a major language divide and the presence of these rituals, the congeries of Enga-speakers are to be distinguished in turn from Hagen; they are alike in the scale and organization of ceremonial exchanges (and see the comparisons drawn by Feil 1984a). Paiela exchanges are less complex, but their structures seem to be much closer to those of Hagen than (say) Gimi. One would not, of course, see the similarities if one started with the gross differences between Paiela and Hagen in terms of demographic and political factors, 'descent group' formation, and so on. Biersack herself compares Paiela gender stereotypes to those of Hagen (1984:119).

14. The ritual foreshadows their full conjugal status, for which it prepares them. The sequence of seclusion and emergence can also be typed as a 'bachelor cult', since officiants stay unmarried in order to direct the ritual.

15. Meggitt's summary of his earlier investigations in the nearby area (Ipili) refers to small, localized patricians (1965:272); Biersack (1983) describes local groups based on a consanguineal nucleus that forms units for bridewealth and homicide compensations. She does not use the term 'clan'.

16. Gillison (1983:49) comments on the crucial absence of 'males' from women's anthropophagous meal other than as the body to be eaten. What is established 'collectively' on the basis of shared attributes (a single gender) with respect to the opposite sex holds a 'particular' status. It should be clear that my general debt to Gillison's work goes far beyond these specific citations.

17. This is strikingly represented in Gillison's account of female seclusion; as one woman told her "We close our doors and the men do not hear the things we say" (1980:169, n. 22). The Gimi equation between the penis and the whole body is another such construction (Gillison 1983:37, et seq.). Identity between flute/penis and the 'whole body' of the men devoured in cannibalism made the bodies definitively 'male', as unitary 'things' enveloped by the female (1983:48).

18. As far as conception beliefs are concerned, Paiela (and Enga), like Hagen, envisage a fetus formed from separate maternal and paternal elements combined together (cf., Biersack 1983), whereas Gimi and other Eastern Highlands cultures regard the mother as providing an empty vessel to be filled (e.g., Langness 1977:13). Biersack (1983:9) specifically argues that "The notion of bound blood [in Paiela conception theory] . . . constitutes an image of antithetical substances locked in combination, . . . the conjunction of distinctive groups created first through alliance . . . and then through consanguinity."

19. He describes the graphic encapsulation of male spirit figures within covert female forms, an interpretation supported by the presence of a band of explicit female figures immediately above the principal row of male clan spirit faces. Obviously, I offer a different interpretation of the relationship in question

from his own, which is that the paintings express the "primacy of female creativity, which in Abelam terms is natural, over male creativity which is cultural in that male access to supernatural power is through ritual" (1973:189).

20. Keesing (1982:28) makes a similar general point about the sexual referent of symbolism. Forge writes: "the phallus among the Abelam is not a simple unitary aggressive symbol. . . . The most obvious question to ask next is what the phallus does mean to the Abelam" (1966:28). The question is prompted by the regular depiction of a row of flying foxes, and the Abelam identification of the penis of the male flying fox as a single female breast.

21. Although there are many differences between Abelam and their Arapesh neighbors, note Tuzin's report (1980:175–176) that Arapesh spirit paintings reproduce figures whose sex—if one takes the identity of the figure as a whole—is ambiguous. By contrast with the ambiguity of the Abelam organ, the ambiguity of the Arapesh whole is here made up of the mix of unambiguously male and female elements.

22. However, with respect to the phallic/uterine aspects of certain bullroarers (the subject of Dundes' paper), Schwimmer (1980b) makes the interesting comment that in one area the double representation possibly connotes a ritual act, that of splitting the coconut. The coconut is split in order to be 'fed' in the cult-house. Splitting is the moment at which a potential relation is established (between fed and feeder).

23. He emphasizes the importance of function rather than form in the relation between an object and its symbol, suggesting we should regard things not as 'standing for' but substituting for one another (e.g., 1980:197).

24. The privileging of sight as an instrument of knowledge in Western culture is too big a subject to do more than mention here (see Plaza 1978:21). I give brief countermention of the widespread Melanesian view that appearance is deceptive, so that the relation between external surface and inner substance is always a matter for speculation. Different kinds of knowledge are implied between the idea that sight is a penetration into the depths of the nature of things and that sight is witness to revelation, to what is brought to the surface.

25. Tuzin notes the specific reciprocity invoked by Arapesh: "We initiated them, now they must initiate our sons!" (1980:32). The result is that "each initiation class is simultaneously initiator and initiated" with respect to different cult spirits on whose behalf the men act (1982:337, original emphasis).

26. Sexual intercourse is construed as a deliberately visible act between the spouses (they 'see' each other), though hidden from others; whether or not conception takes place, and whether the woman's blood is successfully bound by the man's semen can only be known after it has happened. Internal growth is covert; procreative success however (giving birth) is overt, and in this sense the joint reproductive activities of the sexes may be classified as overt by comparison with the wife's secret growing of the husband or the fetus.

27. One might regard sacrifice as a comparable mobilization of domestic relations, creating a channel of communication between and thus 'separating' two parties (ancestors and descendants) whose relation is predicated on unitary ('noncommunicative') interests. The parties are in a prior asymmetric relation that the separation momentarily equalizes.

28. Their relationships are made apparent in that conduct (Wagner 1977a).

6: WORK: EXPLOITATION AT ISSUE

1. Because of the nature of its transference between persons, commodity may be understood as the exchange form of 'private property', alienation being the transfer of private property (Gregory 1982:12: "Commodity exchange is an exchange of alienable things between transactors who are in a state of reciprocal independence"). The three terms property/private property/commodity are merged in my account in so far as these form (within capitalist/commodity economies) a single metaphorical set for conceptualizations of 'ownership' and 'control', that is, of the manner in which persons create relations between themselves through them (Taussig 1980:3).

2. Bloch (1975:204) points to the wide anthropological base to the notion of property relations as types of social relations, property as a 'bundle of rights', and so on (see above, chap. 5). Ollman (1976:14 ff.) emphasizes the relational import of Marx's categories: "Capital, labor, value, commodity, etc., are all grasped as relations." Indeed, the critique to which I refer has been reabsorbed into anthropology as belonging to 'Marxist' theorizing. It is clear that I only touch on a tiny portion of Marxist theorizing within anthropology, and not on Marx's at all. A thorough-going Marxism could not, of course, be eclectic in this manner, nor ignore the primary sources.

3. I refer to 'labor' rather than 'labor power', for the latter indicates an abstract capacity for work, a "productive potential not tied to any particular activity" (Ollman 1976:171) that comes under the direction and definition of the appropriator of it. In the Melanesian context, work usually presents itself in a particular form, not necessarily generalizable beyond the relations to which it belongs (see below, n. 18).

4. Evaluation is inescapable (see Runciman 1983:chap. 5), that is, it is an integral feature of descriptive practice. The specific evaluation I refer to here is required by the original motives of an inquiry, viz. in the case of feminist inquiry whether or not relations between the sexes are egalitarian.

5. I use the term with hesitation, partly because it has different meanings depending on which side of the Atlantic one is, partly because anthropologists who treat both feminism and Marxism do so as much to criticize as to simply draw on ideas that may be labelled as one or the other. Works outside Melanesia that address ideology from a political-economist view with particular reference to 'Marxist' issues include those of Leacock and Sacks mentioned in this chapter; also O'Laughlin 1974; Reiter 1975; Sharma 1980; Caulfield 1981; the several contributors to Etienne and Leacock 1981, and to Young et al. 1981; Harris and Young 1981; and A. Whitehead 1984.

6. In Friedman's words apropos the social relations of production that dominate the material process of production, "Every social system has objective energy costs of reproduction as well as a technologically determined rate of potential surplus, and . . . the society must, in one way or another, relate to these objective conditions of its functioning" (1974:446–447).

7. Thus he observes of sibling relations in Hagen: "Just at the point where

women are exploited as never before [intensification of exchange compels increased production], an institutionalized re-alignment of exchange relationships [between affines] wipes out exploitation by causing men to appropriate pigs from their wives only to present them to their wives' brothers" (1982:107–108). It is not, of course, 'really' wiped out: the kin-based justification for such exchanges merely disguises the fact that the pigs circulate in appropriated form, i.e., as wealth. As far as access to this circulation of wealth is concerned, that a man gives to a wife's brother instead of an unrelated partner does not, in the terms of this kind of argument, make his relations with his wife any more equal. Tuzin (personal communication) points out that he does on the contrary appropriate her sibling. Josephides (1983:303–304) comments on just such a situation. The fact that wealth goes to her brother should not stop one from asking whether the woman can herself acquire prestige from the transaction.

8. See A. Whitehead (1984:179). She quotes Pashukanis who quotes Marx: "At the same time therefore that the producer of labour becomes a commodity, and a bearer of value, man acquires his capacity to become a legal subject and a bearer of rights" (from E. G. Pashukanis, *Law and Marxism*, London: Inklinks, 1978). For an example of common usage, see Etienne and Leacock (1981: 9): "In egalitarian societies . . . it is impossible to alienate people from *their right of access* to basic resources" [my emphasis].

9. Derived I think from an equation between the use-value of one's productive activity and its character as the most important of all human functions: "The human result of the worker alienating the use-value of his labor is the alienated worker" (Ollman 1971:171). Ollman supplies a general exposition of Marx's thesis about the relationship of man to productive activity and to its product (chaps. 19 and 20). The unitary nature of these connections is unremarked: "The worker puts his life into the object" (quoted by Ollman 1971: 141); and the only condition under which the product of labor does not belong to the worker appears to be when it confronts him as an alien power, i.e., as belonging to someone else (Ollman 1971:147). I would add that it is *because* persons are thus constructed with proprietorship over their own persons, according to the commodity metaphor, that to *share* (i.e., to share what is owned) is evidence of equality between them.

This seems a proper observation to make of European ideologies of egalitarianism. To suggest that in hunter-gatherer economies 'sharing' of itself is evidence of equality seems quite misplaced. It of itself does not indicate a measure of equivalence of the kind provided by the European notion that persons in having property to dispose may dispose of it in equal portions (the common measure of the portions being supplied by its abstract social value). Elsewhere I briefly discuss one set of monotheistic 'precapitalist' concepts that locate an ultimate proprietor beyond the individual person, thereby establishing the individual's own singularity (M. Strathern 1985b). See the history of such ideas presented in Hirst and Woolley (1982:pt. 2).

10. Barnett and Silverman present these same assumptions as a facet of everyday (Western) models about the individual, which sees this entity as both dominating and dominated. Thus, the individual is "proprietor of his or her own substantial person" as well as being "aspects of the substantial persons of

others"; and the individual is a "proprietor of property . . . which is both a pre-condition for and an outcome of contract" (1979:75). Proprietorship of an-other is, in this model, an invasion of control of that self (the other's autonomy), and thus domination.

11. Gregory (1980; 1982:chap. 2 passim) employs Marx's distinction be-tween productive consumption and consumptive production. In productive consumption, all production is also consumption in that it involves the using up of materials and labor energies: people in the form of their labor are turned into things. The latter, consumptive production, is the reverse process, the consumption of things necessary for human survival and reproduction. 'Objects' [i.e., 'things'] consumed are turned into people. In his terms, if production as an 'objectification' process converts people's labor and energies into things, consumption as a personification process promotes the survival of people by converting things into persons (1982:33–35).

12. This is so not because ideology is false, but because it encapsulates certain kinds of imaginings and thus certain kinds of interests. The last thing one wants is to repeat Barrett's excruciating embarrassment of being "caught artlessly counterposing 'material conditions' and 'ideology'" (1980: 89) in the company of the then British Marxist avant-garde. The reference is to post-Althusserian developments in the theory of ideology. In the words of McDonough and Harrison:

> [Althusser's] thesis implies a definite break with all conceptualisations of ideology as 'false consciousness' or as a distorted representation of reality. Ideology is not a representation of reality at all. What ideology represents is men's lived relations with reality: it is a relation of the second degree. Althusser insists that this lived relation is necessarily an imaginary [i.e., imagined] one. Ideology then is not a representation of real conditions of existence . . . but a representation of an imaginary relationship of individuals to these real conditions [existing relations of production]. (1978:16–17)

Anthropologists have particular problems in a cross-cultural context, to do with the status of their own imaginary constructs, that is, the relationship set up in their accounts in attempting to represent the representations of others. The con-cept of 'ideology' signals an awareness that in order to comprehend these other representations as imaginings, they must show them to be of second degree.

13. A. Weiner's (1980) statement of her position draws specific attention to Bourdieu (1977), as does Josephides's (1982). She maintains that reciprocity is not an independent mechanism precipitating social forms ('exchange systems') of its own but part of the larger system of 'reproduction'. This rests on the cyclical world view to be found, she argues, in Melanesia where "exchange interaction is reflective of the kinds of symbolic and material values a society accords its reproductive and regenerative flow" (1980:72).

14. For kinship, the point has been long stressed by Godelier (e.g., 1975; compare the discussion in Bloch 1983:167). Whatever organizes the functions of production and distribution, "It is the mechanism performing these functions which dominates . . . and the representation of the mechanism dominates the concerns of people precisely because it acts and regulates the mode of produc-tion" (Bloch 1983:166). Modjeska is explicit as far as kinship in the political economy of the Duna is concerned: "relations of production are relations of

kinship" (1982:51). Hence his earlier point that production is thus represented as that of persons as lineage and family members.

15. Modjeska (1982:95) points out the significance of the division into 'house pigs' and 'exchange pigs' in systems of developed ceremonial exchange, citing Feil's evidence for Enga. See A. Strathern's (1969) original formulation of 'production' and 'finance' in raising wealth for *moka* (ceremonial exchange). However, Feil himself (e.g., 1984b:112) downplays the disjunction between the categories, pointing out that all 'exchange' pigs are also produced at some point as 'house' pigs!

16. She emphasizes that in spite of the claims Kewa women make on the products of work, she enjoys them only as long as she remains married. "A husband and wife appear to have equal rights to their joint income, . . . but if they separate she forfeits her investment" (1983:300). On divorce, women forfeit further claims to the land they have worked upon. This is also true in Hagen.

17. Josephides (1982:3), after Bourdieu (1977:192): "[e]verything conspires to conceal the relationship between work and its product" (1977:176). Bourdieu notes that what prevents the peasant "economy from being grasped *as* an economy" is the impossibility of thinking "of nature as a raw material, or, consequently, to see human activity as *labour*, i.e., a man's struggle against nature" (Bourdieu 1977:172, original emphasis). Conversely, one may add, an 'economic' conceptualization of labor will be bound up with a concept of nature.

18. 'Labor power' is the abstract form in which particular labors present themselves as general 'social' labor (see n. 3). As a commodity, labor power may be regarded as a *product* of domestic labor. But domestic labor itself remains private because it is not abstract labor—the only form in which private labor becomes social labor under commodity production (Smith 1978:209). Domestic labor can sell its product, Smith argues (1978:209), but does not thereby become equalized with other forms. Commodity production, he notes, "expresses the specific historical form of equalization of concrete labours as homogeneous [quantifiable] labour . . . [while] domestic labour . . . is not equal and interchangeable with other concrete labours" (Smith 1978:207).

19. See also Feil (1978; 1982b). Tombema Enga live to the northeast of Mae Enga. Like Hagen, there is a highly elaborated sphere of ceremonial exchange, although Feil also claims a number of contrasts. Principally, he argues, Tombema retain the value of pigs in exchange (and thus the value of 'production') in contrast to the Hagen specialization in 'finance' (evinced in the emphasis on shell valuables in Hagen prestations).

20. In fact he (1984b:242) makes this into a general assertion that where production for exchange is elaborated on the base of pigs (not shells), ties through and involving women are valued and women's position is enhanced, contra Modjeska 1982.

21. I find his emphasis odd after the description of men's and women's joint activities in production. (Are pigs not also the 'property' of the men whose labor went into them?) In these terms I would regard the association of 'house pigs' and domestic labor with women as gender ideology. However, Feil argues

for a complementary relationship between exchange and production in such a way as to make the prominence of men in one and of women in the other non-problematic. Both sexes take "joint, mutual decisions" in this single process (Feil 1984b:80).

22. Modjeska observes of Duna:

There is no question of men being thought of as non-labourers. The domination and presumably exploitation of women by men must be understood in terms of the relations of two classes of labourers, exchanging products and services . . . men are the direct producers of the means of production [in preparing gardens] while women are the direct producers of subsistence and wealth in the form of pigs. (1982:69)

23. Josephides (1983:305) notes Lederman's (1980:493, original emphasis) discussion of Mendi group displays: an evaluation of activities in terms of male/female and group/network distinctions means that "in formal contexts, *not only* are women ruled off stage, but *so also* are the 'personal' identities of men" (Lederman 1980:493). Men eclipse an aspect of their own identities.

24. The point is derived from Damon (1980, 1983a). Use-interest is appropriated by both husband and wife; the husband restores the pig to the household so that its use value may be realized, undoing the original transformation that put an embargo on this realization. The man determines how this takes place. In distinguishing the special nature of this male activity, the work that went into the production of pigs may be regarded as especially 'female'.

25. Or equally the idea of a divided self, which is part of the same proposition. I bring these concepts together to indicate how aspects of the one metaphorical set are raided for different analytical purposes. The problem is that the set does not allow an adequate entry into a multiple construction of personhood that does not rest on a model of a *whole* potentially divisible into parts. (The 'unity' of the Melanesian person is achieved through decomposition, not transcendence.) In terms of the present contrast it belongs to 'commodity' rather than 'gift' thinking.

I juxtapose the following passage from Kuhn's account of the constitution of subjectivity posed by Lacan and its relationship to the structure of private property. The context is the infant's grasp of his own reflection, which "is the moment of simultaneous unity and separation, in that the body is experienced as whole and yet as outside the previous operation of the [experienced] drives" (1978:60). She writes:

The non-unified character of the subject posed by psycho-analysis is argued in relation to the implications of the splitting involved in the specular relation of the mirror phase, so that the operation of ideology is seen as a lived relation of the Imaginary ego-ideal, the unified self, and hence as involving an attempted closure or recuperation of the subject/object split, an Imaginary coherence. The work of ideology is to construct a coherent subject. (1978:63–64)

Earlier she writes that "the operation of ideology is to reconstruct the coherent subject problematised by the very splitting which defines this specular relation" (1978:59). Notions of unitary proprietorship offer one such set of ideological operations. For a eulogy to the restoration of unity through a celebration of use-value production as against exchange value, see Caulfield: "production for

use-value involve[s] a unity between thinking and doing, thus making the process of labor a creative, learning experience" (1981:212).

26. Thus I do not utilize a contrast between conveyance and conversion, Bohannan and Bohannan (1968:234). Conveyances refer to an exchange of unlike items within the same rank category; conversions to the exchange of items across category boundaries. 'Subsistence wealth' and 'prestige wealth' are their terms.

27. For Marx, 'labor' is always instituted as an alienated productive activity (Ollman 1976:169).

28. However, this raises a question about the indigenous limits of the gift economy and how one should interpret resistance to enchainment (see below). Thus Schwimmer (1979), defining alienation as occurring when no equivalent gift is returned by those who extract a person's products, points to the phenomenon, marginal in traditional Melanesian society, of persons who fail to get others to recognize their claims. He does not regard this as applying to women as a category.

29. See for example Gregory (1982:12–44). In so far as I have drawn on 'Marxist' analyses, I have done so through a special reading of them. I appreciate Kalpana Ram's observation (pers. comm.) that I adopt a bourgeois (property oriented) standpoint myself and fail to incorporate a collectivist or socialist reading of political economy writings. My account of 'gift economies' thus neglects to give weight to the manner in which labor might be socialized, i.e., the product returned to the community as a whole. This is also an important strand in critiques of exploitation that distinguish the simple extraction of surplus from differences in the manner of appropriation (some of the contributions to Kahn and Llobera 1981). As in Sacks's account, communal appropriation of surplus labor can be understood as a condition of nonexploitation.

I would add, however, that to *assume* the absence of alienation under conditions of communal as opposed to private ownership belongs in my mind to an ideology of natural 'wholeness' which is itself a bourgeois fabrication. See Bonte's (1981) account of how surplus labor products may be channelled into the reproduction of the 'community' in noneconomic form, e.g., in order to reproduce certain religious relations, but the resultant cattle fetishism in the pastoralist societies with which he is concerned may be analyzed as a realization of surplus and the alienated form of labor. In short, my bourgeois reading is in response to what I detect as a strong private property ideology in much anthropological writing. This defines a limit to my enterprise.

30. Thus he states that a herd of pigs belongs to a wife by virtue of the 'labor' she has invested, though the comment confusingly follows a discussion in which he compares the different relations women have with their fathers and their husbands concerning 'ownership' (1984b:111–112). It is clear that a woman 'owns' a pig herd through the work she does *as a wife*; moreover, the jurisdiction she has over the disposal of pigs is restricted to those she has produced and not to those she has not produced. This leads Feil to analyze pigs as a form of 'property' created by the woman's labor—hence as pigs pass through various transactions on the exchange roads, the control which the original 'owners' can exercise becomes tenuous (1982b:341). For if jurisdiction

is the criterion of ownership he makes it out to be, then pigs passing out of women's hands compromises their inalienability. Feil goes on to say that in the course of the exchanges the question of alienability is no longer at issue. The pigs may be 'alienated from the producers' control', but among nonproducers are being exchanged for advantage and prestige. However (1984a:73, n. 34) there is a final equivocation in his account:

> "[P]igs are not ultimately alienated from their producers. The long exchange chains . . . [mean], however, that 'control', often temporary, does not always rest with the producers, usually women. Both men and women suffer these organisational dilemmas, and it is an outcome of the complexities and structure of an exchange system which has rapidly expanded, not a vehicle by which women are exploited by men.

31. Josephides (1985b:10–11) properly points to the inalienability of land in Kewa, for instance. Men's ownership is not a question of their being able to control and dispose of the land but derives from their indissoluble relation to it. (Women's name is not indissolubly linked to land in the same way.) In Schwimmer's (1979) terms, there is an 'identification' between land and men. It is important to note that the identification is with the land in a preworked sense; it is not because of men's work that the land is theirs (though the work of particular persons may be the basis on which some men of a clan group establish internal claims to particular pieces as against other men of the clan).

32. So that an antithesis is produced between other-directed and self-directed work. Work is not axiomatically 'self-expressive' (as self-activity that realizes the potential of human nature; Ollman 1976:101). On the contrary, to do one's own work in reference to oneself may either have the connotations of absolving others from any responsibility ('his/her own doing!') or else of creating a special relationship, as I describe shortly for women and their horticultural products, again a deliberate exclusion of others.

33. Surplus presupposes the creation of values in addition to the intrinsic, original value of things (the realization of surplus through the relationship between exchange value and use value). Such ideas project a level of 'reality' or 'natural life' upon which society is seen to perform its operations. On the one hand a real concrete increase of items is supposed; on the other hand surplus contains the specific notion that things can be deployed in ways other than those in which they originally manifest themselves. This is one source for the Western metaphor of 'production' (Sahlins 1976); Bonte (1981:38), on the determination of labor under capitalism, writes "only labour which produces surplus value is productive."

34. The following observation was also prompted in discussion with Daniel Miller, for whose insight I am most grateful; and with Nicholas Modjeska who, in commenting on Gregory's thesis of the 'personification' process, noted its concern with the consumption of the meanings of things but not with their materiality.

7: SOME DEFINITIONS

1. The present formulation revises the argument in M. Strathern (1984b). There I stressed the personification process in the production of wealth items

and detached the Melanesian concept of gift as referring to persons and their relations from Western concepts of 'objects' as opposed to 'subjects'. I now address the nature of objectification in a gift economy. The article refers to this as 'detachability', but my terminology was confusing. Josephides's comments (personal communication) on earlier formulations of mine have been a notably important stimulus here, for which I record my gratitude.

2. *Noman* refers to directed action, whether towards the self or towards others. The concept cuts across the Western individual/society split that represents a whole split into parts (A. Strathern 1981b). I thank Andrew Strathern for discussion on this point and for his linguistic elucidation in general.

3. To refer back to Sabarl: Battaglia (1983:298) notes that the active and dynamic *gaba* relations carry overt reference to a contrast between male and female, where the *labe* support idioms do not.

4. See Wagner's 'obviation': "a metaphor for metaphor, 'naming' it by substituting its effect" (1978:32).

5. The Bimin-Kuskusmin of the West Sepik imagine the shadow of the corporeal body after death to be androgynous, a combination of the procreative contributions of males and females (Poole 1981). The subject of Poole's paper is a sacred androgyne who has been removed from the concerns of the domestic-familial domain to a public (though largely secluded) role as ritual officiant for initiation sequences. She is endowed with the qualities of both sexes; he notes that the fertile fluids of this sacred woman are "a female manifestation of male substance" (1981:156). To be made active, however, involves reduction of this identity. Thus during the Bimin-Kuskusmin boy's transformation into a reproducer, if his androgynous body-shadow appears, it must be driven away (Poole 1982:114). Male bones once extracted from the androgynous body become an active force (Poole 1984; A. Weiner 1982).

6. Western recognition of a musical instrument as a sexual object would be based on the idea that it must express or symbolize in exaggerated form something that a person cannot openly say about him/herself. Credulity is strained by the thought that it could be equally a male or female object. But then our attention would be directed to the aesthetic form as the invented, cultural dimension; the music would be taken for granted as an axiomatic feature of musical instruments. To the Melanesian cult performer, the emissions are the crucial mystery.

7. I have had the advantage of reading James Weiner's doctoral thesis (1983), which will appear as *The Heart of the Pearshell* (in press).

8: RELATIONS WHICH SEPARATE

1. Battaglia's (1983a, 1983b) analysis of the combination and separation of male and female identities in Sabarl mortuary ritual is pertinent. I am, in addition, grateful to Martha Macintyre for discussions on Massim societies and respect her reservations about the ethnographic extrapolations on which the following is based. Gregory includes the *kula* in his general account, arguing that, as a system of incremental gift exchange, it differs little from systems found in the Highlands (1982:195).

2. Throughout the matrilineal systems of the Massim, the issue of (extrin-

sic) male work is important with respect to the (intrinsic) uterine identity of the man's children. Further afield, I have found both Nash's discussion of the Nagovisi (1974) of southern Bougainville and Epstein's (1979) psychoanalytically inspired account of Tolai (New Britain) shell money illuminating.

3. In anticipation of later arguments (chap. 9), I note that the food is 'his' because the couple's work is formally defined as creating a product for the husband. It does not 'mediate' a relationship between father and child but rather conflates their corporeal identities. Only when the child is recovered by the subclan (his mother's side), during ceremonies at death, does the father's kin (father's side) recover the food (seed material) implanted in the child (Damon 1983a:316). Goods classified as male are given to the child's subclan in return for goods classified as female. These female goods include large quantities of uncooked yams; within the overall female category, yam, they are of the male type. They are treated as seed yams, and restore to the father's subclan the original food with which he fed the child. What is restored to the subclan is thus similar to that lost: there is no transformation of this food into some other item. As Damon says, for the loss of the brother's male work, his subclan receives in the yam seeds the wherewithal to produce again.

4. When her brother's wife gives birth, the first excrement of the child is handed to her, in recognition of this lien, but she throws it away. This evidence of her brother's work does not come to her in consumable form.

5. A. Weiner (1976:123) elaborates on a similar situation in the Trobriand Islands.

6. One is reminded here of the epilogue to A. Weiner 1976, and the strong contrast the author draws between women's role in the regeneration of kinship and men's seeking renown through independent prestige-making transactions. That kin groups on Muyuw are seen as disposing of detachable parts of themselves in female form reappears in the dogma that represents the society as divided into clans which symmetrically exchange women between themselves (Damon 1983a:306–307).

7. As she describes for Gawa *kitomu*, in another part of the *kula* ring, absolute rights over the disposal of these objects is combined with the fact that they are inalienable from the producers (1977:44–46). For a rather different analysis, see Macintyre (1984) who keeps the term 'semi-alienable' to refer to the disposability of *kitomwa* in Tubetube. On the Trobriands, *kitoma* are valuables that are not yet part of any *kula* road or which have left a road (A. Weiner 1976:129, 180). I thank Annette Weiner for allowing me to see unpublished materials of hers on the Trobriands.

8. Conversely, Muyuw conceptualize *kitoum* as 'productive' items (e.g., Damon 1983a:285). They are apprehended as things that can be used to make something else. *Mwal/veigun* on the other hand are regarded as 'finished articles'.

9. Several of these points bear comparison with MacLean's (1985) provocative analysis of political and domestic relations in Maring.

10. This is increment not surplus, for there is no external measure of this difference: the distinction between the *moka* component and debt lies only within the histories of particular concrete relationships.

11. This would appear to apply to pigs only; there is not the space here, unfortunately, to argue about the mutual metaphorization of pigs as shells and shells as pigs (even though they appear to originate in quite different relationships; see notes 19, 20, in chap. 6).

12. M. Strathern (1981a:181–184) notes certain rhetorical contexts in which relations between spouses are compared to relations with clansmen and with male allies/enemies.

13. Hence the 'trick' of the *moka* gambit (A. Strathern 1971:98) that defies translation into numerical gain and loss. The numbers at any one moment merely stipulate increment and debt.

14. Schwimmer (1973:86) draws on Lévi-Strauss's analyses of identifications, as those between sacrificer and victim, and specifically acknowledges his insight apropos the identity of something intended to be given to another: "If we produce something that is intended to be given away, it was called into being by a prior relationship between donor and recipient" (1973:170, emphasis removed).

15. This is an attempt to describe the conceptual basis of exchange, not a sociological analysis of the kind amply offered in the Hagen ethnography. Thus the units of *moka* exchange, while invariably conceived agnatically, are not always of the order of clans. The organization of ceremonial exchange in fact takes place in contexts in which the particular political identities of the partners are highly relevant—these identities feed into enmities, rivalries, and alliances. *Moka* also mobilizes kinship identities, for example when an occasion is said to compensate matrilateral kin for some form of nurture; but this is very much in the nature of a pretext. These kin ties are taken for granted; they are not themselves altered in the process of the transaction (A. Strathern 1978).

16. The image of 'flow' has captured the imaginations of a number of Melanesianists—D. Brown (1980); A. Weiner (e.g., 1980); O'Hanlon and Frankland (in press), not to speak of Watson who entitled a paper "Society as Organized Flow" (1970). Gregory (1982:chap. 3) refers to velocity. To be true to indigenous metaphors, it must not be things that flow but relations: conventional social life 'flows' more or less spontaneously in the world, as Westerners might imagine time flowing (Wagner 1977b:397). Muyuw do not invent the flow of relations: they make relations appear by differentiating male from female valuables and thus one exchange partner from another; Hagen men do so by incremental additions that similarly differentiate the partners. They strive for the replication of appearance itself (velocity). *Kula* and *moka* valuables thus objectify the speeding up effect that will demonstrate the effectiveness of their efforts. According to further Massim idioms valuables 'walk around', going like people along 'paths' (e.g., A. Weiner 1976:181). Against the smooth, uninterrupted desirability of flow, they show all the recalcitrance of human travellers, getting diverted, being slow, losing their way.

17. Hagen affines and matrilateral kin form only a part of a more general category of *moka* partner; in Tombema Enga by contrast (see chap. 6) ceremonial exchange (*tee*) is always conducted between persons who regard a link through women as intrinsic to the relationship between them (Feil 1984b: 156ff). This contributes, it seems, to a characterization of *tee* partners as un-

equal to one another. Asymmetry comes not simply from the exchange in question, the alternating indebtedness created by the *tee* wealth, but also by this prior kinship. (What Feil refers to as complementarity, however, is not institutionalized to the degree found in many Lowlands New Guinea societies; asymmetry is not 'fixed' into an enduring perception of imbalance between wife-givers and wife-takers, mother's brothers and sister's sons. Although maternal kin are "owners of the child" (Feil 1984b:159) and compensation must be paid for injury and death (compare Meggitt 1965), it is not this field of relationships on which *tee* partnerships are specifically built. Feil himself notes that brothers-in-law form the largest category of *tee* partners.) Overall, Tombema partnerships are not generalizable to the same extent as in Hagen where ties through women, whether they are or are not a rationale for a particular *moka* relationship, are not intrinsic to the temporary inequality set up by the mediation of wealth objects. Feil emphasizes their complementary nature and the noncompetitive, cooperative nature of *tee* partnerships. Competition in Tombema is reserved instead for that body of men who do construct relations with one another on a generalized basis—between clansmen and between clans who are "indistinguishable from each other except by name" (Feil 1984b:157).

18. This need is created by the substance taking one of two forms, with distinctive effect: women's substance (blood) is always in sufficient supply, whereas men's (semen) is not. In the light of the remainder of this chapter, some correlates of this disparity are briefly sketched.

A Daribi embryo is regarded as formed from the contributions of both parents, in the sense that children manifest the substance flow of two linealities, from mother and from father. There is an asymmetry between wife-givers and wife-takers, however, in bridewealth exchanges. Wife-takers give male items and "represent their flow to the wife-givers as that of maleness," giving meat and other adjuncts of male productivity (Wagner 1977a:628); this set of men also represents its relations to its own offspring in terms of male flow. They regard the lineal flow of the wife-givers as that of female substance and receive from the wife-givers female wealth items. Wife-givers themselves regard the giving of their woman as their own lineal flow of 'male' substance: but in the items that accompany this gift they represent this flow as 'female' (in bark cloth, net bags, and adjuncts of female productivity), and distinguish it from what will be passed on to their offspring. A transformation thus takes place that we can compare to that of *moka*. Women emerge as the detachable objects of mediation. Their persons embody a male flow from their kinsmen that the husband's kin interpret as female flow. Departing from their kinsmen as partible metonymic gifts, one could say, they present themselves to their affines as metaphoric gifts, totalizing the identity of the maternal connection.

19. La Fontaine's (1978; 1981) argument about the importance of men's domestic status to their 'adult roles' and the significance of making them into fathers has been influential here. Derived in the first place from African material, she intends its general application, though my Melanesian emphasis turns it somewhat.

20. I refer the reader to Herdt's ethnography for an explication of the rela-

tionship between the cult participants according to the initiation stage they have reached. Novice refers to the junior boys in the early stages of the sequence who are fellated by more senior participants.

21. In the context of analyzing commodity objectification, MacKinnon writes about fetishism as a Western fixation on dismembered body parts. She remarks: "Like the value of a commodity, women's sexual desirability is fetishized: it is made to appear the quality of the object itself, spontaneous and inherent" (1982:26). Objects of desire are indeed the fetishes of a commodity economy (Gregory 1982:7). Herdt argues that the Sambia boys come to experience the flutes as both penis and breast; the subject matter of this confrontation remains in his account an orientation out from the self, towards others, who then assume an object position: "The focus of initiatory symbolism [is] on the child's tie to his mother" (1982:81). The initiate is thus seen as having to redirect his primordial urges and feelings from one object of desire onto another.

22. In terms of the *particular* relations of individuals, however, a boy's ritual sponsor (a pseudo-kinsman who combines maternal and paternal attributes (Herdt 1984b:188), is emphatically not his homosexual partner (see n. 29 below). I would add that metaphorically the body of men as a whole—senior and junior, sponsors and partners—becomes within the cult house a body of 'children', produced by sexual interchanges between men and women which have taken place outside. (In one of their aspects the flutes cry out for milk [Herdt 1982a:78]; they [the men] are also children [see below].)

23. It is superfluous to add that it is only Herdt's full reportage and analysis that makes further extrapolation both possible and of interest.

24. I owe this specific analysis to Gillison's profound exposition of Gimi practices, including work in unpublished papers which I have had the privilege of seeing. (Apropos the gender of the flutes, note that bamboo containers may also be regarded as vaginas [Herdt 1981:250].)

25. The possibility of their being seen to do so over two generations is blocked by marriage conventions that prevent close kin from marrying.

26. Semen flow mirrors marriage transactions between groups: the same clan that donates a wife also contains men who are appropriate homosexual partners, including actual brothers-in-law. A man may thus inseminate both his wife and her younger initiate brother. (He is thought to 'grow' the wife as well as the boy.) Because of sister-exchange, this direction may be reversed for others of the man's clan (Herdt 1984b:193–194).

27. This is significant for the analysis of siblingship, as Kelly makes plain in his description of similar relations in Etoro, on the Papuan plateau. Kelly notes that "brother and sister have analogous relationships of sexual partnership to the sister's spouse" (1977:270). A man's sister's husband is the ideal homosexual partner (1977:232). True sister-exchange, when it takes place, enables brother-sister pairs to continue in co-residence after marriage (1977:136, 148–149). Ordinarily, sisters' husbands will be older than wives' brothers, an asymmetry which one might conjecture makes this category similar to that of the mother's brother in other Highlands kinship systems (an exogenous source of substance). This may or may not hold for Sambia, but I note Herdt's

suggestion (1984b:185) that the symbolization of the adult male's semen replenishment (from a tree) is not symbolic insemination but symbolic breast-feeding.

28. A husband prepares his wife's body for sexual intercourse by initially feeding her as he will have fed her 'younger brother'. It is this semen which is regarded particularly as creating breast milk in her (for his/her child).

29. The equation is concealed, however, by marriage arrangements that emphasize that actual sexual contacts are only possible among unrelated people. A boy's ritual sponsor is called 'mother's brother' and sexual contact between them is prohibited (Herdt 1984b:187–188). One may note here the similar concealment of Etoro 'moieties' in the possible equation between mother and wife (Kelly 1977:203).

9: FORMS WHICH PROPAGATE

1. Some evidence for Hagen is given in M. Strathern (1984b), but the phenomenon is widespread. Hagen women (not men) may be referred to as *mel*, 'things'; but see n. 3 below.

2. Marshall (1983:9) discusses examples of complementary relations between cross-sex siblings. He cites the Kuma (Wahgi): "Wives, they say, are expendable, because a man can always get another, but he has no way of replacing his sister. His sister has a womb. The womb in her body is the one that would have been in his own if he had been a female. It is a short step to considering it as indeed his own womb, though situated outside his body. Cross-sex siblings together constitute . . . a complete human being" (Reay 1976:80). The wealth symbolizes that part of the complete being which is detachable—from the woman's point of view, that part of her relationship with her clan that allows or compels her to move away; other aspects of her clan identity (the 'name' she carries) she is not separated from, for it is such she brings to her affines.

3. See n. 18 in chap. 8. The conditions under which whole male persons are realized as wealth in Hagen are also conditions under which a man is extracted from his agnates as a collectivity, namely when he dies at the hands of another. Homicide compensation for injury to the clan replaces the person of the man much as bridewealth replaces the persons of clan sisters. Reparations made for men lost in war are thus distinct from regular mortuary payments. In the latter case, it is the deceased's maternal clan who realize his person as wealth. Sister's sons are, of course, a detachable 'part' of the maternal clan.

4. Rather than referring to subclan, I have retained A. Weiner's own use of *dala* for what she calls a lineage (see 1976:chap. 2).

5. Damon (1983a:322–323) discusses differences in kinship terminology as part of a wider set of differences between Muyuw and Trobriand 'circulation forms' and kinship transformations (see also Damon 1983b:312–313).

6. Women's skirts and men's axes are, it seems, distinctive wealth objects only on the Trobriands (A. Weiner 1983:160, 167).

7. A. Weiner 1976:112 describes how at one stage of the mortuary ceremonies, the male and female kin of the deceased each carry gifts, the men male wealth and the women female wealth, to the widow/er's *dala*. I refer to trans-

actions between spouses, but of course the father is also an important affinal figure.

8. Brother and sister do make small private gifts to one another, and publicly a woman helps the brother in duties performed for his children (A. Weiner 1976:208). But they mainly 'transact' via the activities of their spouses. (Note that by contrast with Muyuw, a woman does receive the products of her brother's work in consumable form.) It should be added that a brother is not the only man who supplies a woman with yams, and I have simplified the account here in focussing upon him. A woman receives yams from her father, for instance, for which she makes a return of female wealth to his *dala* (A. Weiner 1978:180).

9. Brindley (1984) brings together evidence for the Trobriand equation of yams and children and for the activity of garden work and childbirth. (See A. Weiner 1976:chap. 8, esp. 196–197, 207–210.)

10. And my account draws from ethnographic records where the two are often conflated. Thus I have picked out some of Malinowski's observations as indicating grounds on which to criticize others: so I accuse him on his own 'evidence' of conflating a crucial distinction!

11. Perhaps this is how one should interpret the explicit complementarity of male and female contributions to growth in yam magic spells (A. Weiner 1976:196).

12. See (Herdt 1984:180). The container image is widespread in the Eastern Highlands (e.g., Godelier [1982:14] reports that the Baruya father is said to make and feed the body of the child). In Sambia, a man's semen forms a pool in the womb which eventually coagulates into skin and bone. The fetus is graphically described as encased in blood (Herdt 1981:196–197). In expelling the blood, the woman also expels the semen-fetus. Here the disposability of female blood is emphasized and exaggerated in their approach to menstruation, a topic which Trobrianders treat seemingly lightly.

13. What is true of gender is also true of the Hagen domains of 'the domestic' and 'the wild' (M. Strathern 1980); the one exists as a counterpart world to the other.

14. My rendering of this observation has been sharpened by conversations with Richard Werbner and the opportunity of reading his contribution ("Trickster and the Eternal Return: Self-reference in West Sepik World Renewal") to Bernard Juillerat's symposium, *The Mother's Brother is the Breast: Ritual and Meaning in the West Sepik* (n.d.). I am very grateful for his insights.

15. Recall that wealth exchanges distinguish female *dala* members as dealing with female wealth and male *dala* members with male wealth. The two are held distinct, not merged.

16. It is worth noting that I keep track of the ideas that come from Gillison's work in order to make explicit the specific form which certain issues take in Gimi (see pp. 45–46). Here, my account also draws indirectly on Gillison's further essay on the mother's brother (in press). The blood of a Gimi woman's first menses is in particular thought of as paternal. Salisbury suggests that a Siane child is composed of paternal spirit in the form of semen and of maternal spirit in the form of blood (1965:59); the two types appear to be versions of lineage spirit. (That one comes from an exogenous source, the maternal lineage,

is no contradiction.) Women continuously produce spirit, which Salisbury also notes takes the form of 'paternal blood' (1965:72). But at various points in their maturation, they are also 'fed' spirit, in both male (pork) and female form (opossum). At marriage, the feeding of pork becomes separated from the transmission of the 'pure' lineage spirit which is retained by her natal kin (1965:74).

17. Menstruation is always said to be caused by a husband, the first menses by the woman's 'first husband', the moon. In the ritual, the father-in-law offers the girl her husband's 'water' (semen), while the initiand responds she is only thirsty for the water of her father (Gillison 1980:159).

18. Replication is deliberately enacted. The ceremony of bride-transfer/birth which Sexton describes for Daulo *wok meri* (1982:179) employs doubles: two women play the part of bride-giver/mother to the bride-receiver/daughter group, who also provide two women. The latter pair jointly carry away the child.

19. "In order to take root and prosper, new life must achieve a state of union with the female. As one man expressed it, 'In song, the woman's *auna* [life force] and the food's *auna* are made one. That is how the food grows bigger!'" (Gillison 1980:148).

20. J. Weiner (1982:27) notes that whether food is or is not recognized as being transformable into vital substance, or substance is or is not an object of transaction in exchange relations, will bear on the substitutability of women and wealth in marriage exchanges.

21. Margaret Jolly (personal communication) remarks that the important thing about the identification of pigs and persons (in Vanuatu) is that pigs can *be nurtured*. The 'quasi-kinship' (LiPuma 1979:48) relationship between pigs and their female caretakers is often remarked in Melanesia.

22. One thinks here of the category of Siane 'property' known as 'person-alty'. The term for 'owner' (*amfonka*) is derived from the word for shadow: "As a shadow is attached to the person who casts it, so are objects attached to their *amfonka*, and just as the shadow is identified with the soul, so are objects 'identified' with their *amfonka*" (Salisbury 1962:61). Objects are so identified by the work that has gone into them; they include a range of items, including a woman's growing crops whom she guards against all comers. But see Sexton's comments on this (1984:144). The exclusiveness of the tie (the 'unity') will vary with time—on whether the food is being internally 'grown', whether it is being prepared for another, or whether it is to be given away. Schwimmer (1974:226) describes the moment in Orokaiva myth where taro becomes differentiated— from being female at all stages of its development, it becomes male at the point where it is available for prestation.

23. On the killing of pigs as a productive act, like planting a garden, see LeRoy (1978) for the Kewa.

24. Gimi fears of retention have already been described (see chap. 5). The 'false pregnancy' fears of the neighboring Hua refer to a condition that may afflict either sex (Meigs 1976:52–55; also Hays and Hays 1982:266). It arises when menstrual blood collects in the womb or stomach under circumstances when it can have no outlet (in the man's case, because there is no birth passage).

For men the fear seems to be that instead of releasing partible substance, they will become the receptacle for it and absorb 'female' blood.

25. As gardeners, women cultivate the 'skin' (flesh) of the ground, whose 'bones' the husband owns (Biersack 1984:132). The 'inside' domain (the house-and-gardens area which is the center of domestic activity) is the site of transactions between husband and wife (see above p. 130). Biersack emphasizes the relationship of noncommunication (nonexchange) between a woman and her gardens: that productive activity is conducted in solitude (1984:121). We may recall that growth in persons is thought to occur covertly, under the skin (e.g., 1982:241). This growth is thus contained by the 'skin' which is the surface of men's transactions with the world. Skin, she writes, "like walls and fences, creates a center of exclusivity" (1984:132). It encloses a dumb unity (a 'personal' center she suggests) to be contrasted with the organs of mind and speech that are a 'social' center of communication. The growth transactions to which Biersack refers are unmediated, though I noted that one of the objects of the ritual is also to force a mediating mode on the boys' relationship with the spirit. But for the growth itself to occur, it has to be clandestine (1982:251). Growth happens at night, secretly, and all Paiela growth magic is hidden, 'lest people see' (1982:241).

26. Or the man on whose land she lives. Men's souls or life-substance may be specifically tied to clan territory. Maring idioms refer to clansmen as 'rooted' in soil (Buchbinder and Rappaport 1976; LiPuma 1979).

27. The following discussion of clanship owes much to Rena Lederman's writings on Mendi that she kindly made available to me in unpublished form.

28. A nonagnate is referred to as a "taken and re-planted man," "taken and made-to-be man," "taken and placed man" (A. Strathern 1972:19).

29. I read MacLean's article after formulating my own argument and refer to it for the purposes of comparison.

30. The model of the Hagen clan as a body comprising both males and females is recreated in the course of cult performances in which a community of males enacts the internal division into 'men's and women's' sides (chap. 5 n. 12; also M. Strathern 1984a:22). One might compare Biersack's description of Paiela (cognatic) kin groups. The consanguineal group that 'combines' separate identities internal to itself, in external transactions behaves as an exogamous, gift-giving entity, with "one mind, one body, one talk, one pig herd" (1983:88). In this guise, the group may be referred to as 'male'. Singleness or unity of mind (intention) is regarded by Hagen men and women as an achieved mental state, in opposition to the multiple desires that inevitably inhabit persons and give them 'many minds'. Purposefulness ('single mindedness') is not a unification or making whole of these disparate, conflicting elements but sets them to one side in the interests of pursuing a particular course of action.

31. See Foster's apposite comments on Enga ceremonial exchange, where a line creates a unity from what is simultaneously conceived by the actors as a multiplicity of sources:

> the creation of a straight line out of pigs *from various sources* . . . reflects the influence of a man in the groups from which pigs have been 'pulled'. Accordingly, the gloss

of 'big man' for *kamungo* seems happily appropriate, for the essence of the *kamungo* is his ability to incorporate the identities of others—their productive capacity—into his own. (1985:192, my emphasis)

A. Strathern (1971:190) comments on the Hagen description of a big man as one "at the head of the *moka* who gathers and holds the talk," which incorporates a phrase also used in cult performances to denote male unity. One might liken 'straight' (true) talk to a line of pigs on display. (Goldman 1983: 220; O'Hanlon 1983.)

32. Again a point I have adapted from Werbner (see above n. 14).

33. Modjeska argues that Duna, by contrast with Hagen, do not separate off a sphere of pig circulation (a domain of ceremonial exchange) in which financed pigs become differentiated from domesticated pigs (Modjeska 1982:95). Gregory (1982:166 et seq.) himself touches on aspects of the difference in terms of a contrast between the restricted and balanced exchange of items in some societies of Papua New Guinea, and incremental, delayed exchange in others. Godelier (1982) contrasts great-men and big-men systems, the former with restricted (direct) exchange of women, the latter depending on the mediations of wealth to effect marriage and create kinship.

However, Modjeska does offer a significant division between types of circulation. Even though all transactions with valuables are related to the ends of kinship, he notes a 'battle of the sexes' in the divergent interests of lineages and families (1982:103 et seq.). Men tend to promote the exchange of live pigs between lineages (his circuit I), where women desire sacrifice, which is the rationale for internal consumption (circuit II). Sacrifice defines domestic sociality: it "integrates the men and women of the lineage in their internal relations of production" (1982:104). This is in effect a sphere of unmediated relations. Thus the ancestors' feeding on pork is known through the effects that follow; there is no other sign or message of their having fed. It is a gift-less transaction, as are relations between the men and women, for they do not give to one another but join together in the eating of meat. Modjeska himself argues that Duna sacrifice corresponds to a communal mode of surplus appropriation. "Those who have mixed their labours in production partake mutually in consumption. It contrasts with exchange, which is an inegalitarian mode" (1982:105).

34. I argued the point for the Wiru of the Southern Highlands (M. Strathern 1981b; 1984b). Wiru sustain payments to maternal kin throughout their lives, or to their substitutes: differentiation is never finalized.

35. The kinds of kin-based transactions referred to here include bridewealth, mortuary, and child payments, as well as exchanges accompanying initiation and other kin celebrations. An example of a high degree of politicization is found in Chimbu (e.g., P. Brown 1961; 1964; 1970).

36. One example, Wiru of the Southern Highlands, is discussed in M. Strathern 1981b.

10: CAUSE AND EFFECT

1. Contrast his more subtle discursive observations. He writes that it is "impossible for a man . . . to support himself independent of his relationships"

(1979:154). "If a man has a curse laid on him by an angry maternal uncle and is driven out of the society, he feels 'in perdition'. Having been obliged to flee, he no longer has any relationship through which to find himself again. Not even his speech manifests his being, because his being has no correspondence in society and answers to no recognizable personage. He suffers from losing his role in which he felt himself to be specifically a personage. He no longer exists socially. Feeling he is nothing other than a social being, he suffers from not being. *He needs to be able to be summoned*" (1979:155, my emphasis).

2. [See fig. 5 over.] Although Young (1983:266) is commenting on the conceptualization of historical time as an alternating sequence of plenty and famine on Goodenough, another Massim society, he reproduces in this context Jenness and Ballantyne's depiction of incized patterns (fig. 5A). It evoked for Young the timeless serpents whose myths are shed along the sinuous paths of their travels, as they might have shed wealth if the myths had turned out otherwise (1983:chap. 3). Damon (1980:280) depicts the way a Muyuw person's name (his 'hand') travels along a *kula* chain as an alternating process in which one man's immediate partner (*veiyou-*) is the route through which the name of his partner's partners (*-mul*) comes to him. In relation to figure 5B, Damon explains that the valuable C receives from D will be referred to as E's 'hand': "what this means is that the direct exchange between any two partners is always conceived as an exchange between the people on either side of them" (1980:280). In this case, D is the agent for that exchange. *-Mul* may in fact refer to any number of partners beyond the immediate one (D).

3. I wish I could have taken advantage of Jadran Mimica's monograph, *Intimations of Infinity* (in press), based on an analysis of the number system of the Iqwaye, who belong to the same language family as Sambia and Baruya. Mimica describes the (mathematical) manner in which multiplicity is converted into unity and the mythology of sociality and personhood so entailed.

4. In Hagen, these alternatives are gendered: what is true of *any* mind is also seen as split between the characteristically 'many minds' of women and the 'one mind' of men.

5. Given the way events are subsequently discussed and reinterpreted, and given the expectation of multiple views (O'Hanlon 1983), the unity of the audience's judgements is also, of course, a fabrication.

6. Hence my argument that the Hagen clan 'borrows' a kinship metaphor in its self-representation as exogamous (see chap. 9). This endows it with a prioritization of sorts.

7. In reference to Wahgi (Western Highlands), O'Hanlon and Frankland (in press) characterize a person's relations with his/her mother's brother not as a matter of their 'sharing' blood but the one as a source of the other's. Thus the mother's brother 'grows' his sister's child. (See D. Brown 1980:306). I would also refer to the emphasis Gewertz places on a similar concept (for the Sepik River Chambri). She stresses the asymmetry of kin debts: persons are regarded as owing their lives to their mothers' clans, for instance, who are thus their origin or cause (Gewertz 1984). As she observes, for this culture causes are more important than effects (personal communication). My formulation of cause-effect relations owes much to this insight from Chambri.

Refer to note 2.

A. From Young 1983: 266, writing on Goodenough Island.

Either the chevron, /\/\/\/\ , or the continuous curve,
the latter usually double, ⁓⁓⁓ appears in most of the carving, whether on the canoe, the drum, the club or the bowl; they are frequently used to separate two patterns.

(Jenness and Ballantyne 1920: 199–200)

B. From Damon 1980: 280, writing on Muyuw.

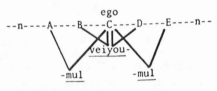

Fig. 5. Two Images from the Massim.

8. Vegetative idioms deserve treatment by themselves. I would just mention the suggestive material in Gell (1975) (especially on the symbolism of trees and growth); and from a quite different part of Melanesia, Goodale (1980).

9. His concern is with the way Avatip cosmology does not reflect but appears to provide a 'wholly alternative' version of the social order, which turns out to be a projection of interests, not of moral rules. Bloch (1980) tries to show a domain of ritual that not only does not affirm other 'social values' beyond itself but carries messages that go against those of nonritual discourse.

10. Also Wagner (1975), and see above chapter 7, n. 4. These several forms of deconstitution could be gathered under the rubric of obviation.

11. One may cite the concerns that in many areas surround female fertility (e.g., Van Baal 1984). Theories of the accretion and depletion of vital fluids (Kelly 1976), or of the running down of the universe (Sørum 1984), construct a particular anxiety about origins, and on the ritual creation of anxiety see Poole (1982), Tuzin (1982).

12. The argument is spelled out in M. Strathern (in press), which compares Hagen mortuary metaphors for bridewealth with the corresponding Wiru equation between bridewealth and childbirth payments.

13. The sequence is explicit in Gimi. See, for instance, Gillison (1983:47). In Hagen "The bride's kin are said to 'eat' the bridewealth, while the *husband* 'eats' (i.e., has sexual intercourse with) the bride" (A. Strathern 1982b:128, my emphasis). The term for penetration on the husband's side is also the term for striking, killing, or planting, that is, having an effect on another. To be the

recipient of an effect, such as a blow, is to be 'struck' by that effect, or 'eaten' by it in the case of pain and misfortune.

14. A converse of this can be seen in the poignant 'witchcraft' beliefs of people such as Hageners (e.g., A. Strathern 1982b) who regard greed as ultimately consuming the person whom it drove to being greedy. What appears to the Western mind as a confusion of substance and identity can be understood as the regressive substitution of acts.

15. One might underline Tuzin's (1982) plea that we attend to the question of pain in ritual action which participants may also perceive as cruel. See Hays and Hays (1982:282, 284) on the Ndumba idea that pain strengthens the body.

11: DOMINATION

1. The first principle of Fox's four fundamental tenets of kinship systems is presented as a "fact of life," viz. "The women have the children" (1967:31). See La Fontaine's critique (1981:333–334).

2. The words are Rubin's (1975:172), quoting Mauss's *The Gift.* She adduces a comment by Sahlins in much the same vein (in stateless societies the gift achieves civil peace).

3. As in Elshtain's case (see below), this may be inspired by Mitchell's initial incorporation of Lévi-Strauss's thesis into her *Psychoanalysis and Feminism* (e.g., McDonough and Harrison 1978:20–21). Mitchell faithfully reproduces his argument that the exchange of women is the exchange of signs, i.e., values attached to particular relationships. However, elsewhere (1971:106) she refers to the biological function of maternity as a universal, atemporal fact. Eisenstein (1984:chap. 2) comments on Ortner's use of Lévi-Strauss. I make these citations as a matter of interest in the way anthropological kinship theory has been used outside the subject. On the other hand, Sayers (1985:99–100) links together Mitchell's and Rubin's approaches as Lacanian versions of psychoanalysis.

4. In *The Elementary Structures of Kinship,* he refers mainly to women as objects of sexual desire and as significant economic producers rather than in terms of their childbearing capacities.

5. See Lévi-Strauss (1969:42) on every individual having access "to the women of the group." He also refers to 'the group' as controlling 'the distribution' of women (1969:32). I put it thus because although such a reading is clearly possible from the original, it does not do justice to the overall account. See, for example, Friedman's comment on marriage exchange and how it is misunderstood (1974:452). It is unfortunate that Lévi-Strauss should have found it necessary to account for the value of women through what in English translates into a commodity idiom. Or perhaps one should regard it as an ideological oversight. There is no doubt that this has been received as one of the central messages of this book by feminist and nonfeminist anthropologists alike.

6. See also Elshtain (1984:63–64). Both Mitchell (1975) and Lévi-Strauss (1969), she argues, are at fault here, the latter in a way that goes against his own evidence.

7. And generally. I pull out Schneider's quotation from Scheffler (1974:749), that "the foundation of any kinship system consists in the folk-cultural theory designed to *account for the fact that women* give birth to children" (Schneider's emphasis; 1984:125). Also Van Baal, "Motherhood is the basis of all kinship" (1975:79).

8. I have since come across the following passage from Mitchell (1971: 109):

> reproduction in our society is often a kind of sad mimicry of production. Work in a capitalist society is an alienation of labour in the making of a social product which is confiscated by capital. But it can still sometimes be a real act of creation. . . . Maternity is often a caricature of this. The biological product—the child—is treated as if it were a solid product. Parenthood becomes a kind of substitute for work, an activity in which the child is seen as an object created by the mother, in the same way as a commodity is created by a worker. . . . [t]he mother's alienation can be much worse than that of the worker. . . . The child as an autonomous person, inevitably threatens the activity which claims to create continually merely as a *possession* of the parent. Possessions are felt as extensions of the self. (original emphasis)

Kristeva refers to the (Western) experience of pregnancy "as the radical ordeal of the splitting of the subject: redoubling up of the body, separation and co-existence of the self and of an other," and as consequently a "fundamental challenge to identity" which is accompanied by a narcissistic fantasy of totality (1981:31). The arrival of the child, however, leads the mother into a labyrinthine love for another, where the ability to succeed in guiltless maternity becomes a true 'creation'.

I would also refer to the exposition by O'Brien of Hegel's formulation of reproduction (the unity of the conjugal couple produces a new entity that both is and is not themselves), in which she points to his neglect of the role played by female labor. She writes: "the separations of which Hegel speaks are differentiated by gender. Man's seed, once alienated, is permanently estranged. . . . Women part from a whole child, but this alienation is mediated by labor. By her labor, the woman confirms two very important things. One, obviously, is the knowledge of this child as in a concrete sense *her* child, the product of her labor, a *value* that her labor has created. The second is the experience of an integration with the actual continuity of her species" (1982:106, original emphasis).

9. Compare Mathieu's (1984) insistence that maternity anywhere involves the conventional ('social') allocation of mothers to children born into the community, i.e., that childbirth is a social act.

10. It also leads to the awkward task of having to identify the positions in privilege, and thus the 'central institutions' of society, in order to measure women's exclusion and disqualification from them (e.g., Schlegel 1977:18–19). See pp. 67–68.

11. Compare Nadel (1957:10–11): "All relationships, through the linkage or mutuality they signify, serve to 'position', 'order', or 'arrange' the human material of societies."

12. Where these appear to deny communication as in unprovoked acts of violence, or between mother and speechless child, they may be held to exhibit

'natural' behavior (pathological in the case of the former, biological in the case of the latter, but in either case as less than 'social' in character)!

13. Obviously I agree with Harrison's remarks (1985a:127) that it would be "misleading to regard the religious and domestic perspectives as 'models' held respectively by men and women (cf. Ardener 1972). The ritual and familial ideologies are not properties of two social groups but of two organisational domains". See also M. Strathern (1981a:169, 184).

14. One would expect, therefore, to find such appropriation to be specific to social contexts, as indeed Collier and Rosaldo (1981) indicate in their discussion of mothers in societies where women are celebrated neither as nurturers nor as the givers of life.

15. Langness (1977) stresses men's interest in childbirth but from the perspective of their 'control' of the relationship between mother and child.

16. Although he suggests that it is the inclination to care-giving developed from these functions which "makes women immensely valuable to society in general, and to men in particular" (Van Baal 1975:107).

17. Women are the vital audience for men's productions. The remarks apply particularly to the Highlands, and specifically to the Eastern Highlands male cults of both a homosexual and nonhomosexual kind. (Gimi men's houses in which men initiate their sisters' sons are referred to in song as the 'nests' of birds; in growth spells, the nest of the echidna is glossed as the maternal womb [Gillison 1980:146–180]. A woman menstruates, by contrast, in a 'flute house' [1980:156].) Elsewhere, as in the Sepik, cult houses themselves may have explicitly feminine characteristics; the matrilineage plays this role prominently in the Massim.

18. Biersack (1984) argues that Paiela men are the organizers of procreation through their exchanges. If men are also agents in such contexts, it is because of women's prior actions at other times and the acts it is anticipated they will perform.

19. Although I use the instance of childbirth, the same could be said of horticultural production. LiPuma (1979:45) writes of Maring that they "are quite explicit that the productive efficacy of women follows from the ritual efficacy of men [in propitiating the ancestors]."

20. On Paiela metaphors of big men and small women, see Biersack (1984).

Bibliography

Bibliography

Note: The bibliographic limit of this work is 1985. Material available to me then but published since is noted *in press,* with the reference following.

Adams, Parveen. 1979. "A note on the distinction between sexual division and sexual differences." *m/f* 3.

Allen, Michael R. 1967. *Male Cults and Secret Initiations in Melanesia.* Melbourne: Melbourne University Press.

————. 1981a. *Vanuatu. Politics, Economics and Ritual in Island Melanesia.* Sydney: Academic Press.

————. 1981b. "Rethinking old problems: matriliny, secret societies and political evolution." In M. R. Allen, ed. *Vanuatu. Politics, Economics and Ritual in Island Melanesia.* Melbourne: Melbourne University Press.

————. 1984. "Elders, chiefs, and Big Men: authority legitimation and political evolution in Melanesia." *American Ethnologist* 11:20–41.

Ardener, Edwin. 1972. "Belief and the problem of women." In J. S. La Fontaine, ed. *The Interpretation of Ritual.* London: Tavistock Publications.

Ardener, Shirley, ed. 1975. Introduction to *Perceiving Women.* New York: Wiley and Sons.

Atkinson, Jane Monnig. 1982. "Anthropology" [Review Essay]. *Signs: Journal of Women in Culture and Society* 8:236–258.

Augé, Marc. 1982. *The Anthropological Circle. Symbol, Function, History.* Trans. by M. Thom. Cambridge: Cambridge University Press.

Barnes, John A. 1962. "African models in the New Guinea Highlands." *Man* n.s. 62:5–9.

————. 1973. "Genetrix: genitor::nature: culture?" In J. R. Goody, ed., *The Character of Kinship.* Cambridge: Cambridge University Press.

Barnett, Steve and Martin G. Silverman. 1979. *Ideology and Everyday Life.*

Anthropology, Neomarxist Thought, and the Problem of Ideology and the Social Whole. Ann Arbor: University of Michigan Press.

Barrett, Michèle. 1980. *Women's Oppression Today. Problems in Marxist Feminist Analysis.* London: Verso.

Barth, Fredrik. 1975. *Ritual and Knowledge Among the Baktaman of New Guinea.* New Haven: Yale University Press.

Bateson, Gregory. 1958 [1938]. *Naven. A Survey of the Problems Suggested by a Composite Picture of a Culture of a New Guinea Tribe Drawn from Three Points of View.* Stanford: Stanford University Press.

Battaglia, Debbora. 1983a. "Projecting personhood in Melanesia: the dialectics of artefact symbolism on Sabarl Island." *Man* n.s. 18:289–304.

———. 1983b. "Syndromes of ceremonial exchange in the eastern Calvados: the view from Sabarl Island." In J. W. Leach and E. R. Leach, eds. *The Kula. New Perspectives on Massim Exchange.* Cambridge: Cambridge University Press.

———. 1985. "'We feed our father': paternal nurture among the Sabarl of Papua New Guinea." *American Ethnologist* 12:427–441.

Battel, Roísín et al. 1983. "So far, so good—so what? Women's studies in the U.K." *Women's Studies International Forum* 6:251–343.

Beer, Gillian. 1983. *Darwin's Plots. Evolutionary Narrative in Darwin, George Eliot and Nineteenth Century Fiction.* London: Routledge and Kegan Paul.

Bell, Diane. 1983. *Daughters of the Dreaming.* Melbourne: McPhee Gribble/ George Allen and Unwin.

Berndt, Ronald M. 1962. *Excess and Restraint.* Chicago: University of Chicago Press.

Biersack, Aletta. 1982. "Ginger gardens for the ginger woman: rites and passages in a Melanesian society," *Man* n.s. 17:239–258.

———. 1983. "Bound blood: Paiela 'conception' theory interpreted." *Mankind* 14:85–100.

———. 1984. "Paiela 'women-men': the reflexive foundations of gender ideology." *American Ethnologist* 10:118–138.

Bloch, Maurice. 1975. "Property and the end of affinity." In M. Bloch, ed. *Marxist Analyses in Social Anthropology.* London: Malaby Press.

———. 1977. "The past and the present in the present." *Man* n.s. 12:55–81.

———. 1980. "Ritual symbolism and the nonrepresentation of society." In M. LeCron Foster and S. H. Brandes, eds. *Symbol as Sense.* New York: Academic Press.

———. 1983. *Marxism and Anthropology: The History of a Relationship.* Oxford: Clarendon Press.

———. 1985. "From cognition to ideology." In R. Fardon, ed. *Power and Knowledge.* Edinburgh: Scottish Academic Press.

———. In press. "Descent and sources of contradiction in representations of women and kinship." In J. F. Collier and S. J. Yanagisako, eds. *Gender and Kinship: Essays Toward a Unified Analysis.* Stanford: Stanford University Press. [1987]

Bloch, Maurice and Jonathan Parry, eds. 1982. Introduction to *Death and the*

Regeneration of Life. Cambridge: Cambridge University Press.

Bohannan, Paul and Laura Bohannan. 1968. *Tiv Economy.* London: Longmans.

Bonte, Pierre. 1981. "Marxist theory and anthropological analysis: the study of nomadic pastoralist societies." In J. S. Kahn and J. R. Llobera, eds. *The Anthropology of Pre-Capitalist Societies.* London: Macmillan.

Boon, James A. 1982. *Other Tribes, Other Scribes. Symbolic Anthropology in the Comparative Study of Cultures, Histories, Religions, and Texts.* Cambridge: Cambridge University Press.

Bourdieu, Pierre. 1977. *Outline of a Theory of Practice.* Trans. by R. Nice. Cambridge: Cambridge University Press.

Bowles, Gloria and Renate Duelli Klein. 1983. *Theories of Women's Studies.* London: Routledge and Kegan Paul.

Bowden, Ross. 1984. "Art and gender ideology in the Sepik." *Man* n.s. 445–458.

Brindley, Marianne. 1984. *The Symbolic Role of Women in Trobriand Gardening.* Pretoria: University of South Africa.

Brown, David J. J. 1980. "The Structuring of Polopa Kinship and Affinity." *Oceania* 50:297–331.

Brown, Paula. 1961. "Chimbu Death Payments." *Journal of the Royal Anthropological Institute* 91:77–96.

———. 1962. "Non-agnates among the patrilineal Chimbu." *Journal of the Polynesian Society* 71:57–69.

———. 1964. "Enemies and Affines." *Ethnology* 3:335–356.

———. 1970. "Chimbu transactions." *Man* n.s. 5:99–117.

———. 1978. *Highland People of New Guinea.* Cambridge: Cambridge University Press.

Brown, Paula and Georgeda Buchbinder, eds. 1976. *Man and Woman in the New Guinea Highlands.* American Anthropological Association, spec. pub. 8.

Buchbinder, Georgeda and Roy A. Rappaport. 1976. "Fertility and death among the Maring." In P. Brown and G. Buchbinder, eds. *Man and Woman in the New Guinea Highlands.* American Anthropological Association, spec. pub. 8.

Bujra, Janet M. 1978. "Introductory: female solidarity and the sexual division of labour." In P. Caplan and J. M. Bujra, eds. *Women United, Women Divided: Cross-Cultural Perspectives on Female Solidarity.* London: Tavistock Publications.

Caplan, Patricia and Janet M. Bujra, eds. 1978. *Women United, Women Divided: Cross-Cultural Perspectives on Female Solidarity.* London: Tavistock Publications.

Carrier, James. n.d. "Cultural content and practical meaning: the construction of symbols in formal American culture." MSS.

Caulfield, Mina Davis. 1981. "Equality, sex, and mode of production." In G. D. Berreman and K. M. Zaretsky, eds. *Social Inequality.* New York: Academic Press.

Chodorow, Nancy. 1978. *The Reproduction of Mothering. Psychoanalysis and the Sociology of Gender.* Berkeley, Los Angeles, London: University of California Press.

Chowning, Ann. 1977 [1973]. *An Introduction to the Peoples and Cultures of Melanesia.* Menlo Park: Cummings Pub. Co.

Clay, Brenda J. 1977. *Pinikindu: Maternal Nurture, Paternal Substance.* Chicago: University of Chicago Press.

Clifford, James. 1982. *Person and Myth: Maurice Leenhardt in the Melanesian World.* Berkeley, Los Angeles, London: University of California Press.

Collier, Jane F. and Michelle Z. Rosaldo. 1981. "Politics and gender in simple societies." In S. B. Ortner and H. Whitehead, eds. *Sexual Meanings.* New York: Cambridge University Press.

Cook, Edwin A. and Denise O'Brien, eds. 1980. *Blood and Semen: Kinship Systems of Highland New Guinea.* Ann Arbor: University of Michigan Press.

Counts, David and Dorothy Counts. 1974. "The Kaliai Lupunga: disputing in the public forum." In A. L. Epstein, ed. *Contention and Dispute.* Canberra: Australian National University Press.

Damon, Frederick H. 1980. "The Kula and generalised exchange: considering some unconsidered aspects of *The elementary structures of kinship*." *Man* n.s. 15:267–292.

———. 1983a. "Muyuw kinship and the metamorphosis of gender labour." *Man* n.s. 18:305–326.

———. 1983b. "What moves the kula: opening and closing gifts on Woodlark Island." In J. W. Leach and E. R. Leach, eds. *The Kula. New Perspectives on Massim Exchange.* Cambridge: Cambridge University Press.

de Lepervanche, Marie. 1967–1968. "Descent, residence and leadership in the New Guinea highlands." *Oceania* 37:134–158; 38:164–189.

Dundes, Alan. 1976. "A psychoanalytic study of the bullroarer." *Man* n.s. 11:220–238.

Eisenstein, Hester. 1984. *Contemporary Feminist Thought.* Sydney: Unwin Paperbacks.

Elshtain, Jean Bethke. 1981. *Public Man, Private Woman. Women in Social and Political Thought.* Princeton: Princeton University Press.

———. 1982. "Feminist discourse and its discontents: language, power, and meaning." In N. O. Keohane, M. Z. Rosaldo and B. C. Gelpi, eds. *Feminist Theory. A Critique of Ideology.* Sussex: The Harvester Press.

———. 1984. "Symmetry and soporifics: a critique of feminist accounts of gender development." In B. Richards, ed. *Capitalism and Infancy.* London: Free Association Books.

Endicott, Karen Lampell. 1981. "The conditions of egalitarian male-female relationships in foraging societies." *Canberra Anthropology* 4:1–10.

Ennew, Judith. 1981. "Wrapping up reality: the ethnographic package" [Review Article]. *Cambridge Anthropology* 6:48–60.

Epstein, Arnold L. 1979. "Tambu: the shell money of the Tolai." In R. H. Hook, ed. *Fantasy and Symbol.* London: Academic Press.

Ernst, Thomas M. 1978. "Aspects of meaning of exchanges and exchange items among the Onabasulu of the Great Papuan Plateau." *Mankind* 11:187–197.

Etienne, Mona and Eleanor Leacock, eds. 1981. Introduction to *Women and Colonization. Anthropological Perspectives.* New York: Praeger.

Evans-Pritchard, E. E. 1940. *The Nuer. A Description of the Modes of Livelihood and Political Institutions of a Nilotic People.* Oxford: Clarendon Press.

Faithorn, Elizabeth. 1975. "The concept of pollution among the Kafe of the Papua New Guinea Highlands." In R. Reiter, ed. *Toward an Anthropology of Women.* New York: Monthly Review Press.

———. 1976. "Women as persons. Aspects of female life and male-female relations among the Kafe." In P. Brown and G. Buchbinder, eds. *Man and Woman in the New Guinea Highlands.* American Anthropological Association, spec. pub. 8.

Fardon, Richard. 1985. "Sociability and secrecy: two problems of Chamba knowledge." In R. Fardon, ed. *Power and Knowledge: Anthropological and Sociological Approaches.* Edinburgh: Scottish Academic Press.

Feil, Daryl K. 1978. "Women and men in the Enga tee." *American Ethnologist* 5:263–279.

———. 1982a. "From pigs to pearlshells: the transformation of a New Guinea highlands exchange economy." *American Ethnologist* 9:291–306.

———. 1982b. "Alienating the inalienable" [correspondence]. *Man* n.s. 17: 340–343.

———. 1984a. "Beyond patriliny in the New Guinea Highlands." *Man* n.s. 19:50–76.

———. 1984b. *Ways of Exchange. The Enga 'tee' of Papua New Guinea.* St. Lucia: University of Queensland Press.

Finney, Ben R. 1973. *Big-men and Business: Entrepreneurship and Economic Growth in the New Guinea Highlands.* Canberra: Australian National University Press.

Forge, Anthony. 1966. "Art and environment in the Sepik." *Proc. Royal Anthropological Institute.* 1965. 23–31.

———. 1972. "The golden fleece." *Man* n.s. 7:527–540.

———. 1973. "Style and meaning in Sepik art." In A. Forge, ed. *Primitive Art and Society.* London: Oxford University Press.

Fortes, Meyer. 1969. *Kinship and the Social Order.* Chicago: Aldine Pub. Co.

Foster, Robert J. 1985. "Production and value in the Enga *Tee.*" *Oceania.* 55:182–196.

Fox, Robin. 1967. *Kinship and Marriage. An Anthropological Perspective.* Harmondsworth: Penguin Books.

Frankenberg, Ronald. 1978. "Economic Anthropology or Political Economy (I): the Barotse social formation—a case study." In J. Clammer, ed. *The New Economic Anthropology.* London: Macmillan.

Friedl, Ernestine. 1975. *Women and Men: An Anthropologist's View.* New York: Holt, Rinehart and Winston.

Friedman, Jonathan. 1974. "Marxism, structuralism and vulgar materialism." *Man* n.s. 9:444–469.

Gardener, Don S. 1983. "Performativity in ritual: the Mianmin case." *Man* n.s. 18:346–360.

Gardener, Don and Nicholas Modjeska eds. 1985. *Recent studies in the political*

economy of Papua New Guinea societies. Mankind special issue 4.

Gatens, Moira. 1983. "A critique of the sex/gender distinction." *Beyond Marxism, Intervention.* special issue, 143–160.

Gell, Alfred. 1975. *Metamorphosis of the Cassowaries: Umeda Society, Language and Ritual.* London: The Athlone Press.

Gellner, Ernest. 1982. "Nationalism and the two forms of cohesion in complex societies." *Proceedings of the British Academy.* Vol. lxviii, 165–187.

Gewertz, Deborah B. 1983. *Sepik River Societies. A Historical Ethnography of the Chambri and their Neighbors.* New Haven: Yale University Press.

Gewertz, Deborah and Edward Schieffelin, eds. 1985. *History and Ethnohistory in Papua New Guinea. Oceania Monograph* 28, Sydney.

Gillison, Gillian S. 1980. "Images of nature in Gimi thought." In C. MacCormack and M. Strathern, eds. *Nature, Culture and Gender.* Cambridge: Cambridge University Press.

———. 1983. "Cannibalism among women in the Eastern Highlands of Papua New Guinea." In P. Brown and D. Tuzin, eds. *The Ethnography of Cannibalism.* Washington: Soc. Psychological Anthropology.

———. In press. "Incest and the atom of kinship: The role of the mother's brother in a New Guinea Highlands society." [1987: *Ethos* 15:166–202.]

Godelier, Maurice. 1975. "Modes of production, kinship, and demographic structures." In M. Bloch, ed. *Marxist Analyses and Social Anthropology.* London: Malaby Press.

———. 1977 [1973]. *Perspectives in Marxist Anthropology.* Trans. by R. Brain. Cambridge: Cambridge University Press.

———. 1982. "Social hierarchies among the Baruya of New Guinea." In A. J. Strathern, ed. *Inequality in New Guinea Highland Societies.* Cambridge: Cambridge University Press.

Godelier, Maurice and P. Bonte. 1976. "Le problème des formes et des fondements de la domination masculine." *Les Cahiers du Centre d'études et de recherches marxistes* 128.

Goldman, Laurence. 1983. *Talk Never Dies. The Language of Huli Disputes.* London: Tavistock Publications.

Goodale, Jane C. 1980. "Gender, sexuality and marriage: a Kaulong model of nature and culture." In C. P. MacCormack and M. Strathern, eds. *Nature, Culture and Gender.* Cambridge: Cambridge University Press.

Goodenough, Ward H. 1970. *Description and Comparison in Cultural Anthropology.* Cambridge: Cambridge University Press.

Goody, Jack. 1977. *The Domestication of the Savage Mind.* Cambridge: Cambridge University Press.

Gourlay, Kenneth A. 1975. "Sound-producing instruments in traditional society: a study of esoteric instruments and their role in male-female relations." *New Guinea Res. Bull.* 60, Canberra and Port Moresby: Australian National University.

Gregory, Christopher A. 1980. "Gifts to men and gifts to god: gift exchange and capital accumulation in contemporary Papua." *Man* n.s. 15:626–652.

———. 1982. *Gifts and Commodities.* London: Academic Press.

Gudeman, Stephen and Mischa Penn. 1982. "Models, meanings and reflexiv-

ity." In D. Parkin, ed. *Semantic Anthropology*. London: Tavistock Publications.

Haraway, Donna. "A manifesto for cyborgs: science, technology, and socialist feminism in the 1980s." *Socialist Review* 80:65–107.

Harris, Olivia. 1981. "Households as natural units." In Kate Young, Carol Wolkowitz, and Roslyn McCullagh, eds. *Of Marriage and the Market*. London: C.S.E. Books.

Harris, Olivia and Kate Young. 1981. "Engendered structures: some problems in the analysis of reproduction." In J. S. Kahn and J. R. Llobera, eds. *The Anthropology of Pre-Capitalist Societies*. London: Macmillan.

Harrison, Simon. 1984. "New Guinea highland social structure in a lowland totemic mythology." *Man* n.s. 19:389–403.

———. 1985a. "Concepts of the person in Avatip religious thought." *Man* n.s. 20:115–130.

———. 1985b. "Ritual hierarchy and secular equality in a Sepik River village." *American Ethnologist* 12:413–426.

Hawkins, Mary. 1984. "Gender symbolism and power relations: a reassessment of the Amb Kor cult of Mt. Hagen." *Mankind*. 14:217–224.

Hays, Terence E. and Patrica H. Hays. 1982. "Opposition and complementarity of the sexes in Ndumba initiation." In G. H. Herdt, ed. *Rituals of Manhood*. Berkeley, Los Angeles, London: University of California Press.

Herdt, Gilbert H. 1981. *Guardians of the Flutes: Idioms of Masculinity*. New York: McGraw Hill Book Co.

———. 1982a. "Fetish and fantasy in Sambia initiation." In G. Herdt, ed. *Rituals of Manhood*. Berkeley, Los Angeles, London: University of California Press.

———. 1982b. "Sambia nosebleeding rites and male proximity to women." *Ethos* 10:189–231.

———. 1982c. Preface to *Rituals of Manhood: Male Initiation in Papua New Guinea*. Berkeley, Los Angeles, London: University of California Press.

———. 1984a. Preface to *Ritualized Homosexuality in Melanesia*. Berkeley, Los Angeles, London: University of California Press.

———. 1984b. "Semen transactions in Sambia culture." In G. Herdt, ed. *Ritualized Homosexuality in Melanesia*. Berkeley, Los Angeles, London: University of California Press.

Herdt, Gilbert H. and Fitz John P. Poole. 1982. "'Sexual antagonism': the intellectual history of a concept in New Guinea anthropology." In F. J. P. Poole and G. H. Herdt, eds. *Sexual Antagonism, Gender and Social Change in Papua New Guinea. Social Analysis*. special issue 12.

Hirschon, Renée, ed. 1984. *Women and Property, Women as Property*. London: Croom Helm.

Hirst, Paul and Penny Woolley. 1982. *Social Relations and Human Attributes*. London: Tavistock Publications.

Hutt, Corinne. 1972. *Males and Females*. Harmondsworth: Penguin Books.

Hyndman, David. 1982. "Biotype gradient in a diversified New Guinea subsistence system." *Human Ecology* 10:219–259.

Illich, Ivan. 1982. *Gender*. New York: Pantheon Books.

Jameson, Frederick. 1985. "Postmodernism and consumer society." In H. Foster, ed. *Postmodern Culture*. London and Sydney: Pluto Press.

Jenness, D. and A. Ballantyne. 1920. *The Northern D'Entrecasteaux*. Oxford: Clarendon Press.

Jolly, Margaret. 1981. "People and their products in South Pentecost." In M. R. Allen, ed. *Vanuatu. Politics, Economics and Ritual in Island Melanesia*. Sydney: Academic Press.

————. 1982. "Birds and Banyans of South Pentecost: Kastom in anti-colonial struggle in South Pentecost, Vanuatu." In R. Keesing and R. Tonkinson, eds. *Reinventing Traditional Culture: The Politics of Kastom in Island Melanesia. Mankind*. special issue 13:338–357.

————. 1984. "The anatomy of pig love: substance, spirit and gender in South Pentecost, Vanuatu." *Canberra Anthropology* 7:78–108.

————. In press. "From corporeality to commodity: food and gender in South Pentecost, Vanuatu." In L. Manderson, ed. *Gender, Substance and Subsistence: Food and Social Relations in the Pacific. Journal de la Société des Océanistes*. special issue.

Jorgensen, Daniel, ed. 1983. "Concepts of conception: procreation ideologies in Papua New Guinea." *Mankind*. special issue 14.

Josephides, Lisette. 1982. *Suppressed and Overt Antagonism: A Study in Aspects of Power and Reciprocity among the Northern Melpa*. Research in Melanesia, Occasional Paper 2. Port Moresby: University of Papua New Guinea.

————. 1983. "Equal but different? The ontology of gender among the Kewa." *Oceania*. 53:291–307.

————. 1985a. *The Production of Inequality. Gender and Exchange among the Kewa*. London: Tavistock Publications.

————. 1985b. "Bulldozers and kings; or talk, name, group and land: a Kewa political palindrome." In *Women in Politics in Papua New Guinea*. Australian National University working paper 6. Canberra: Department of Political and Social Change.

Kahn, Joel S. and Josep R. Llobera. 1981. *The Anthropology of Pre-Capitalist Societies*. London: Macmillan.

Keesing, Roger M. 1982. Introduction to G. H. Herdt, ed. *Rituals of Manhood, Initiation in Papua New Guinea*. Berkeley, Los Angeles, London: University of California Press.

Kelly, Raymond C. 1976. "Witchcraft and sexual relations: an exploration in the social and semantic implications of the structure of belief." In P. Brown and G. Buchbinder, eds. *Man and Woman in the New Guinea Highlands*. American Anthropological Association, spec. pub. 8.

————. 1977. *Etoro Social Structure: A Study in Structural Contradiction*. Ann Arbor: University of Michigan Press.

Keohane, Nannerl O. and Barbara C. Gelpi. 1982. Foreword to N. O. Keohane, M. Z. Rosaldo and B. C. Gelpi, eds. *Feminist Theory: A Critique of Ideology*. Sussex: The Harvester Press.

Kovel, Joel. 1984. "Rationalization and the family." In B. Richards, ed. *Capitalism and Infancy*. London: Free Association Books.

Kristeva, Julia. 1981. "Women's time." Trans. by A. Jardine and H. Blake. *Signs: Journal of Women in Culture and Society* 7:13–35.

Kuhn, Annette. 1978. "Structures of patriarchy and capital in the family." In A. Kuhn and A. M. Wolpe, eds. *Feminism and Materialism: Women and Modes of Production.* London: Routledge and Kegan Paul.

Kuhn, Annette and Anne Marie Wolpe. 1978. "Feminism and materialism." In A. Kuhn and A. M. Wolpe, eds. *Feminism and Materialism: Women and Modes of Production.* London: Routledge and Kegan Paul.

La Fontaine, Jean S. 1978. Introduction to *Sex and Age as Principles of Social Differentiation.* A.S.A. 17. London: Academic Press.

———. 1981. "The domestication of the savage male." *Man* n.s. 16:333–349.

Langness, Lewis L. 1964. "Some problems in the conceptualization of Highlands and social structures." In J. B. Watson, ed. *New Guinea: The Central Highlands. American Anthropologist* 66, spec. pub.

———. 1967. "Sexual antagonism in the New Guinea Highlands: a Bena Bena example." *Oceania* 37:161–177.

———. 1977 [1974]. "Ritual, power, and male dominance in the New Guinea Highlands." In R. Fogelson and R. N. Adams, eds. *The Anthropology of Power.* New York: Academic Press.

———. 1982. "Discussion." In F. J. P. Poole and G. H. Herdt, eds. *Sexual Antagonism, Gender, and Social Change in Papua New Guinea. Social Analysis.* special issue 12.

Langness, Lewis L. and John Weschler. 1971. *Melanesia. Readings on a Cultural Area.* Scranton: Chandler Publishing Company.

Leach, Edmund R. 1957. "The epistemological background to Malinowski's empiricism." In R. Firth, ed. *Man and Culture.* London: Routledge and Kegan Paul.

Leach, Edmund R. and Jerry W. Leach, eds. 1983. *The Kula. New Perspectives on Massim Exchange.* Cambridge: Cambridge University Press.

Leacock, Eleanor Burke. 1978. "Women's status in egalitarian society: implications for social evolution." *Current Anthropology* 19:247–275.

———. 1981. *Myths of Male Dominance.* New York: Monthly Review Press.

———. 1982. "Relations of production in band society." In E. B. Leacock and R. Lee, eds. *Politics and History in Band Societies.* Cambridge: Cambridge University Press.

Leahy, Michael and Maurice Crain. 1937. *The Land That Time Forgot: Adventures and Discoveries in New Guinea.* New York: Funk and Wagnalls Company.

Lederman, Rena. 1980. "Who speaks here? Formality and the politics of gender in Mendi." *Journal of the Polynesian Society* 89:479–498.

———. In press. "Contested order: gender constructions and social structures in Mendi." In P. Sanday, ed. *Beyond the Second Sex.*

Leenhardt, Maurice. 1979 [1947]. *Do Kamo. Person and Myth in the Melanesian World.* Trans. by B. M. Gulati. Chicago: University of Chicago Press.

LeRoy, John. 1978. "Burning our trees: metaphors in Kewa songs." In E. Schwimmer, ed. *The Yearbook of Symbolic Anthropology 1.* McGill–Queen's University Press/Hurst.

———. 1979. "The ceremonial pig kill of the South Kewa." *Oceania* 49:179–209.

Lessing, Doris. 1981. *The Sirian Experiments*. London: Jonathan Cape.

Lévi-Strauss, Claude. 1969 [1949]. *The Elementary Structures of Kinship*. Trans. by J. H. Bell, J. R. von Sturmer, and R. Needham. London: Eyre and Spottiswoode.

Lewis, Gilbert. 1980. *Day of Shining Red. An Essay on Understanding Ritual*. Cambridge: Cambridge University Press.

Lindenbaum, Shirley. 1976. "A wife is the hand of man." In P. Brown and G. Buchbinder, eds. *Man and Woman in the New Guinea Highlands*. American Anthropological Association, spec. pub. 8.

———. 1984. "Variations on a sociosexual theme in Melanesia." In G. H. Herdt, ed. *Ritualized Homosexuality in Melanesia*. Berkeley, Los Angeles, London: University of California Press.

LiPuma, Edward. 1979. "Sexual asymmetry and social reproduction among the Maring of Papua New Guinea." *Ethnos* 44:34–57.

Lloyd, Genevieve. 1983. "Reason, gender, and morality in the history of philosophy." *Social Research* 50:490–513.

———. 1984. *The Man of Reason. 'Male' and 'Female' in Western Philosophy*. London: Methuen and Company.

Löfgren, Orvar. In press. "Deconstructing Swedishness: culture and class in modern Sweden." [In A. Jackson ed., *Anthropology at Home*. ASA 25. London: Tavistock Publications, 1986]

Macintyre, Martha. 1984. "The problem of the semi-alienable pig." *Canberra Anthropology* 7:109–123.

MacKinnon, Catharine A. 1982. "Feminism, Marxism, method, and the state: an agenda for theory." In N. O. Keohane, M. Z. Rosaldo and B. C. Gelpi, eds. *Feminist Theory. A Critique of Ideology*. Sussex: The Harvester Press.

MacLean, Neil. 1985. "Understanding Maring marriage: a question of the analytic utility of the Domestic Mode of Production." In D. Gardner and N. Modjeska, eds. *Recent Studies in the Political Economy of Papua New Guinea Societies. Mankind* 15, spec. issue 4.

Malinowski, Bronislaw. 1929. *The Sexual Life of Savages in North-Western Melanesia*. London: Geo. Routledge and Sons.

———. 1935. *Coral Gardens and Their Magic. A Study of the Methods of Tilling the Soil and of Agricultural Rites in the Trobriand Islands*. Vol. I. New York: American Book Co.

Marks, Elaine and Isabelle de Courtrivon. 1985 [1980]. *New French Feminisms*. Brighton: The Harvester Press Ltd.

Marriott, McKim. 1976. "Hindu transactions: diversity without dualism." In B. Kapferer, ed. *Transaction and Meaning*. Philadelphia: ISHI Publications (ASA Essays in Anthropology 1).

Marshall, Mac. 1983. Introduction to M. Marshall, ed. *Siblingship in Oceania. Studies in the Meaning of Kin Relations*. ASAO Monograph 8. Lanham: University Press of America.

Martin, M. Kay and Barbara Voorhies. 1975. *Female of the Species*. New York: Columbia University Press.

McDonough, Roisin and Rachel Harrison. 1978. "Patriarchy and relations of production." In A. Kuhn and A. M. Wolpe, eds. *Feminism and Materialism*. London: Routledge and Kegan Paul.

Mathieu, Nicole-Claude. 1984 [1977]. "Biological paternity, social maternity." Trans. by D. Leonard. *Feminist Issues* 4:63–71.

Matthews, Jill Julius. 1984. *Good and Mad Women. The Historical Construction of Feminity in Twentieth Century Australia*. Sydney: George Allen and Unwin.

Mauss, Marcel. 1954 [1925]. *The Gift: Forms and Functions of Exchange in Archaic Societies*. Trans. by I. Cunnison. London: Cohen and West.

Mead, Margaret. 1935. *Sex and Temperament in Three Primitive Societies*. London: Geo. Routledge and Sons.

———. 1950. *Male and Female. A Study of the Sexes in a Changing World*. London: Victor Gollancz Ltd.

Meggitt, Mervyn J. 1964. "Male-female relationships in the highlands of Australian New Guinea." In *New Guinea: The Central Highlands. American Anthropologist* 66, spec. pub.

———. 1965. *The Lineage System of the Mae-Enga of New Guinea*. Edinburgh: Oliver and Boyd.

Meigs, Anna S. 1976. "Male pregnancy and the reduction of sexual opposition in a New Guinea Highlands society." *Ethnology* 15:393–407.

———. 1984. *Food, Sex and Pollution. A New Guinea Religion*. New Brunswick: Rutgers University Press.

Milton, Kay. 1979. "Male bias in anthropology?" *Man* n.s. 14:40–54.

Mitchell, Juliet. 1971. *Woman's Estate*. Harmondsworth: Penguin Books.

———. 1975. *Psychoanalysis and Feminism*. Harmondsworth: Penguin Books.

Modjeska, Nicholas. 1982. "Production and inequality: perspectives from central New Guinea." In A. J. Strathern, ed. *Inequality in New Guinea Highlands Societies*. Cambridge: Cambridge University Press.

Munn, Nancy D. 1977. "The spatiotemporal transformations of Gawa canoes." *Journal de la Société des Océanistes* 33:39–54.

———. 1983. "Gawan kula: spatiotemporal control and the symbolism of influence." In J. W. Leach and E. R. Leach, eds. *The Kula*. Cambridge: Cambridge University Press.

Nadel, Sigmund F. 1957. *The Theory of Social Structure*. London: Cohen and West.

Nash, Jill. 1974. "Matriliny and modernisation: the Nagovisi of South Bougainville." *New Guinea Res. Bull.* 55. Port Moresby and Canberra: The Australian National University.

Needham, Rodney. 1971. "Remarks on the analysis of kinship and marriage." In R. Needham, ed. *Rethinking Kinship and Marriage*. ASA 11. London: Tavistock Publications.

Newman, Philip L. 1965. *Knowing the Gururumba*. New York: Holt, Rinehart and Winston.

Newman, Philip L. and David J. Boyd. 1982. "The making of men: ritual and meaning in Awa male initiation." In G. H. Herdt ed. *Rituals of Manhood*. Berkeley, Los Angeles, London: University of California Press.

Oakley, Ann. 1972. *Sex, Gender and Society*. London: Temple Smith.

O'Brien, Mary. 1982. "Feminist theory and dialectical logic." In N. O. Keohane, M. Z. Rosaldo, and B. C. Gelpi, eds. *Feminist Theory*. Sussex: The Harvester Press.

O'Brien, Denise and Sharon W. Tiffany. 1984. *Rethinking Women's Roles: Perspectives from the Pacific*. Berkeley, Los Angeles, London: University of California Press.

O'Hanlon, Michael. 1983. "Handsome is as handsome does: display and betrayal in the Wahgi." *Oceania* 53:317–333.

O'Hanlon, Michael and Linda Frankland. In press. "With a skull in the netbag: prescriptive marriage and marilateral relations in the New Guinea Highlands." [1986: *Oceania* 56:181–198.].

O'Laughlin, Bridget. 1974. "Mediation of contradiction: why Mbum women do not eat chicken." In M. Z. Rosaldo and L. Lamphere, eds. *Women, Culture and Society*. Stanford: Stanford University Press.

Ollman, Bertell. 1976 [1971]. *Alienation. Marx's Conception of Man in Capitalist Society*. Cambridge: Cambridge University Press.

Ortiz, Sutti. 1979. "The estimation of work: labour and value among Paez farmers." In S. Wallman, ed. *Social Anthropology of Work*. ASA 19. London: Academic Press.

Ortner, Sherry B. 1974. "Is female to male as nature is to culture?" In M. Z. Rosaldo and L. Lamphere, eds. *Woman, Culture and Society*. Stanford: Stanford University Press.

Ortner, Sherry B. and Harriet Whitehead. 1981. "Introduction: accounting for sexual meanings." In S. B. Ortner and H. Whitehead, eds. *Sexual Meanings. The Cultural Construction of Gender and Sexuality*. Cambridge: Cambridge University Press.

Owens, Craig. 1985. "The discourse of others: feminists and postmodernism." In H. Foster, ed. *Postmodern Culture*. London and Sydney: Pluto Press.

Pajaczkowska, Claire. 1981. "Introduction to Kristeva." *m/f* 5/6:147–157.

Plaza, Monique. 1978. "'Phallomorphic power' and the psychology of 'woman': a patriarchal chain." *Ideology and Consciousness*. 4:5–36.

Poole, Fitz John P. 1981. "Transforming 'natural' woman: female ritual leaders and gender ideology among Bimin-Kuskusmin." In S. Ortner and H. Whitehead, eds. *Sexual Meanings*. New York: Cambridge University Press.

———. 1982. "The ritual forging of identity: aspects of person and self in Bimin-Kuskusmin male initiation." In G. H. Herdt, ed. *Rituals of Manhood*. Berkeley, Los Angeles, London: University of California Press.

———. 1984. "Symbols of substance: Bimin-Kuskusmin models of procreation, death, and personhood." *Mankind* 14:191–216.

Poole, Fitz John P. and Gilbert H. Herdt. eds. 1982. *Sexual Antagonism, Gender, and Social Change in Papua New Guinea*. *Social Analysis*. special issue 12.

Quinn, Naomi. 1977. "Anthropological studies on women's status." In *Annual Review of Anthropology*. Palo Alto: Annual Reviews Inc.

Radcliffe-Brown, A. R. 1930–1931. "The social organization of Australian tribes." *Oceania* I:34–63; 206–246; 322–341; 426–456.

———. 1940. "On social structure." *Journal R.A.I.* 70:1–12.

Rapp, Rayna. 1979. "Anthropology" [Review Essay]. *Signs: Journal of Women in Culture and Society* 4:497–513.

Read, Kenneth. 1954. "Cultures of the Central Highlands, New Guinea." *Southwestern Journal of Anthropology* 10:1–43.

———. 1971 [1952]. "Nama cult of the Central Highlands, New Guinea." In L. L. Langness and J. C. Weschler, eds. *Melanesia. Readings on a Cultural Area.* Scranton: Chandler Publishing Co.

———. 1982. "Male-female relationships among the Gahuku-Gama: 1950 and 1981." In F. J. P. Poole and G. H. Herdt, eds. *Sexual Antagonism. Social Analysis.* special issue 12.

———. 1984. "The *nama* cult recalled." In G. H. Herdt, ed. *Ritualized Homosexuality in Melanesia.* Berkeley, Los Angeles, London: University of California Press.

Reason, David. 1979. "Classification, time and the organization of production." In D. Reason and Roy F. Ellen, eds. *Classifications in their Social Context.* London: Academic Press.

Reay, Marie O. 1959. *The Kuma. Freedom and Conformity in the New Guinea Highlands.* Melbourne: Melbourne University Press.

———. 1976. "When a group of men takes a husband." *Anthropological Forum* 4:77–96.

Reiter, Rayna R. [Rapp]. 1975. *Toward an Anthropology of Women.* New York: Monthly Review Press.

———. 1975. "Men and women in the south of France: public and private domains." In R. Reiter, ed. *Toward an Anthropology of Women.* New York: Monthly Review Press.

Richards, Janet Radcliffe. 1982 [1980]. *The Sceptical Feminist: A Philosophical Enquiry.* Harmondsworth: Pelican Books.

Rivière, Peter G. 1971. "Marriage: a reassessment." In R. Needham, ed. *Rethinking Kinship and Marriage.* ASA 11. London: Tavistock Publications.

Rogers, Susan C. 1978. "Woman's place: a critical review of anthropological theory." *Comparative Studies in Society and History* 20:123–162.

Róheim, Geza. 1926. *Social Anthropology: A Psychoanalytic Study in Anthropology and a History of Australian Totemism.* New York: Boni and Liveright.

Rosaldo, Michelle Z. 1974. "Woman, culture, and society: a theoretical overview." In M. Z. Rosaldo and L. Lamphere, eds. *Woman, Culture and Society.* Stanford: Stanford University Press.

———. 1980. "The use and abuse of anthropology: reflections on feminism and cross-cultural understanding." *Signs: Journal of Women in Culture and Society* 5:389–417.

Rosaldo, Michelle Z. and Louise Lamphere. eds. 1974. *Woman, Culture, and Society.* Stanford: Stanford University Press.

Rubel, Paula G. and Abraham Rosman. 1978. *Your Own Pigs You May Not*

Eat: A Comparative Study of New Guinea Societies. Chicago: University of Chicago Press.

Rubin, Gayle. 1975. "The traffic in women: notes on the 'political economy' of sex." In R. Reiter, ed. *Toward an Anthropology of Women*. New York: Monthly Review Press.

Rubinstein, Robert L. 1981. "Knowledge and political process in Malo." In M. R. Allen, ed. *Vanuatu. Politics, Economics and Ritual in Island Melanesia*. Sydney: Academic Press.

Runciman, W. G. 1983. *A Treatise on Social Theory. Vol. 1: The Methodology of Social Theory*. Cambridge: Cambridge University Press.

Ryan, D'Arcy. 1959. "Clan formation in the Mendi Valley." *Oceania* 29:257–289.

Sacks, Karen. 1975. "Engles revisited: women, the organization of production and private property." In R. Reiter, ed. *Toward an Anthropology of Women*. New York: Monthly Review Press.

———. 1979. *Sisters and Wives: The Past and Future of Sexual Equality*. London: Greenwood Press.

Sahlins, Marshall. 1972. *Stone Age Economics*. Chicago and New York: Aldine, Atherton Inc.

———. 1976. *Culture and Practical Reason*. Chicago: Chicago University Press.

Salisbury, Richard F. 1956. "Unilineal descent groups in the New Guinea Highlands." *Man* 54:2–7.

———. 1962. *From Stone to Steel: Economic Consequences of a Technological Change in New Guinea*. Melbourne: Melbourne University Press.

———. 1965. "The Siane of the Eastern Highlands." In P. Lawrence and M. J. Meggitt, eds. *Gods, Ghosts and Men in Melanesia*. Melbourne: Oxford University Press.

Sayers, Janet. 1982. *Biological Politics. Feminist and Anti-Feminist Perspectives*. London: Tavistock Publications.

———. 1985. "Sexual contradictions: on Freud, psychoanalysis and feminism." *Free Associations* 1:76–104.

Scheffler, Harold W. 1974. "Kinship, descent and alliance." In J. J. Honigman, ed. *Handbook of Social and Cultural Anthropology*. Chicago: Rand-McNally.

———. 1985. "Filiation and affiliation." *Man* n.s. 20:1–21.

Schieffelin, Edward L. 1980. "Reciprocity and the construction of reality." *Man* n.s. 15:502–517.

———. 1985. "Performance and the cultural construction of reality." *American Ethnologist* 12:707–724.

Schlegel, Alice, ed. 1977. *Sexual Stratification: A Cross-Cultural View*. New York: Columbia University Press.

Schneider, David M. 1965. "Some muddles in the models: or, how the system really works." In M. Banton, ed. *The Relevance of Models for Social Anthropology*. ASA 1. London: Tavistock Publications.

———. 1968. *American Kinship: A Cultural Account*. Englewood Cliffs: Prentice-Hall.

————. 1983. "Conclusions" to M. Marshall, ed. *Siblingship in Oceania.* ASAO Monograph 8. Ann Arbor: University of Michigan Press.

————. 1984. *A Critique of the Study of Kinship.* Ann Arbor: University of Michigan Press.

Schwimmer, Erik. 1973. *Exchange in the Social Structure of the Orokaiva.* London: C. Hurst and Co.

————. 1974. "Objects of mediation: myth and praxis." In I. Rossi, ed. *The Unconscious in Culture: The Structuralism of Claude Lévi-Strauss in Perspective.* New York: E. P. Dutton and Co.

————. 1979. "The self and the product: concepts of work in comparative perspective." In S. Wallman, ed. *Social Anthropology of Work.* London: Academic Press.

————. 1980a. "The limits of the economic ideology: a comparative anthropological study of work concepts." *International Society of Science Journal* 32:517–531.

————. 1980b. *Power, Silence and Secrecy.* Toronto: Victoria University, Toronto Semiotic Circle Prepublications.

————. 1984. "Male couples in New Guinea." In G. H. Herdt, ed. *Ritualized Homosexuality in Melanesia.* Berkeley, Los Angeles, London: University of California Press.

Sciama, Lidia. 1981. "The problem of privacy in Mediterranean anthropology." In S. Ardener, ed. *Women and Space.* London: Croom Helm.

Sexton, Lorraine D. 1982. "'Wok Meri': a women's savings and exchange system in Highland Papua New Guinea." *Oceania* 52:167–198.

————. 1983. "Little women and big men in business: a Gorokan development project and social stratification." *Oceania* 54:133–150.

————. 1984. "Pigs, pearlshells, and 'women's work': collective response to change in Highland Papua New Guinea." In D. O'Brien and S. Tiffany, eds. *Rethinking Women's Roles.* Berkeley, Los Angeles, London: University of California Press.

Shapiro, Judith. 1979. "Cross-cultural perspectives on sexual differentiation." In H. Katchadourian, ed. *Human Sexuality. A Comparative and Developmental Perspective.* Berkeley, Los Angeles, London: University of California Press.

————. 1983. "Anthropology and the study of gender." In E. Langland and W. Gove, eds. *A Feminist Perspective in the Academy.* Chicago: Chicago University Press.

Sharma, Ursula. 1980. *Women, Work, and Property in North-West India.* London: Tavistock Publications.

Sillitoe, Paul. 1979. *Give and Take: Exchange in Wola Society.* Canberra: Australian National University Press.

Smith, Paul. 1978. "Domestic labour and Marx's theory of value." In A. Kuhn and A. M. Wolpe, eds. *Feminism and Materialism.* London: Routledge and Kegan Paul.

Sørum, Arve. 1984. "Growth and decay: Bedamini notions of sexuality." In G. H. Herdt, ed. *Ritualized Homosexuality in Melanesia.* Berkeley, Los

Angeles, London: University of California Press.

Souter, Gavin. 1964. *New Guinea: The Last Unknown*. Sydney: Angus and Robertson.

Spect, James and Peter J. White. 1978. *Trade and Exchange in Oceania and Australia. Mankind*. special issue 11.

Sperber, Dan. 1975. *Rethinking Symbolism*. Trans. by A. L. Morton. Cambridge: Cambridge University Press.

Stanley, Liz and Sue Wise. 1983. *Breaking Out: Feminist Consciousness and Feminist Research*. London: Routledge and Kegan Paul.

Stolcke, Verena. 1981. "Women's labours: the naturalisation of social inequality and women's subordination." In K. Young, C. Wolkowitz and R. McCullach, eds. *Of Marriage and the Market*. London: C.S.E. Books.

Strathern, Andrew J. 1969. "Descent and alliance in the New Guinea Highlands." *Proc. Royal Anthrop. Inst.* 1968:37–52.

———. 1969. "Finance and production: two strategies in New Guinea Highland exchange systems." *Oceania* 40:42–67.

———. 1971. *The Rope of Moka. Big Men and Ceremonial Exchange in Mount Hagen*. Cambridge: Cambridge University Press.

———. 1972. *One Father, One Blood*. Canberra: Australian National University Press.

———. 1975. "Why is Shame on the Skin?" *Ethnology* 14:347–356.

———. 1977. "Melpa food-names as an expression of ideas on identity and substance." *Journal of Polynesian Society* 86:503–511.

———. 1978. "'Finance and production' revisited: in pursuit of a comparison." In G. Dalton, ed. *Research in Economic Anthropology* 1:73–104.

———. 1979. "Men's house, women's house: the efficacy of opposition, reversal, and pairing in the Melpa *Amb Kor* cult." *Journal of Polynesian Society* 88:37–51.

———. 1981. "'Noman': representations of identity in Mount Hagen." In L. Holy and M. Stuchlik, eds. *The Structure of Folk Models*. London: Academic Press.

———. 1982a. "Two waves of African models in the New Guinea Highlands." In A. J. Strathern, ed. *Inequality in New Guinea Highlands Societies*. Cambridge: Cambridge University Press.

———. 1982b. "Witchcraft, greed, cannibalism and death: some related themes from the New Guinea Highlands." In M. Bloch and J. Parry, eds. *Death and the Regeneration of Life*. Cambridge: Cambridge University Press.

———. 1983. "The kula in comparative perspective." In J. W. Leach and E. R. Leach, eds. *The Kula*. Cambridge: Cambridge University Press.

Strathern, Marilyn. 1972. *Women in Between: Female Roles in a Male World*. London: Seminar (Academic) Press.

———. 1975. "No money on our skins. Hagen migrants in Port Moresby." *New Guinea Res. Bull.* 61. Canberra: Australian National University.

———. 1978. "The achievement of sex: paradoxes in Hagen gender-thinking." In E. Schwimmer, ed. *Yearbook of Symbolic Anthropology 1*. McGill-Queen's University Press/Hurst.

———. 1980. "No nature, no culture: the Hagen case." In C. MacCormack

and M. Strathern, eds. *Nature, Culture and Gender*. Cambridge: Cambridge University Press.

———. 1981a. "Self-interest and the social good: some implications of Hagen gender imagery." In S. Ortner and H. Whitehead, eds. *Sexual Meanings: The Cultural Construction of Gender and Sexuality*. New York: Cambridge University Press.

———. 1981b. "Culture in a netbag. The manufacture of a subdiscipline in anthropology." *Man* n.s. 16:665–688.

———. 1984a. "Domesticity and the denigration of women." In D. O'Brien and S. Tiffany, eds. *Rethinking Women's Roles: Perspectives from the Pacific*. Berkeley, Los Angeles, London: University of California Press.

———. 1984b. "Subject or object? Women and the circulation of valuables in Highlands New Guinea." In R. Hirschon, ed. *Women and Property, Women as Property*. London: Croom Helm.

———. 1985a. "Kinship and economy: constitutive orders of a provisional kind." *American Ethnologist* 12:191–209.

———. 1985b. "John Locke's servant and the *hausboi* from Hagen: thoughts on domestic labour." *Critical Philosophy* 2:21–48.

———. In press. "Producing difference: connections and disconnections in two New Guinea Highlands kinship systems." In J. F. Collier and S. J. Yanagisako eds. *Gender and Kinship: Essays Toward a Unified Analysis*. Stanford: Stanford University Press. [1987]

Strauss, Hermann. 1962. *Die Mi-Kultur der Hagenberg-Stämme im östlichen Zentral-Neuguinea*. Hamburg: Cram, de Gruyter and Co.

Tiffany, Sharon. 1978. "Models and the social anthropology of women: a preliminary assessment." *Man* n.s. 13:34–51.

Taussig, Michael T. 1980. "Reification and the consciousness of the patient." *Soc. Sci. Med.* 14B:3–13.

Tsing, Anna Lowenhaupt and Sylvia Junko Yanagisako. 1983. "Feminism and kinship theory." *Current Anthropology* 24:511–516.

Tuzin, Donald F. 1974. "Social control and the tambaran in the Sepik." In A. L. Epstein, ed. *Contention and Dispute*. Canberra: ANU Press.

———. 1980. *The Voice of the Tambaran: Truth and Illusion in Ilahita Arapesh Religion*. Berkeley, Los Angeles, London: University of California Press.

———. 1982. "Ritual violence among the Ilahita Arapesh." In G. H. Herdt, ed. *Rituals of Manhood*. Berkeley, Los Angeles, London: University of California Press.

Tyler, Stephen A. 1984. "The poetic turn in postmodern anthropology: the poetry of Paul Friedrich" [Review article]. *American Anthropologist* 86: 328–336.

Van Baal, J. 1975. *Reciprocity and the Position of Women*. Amsterdam: van Gorcum.

———. 1984. "The dialectics of sex in Marind-Anim culture." In G. H. Herdt, ed. *Ritualized Homosexuality in Melanesia*. Berkeley, Los Angeles, London: University of California Press.

Verdon, Michel. 1980. "Descent: an operational view." *Man* n.s. 15:129–150.

Vicedom, Georg F. and Herbert Tischner. 1943–1948. *Die Mbowamb: die*

Kultur der Hagenberg-Stämme im östlichen Zentral-Neuguinea. 3 vols. Hamburg: Cram, de Gruyter and Co.

Wagner, Roy. 1967. *The Curse of Souw.* Chicago: Chicago University Press.

——. 1972. *Habu: The Innovation of Meaning in Daribi Religion.* Chicago: University of Chicago Press.

——. 1974. "Are there social groups in the New Guinea Highlands?" In M. J. Leaf, ed. *Frontiers of Anthropology.* New York: D. Van Nostrand Company.

——. 1975. *The Invention of Culture.* Englewood Cliffs: Prentice-Hall.

——. 1977a. "Analogic kinship: a Daribi example." *American Ethnologist* 4:623–642.

——. 1977b. "Scientific and indigenous Papuan conceptualizations of the innate: a semiotic critique of the ecological perspective." In T. Bayliss-Smith and R. Feachem, eds. *Subsistence and Survival.* London: Academic Press.

——. 1978. *Lethal Speech: Daribi Myth and Symbolic Obviation.* Ithaca: Cornell University Press.

——. 1983. "The ends of innocence: conception and seduction among the Daribi of Karimui and the Barok of New Ireland." In D. Jorgensen, ed. *Concepts of Conception: Procreation Ideologies in Papua New Guinea. Mankind* 14, special issue.

Wallman, Sandra. 1978. "Epistemologies of sex." In L. Tiger and H. Fowler, eds. *Female Hierarchies.* Chicago: Beresford.

Warry, Wayne. 1985. "Politics of a new order: the Kafaina movement." In *Women in Politics in Papua New Guinea.* A.N.U., working paper 6. Canberra: Department of Political and Social Change.

Watson, James B. 1970. "Society as organized flow: the Tairora case." *Southwestern Journal of Anthropology* 26:107–124.

Weiner, Annette B. 1976. *Women of Value, Men of Renown: New Perspectives in Trobriand Exchange.* Austin: University of Texas Press.

——. 1978. "The reproductive model in Trobriand society." In J. Specht and J. P. White eds. *Trade and exchange in Oceania and Australia. Mankind* special issue 11.

——. 1980. "Reproduction: a replacement for reciprocity." *American Ethnologist* 7:71–85.

——. 1982. "Sexuality among the anthropologists: reproduction among the informants." In F. J. P. Poole and G. Herdt, eds. *Sexual Antagonism, Gender, and Social Change in Papua New Guinea. Social Analysis* special issue 12.

——. 1983. "'A world of made is not a world of born': doing kula in Kiriwina." In J. W. Leach and E. R. Leach, eds. *The Kula. New Perspectives on Massim Exchange.* Cambridge: Cambridge University Press.

Weiner, James F. 1979. "Restricted exchange in the New Guinea Highlands." *Canberra Anthropology* 2:75–93.

——. 1982. "Substance, siblingship and exchange: aspects of social structure in New Guinea." *Social Analysis* 11:3–34.

——. In press. *The Heart of the Pearlshell: The Mythological Dimension of Foi Sociality.* Berkeley, Los Angeles, London: University of California Press.

Whitehead, Ann. 1984. "Men and women, kinship and property: some general issues." In R. Hirschon, ed. *Women and Property: Women as Property*. London: Croom Helm.

Yanagisako, Sylvia Junko. 1979. "Family and household: the analysis of domestic groups." In *Annual Review of Antrhopology* 8. Palo Alto: Annual Reviews Inc.

Yeatman, Anna. 1984. "Gender and the differentiation of social life into public and domestic domains." In A. Yeatman, ed. *Gender and Social Life*. *Social Analysis*. special issue 15.

Young, Kate, E. Wolkowitz and R. McCullagh. eds. 1981. *Of Marriage and the Market. Women's Subordination in International Perspective*. London: C.S.E. Books.

Young, Michael. 1983. *Magicians of Manumanua: Living Myth in Kalauna*. Berkeley, Los Angeles, London: University of California Press.

Indexes

Author Index

Adams, Parveen, 65, 123
Allen, Michael R., 5, 47, 348n, 359nn
Ardener, Edwin, 52, 356n, 383n
Ardener, Shirley, 72, 355n, 356n
Atkinson, Jane Monnig, 34, 37, 73
Augé, Marc, 37

Barnes, John A., 316, 352n
Barnett, Steve, 135, 143, 358n, 363–364n
Barrett, Michele, 24, 27, 65, 123, 354nn, 364n
Barth, Fredrik, 300
Bateson, Gregory, 70–71, 334–335
Battaglia, Debbora, 171, 172–173, 186, 270–272, 292, 369nn
Battel, Roísín, 350n
Beer, Gillian, 6, 7
Bell, Diane, 34
Berndt, Ronald M., 50, 325
Biersack, Aletta, 93–94, 108, 116–119, 124, 130, 181, 248, 254, 277, 289, 358n, 360nn, 377n, 383nn
Bloch, Maurice, 82, 102, 174, 252, 362n, 364n, 380n
Bohannan, Laura, 367n
Bohannan, Paul, 367n
Bonte, Pierre, 152, 367n, 368n
Boon, James A., 311
Bourdieu, Pierre, 9, 172, 303–304, 364n, 365n
Bowden, Ross, 64, 358n
Bowles, Gloria, 350n

Boyd, David, 55, 358n
Brindley, Marianne, 233, 243, 375n
Brown, David J. J., 371n, 379n
Brown, Paula, 5, 50, 166, 352n, 378n
Buchbinder, Georgeda, 71, 186, 377n
Bujra, Janet M., 25, 355n

Caplan, Patricia, 25, 355n
Carrier, James, 353n
Caulfield, Mina Davis, 362n, 366–367n
Chodorow, Nancy, 355–356n
Chowning, Ann, 5
Clay, Brenda J., 174, 183, 185, 186, 190
Clifford, James, 175
Collier, Jane F., 47, 139, 383n
Cook, Edwin A., 5
Counts, David, 289
Counts, Dorothy, 189
Crain, Maurice, 351n

Damon, Frederick H., 192–199 passim, 202, 203, 205, 267, 366n, 370nn, 374n, 379n, 380n
de Courtivron, Isabelle, 9
de Lepervanche, Marie, 48, 50
Dundes, Alan, 65, 126, 359n, 361n

Eisenstein, Hester, 24, 28–29, 349n, 381n
Elshtain, Jean Bethke, 9, 24, 30, 312–313, 343, 350n, 354–355n, 381n
Endicott, Karen Lampell, 141
Ennew, Judith, 349n

Subject Index

Abelam (Middle Sepik), 125, 360–361nn
Aesthetic: as constraint, 189, 286–287, 328; of form, 180–181, 188, 190; judgment, 277–278, 281
African: kinship theories, 104; models in New Guinea Highlands, 50
Agency: and incompleteness, 222; transformed, 156–157
Agent, 268–305 passim; appearance of, 277, 288–289; distinguished from 'person', 273; as individual actor, 231, 302; Melanesian concept of, 272, 324, 333, 337; as subject, 268–274; transformed, 156–157; Western concept of, 137, 140–141, 158
Alienation, 142, 151–159 passim, 160–162, 193, 367–368n; in commodity relations, 162
Alternation: between aesthetic forms, 182, 201, 298; between two types of sociality, 14–15, 96–97, 187, 188, 284, 287, 380n
Analysis, as literary form, ix, 6–8, 17–18, 309
Analogic: gender, 298–305; kinship, 278
Analogy, 14, 30, 31, 182; between clans, 259; between male/female, 185, 233–234, 241–243, 298–302, 304, 373n; between persons/substance and wealth, 207–209, 213, 229; between relations, 278; semen and blood, 216, 245–248, 376n; semen and milk,

210–219 passim, 242, 248; between societies, 30; between substances, penis and breast, 210–219 passim, 361n, 373n; yam and child, 235–239 passim
Ancestors, 54, 80, 112, 181, 235, 253, 263
Androgyny: of boys in homosexual ritual, 212, 215; as 'completed' persons, 222, 262, 302; image of, 14–15, 122, 125–132, 184–185, 298, 369n; wealth in form of, 201, 205
Anthropology and feminism. *See* Feminist anthropology
Anthropophagy, 114–115, 360n
Antagonism, between sexes. *See* Sexual antagonism
Appropriation of labor. *See* Control
Arapesh (Middle Sepik), 286, 361nn, 380n
Audience, 118, 181, 260, 286, 289–291, 293, 383n; unity of, 278, 379n
Australia, Aboriginal, 47, 351n
Authorship: of acts, 140–141, 158, 273; of convention, 319, 322–323, 329; Western concept of, 104, 119, 135, 155, 162
Autonomy: in personal action (Hagen), 89–90; Western concept of, 157–158, 322, 324
Avatip (Sepik), 286
Awa (Eastern Highlands), 358n

Note: Locations in Papua New Guinea are in some cases designated by geopolitical or linguistic region rather than by province.

Designer: U.C. Press Staff
Compositor: Prestige Typography
Text: 10/13 Sabon
Display: Sabon